Jack

Ja

THE LIFE AND
MANY LOVES OF
JACK NICHOLSON

ck

THE GREAT SEDUCER

Edward Douglas

HarperEntertainment

An Imprint of HarperCollins*Publishers*

HarperCollins books may be purchased for educational, business, or sales promotional use. For information please write: Special Markets Department, HarperCollins Publishers Inc., 10 East 53rd Street, New York, NY 10022.

FIRST EDITION

Designed by Renato Stanisic

Printed on acid-free paper

Library of Congress Cataloging-in-Publication Data

Douglas, Edward.
 Jack : the great seducer / Edward Douglas.—1st ed.
 p. cm.
 ISBN 0-06-052047-7 (hardcover : alk. paper)
 1. Nicholson, Jack. 2. Motion picture actors and actresses—United States—Biography. I. Title.

PN2287.N5A64 2004
791.4302'8'092—dc22
[B] 2004042487

04 05 06 07 08 WBC/RRD 10 9 8 7 6 5 4 3 2 1

For William M. Mendenhall, M.D.
"Doctor Bill"

To catch the life that throbbed behind the work, this is our task.

—LEON EDEL, *HENRY JAMES*

Contents

Prologue

No Need for Viagra

One of the most surprising things Cynthia Basinet saw during her millennial love affair with Jack Nicholson, the leading American actor of his time, with seventy-eight movies in forty-five years, was the sight of the legendary superstar, who was worth $250 million, bringing home a doggie bag from a caterer's spread.[1] "He'd come home with the food from the set, all this Mexican refried beans and shit," Basinet said.[2] During the same decade that he reaped $50 million for *Batman*, in salary and a brilliant back-end deal that gave him a share of merchandising—T-shirts, motorized Batmobiles, and a dozen other related items—the humble doggie bag seemed extraordinary to Basinet, as it would to anyone who saw him toss the bartender at the 2003 SAG Awards a $100 tip for a single glass of wine,[3] but it after all only encapsulated the essence of the character of Jack Nicholson—the serious actor who would do any concept movie (including Adam Sandler's *Anger Management*) if the price was

right, the great lover who couldn't keep a woman, the generous friend and husband who helped the former wife and mother of his son pay for a $600,000 house and later tried to repossess it and evict her. "Don't ask him to put out $100 for dinner, but if you need $100,000, there's no problem," producer Harold Schneider said.[4] He was a nest of contradictions carried to unimaginable extremes, just as his dancing eyebrows and flashing smile, the most familiar trademarks on the world's screen since Brando's biceps, concealed an unfixably morbid inner life. But whatever his issues, they haven't interfered with his reign as one of the world's favorite personalities, from the time he flashed his irresistible charm in *Easy Rider* in 1969 to his Oscar-winning curmudgeon in *As Good as It Gets* in 1998, his masterful turn as a hollow man in 2003's *About Schmidt*, and his aging playboy in 2004's *Something's Gotta Give*, a film that bears remarkable parallels with the actor's personal dilemma.

"He hadn't fallen in love since Anjelica [Huston], he said to me," recalled Basinet. "The saddest thing about Jack is, I know that man loves me more than anything in the world, but he does not know how to love, or he loves in a mean way. I had to teach him to love. You have to walk him along." As Alexander Payne, Nicholson's *About Schmidt* director, observed, great actors "have a very special relationship with the camera—it's almost as though they're able to tell the camera things they can't tell any single real person."

Asked how she first met Nicholson, Basinet said, "You come to this town as a model, who else are you going to meet? I mean, if you like to have a good time, you're used to a certain energy, and you're hitting the nightclubs." Actually, the first time she saw him wasn't in Los Angeles but in France, where, already a red-haired, raving beauty, she was working as a model. One night, she went to a Paris nightclub with some friends, including a man she'd been dating. Nicholson, who was often attracted to models, sat at a nearby table with director Roman Polanski, a close friend, and

some others. Cynthia was feeling ill at ease that evening. "All these friends of mine were together because of me, but we weren't really relating," she later recounted. "I felt really lonely." Then she spotted Nicholson, who didn't seem to be paying any attention to his companions, either. "He smiled at me as if he realized I was as lonely and stranded as he." Somehow she related to him more than to her friends; it was as if both she and the famous stranger wanted "something more" out of life—and that life itself was never quite enough, that reality had fallen short of their dreams. "It was just a brief encounter, when our eyes met," she recalled, but it set something in motion. "What I had been envisioning in an ideal man was actually embodied in one: Jack."

She'd first been struck with the actor when, at twenty-two, she'd seen *Terms of Endearment*, around the time she was breaking up with her husband, but her awareness of the star went all the way back to her childhood in the San Fernando Valley, where she'd been born to a mother who was an artist and a father who was a working man. When the family moved to Northern California, she grew up wanting to be a singer, but most of her free time was devoted to looking after a retarded brother. She was eight or ten years old when her father saw Nicholson in *Easy Rider* and was so impressed he started riding his motorcycle again. "I felt as though my dad was grooming me to be a particular man's wife, and I grew up feeling a certain person would embody my dreams." She started to think about what would be her "ideal man, and to romance about him," and from about fifteen on, she began to have dreams about the house they would live in; it wasn't a mansion, wasn't even particularly fancy, and there was something very lived-in about it, almost rundown.

At nineteen, she married a "frigging spoiled brat"—an ex-baseball player who worked for a computer-parts distribution company in Northern California. They had a son, Jonathan, but

the marriage soon fell apart. She went to Los Angeles, where, instead of realizing her ambition to sing, she found it easier, with her natural beauty, to fall into modeling—and to postpone her music career for whatever man was in her life. Modeling led to the jet set and an engagement to a man who had an elaborate estate abroad. Shortly after this relationship ended, she encountered Nicholson at the Paris nightclub.

Back in Los Angeles in the 1990s, she saw the superstar again. "I often ran across him in Hollywood, and he'd come up to me in clubs and say something kind of inane. My girlfriends were saying, 'Guess who called me last night? Jack Nicholson.' He was hitting on everybody." For a while, they were no more than passing ships in the night. Still, she couldn't get him out of her mind, sensing a strange affinity that somehow already existed. When she started taking acting classes, the other students called her "a female version of Jack Nicholson." Then she heard that he was also going to be a guest at a Beverly Hills party she was attending, and decided, If he shows up, I'm going to make a concerted effort to talk to him, civilly, just to see what he's about.

The party was a very small one indeed. There were only a couple of other guests, and one of them, like Cynthia, was a redhead. Nicholson walked in looking "really cool" in a Hawaiian shirt and clear horn-rimmed glasses. "It was just like my dad had shown up," she recalled. "Jack had some Jim Beam and he went to put ice in it and then saw me and suddenly dropped the ice on the bar. He swooped down on it so fast, like no one would see it, and placed it in his glass, all the while trying to remain really suave. I thought he was so cute doing that. He came over and sat down next to me and started ranting on about what had just happened when he was in his car in traffic, and what had been playing on the radio." An odd sensation came over her as she realized some kind of ESP was going on between them. "He was expressing things I was already

4

thinking in my head," she remembered. "I also started to see how much he was like my dad—a union man, union boss, head of a plumbing company. Hanging out with Jack was like sitting in the garage with my dad and his friends."

Later, they gravitated to a couch and relaxed together, talking easily. Cynthia, without explanation or warning, lay her head on his stomach. "Uh-oh," Jack said, "I better, like, run to the bathroom." As he started to get up, she grabbed his arm, as if implying, You're not going anywhere. "I yanked him back down," she recalled. "In my mind, I'd already had signs that it was going to happen this way, and the symbol I'd been given in a dream had to do with stomachs. Six months prior to meeting Jack, I had this dream. I have a lot of prophetic ones that guide me in my life. In this dream I was getting married, but all I could see of the groom was his stomach, and it was Harvey Keitel's stomach." Keitel had been Nicholson's costar in *The Two Jakes* earlier in the nineties.

The day following the dream, she was invited to a barbecue, and when she arrived, she saw Harvey Keitel sitting in a Buddhist position, almost naked. "I could see his gut," she said, "and I thought, Damn, that's not the one. Though he wasn't my type, I sat back and enjoyed the party, letting the other girls enjoy Harvey. So, cut to this night with Jack, we go to sit down on the couch and for some weird reason, I feel like I'm home and I put my head on his stomach."

Not surprisingly, he invited her to go home with him. "I'd come to a fork in the road," she remembered, "and I said to myself, Well, I can either go home, which is nearby, or I can say, Well, Basinet, you can go with Jack, and become a woman who is led by her pursuits. I have nothing to lose. I'm not with anybody at the moment. If you step away, later you'll say, Oh, my God, and if you stay, he'll give you his stuff, the key to why it's succeeded for him for so long." She was at a place in her life, she later recalled, "when you realize,

you better pull back, find out why all these things give you a good time and then make a product from that." That's how she'd fallen into modeling after nightclubs and jet setting, and how, later on, she would decide to break into show business as a singer.

Though Nicholson was still in an off-again, on-again relationship with a former waitress named Rebecca Broussard, whom he'd cast as his secretary in *The Two Jakes* and who was trying, not very successfully, to become an actress, "he made it very clear he was available," Basinet said, "and so I didn't feel funky."

They left the party together, but she insisted on using her own car. "I don't trust a man that much to drive me," she said. Nicholson lived on Mulholland Drive, the high ridge of mountains that separates Beverly Hills from the San Fernando Valley, and when Cynthia walked into his house, she said, "Well, dang!" It was the same as the lived-in, time-worn house she'd seen in her dream years ago. "It had the same little baby kiddie piano in the entranceway. I had wanted one my entire life. My parents had one in the attic, but they'd never let me touch it because they were sure I'd break it.

"Jack's house was two-story, very family style, with a deck. Being raised on art and following artists' careers, I noticed his paintings. I had posters of the same frigging art he had on his walls, only his were the originals. And he had a framed quote by Eleanor Roosevelt in his bathroom. My first thought about his house was, It could be redone really cool. It needed some new energy. The kitchen's old. The whole place is kind of run down a bit. Jack wants to be loved so much that he helps so many other people and not himself, like not redoing the linoleum in the family room and the carpets. He's just caught in a mode."

And she was caught in his spell—that old Jack magic—especially when he put on some music, standard romantic jazz- and pop-era classics. "A key thing between us was always the music,"

she said. "We were a little wild, happy just to find somebody to play with. There were no servants there—it was the holidays—and we were both lonely. Suddenly, we were all over each other. He was a virile lover, though obviously well into midlife. This was just prior to the advent of Viagra, and there was no way he could have been on it. That man did not need Viagra around me. [Later, when Viagra went on the market, Nicholson was an early investor in the company,[5] and commented, in 2004, 'I only take Viagra when I'm with more than one woman.']6 He's just a really endearing person, and there was something else. I was taking acting classes, wanted to be an actress, and Jack Nicholson was an actor. I projected my fantasy on him, and he got it and played it back. Later, we relaxed and watched TV."

He brought out another stack of recordings. "People send him a lot of recordings so he has lots of music," she said. "He used to make cassette tapes of his favorite songs, putting them all together. He has such a great knowledge of music. He remembers every frigging song."

Finally, they went down to the kitchen, where she gradually became aware of "weird little coincidences." They both liked to drink Earl Grey tea. Then, when she went to the bathroom, she saw that she and Nicholson used the same fragrance. "It was a flowery female one and a woodsy male one. I keep my perfume in the car, so I don't know if [he took it, but] it would disappear."

While still in the bathroom, she noticed that it was "filled with all these great paintings, including a Picasso, nudes, and little pencil markings, like the ones I used to make to chart my son's growth in height through the years. I stood there trying to figure out how old his daughter was, and whether he'd let her come in there, because—well, you know how sexuality is perceived, and there was a painting that, when you sat on the toilet, you looked at. Picasso or something, a woman lying back. I'm not saying there's anything

bad with your daughter seeing nudes, but she needs to validate her own insides before you start showing her projected images, especially when you're a father who's known to have issues of [sexuality]."

They continued to hang out that night, and then, as she started to leave, they shook hands.

"No matter what happens, let's be friends," she told him. He nodded and said, "We'll always be friends through thick and thin."

For the next two weeks, she occasionally thought about his daughter and the bathroom nude painting, and when she saw him again, he asked her, "You think it's okay that I bring 'Lorraina' [in the bathroom] and measure her height?"

"I was thinking about it last week," she said. "You can judge [for yourself], but I would get rid of that picture across from the toilet."

From that moment on, "we were together, and we were friends, then best friends," she said, "and we couldn't wait to talk to each other. More than anything, I just knew that this was a neat friendship." As lovers, they were always growing and changing. "It was wild in the beginning but then after a while, it was like the key just fit. It was like home." He wasn't a movie star to her anymore; just "that cute guy that sang to me and danced for me."

In the routine they developed, Nicholson came to her place Sunday evenings after spending the day with his two young children, usually wearing a golf sweater and khakis. "I fit into his life better that way, helping him wind down and start the week; I just felt we could get along better after he saw the kids on Sunday. Then I got confused about what day it was, and the first time he came to my house, it took him two and a half hours. He'd been way out in Malibu with Sean Penn [Nicholson's director for *The Crossing Guard* and *The Pledge* in the nineties]. Then he arrived at his house and called, and I still coaxed him to come. Later, when I realized

how fast he'd been driving, I was sorry I'd urged him to come. I thought, You don't have the right to play with another person's soul. Nor do you have a right to jeopardize [the Jack Nicholson industry]. A lot of people are very dependent on the commerce he creates. For four decades, people have been making money off him, and in time I would try to protect him from people using him, because it totally drained his energy. Gradually, I realized we were both alike in that we have a bit of the chameleon in us. We completely come in and project who we are, and take over a room and goof with it. Or, especially when the company is interesting, we mold ourselves into the group. Jack is wonderful to talk politics and music with."

Eventually she met Nicholson's old friends Warren Beatty and Robert Evans. The latter held court in his Beverly Hills mansion, but Cynthia found to her surprise that she couldn't relate to his friends, let alone take over the room. "I knew Bob from before Jack, but I just didn't want to be with those people. Sometimes he would just have these two women there. One time I met a couple of women up there and they were talking, and I could see that they just had a different reason of why they were in Hollywood, and what they were getting out of it, which is fine." Unlike Basinet, the glamour girls at Evans's house never seemed to be working on a project, and Basinet always had one in development, her current interest being "a book on facials."

Presumably that was a topic that would have interested the world-class beauties who flocked to Evans, but Basinet couldn't extract any feedback from these girls, who, she decided, didn't appear to spend much time thinking. She gave up on the scene at Evans's house, but elsewhere in L.A., whenever she found herself surrounded by superstar trendsetters and rich, fashion-conscious consumers, she regarded everything they did and said as potential merchandising opportunities, products or practices to go national

with, whether as a beauty expert, health guru, physical trainer, New Age counselor, nouvelle cuisine chef, or, ideally, as a performer. California was the breeding ground of them all.

"I ran into Warren [Beatty] twice," she remembered. Many of Nicholson's memories were tied to Beatty; the two men had in common a "history of the way you treat women and the way you are," she said. "I think Jack has just such a brilliant mind, and I think Warren's a charmer. Jack's mind is learned, absorbed knowledge, not like Warren's freethinking. Jack's a lot more sincere, more cerebral.

"Jack began trying to find what would keep me around, what it was I wanted. We were so shy of each other that he would shake around me. His fame couldn't buy me, not even when he put his Oscars in front of me. We really didn't talk about work or movies; we talked about ourselves. I'd buy him Godiva chocolates, but the smallest little box, so he could eat the whole thing. The guy's a genius, but he'd kind of lost his mind at this point and I began to suspect that it was too much work to have a relationship with this man. There were just too many walls to scale. He gave me a necklace and told me that it was paste [fake]. I wore it, and about a week later, my neck turned green."

"You know," Cynthia told him, "the necklace you gave me is turning green. Why would that be? It must not be real gold."

"It's not?" Nicholson said. "I think I paid two hundred dollars for it."

As Basinet would discover, loving Jack Nicholson would turn into both an obstacle course with increasingly difficult hurdles, and a maze with no way out, like the treacherous hedge that defeated Jack Torrance in *The Shining*. Along with the experience of some of the other noncelebrities who loved Nicholson,

Basinet's time with him followed a pattern strikingly unlike that of such public personalities in his emotional life as Michelle Phillips, Anjelica Huston, and Lara Flynn Boyle. In the non-celebrity configuration, repeated over and over, an obscure woman became obsessed with Nicholson after making love with him, was ardently sought and courted, but strictly kept in the background, in an atmosphere of secrecy. These became the women of the harem, an unofficial, unstructured, floating sorority in which the members never met one another, but were all too aware of one another's existence. Nicholson seemed to want them and at the same time was repelled by them, a strange but unmistakable echo of his initial experiences with women—his grandmother, whose child he thought he was; his mother, who told him she was his sister; and his aunt, who also passed as a sister. These three extraordinary New Jersey women were responsible, in their well-meaning but lying ways, for bringing him into the world and raising him without ever letting him know that he was illegitimate, or who his true parents were. Denied his own mother, he would, in a sense, and perhaps understandably, never forgive womankind.

So much was going on in Nicholson's heart, too much for Basinet to deal with, like the ghost of Anjelica Huston and Nicholson's seventeen-year affair with her; Rebecca Broussard, the mother of two of his children, Ray and Lorraine, both born in the nineties; and the hellcat TV-series actress Lara Flynn Boyle, whose power over Nicholson seemed total and unbreakable despite frequent fights and breakups. How, in the midst of all this, could a warm and viable love affair proceed? Basinet knew she would be entering a world unlike any she'd ever known, but at least she'd be with a man who was her ideal friend and lover, possibly offering precious opportunities from the red-hot center of Hollywood power.

Young, talented, pretty, and with many available options for a safer life, she decided to plunge into Nicholson's world, headlong

and holding nothing back. They made quite a match, Nicholson with "that little bit of male fascism that makes him dangerous, and, hence, attractive," as *New Yorker* critic Pauline Kael once wrote, and Basinet, with her steely tenacity that would prove, as Nicholson discovered, as strong as her devotion.

Chapter One

THE PRINCE OF SUMMER

Just as Nicholson ultimately became remote and unattainable for Cynthia Basinet, so were his parents forever distant from Nicholson. "I became conscious of very early emotions about not being wanted," he said, "feeling that I was a problem to my family as an infant." Quite literally, his parents would never permit him to know them—not even their real names or exact relationships.

According to one theory, his father was a man named Don Furcillo-Rose, who impregnated Nicholson's mother, June Frances Nicholson, then a beautiful, red-haired, seventeen-year-old New Jersey girl and aspiring movie star, who'd been courted by gangsters and prizefighters, and appeared as a showgirl in a Leonard Sillman revue on Broadway. Furcillo-Rose, a song-and-dance man who'd worked the Jersey Shore with various bands, was married to another woman and had already fathered a son. Angry and outraged, June's mother, Ethel May, banished him from her pregnant daughter's presence in 1936, months before the birth of Jack Nicholson.[1]

According to another theory, Nicholson's father was a band-leader/pianist/dance-studio owner who'd played the Jersey circuit with Jackie Gleason; his name was Eddie King, and he had featured June Nicholson on his radio show *Eddie King and His Radio Kiddies* before getting her pregnant. Later, threatened with deportation as an illegal immigrant, King went into hiding in Asbury Park, fearing that admission of having sex with a teenager would get him into even deeper trouble with the law. He was finally cleared and later married an employee at his dance studio.[2]

Even June herself wasn't sure who Jack's father was, and as Jack would later put it, he belonged to his "own downtrodden minority: the bastard."[3] Putting the best possible face on his illegitimacy and its inevitably destabilizing effect on his life,[4] he convinced himself that he had "the blood of kings flowing through my veins."

Jack's thirty-nine-year-old grandmother, Ethel May Nicholson (or "Mud," as he later nicknamed her), was a slender, pretty brunette. Gifted as a seamstress and painter, she was capable of taking care of herself and others, which was often necessary. Her alcoholic husband, a dapper window dresser named John J. Nicholson, decorated for Steinbach department stores in Asbury Park, but disappeared on binges and could be counted on for nothing. When Ethel May learned that her daughter was pregnant out of wedlock, she made an extraordinary decision. As the only female in the house who was married, Ethel May would assume the baby's parenting, even claiming to be his mother. Her decision was tacitly accepted by John J., June, and Lorraine. "You can't imagine the stigma and shame for a mother and child in that situation at that time," said "Rain"—Nicholson's nickname for his pretend sister Lorraine—who was fourteen when June became pregnant.[5]

After considering abortion,[6] June crossed the Hudson River to Manhattan and remained there until the baby's birth, on April 22, 1937, at Bellevue Hospital. When Jack was two months old, she

returned home. Lorraine related, "Right after that, [June] got a job and was gone, which was OK. Mud just grabbed that baby and made him hers. My mother lived and breathed Jack. Everything Jack did was great to us." Neighbors naturally gossiped, speculating on the identity of the father, many of them later noticing the resemblance between Jack and Eddie King, but eventually they accepted that the boy was Ethel May's "change-of-life baby." Jack grew up thinking that June, his true mother, was his sister, and that Lorraine, his aunt, was his other sister. When Jack was in his teens, Lorraine was tempted to tell him the truth—that June, not Ethel May, was his mother—but she held back, and he continued to live in ignorance until he was thirty-seven years old, long after he'd achieved stardom. "They were both so afraid of losing him," Lorraine recalled. Ethel May and June suspected, not surprisingly, that he'd lash out at them in rage for practicing such gross deception. "He grew up with three mothers," Lorraine added, "and even though he wasn't close to June, no one ever deserted Jack."

Though it was a merciful act in many respects, Jack was surrounded by crafty and deceitful women, a situation that would forever influence his attitude toward women. "Jack has a right to be angry—a legitimate beef," Lorraine said in 1994. "If he's got hangups today, they're legitimate, too." Not until 1974, when he was contacted by a *Time* magazine reporter researching a cover story, was the secret so long and scrupulously guarded by Ethel May, June, and Lorraine finally exposed. Upon learning that he was illegitimate, Jack was devastated, his entire sense of identity undermined and savaged, but at last he understood why he'd always felt like a second-class citizen, and why his lack of self-esteem always destroyed his love affairs and attempts at marriage. In 1975 he referred to "a terrible realization I had as an infant that my mother didn't want me . . . and along with that came desperate feelings of need. Basically . . . I relate to women by trying to please

them as if my survival depended on them. In my long-term relationships, I'm always the one that gets left."[7]

Denied his real mother, he would never stop searching for her, and all his intimate relationships with women would be shaped by what had happened there on the Jersey Shore. "Somehow," he later ruminated, "in the sexual experience, I was making the woman into a sort of a mom—an authoritarian female figure; that made me feel inadequate to the situation, small and childish. I indulged myself in a lot of masturbatory behavior. I solved none of these problems in therapy. I worked them out for myself, but any of them might reappear."[8]

As journalist Chrissy Ulley sagely wrote in the *London Sunday Times* in 1996, "Despite this 'I love women, I love the company of women' line that he's always pushing, you know for sure that the reverse is true—that men who love women like this are in awe of them, they fear them, they don't understand them, but they understand how to play them, how to hurt them, how to make it work."

The wild philandering of Jack Nicholson, America's preening Don Juan, a pioneer and hero of the sex revolution of the sixties and seventies, was a reaction to his own bizarre, traumatic, and troubled childhood. "Under the circumstances, it's a miracle that I didn't turn out to be a fag," he said.[9] What he didn't escape, however, were "castration fears"[10] and "homosexual fears."[11]

The most urbanized, densely populated state in the United States, New Jersey is a noisy, blue-collar melting pot, but at the same time, beautiful in places like Cape May, rich in history, and one of the key cradles of American independence. In 1776, Gen. George Washington staged a surprise attack against the Hessians at Trenton, followed by the Revolutionary Army's victories at Princeton—

which briefly became the U.S. capital—and Morristown. In 1904, Mark Twain and Henry James met at the home of their publisher, Harper's Col. George Harvey, at Deal Beach. Jersey was the home of three of America's best-loved poets, Walt Whitman of Camden, William Carlos Williams of Rutherford, and Allen Ginsberg of Paterson. At Princeton University, Woodrow Wilson was chief administrator before becoming president of the United States and Albert Einstein dreamed up the atomic bomb. The first movie was made there in 1889, Thomas Edison established the first movie studio near his labs in West Orange in 1892, and the first drive-in theater opened in Jersey in 1933. The state also lays claim to the first pro basketball game, played in 1896.

Jersey was the home of Terry Malloy of *On the Waterfront*, Tony Soprano, Joey "Pants" Pantoliano, the Amboy Dukes, Paul Robeson, President Grover Cleveland, Count Basie, Connie Francis, Whitney Houston, Meryl Streep, and Frank Sinatra, whose mother, Dolly, performed illegal abortions in Hoboken. The fabled Jersey Shore—127 miles from Sandy Hook to Cape May, dotted with holiday towns ranging from skanky to tony—spawned Jack Nicholson, Bruce Springsteen, Danny DeVito, and the annual Miss America contest at Atlantic City. Just a stone's throw from the beach and the famous boardwalk, Nicholson grew up in the middle-class section of Neptune City. "I was never an underprivileged kid," he said, and added, ironically, "I caddied at very nice golf courses."[12]

But he could also admit, "I lived a tense life . . . I never had great relationships with my family."[13] In local bars, the man he called his father, John Joseph Nicholson, whom he'd later discover was his grandfather, would put away thirty-five shots of three-star Hennessy while Jack drank eighteen sarsaparillas. John J. was a "snappy dresser" and a "smiley Irishman," cheered at firehouse games as "a great baseball player" before he discovered apricot

brandy. Many years later, in 1987, Jack's love for John J. would be immortalized in his sympathetic portrayal of him as the Francis Phelan character in one of his best films, *Ironweed*. "I never heard him raise his voice," Jack recalled. "I never saw anybody be angry with him, not even my mother. He was just a quiet, melancholy, tragic figure—a very soft man." Before long, John J. disappeared, abandoning his family, though, like Francis Phelan in *Ironweed*, he occasionally and unexpectedly showed up, usually at Christmas, perhaps toting a raw turkey, as in *Ironweed*.

At 2 Steiner Avenue, in a roomy two-story house near Route 35, the Nicholson family's circumstances steadily improved as the independent and resourceful Ethel May established her own small business as a hairdresser, running a beauty parlor out of her home. Although her well-to-do Pennsylvania Dutch Protestant father, who was president of the Taylor Metal Company, had disowned her for marrying John J., a Roman Catholic, her family eventually forgave her and lent her the money to purchase a permanent-wave machine and beautician lessons in Newark.

After Jack's real mother, June, left home to tour as a dancer on the road, she married a handsome test pilot, Murray "Bob" Hawley Jr., during World War II, and remained in Michigan, where she'd been stranded in 1943. "She was a symbol of excitement" to Jack, who remembered her as "thrilling and beautiful." Lorraine, June's younger sister, married a railroad brakeman for the line that later became Conrail; George "Shorty" Smith, a former all-state football player, served as Jack's mentor and surrogate father. Shorty was an irresistible charmer and ladies' man, and Jack doted on him, later affectionately describing him as a barfly bullshitter. Obviously it was from his family that Jack Nicholson picked up two important lifelong loves: showbusiness and sports—and perhaps something else. Speaking of Shorty, Lorraine said he was an alcoholic, but so beguilingly "sweet" that women would let him get away with

anything, including "pinching boobs, that most men would've been killed for."[14]

Jack once described himself in childhood as "a Peck's Bad Boy and a freckle-faced mischief-maker."[15] Lorraine agreed and went even further, adding that he was spoiled rotten, lying down on the floor and throwing kicking and screaming tantrums by the time he was six. He insisted on Ethel May's undivided attention, and if she so much as left him to answer the phone, his temperamental demonstrations "rocked the house like an earthquake," Lorraine remembered. Understandably, years later, when he delivered the murderous "Heeeere's Johnny!" line in *The Shining*, very little rehearsal was required.

The troubled child was "overweight since I was four years old," Nicholson later said.[16] He would emerge from his origins in a houseful of women with a cynical philosophy about relations between the sexes: "[Women] hate us, we hate them; they're stronger, they're smarter; and, most important, they don't play fair."[17] Where such ideas came from, he perhaps unwittingly indicated in a 2003 press conference for *About Schmidt*, in which he described a melancholy preschool experience with Ethel May and Lorraine. "I'm one of the kids who actually got coal for Christmas one year," he said. "I had sawed the leg off the dining room table and then refused to cop. They went all the way down the line with me. I opened the package and there it was—coal." He cried so hard the women finally relented and gave him his real presents—a sled and a baseball bat. "I had my way in the end," he said.[18]

Early passions included the movies (he was a fan from the time he caught Bing Crosby and Barry Fitzgerald in *Going My Way* in 1945); sports (football and baseball; John J. took him across the river to see Mel Ott hit a homer); and comic books. "*Batman* was my favorite," he said, and added, "The Joker was my favorite character." After playing the Joker in 1989's *Batman*, he remarked,

"There are certain parts people say you're born to play. The Joker would be one of them for me."

Significantly, the Joker was a dark, malevolent figure, and in Nicholson's youth, the sense of something sinister was never far from his consciousness, the feeling that something was wrong with him—an ineradicable fatal flaw he could not escape. At six, he visited June and her husband, Murray, in Michigan, where the mother and son's resemblance did not go unnoticed. Jack decided he wanted to stay, and Murray's sister Nancy Hawley Wilsea was present the day he wouldn't let go of June, screaming, "Don't let her fool you. She's really my mother. . . . Please, I want to stay."[19] Nicholson later denied that he'd ever caught on to the deception: "I never heard anything. Either that or I had the most outstanding selective hearing imaginable. It doesn't matter. I had a great family situation there. It worked great for me."[20]

When June and her aviator husband, Murray Hawley, moved east, Jack spent more time with them. Scion of an old, established Connecticut family, Murray was the son of a noted orthopedic surgeon, and Murray and June lived "a very country-club life in Stony Brook, Long Island, where I always spent my summers in this very nice upper-class atmosphere," he later told *Rolling Stone*.[21] He grew close to their daughter, Pamela. Born in 1946, she was Jack's half-sister, nine years his junior. Pamela would call him "Uncle Jack" until it was disclosed in 1974 that they were actually half-brother and half-sister. June's marriage also produced a son, Murray Jr., before it ended in divorce.

Basketball was Jack Nicholson's chosen sport; he participated in the game at Theodore Roosevelt Elementary, near Shark River, in an area adjacent to a black ghetto, "so my early basketball experience was being the token white," he recalled. Already a streetwise hustler, Nicholson used the game as a way to cheat people out of their money. His friend Dutch Nichols remembered that every

weekend, he and "Chubs," as he referred to the perpetually over-weight Nicholson, would grab a basketball and follow the railroad tracks to Bangs Avenue, a dangerous Asbury Park neighborhood, dribbling all the way. They played two-on-two with any willing sucker, deliberately losing and then raising the stakes, starting at a dollar and quickly escalating to five dollars.

"Dutch would be shooting around," Nicholson said, "missing everything, looking geekish, and [I] would be just sort of looking like Chubs . . . built low to the pavement, crazy eyes and slower than Sunday traffic on the Garden State."[22] Occasionally the scam of purposely losing the first round stopped working. One day, their opponents demanded their winnings after one round, but Nichol-son complained that he was carrying the money in his sock.

"You don't want me to have to take off my shoe and sock and everything, do ya? Don'tcha wanna play again?"

After some grousing, his gullible victims fell for it, and lost the next round—and five dollars, which Dutch and Jack grabbed and scrammed.

"Good thing you had that money in your sock, Chubs, 'cause I didn't have a red cent," Dutch said.

"Dutch, the only thing I got in my sock is a hole," Jack con-fessed.[23]

Mrs. Ginny Doyle, who taught Nicholson from ages eight through twelve, said he "never did a lick of work and always got the highest marks."[24] He wasn't "bookish smart," she added, and he "preferred being known as the clown."[25] The pranks and jokes didn't fool Mrs. Doyle, who realized that "he was unhappy, disap-pointed by his father."[26] The male bonding that he missed at home was amply available at school, especially in the toilets, locker rooms, and on the basketball court, where he embraced it with a vengeance. "I had a preadolescent mild homosexual experience as a child," he said in 1972.[27]

Though a Protestant, Ethel May gave her children a Catholic upbringing, deferring to John J.'s religion, and Jack was baptized in 1943 at the Church of the Ascension in Bradley Beach. He "sought out Catholicism on his own," he said, and he considered it "a smart religion," but he ended up an agnostic.[28] His only religion was, and remains, show business, which he was already so obsessive about as a boy that he sat through *The Babe Ruth Story*, the 1948 biopic starring William Bendix, five times. After that, all he talked about was acting. At school, he was invariably the first to volunteer for variety shows, and, in the eighth grade, he "sang ['Managua] Nicaragua' in a very fabulous Roosevelt family school variety show," he recalled. "I was supposed to be Frank Sinatra; my costume was a crepe paper, yellow and red, like Phillip Morris, and I thought, What does this have to do with Frank Sinatra?"

By the age of fourteen, "Chubs" stood at five feet nine, had dark brown hair, brownish green eyes, and slightly pointed ears, and was still running to fat, weighing 180 pounds.[29] The family moved to a flat at 505 Mercer Avenue in Spring Lake, a few miles south of Neptune. He started high school in 1950, when rock 'n' roll hadn't yet begun, but cool was in, spearheaded long before Elvis Presley by Ray Charles and Johnnie Ray. "I started off with Harry James," he said, "then *South Pacific* and all those wonderful old songs. [Although] we're the original rock 'n' roll generation, there's a crease in between there, a certain era of music that's never been revived, songs that were hits when I was in grammar school: 'A Huggin' and a-Choppin',' 'Open the Door, Richard.'"[30]

Classmates at Manasquan High School differ in their accounts of Nicholson's social status. Nancy Purcell, today a sixty-eight-year-old Unity Church minister and mother of three daughters in Lynchburg, Virginia, recalls him as "everybody's friend. A real outgoing, fun kid."[31] A less charitable classmate referred to him as "a fat Irish kid who wasn't good enough to play basketball so he man-

aged the team and worked the scoreboard."[32] Nicholson went out for freshman football but was too runty for the varsity; he also went out for freshman basketball and later made high claims for his performance as the "sixth man" who "steadies the team."

Whatever his ability, and despite his lack of self-esteem, Nicholson was a popularity-seeker nonpareil, and sports was the surest route to acceptance in Manasquan's in-crowd of jocks and cheerleaders. Having popular friends gave him the feeling of self-respect he lacked inside. "Someone like me always worries about the cataclysmic experience that might jerk away the facade and expose you as the complete imbecile that, deep in your heart, you know you are," he later said,[33] adding, "peer group was everything."

He successfully cultivated a cool attitude, imitating the style of the class favorites he observed at their hangout, the Spring Lake canteen in the local library's basement, where the boys wore pegged corduroys, single-button suit coats, and stiletto thin ties. "It was the age of the put-on," he said. "Cool was everything. Collars were up, eyelids were drooped. You never let on what bothered you. . . .[34] There was a lot of visible rebellion, aside from the D.A. haircut. I used to like to go to school in a pair of navy-blue cuffed pegged pants, a black or navy-blue turtleneck sweater, maybe a gray coat over it, and a black porkpie hat that I'd gotten from the freeway in a motor accident that involved a priest."[35] One of his classmates was future astronaut Russell Schweikert.[36]

With Nicholson's wit and creativity, he was able to charm the golden ones, and soon was going with them to the beach, to New York, or the Algonquin Theater on Main Street in Manasquan, watching his favorite actors, Marlon Brando and Henry Fonda. He wrote sports stories for the school newspaper, *The Blue and Gray*, and, foreshadowing *One Flew Over the Cuckoo's Nest*, played a nut case in a school production of *The Curious Savage* by John Patrick.

"When we had a dance you just got the greatest suit you could get a hold of," he said. "Always pegged, pleats, blue suedes, thinnest tie, shoulders, one button in front." In 2003 he added, "My records were played at school dances." Classmate George Anderson stated, "Jack wasn't one of the heroes, but he made them his friends."[37]

Basketball, Nicholson once said, "is the classical music of sports. It's a question of match-ups, plays, grace, strength, speed—the most competitive game, bar none."[38] In his sophomore year he was busted down to equipment manager, keeping score and looking after uniforms and balls. His uncontrollable temper got him into trouble when, enraged by a rival team's stratagems, he invaded their locker room and trashed their equipment. Thereafter, he was banned from all Manasquan sports.[39] "He was really not an athlete," explained George Bowers, Manasquan's assistant coach, but Dutch Nichols, one of the school's best athletes, defended Jack, blaming a "personality conflict" with the coach. According to Dutch, Nicholson knew how to dribble, was fast on his feet, and managed a neat outside shot.

After shedding his baby fat, Nicholson had a moderately athletic physique. People were beginning to notice his sharply etched facial features, all the more noticeable under his spiky crewcut hair and eagle-wing eyebrows.

One day in 1953, as he stood talking in the hallway at school with Nancy Purcell, who'd just broken up with her boyfriend, Nancy said she'd probably spend the senior prom night at home. Sixteen and still a junior, Nicholson said, "You have to go. I'll take you." That night he arrived at her house in a gray suit, and slipped a white carnation corsage on her wrist. She wore a black and white formal her mother had made, and remembered that Nicholson "was a great dancer." The prom ended with a jitterbug, and later they went to an après-prom party, then directly home. He was a

"sweet" teenager who "didn't kiss me goodnight," she said. "It was our one and only date."[40]

The psychological baggage he was carrying prevented the normal development of a healthy ego; he didn't particularly like himself, even disdaining his most unarguably attractive feature: "I don't like my smile," he said.[41] His Achilles' heel was "lack of self-confidence," he added. "Sometimes I'm not able to take in the positive communication that's directed at me because I'm not sure I deserve it."[42]

In his senior year he decided he wanted to become a journalist or a chemical engineer. Taking note of his keen intelligence and chiseled good looks—heroic brow, dazzling eyes, perfect nose, wide smile, and shining, even teeth—Lorraine urged him to leave home and make something of himself, but all he wanted to do at that point was have a good time. He and his friends would "go to New York on weekends, get drunk, see ball games, bang around. . . . School was out, we just went to the beach all summer. And had fun, getting drunk every night." Even friends who didn't necessarily like him or consider him attractive began to call him "the Great Seducer," he said, "because I seemed to have something invisible but unfailing." That something, of course, was charisma—star quality.

As a lifeguard at Bradley Beach during his sixteenth summer, he met his first movie actor, Cesar Romero, star of such Twentieth Century-Fox Technicolor extravaganzas as *Coney Island* and *Carnival in Costa Rica*. When Nicholson asked him what Hollywood was like, the Latin leading man said, "Hollywood is the lousiest town in the world when you're not working," but nothing could dampen Nicholson's elation that special summer, when he was lean, glowing with youthful handsomeness, and had all the right moves. He was "tremendously streamlined . . . in the water," his

future partner, Anjelica Huston, said years later. "Jack swims like Esther Williams."[43] Standing in a boat just beyond the breakers and sporting his mirrored sunglasses, white oxide on his nose and lips, a black coat, and a prisoner's hat, he preened for admiring girls from Teaneck, New Jersey. "When you got to be a lifeguard," he said, "you were the prince of summer. . . . It didn't do me much good, but a lot of other guys made a lot of hay with it. . . . Like most people of that generation, I didn't think I was adept at anything."[44] His classmates voted him both the class optimist and the class pessimist.[45]

He considered attending the University of Delaware but knew it would entail a "double effort" to afford it. "I was lazy," he said, "and I had been working since I was eleven." Now seventeen, he began to feel that his destiny lay in Los Angeles, where June had relocated in 1953. New Jersey, he decided, was "a futile state." After his graduation in 1954, he suddenly disappeared, flying to California on money borrowed from Lorraine. "I turned around one day and he was gone," said Dutch Nichols. "No goodbyes."

Nicholson had sound reasons for making a hasty exit, later explaining, "I think it's very important for people to have something to leave home for. . . . Otherwise, it's the gin mill and mom."[46] Ironically, if unwittingly, it was to his mom he was fleeing, though he still believed June to be his sister.

Harry Gittes, one of Nicholson's earliest Hollywood friends, said, "Jack's 'mother' wanted to be in the movies and so did he, and he followed her out here, not even realizing she was his mother at the time." He arrived in L.A. in September 1954, wearing the standard Ivy League fifties' uniform—sweater; poplin, khaki-colored windbreaker with a zip front; blue jeans; and penny loafers.

Staying with June and her children in an Inglewood apartment, he rarely ventured out for the first six months except to shoot pool or go to the beach or racetrack, where he'd sometimes win

$300 to $400 on the horses. "It was great, just like home," he said.[47] Finally, a big loss forced him to give up gambling. "I had no friends," he recalled, "I was living on my own. . . . I had no car. . . . It seemed like ninety years before I got to know some people."[48] Ethel May came out from New Jersey to help June, a heavy drinker, with her children, and eventually settled in L.A. herself.[49]

His half-sister, Pamela, who had a full face with freckles and bangs, was important to him, affording the hero-worship that helped keep his confidence up as he labored in a menial job in a toy store. June, a secretary at an aircraft corporation, refused to encourage his artistic side, fearing that he would get no further than she had. Both having bad tempers, they turned her apartment into a battleground. "She hated me," he said. "No, not hated me. I mean, we used to have incredible fights. She projected all her fears onto me. By the end of her life [she would die at forty-four], she was a total conservative and she saw me as a bum. She felt her own experiment had been nothing but doom. And there I was, this promising person frittering away his life as an unsuccessful actor."[50]

Retreating to the beach, Nicholson first tasted the heady, marijuana-scented atmosphere of the Beat Generation.[51] Jack Kerouac had visited L.A. in 1947, and by the midfifties his moral and cultural revolution had started on the West Coast. A few years later Janis Joplin would make Venice Beach her first California stop, long before she settled in San Francisco. In Venice, Nicholson discovered crumbling faux-Venetian palaces and canals filled with garbage, but Ocean Front Walk was teeming with the bikers and bohemians—the first-generation West Coast beatniks. In bull sessions at the Venice West Coffee House, the Grand Hotel, the Carousel, the Westwind, the Matchbox, and the Gas House, they formulated the beat agenda, defying authority and rejecting the values of a mainstream America obsessed with appliances, tail fins, and TV. "This scruffy, lazy, ineffectual, and inept bunch of

dropouts were actually engaged in a moral quest," said David Carradine, who read poetry at the Venice West before striking it rich in the *Kung Fu* television series and playing Woody Guthrie in *Bound for Glory*. "Thomas Jefferson, Thoreau, Gandhi, Socrates, Christ all told us to set out on this search; and they were all held up to us as models."

Nicholson loved making the scene, describing it as "jazz and staying up all night on Venice Beach."[52] In a 1969 interview, he added, "I'm part of the generation that was raised on the Beats, West Coast cool jazz, *Exodus*, Jack Kerouac. I think silent people make better movies anyway, since film is a visual medium. Silent Generation? I guess I'm not so silent myself. I'm maybe the spokesman for the Silent Generation."[53]

But as far as June was concerned, he was going to hell in a hand basket. A later friend of Nicholson's, John Herman Shaner, who appeared on television in *The Walter Winchell File* and *M Squad*, had drinks one night with June, and recalled, "She was bitter that show business had passed her by, and she didn't make it. . . . That is what she said: That she had a lot of talent and it was never recognized. And that she was worried about Jack. . . . She thought he was exceptionally smart. I'm not so sure she was happy about him being an actor."[54] More to the point, she wanted her son to get a job or go back to school and train for a profession. Later, Nicholson said, "I can imagine that at times of high conflict June was dying to say to me, 'Do it because I'm your mother, you prick!'"[55]

When the atmosphere in the apartment turned toxic, she finally kicked him out. Though he would nurse a grudge, it was as if he'd at last been liberated to get into the movies, and he walked all the way from Inglewood to Sunset Boulevard, traversing Baldwin Hills and trudging up endless La Brea. He didn't speak to June for over a year, later recalling, "She thought I'd had enough time to ex-

periment, that all I was interested in was running around, getting high, and pussy. Naturally, I strongly disagreed with her."[56]

The big lie hadn't worked for either June or Jack, creating confusion and anger all around. Not until decades later, when the truth was out, was Nicholson able to say, "Certain things about my relationship with my actual mother, whom I thought was my sister . . . were clarified when I learned the truth. Just small things, like body English. Your mother relates to you differently than your sister does. I felt a new empathy for my mother. I remember thinking, when my sister doted on me, What are you worried about? But of course a mother would worry."[57]

Clearly, he was getting nowhere fast in Los Angeles, either professionally or personally. Don Devlin, another early Hollywood pal, said, "Jack started his sexual career later than most of his friends. He was a very good boy, and behaved himself extremely well in his early years."

He could easily have sunk into terminal lethargy, and the world would never have heard of him. "I am an anti-work-ethic person," he said. "The only question I ever asked myself was whether I should have ever done anything at all."[58]

Then, one fateful day, he decided to go over to Culver City, to Metro-Goldwyn-Mayer, the largest of the movie studios, and try his luck.

Chapter Two

HIP, SLICK, AND COOL

In show business, the mail room is the traditional starting place for pushy, ruthless, sexy go-getters like Sammy Glick, the unstoppable protagonist of Budd Schulberg's novel *What Makes Sammy Run*. Helen Gurley Brown, David Geffen, Barry Diller, Mike Ovitz, Bryan Lourd, and Kevin Huvane are classic examples of shrewd trainees who plundered the mail-room files, reading big shots' letters and memos to learn the business.[1] It was on Metro-Goldwyn-Mayer's bottom rung, the cartoon-department mail-room, that Jack Nicholson landed, in May 1955, after applying to the studio's labor-relations desk "and going back until I found a moment when nobody had a cousin or a brother or anybody out of work," he recalled.[2]

He also "got into acting by being a fan—I wanted to see some movie stars." For $30 a week, he delivered messages and mail, largely for animation virtuosi Fred Quimby, William Hanna, and Joseph Barbera, creators of the Tom and Jerry Cartoons. A

starstruck eighteen-year-old, Nicholson spotted such celebrities on the lot as Gene Kelly, Rita Moreno, and Grace Kelly, and, in his spare time, helped organize a studio softball league, playing outfield. He also belonged to the animation golf team, having been introduced to the sport by June.

After moving into an apartment in Culver City, he acquired a black '49 Studebaker—and two roommates: a Jersey high school chum, Jon Epaminondas, who showed up in L.A. in the autumn of 1955, and a colleague from Metro known as "Storeroom Roger," who worked in the props department. Epaminondas, a sinewy ex-marine, was trying to make it in show business. Often, the three roommates went to the movies, after Nicholson decided what they should see. He chose topflight American fare like *Picnic* and *The Man With the Golden Arm*, or foreign films like Henri-Georges Clouzot's *Diabolique*. The era of art-house cinema was just dawning, and Nicholson's first great teachers were the "ini's," as he called them: Federico Fellini and Roberto Rossellini, as well as Michelangelo Antonioni, Ingmar Bergman, and Luchino Visconti. Finding little honesty in American film acting, he respected the gutsiness and earthy power coming from overseas, as well as the stark symbolism of Bergman.

On occasion the roommates triple-dated, making the scene on the Sunset Strip, where they hung out at the Unicorn, a coffee house–bookstore. One night at the Hollywood Palladium, during a sensuous slow dance to a big band, Nicholson ended up "shooting off into the girl." Running to the men's room, he blotted his trousers with toilet paper.[3] Another time, the three amigos picked up some Vegas dancers and repaired to the girls' apartment. "My point of view was simply to try to seduce everyone I could," Nicholson later recalled. "I had trouble with *ejaculatio praecox*. . . . [I'd] poke her eight times and right away [I was] coming." In order to bring his partners to orgasm, he'd get "the chicks off without

balling them through manipulation of some kind, or [I'd get] another chick to share the load." If he went three days without having sex, he'd become "filled up, and then I'd have a premature ejaculation, which is really a form of impotence. The root of it all was some kind of pleasure denial; it was pretty unsatisfactory for the women involved."[4]

Sometimes he had better luck having sex with a girl he didn't like. "I had a few hate-fucks and they were groovy," he said.[5] Later, with the help of Reichian therapy, he developed stamina as a lover, but he never achieved a satisfactory feeling about himself. Nothing would ever be enough, and life would always disappoint him, except when he was at the movies, which took him "away from reality, from what's outside the theater, for a couple of hours. I'm a romantic. I see reality, know how things are. . . . But I want them to be another way—something more." Women were a particular disappointment. "In my fantasy," he said, "I've wanted the women I've known to be that something more. I've let myself imagine that they have been. But I also see what they are. That's why I've never settled down with a woman."[6] His dissatisfaction with womankind—roughly half the population of the planet—amounted to a dissatisfaction with life in general, which sprang, of course, from his fundamental dislike of himself. Though attractive and likable as an adult, he would always be the lost child who felt unwanted, the overweight kid called Chubs, chasing after cheerleaders and jocks. Self-esteem and contentment eluded him.

In early July 1955, Nicholson's grandfather, whom he still thought of as his father, was hospitalized in Neptune with cancer of the colon and a heart condition, dying two weeks later of cardiac arrest. The loyal and steadfast Lorraine had cared for him throughout his final illness. Catholic burial followed on July 26 at Neptune's Mount Calvary Cemetery. Nicholson thought it prohibitively expensive to fly back to New Jersey "just to go to a fu-

neral."[7] Though he understandably had little respect for John J., he loved him dearly, and his influence would show up in many ways in the years to come—the glasses Nicholson would wear in *Easy Rider*; virtually the entire characterization of Francis Phelan in *Ironweed*; and Nicholson's dapper wardrobe, particularly his spectator shoes. John J. was basically a good egg, despite rampant irresponsibility, and as Nicholson grew older and learned that John J. was his grandfather instead of his father, it would become easier to forgive him for abandoning the family. "I certainly knew my father," he would say in 2004. "He just didn't happen to be my biological father."[8]

In Culver City, on the Metro lot one day, Nicholson caught the eye of producer Joe Pasternak.

"Hiya, Joe!" said the feisty messenger.

The veteran producer of *Destry Rides Again* and *The Great Caruso* arranged for Nicholson to have a screen test but later dismissed him as too high-voiced for the movies and advised him to "get some diction lessons and some acting classes while you're at it." Nicholson hadn't come to California to go to school, which sounded too much like work, and when Pasternak learned that his counsel had been ignored, he told Bill Hanna, "What's wrong with the kid—everybody wants to be an actor."

Nicholson certainly did, but hopefully via an easier path. Like Shelley Winters and Marilyn Monroe before him, he haunted Schwab's Drug Store on Sunset Boulevard. He went on casting calls and engaged an agent, Fred Katz, but Katz was a dinosaur from the age of vaudeville, and came up with no jobs. In the spring of 1956, Bill Hanna arranged for Nicholson to become an apprentice at the Players' Ring Theater on Santa Monica Boulevard near La Cienega, and Nicholson appeared in the small role of Phil, a prep-school student, in *Tea and Sympathy*, along with Felicia Farr (the future Mrs. Jack Lemmon), Edd Byrnes, and Michael Lan-

don. While the latter two scored TV series and went on to fame as Kooky in *77 Sunset Strip* and Little Joe in *Bonanza,* respectively, Nicholson toiled on in obscurity, but at least he made some valuable contacts at the Players' Ring, including Dennis Hopper, who had a leading role before dropping out to do a movie. Actor John Gilmore, who received good notices in William Inge's *A Loss of Roses,* recalled that Nicholson always seemed like an outsider, and Nicholson later explained, "I was on fire at this point inside myself, but none of it was visible to anybody; it was all covered up with fake behavior."[9]

His job at MGM was in peril. The movie industry had entered a period of radical change due to increasing competition from TV, which was still fairly new in the 1950s but catching on fast. Tightening its belt, MGM decided to eliminate cartoon and short-subject production, shutting down the animation department. "I thought, This is it," Nicholson recalled. "I'm not meant to be an actor. Then I didn't work for nine months, a year. I didn't make another penny. I [was] living on unemployment." At last he found work as an actor in television on *Matinee Theater,* where he was billed eighth in a cast of nine, and on *Divorce Court,* which paid him $350 a week. In his first year of acting, he earned $1,400; in his second, $1,900.

Unrewarding parts on television led to his lifelong disdain of the medium, which he referred to as "the cancer of film," the opium of a "post-literate generation."[10] Much more fulfilling were the dramatic classes he finally began to take, at the suggestion of a Metro pal, aspiring actress Luana Anders. Jeff Corey had coached James Dean, Pat Boone, Anthony Perkins, Dean Stockwell, and countless others in the garage behind his house on Cheremoya Avenue in Hollywood, charging ten dollars for two classes a week. A character actor who'd appeared in *My Friend Flicka,* one of Nicholson's favorite movies, and *Bright Leaf*, Corey was no longer able to

work in films because he'd run afoul of the House Committee on Un-American Activities (HUAC), which in the fifties thoroughly intimidated the Hollywood studio chiefs and landed many performers, directors, and writers on the infamous blacklist.

A classmate of Nicholson's, Robert Towne, an English major at Pomona who resembled Donald Sutherland, assured Nicholson he was going to be a star. Another classmate, Carole Eastman, was also supportive, but Jeff Corey was much less sanguine and even considered "terminating [Nicholson] for lack of interest." Fortunately, Nicholson "never got pissed off or uptight about criticism," Corey recalled. More impressed with Nicholson on the tennis court than in acting sessions, Corey said his student "played a very muscular game, like a New Jersey kid . . . ballsy, fun-loving." Often, before class, Nicholson played handball with Robert Blake, the former child star of *Our Gang* movies, later immortalized as Little Beaver in TV's *Red Ryder*, and, later still, as the suspected murderer of his wife Bonnie Lee Bakley.

When Nicholson's Culver City roommate Jon Epaminondas left for New York to study at the American Academy of Dramatic Arts, he found himself homeless, and had to count on Bob Towne to put him up, or on Ethel May, who lived in Inglewood, or June, who'd moved with her children to North Hollywood. In a pinch, he could always stay with Luana Anders or, better still, with his new girlfriend, Georgianna Carter, a blonde he met in acting class, whose parents always made him feel welcome. The first of numerous young women to believe he had matrimony in mind, Georgianna thought Nicholson "boyish," with a "soft look . . . which he lost somewhere along the line."[11] He took her to Ethel May's apartment for a fried-eggplant dinner, after which he treated the women to his W. C. Fields imitation. Ethel May liked Georgianna so much she gave her a permanent wave. "Pretty soon," Georgianna recalled, "I couldn't do without him."[12]

June sometimes drove to work with Georgianna, who was employed at JC Penney in the San Fernando Valley. Lorraine and Shorty also moved to California, and after Lorraine found work as secretary to a buyer, Nicholson brought friends to Sunday dinner at their apartment in Burbank. Everyone assumed that Nicholson and Georgianna would get married—everyone but Nicholson, who had his hands full at the time helping take care of June's children, Pamela and Murray. After her husband died of a brain tumor in Canada, June raised the children alone, and Nicholson contributed to their support.

Eventually Nicholson and Bob Towne, whom he nicknamed "Flick," took an apartment together in Hollywood.[13] They tried to pick up starlets, who were a notch above acting students in the Hollywood pecking order, but these ambitious girls weren't interested in nobodies.[14] The apartment-sharing experiment with Towne proved equally unsuccessful. "I tried moving in with Towne, but that only lasted one day . . . I don't think either of us was particularly easy to live with," Nicholson later recounted.

Although Marlon Brando, Montgomery Clift, and James Dean dominated the contemporary, naturalistic acting style, Nicholson decided to resist their influence, because they were "as great as it gets," and the public didn't "need any more of these people. . . . When I started off there were twenty-five people walking around L.A. in red jackets who looked exactly like James Dean because he was very extreme and quite easy to imitate—which missed the point entirely."[15] The great character actors of the past were his models—Charley Grapewin, Walter Huston, Walter Brennan, Edward Arnold, Charles Bickford, Spencer Tracy, and Humphrey Bogart, who depended less on naturalism than old-fashioned theatricality. He also admired Steve Cochran, the raven-haired, virile heavy in *The Best Years of Our Lives*, *Storm Warning*, and *The Beat Generation*. As for "my favorite film actor or actress,"

he singled out the most mannered, histrionic thespian of them all, Bette Davis. Determined to be his own man, he eschewed slavish adherence to any single acting theory.

Jeff Corey was in many respects ideally suited to be Nicholson's first coach, for he was also eclectic in his approach to acting. Although well versed in the Stanislavsky Method, the technique that shaped Brando, Geraldine Page, Kim Stanley, Paul Newman, and a host of mid-twentieth-century stars, Corey also drew on such other disciplines as the more formal, less intuitive Delsarte chart, which listed the logical gesture to accompany emotional, physical, and psychological states. One of Nicholson's classmates, good-looking six-footer Roger Corman, who was about to launch a whole new genre, the exploitation film, later recalled, "I was impressed by Jack from the beginning, particularly in the improvisations, in which he combined dramatic power with humor, never at the expense of the drama, but in support of it, giving it additional dimension and color. It is rare for an actor to have that broad a range." Nicholson later stressed that the essential ingredient in improvised acting was spontaneity: "It's from the subconscious that the unpredictable comes. . . . [and] much of the actor's techniques deal with his ability to answer his impulses spontaneously."

The citadel of the Method was Lee Strasberg, Elia Kazan, and Cheryl Crawford's Actors Studio in Manhattan, where Marilyn Monroe, at the peak of her fame, was studying in the fifties, and Nicholson wanted to get into its L.A. branch, Actors Studio West. He auditioned the same night as an Off-Off-Broadway actress named Anna Mizrahi, a Sephardic Jew from Venezuela who'd recently moved to L.A. Lee Strasberg said, "I've never seen such a sensational pair of legs," and browbeat the panel of judges into accepting Mizrahi and turning down Nicholson. Lee Grant, one of the judges, recalled, "We violently objected. I mean, Jack was going to go on to be one of the great and we knew it."[16] As Nichol-

son explained in 1976, the Studio held him "in abeyance" for years, though it accepted his contemporaries, including Steve McQueen, Faye Dunaway, Jane Fonda, Robert Duvall, Al Pacino, Robert De Niro, Dustin Hoffman, and Sally Field. Nicholson's impression was that the Studio's powers-that-be thought he "act[ed] too well. . . . The person evaluating didn't know if I was that way or I was just acting."

In 2004 Nicholson added, "There's probably no one who understands Method acting better academically than I do, or actually uses it more in his work."[17]

Since Jeff Corey "didn't think I would make it in films," Nicholson recalled,[18] he went on to study with Eric Morris, author of the acting text, *No Acting Please*, and actor Martin Landau, future Oscar winner for *Ed Wood*. After the Landau class broke up, he again tried to get into Actors Studio West. Accepted at last, he undertook one of the techniques Strasberg taught known as "diagnosis of the instrument," and later described it:

"Stand there in class, weight equally distributed on both feet, don't move, look at the class, relate to each person in a real way, sing a nursery rhyme [such as 'Three Blind Mice'] with each syllable a beginning and an end unto itself, and don't run 'em together 'cause it's not about singing. Very, very few people could do it. . . . The idea is to get the physical body, the emotional body, and the mental body into neutral. Then you should be able to hear through the voice what's actually happening inside. . . . It's a way of locating the tensions, the tiny tensions, the problems with your instrument that get in the way of getting into a role. . . . One of the main ones everyone's got is heinie tension. . . . You have to get to nothing before you can do anything."[19]

In his first scene as a member of the Actors Studio, Nicholson, Sally Kellerman, and Luana Anders performed an unproduced play about God by their friend Henry Jaglom, who'd later write and

direct Nicholson's film, *A Safe Place*. "Nicholson was absolutely electric," said Jaglom, "and everybody began asking, 'Who the fuck is this?'" Nicholson and Kellerman, who was then thirty pounds overweight,[20] spent a lot of time offstage as well; "Sally Kellerman used to sit on my lap and tell me about her boyfriends and her problems," he recalled.[21] They assuaged their anxieties and insecurities by consuming "sweeties and souries"—ice cream and potato chips. For Sally, Nicholson was "always available when I needed him—a true friend."

Together with Don Devlin, later the coproducer of the Julie Christie film *Petulia*, and Harry Gittes, a photographer, Nicholson rented a house at Fountain Avenue and Gardner Street, which became "the wildest house in Hollywood for a while," according to Nicholson.[22] Gittes said that when their circle of friends went on the town Saturday nights, they always consulted Nicholson first, because he knew where the parties were. "You pick up Harry and bring him to Bill's and we'll all meet there," Nicholson would say, planning everyone's social life and putting together events. Already, he had a retinue that streamed behind him like the tail of a comet.

Later the namesake of Jake Gittes in *Chinatown*, Harry Gittes was born in Brookline, Massachusetts. "Jack and I met at some party in Laurel Canyon," he recalled. "I was trying to get a start in the ad business, the only person in his crowd who didn't want to be an actor. Jack was young and gorgeous and already going bald, but not trying to hide it, so people would be able to come to grips with it. We used to ride around in a Volkswagen; we'd pull up next to a carful of girls, and he'd just smile, and they'd flip out of their minds. I wouldn't even be there."

Nicholson and Gittes started a show-business softball league. "Guys really bond best over sports," Gittes said. "I was convinced that my mother liked him better than she liked me and that he

liked her better than he liked me. My father died when I was three and a half years old. So [like Nicholson] I didn't have a father either. I had a very tough stepfather. I was brought up by a very strong mother."

According to Gittes, Nicholson already had his career and personal life all laid out in a master plan. "Jack, it's like Stalin and his five-year plans," Gittes told him, and added, "He's so fast and can ad-lib so well that people think what he does is off-the-cuff. That's the biggest misconception about Jack Nicholson. It's all planned. He's very calculating. Every five years, he comes up with a new five-year plan."

As the L.A. Beat Generation scene moved inland from Venice Beach to the Sunset Strip, Nicholson's social life began to sizzle. According to cartoonist/playwright Jules Feiffer, who'd later write *Carnal Knowledge*, the fifties were the cauldron of all that would come to a boil in the following decade. "In the 50's, there was rage and dissent, however closeted it was. The patina was conformist, but exciting things happened. Abstract Expressionism was quietly emerging, the whole civil rights movement was begining and in Paris, Beckett was writing *Waiting for Godot*. The culture was reinventing itself under a patina of conformity."[23] Stylistically and intellectually, Nicholson's generation would translate complex existential dilemmas into streetwise American vernacular. As critic Frank Rich would write in 2003, the Beats and their offshoots, the hippies, provided "the template for much of the music, mores, and social change that now define mainstream American life."[24]

Roger Corman said Nicholson "was part of the hip scene in Hollywood, of which I was a part, but on the outskirts. Jack was in the center." The Beat Generation flowered in such coffeehouses and bars as Mac's, Luan's, Barney's Beanery, the Renaissance, and the Sea Witch. They flocked to the Troubadour to see jive-talking comedian Lenny Bruce use obscenity to dynamite the impacted

repressions and prejudices of middle-class society. At the same venue, Joni Mitchell, the Byrds, and the Doors would shortly revitalize popular music. Sally Kellerman was waitressing at Chez Paulette's, where Nicholson got into a disagreement with a hood, and was on the verge of a fight when Robert Blake intervened and defused the situation.[25] At Pupi's, Nicholson told an officious waitress, "You say one word and I'll kick you in your pastry cart," later reprising the scene in *Five Easy Pieces*.[26] Many evenings started at the Unicorn, and, when it closed for the night, moved on to the Sea Witch. If Nicholson didn't score on the Strip or Santa Monica Boulevard, he'd hit Cosmo Alley, a coffeehouse between Hollywood Boulevard and Selma, where he once caught sight of Brando visiting his waitress-girlfriend. At Ash Grove, a folksingers' club on Melrose Avenue, Nicholson blacked out after leaving with singer Jack Elliot and actor John Gilmore.[27]

Everyone usually ended up at Canter's Delicatessen on Fairfax for the best brisket, pastrami, and matzo ball soup west of the Hudson River. Often, Nicholson went to BYOB parties, and hosted quite a few himself when he shared the house on Fountain Avenue with actor/producer Bill Duffy. "We'd get nineteen half-gallons of Gallo Mountain Red and get everybody drunk," Nicholson recalled. "I guess you could call them orgies by the strictest definition [but] . . . I've never been in an orgy of more than three people. . . . We smoked a lot of dope, usually in the toilet or out in the backyard or driveway, 'cause it wasn't cool to do it in public."[28]

In these dawning days of the sexual revolution, Nicholson found it impossible to "go to sleep if I wasn't involved in some kind of amorous contact." Roommates moved in and out of Fountain and Gardner, including sculptor Dale Wilbourne, who married Georgianna Carter, and was succeeded by photographer Dale Robbins and actors Bill Duffy and Tom Newman. "There was a

pinochle game going or we would have folk-singing or wine-drinking nights two or three times a week," Duffy recalled. "Jack's room was always neat. His desk where he used to write all the time was piled with books." With acting jobs so scarce, Nicholson's current five-year plan was to become a screenwriter or director.

According to Don Devlin, Nicholson's personal life could hardly have been more active, or explosive. "Once he got into his seductive mode, he really went after it with a vengeance," Devlin recalled. "These [relationships] were very strong and filled with huge emotional ups and downs, every one of them falling into an identical pattern. Jack is such an overwhelming character that girls were always madly in love with him. Then he starts to behave fairly bad, then he starts to lose the girl, then he goes chasing after her again, then the relationship changes—the girl usually gets the upper hand. . . . Then he becomes like a little boy."[29]

An exception to this pattern was Helena Kallianiotes, a belly dancer who worked in a Greek dive in Hollywood. Like Gittes and Harry Dean Stanton, she became a part of Nicholson's extended family, remaining in his life for decades. "I was married but breaking up, so were Jack and his girlfriend," Kallianiotes recounted. "So, I ended up [living with Nicholson]. It just evolved. Jack has always protected me—even from the beginning when I showed up at his house with a black eye. I brought a couple of couches. . . . Jack had a yellow Volkswagen convertible complete with dents."

THE CRY BABY KILLER

At last, the professional breaks started coming in 1957.[30] His first agent, Fred Katz, died 1956, and in September the following year, in Schwab's Drug Store, he met his next agent, Byron Griffith, who represented James Darren and Connie Stevens, and helped secure

Nicholson the leading role in *The Cry Baby Killer*, produced by Roger Corman, who in a few short years had become a major force in independent films. Though Nicholson later said that acting classes prepare a student for his eventual shot at stardom, *The Cry Baby Killer* would be the first, but not the last, of numerous shots that fizzled for Nicholson, despite all his studies under Jeff Corey and others. Nor would years of working in Roger Corman films turn Nicholson into a star. "Fast and cheap" could have been Corman's motto, for his usual deal with American International Pictures (AIP) was to deliver a film for $50,000 as a negative pickup fee, plus $15,000 as an advance against foreign sales. Being directed by Corman was the antithesis of glamour. As soon as Corman finished one shot, he'd tell the actors to grab a reflector and follow him to the next setup. Though spartan on the set, he lived lavishly, owning, in his thirty-first year, when he met Nicholson, a Beverly Hills canyon home. Already a veteran producer of fifteen movies, he dated such actresses as Gayle Hunnicutt (later Mrs. David Hemmings) and Talia Shire of future *Rocky* fame.[31]

Many of the seminal figures of the burgeoning 1970s film renaissance—the so-called New Hollywood—sprang from the Corman factory: Nicholson, Bruce Dern, Peter Fonda, Dennis Hopper, Sally Kirkland, Robert De Niro, Peter Bogdanovich, James Cameron, Francis Ford Coppola, Ron Howard, Robert Towne, Martin Scorsese, and even Sylvester Stallone, who showed up in Corman's *Death Race 2000* and *Capone* a year before *Rocky* made him a star.[32] For a salary of $500, Corman offered hopefuls a way of breaking into an industry notorious for screening almost everyone out, rather than welcoming new talent.

A *Rebel Without a Cause* wannabe about a sensitive high school student who turns juvenile delinquent, *The Cry Baby Killer* was budgeted at $7,000, and took only ten days to film. At a sneak preview on Hollywood Boulevard in 1960, Nicholson was rocked by

alternate jolts of pride and disgrace, later calling it "a horrible ex-
perience . . . because the audience just went absolutely berserk. . . .
I'm happy that most people haven't seen them," he added, refer-
ring to all the Corman films and other B's he made over the next
ten years.

He played another vulnerable teenager in *Too Soon to Love*, an
exploitation picture about premarital sex and bickering parents. In
a small role in *Little Shop of Horrors*, originally titled *The Passion-
ate People Eater*, and shot for $30,000, he played a masochistic den-
tal patient who insists, "No Novocain—it dulls the senses." When
Nicholson attended the opening at the Pix Theater at Sunset and
Gower, he remembered how the audience had laughed at his first
film. "I took a date," he recalled, "and when my sequence came up,
the audience went absolutely berserk again. They laughed so hard
I could barely hear the dialogue. I didn't quite register it right. It
was as if I had forgotten it was a comedy since the shoot. I got all
embarrassed because I'd never really had such a positive response
before." For a low-budget 1960 B picture, *Little Shop of Horrors*
would prove to be remarkably durable, later spawning a 1982 Off-
Off-Broadway musical, which was so successful it moved to Off-
Broadway's Orpheum Theater and ran through 1987. David
Geffen's 1986 movie version of the musical starred Rick Moranis,
Ellen Greene, Vincent Gardenia, John Belushi, Steve Martin, John
Candy, and Bill Murray. Then, in a 2003 revival directed by Jerry
Zaks, the musical again emerged as a hit of the Broadway season.

In the spring of 1960, Nicholson tried out for his first main-
stream production, *Studs Lonigan*, Philip Yordan's version of James
T. Farrell's ambitious trilogy of lower-middle-class, Irish Catholic
life in Chicago from 1912 to the early 1930s. Warren Beatty was
to play the lead, but, even though he was still an unknown, Beatty
demanded rewrites, and was swiftly dropped. Handsome but inef-
fectual Christopher Knight won the lead, and Nicholson was

wasted as a gang member named Weary Reilly. "The reason I got it, I think, is that readings consisted of improvising situations from the book and I was the only actor in Hollywood with the stamina and energy to read the seven-hundred-page trilogy," he said. "I was pretty strong in improvisation because everything [Jeff Corey] teaches is from the basic root of improvisation."[33] But the film was "no more than a pale flicker of Farrell's massive trilogy," according to the *New York Herald-Tribune*'s reviewer. As in all his early efforts, Nicholson showed not a trace of the gigantic talent that would later burn up the screen in *Easy Rider*.

In 1960's *The Wild Ride*, he played a psychotic killer in the mold of Brando's *The Wild One*, and Georgianna Carter played his girlfriend. Nicholson dismissed the film as "just bad. . . . I needed the work. . . . [It] was the only job I could get. Nobody wanted me."[34] By the time it was released, Nicholson and Georgianna had broken up, despite his friend John Herman Shaner's attempt to effect a reconciliation at a fish fry. "We had an argument about getting married," Georgianna recalled. "I was stunned to hear that [Jack] didn't want to." He was more interested in Sandra Knight, but he played the field, also dating dancer Lynn Bernay, a former Rockette. According to Bernay, he made her feel more like "a sister" than a girlfriend. He later explained, "You can't make a movie unless you're making a woman or at least thinking about making a woman, and that is the secret of my craft."[35]

He met his next agent, Sandy Bresler, when he joined the Air National Guard, which Nicholson called "the great rich kids' draft dodge. We were all draft dodgers. We didn't want to be in there. I started worrying about going into the Army in about the fourth or fifth grade in New Jersey. I wasn't afraid of getting killed. I just didn't want to waste the time." He was not called up for active duty until the summer of 1961, during the international crisis over the Berlin Wall. "It was one of the great JFK's big numbers before they

got mad and shot him," Nicholson said. "We waited it out in Van Nuys, a whole year. We all hated it. . . . I have the effect of completely demoralizing whatever unit I'm in, in a thing like that. There's just something about me. . . . You do learn something. You could say the same thing about jail, but I didn't see any guys rushing off to get in."[36] He would later draw heavily on this experience for his role in *One Flew Over the Cuckoo's Nest*, in which he'd incite the inmates of a mental institution to rebel against mindless authority.

Then just beginning as an agent, Sandy Bresler was his bunk mate when they served together at Lackland Air Force Base in San Antonio, Texas. Nicholson underwent training as a firefighter, and found it "exhilarating" to be set afire in his asbestos burn-proof firefighter's gear.

Although he worked in Senator John F. Kennedy's first presidential campaign, he became disillusioned after Kennedy's victory, objecting to the president's aggressive Cold War policy and the Bay of Pigs. Perhaps no politician could have pleased him, for his hero was the saintly Mahatma Gandhi. Despite Nicholson's conviction that "overstepping in politics minimizes our effect as an artist," he held some strong views, including one that committed him to absolute nonviolence. "I'm not willing to shoot anyone," he said, "not even one person to save twelve." In 1964, he would crash the Democratic National Convention in L.A. with John Herman Shaner and director Monte Hellman. When Nicholson shook hands with President Lyndon B. Johnson and held on a little too long, savoring the sensation of touching absolute power, the security guards started to move in, but Nicholson let go just before they sprang into action. Later, after he became famous, he would support liberal presidential hopeful George McGovern, but somewhat halfheartedly, explaining he didn't offer more financial help because "the money symbol in politics is obviously a dangerous

one, as time has shown." The one issue outside of show business he felt passionately about was the legalization of dope. "I'm on all those referendums like the marijuana initiative," he said, "and I send them money."[37] According to Beverly Hills psychiatrist Carole Lieberman, marijuana is "a gateway drug—people think it's harmless, but if you use it, it's easier to go to the next step, using pills or cocaine or heroin."[38] Twenty years later, Nicholson said, "I'm sorry I ever said I smoked pot."[39]

In the summer of 1961, Nicholson and Burt Reynolds were up for the same part in the quickie Western *The Broken Land*, and Nicholson won because he knew how to ride a horse, having learned at Sam's Rocking Horse Stables in a distant part of Griffith Park in Burbank. Though Nicholson's career was as lackluster as the B pictures he was making, at last his personal life began to make sense. On June 17, 1962, in his twenty-fifth year, he married twenty-two-year-old Sandra Knight, a barefoot-hippie type from Pennsylvania with long brown hair, "beautiful and very voluptuous, big bosoms and lots of hair," in Helena Kallianiotes's description. "She and Jack kind of looked alike—had the same nose. . . . They were fiery."[40] Millie Perkins, the ex-Mrs. Dean Stockwell, was matron of honor, and Harry Dean Stanton was best man. The newlyweds moved around the corner from Nicholson's old apartment at Fountain and Gardner, making their home at 7507 Lexington.

THE RAVEN *AND* THE TERROR

When Nicholson went to work again for Roger Corman in *The Raven*, his costars were the legendary horror-movie actors Vincent Price, Boris Karloff, and Peter Lorre. Since Price, star of *The Fly* and *House of Wax*, was one of Ethel May's favorites, Nicholson

brought her to the set and introduced her around. Price, Karloff, and Lorre mistakenly assumed that Jack Nicholson was the son of AIP cofounder Jim Nicholson. "Vincent and Boris used to joke among themselves, 'Nepotism! Nepotism!' and roar with laughter," recalled Sam Arkoff, the other partner in AIP.[41] "Jack was somewhat in awe of Karloff, Lorre, and Price," Corman said, "and they treated him very well because they could see in their improvisations together during rehearsals that he was good. He worked very well with them."

"I loved those guys," Nicholson said. "It was a comedy, and Roger gave us a little more time to improvise on the set." Unwittingly, Nicholson was getting experience as a screenwriter, since the actors made up scenes as they went along. He stayed up late at nights, knocking out a screenplay with Don Devlin, *Thunder Island*, about international politics and an assassination attempt, later filmed by Twentieth Century-Fox as a B-budget action picture with Gene Nelson and Fay Spain in the leading roles. While still working on *The Raven*, Nicholson picked the brains of Peter Lorre, star of the German classic *M* and *The Beast With Five Fingers*. "I was mad about him," Nicholson recalled, "one of the most sophisticated men I ever knew." Lorre told him stories about Humphrey Bogart, his costar in *The Maltese Falcon* and *Casablanca*, as well as about Bertolt Brecht and the Nazi era in Germany.

When *The Raven* wrapped, Corman realized he still had two days' use of the expensive Gothic sets, and quickly cooked up another horror quickie, *The Terror*, offering Nicholson the leading role opposite Karloff.

"Great," Nicholson said, "but I need some money. Can Sandy [Sandra Knight] play the lead?"

"Sure," Corman agreed, and later added, "I cast Sandra in several other films. I always thought she'd go on to have a major ca-

reer. For whatever reason, she didn't, but she had the beginnings of a good career and appeared in a number of films. Perhaps she gave it up after they married—I don't know. It seemed to me that they were a perfect couple. She had some of the same characteristics Jack had, including intelligence and a sense of humor."

If marriage wasn't good for Sandra's career, it was, in Nicholson's view, a setback for his as well. Even before he was famous, he liked being known as a rogue. "It was good for business," he told *Playboy* interviewer David Sheff in 2004. "On the other hand, I settled down for a while when I was twenty-five, and that was less good for my career."[42]

"Why was it good for business?" Sheff inquired.

Since Nicholson was not yet famous at twenty-five, why would a reputation as a stud have been of any use in getting roles, unless casting directors were expecting sexual favors? But Nicholson only replied, "It's better than being thought of as a shit."[43] Years later, in 2004, he told *Esquire*'s Mike Sager, "If I had started out today, would I have wound up doing porn pictures to make a living?"[44]

Corman assigned his "ace assistant," Francis Ford Coppola, to direct *The Terror*'s exterior shots, which were filmed in Big Sur, a wilderness area of mountains and seacoast in north-central California, near Monterey. There, amid giant redwoods, soaring eagles, and cliffs that plunged a thousand feet down to the Pacific Ocean, Nicholson and his wife had one of their happiest times. "Sandra got pregnant up in Big Sur with our daughter, Jennifer," he recalled.

Working with Coppola proved difficult. While filming in the surf off Pfeiffer Beach, the actor nearly drowned in his waterlogged period costume. "I came flying out of there and just threw that fucking costume off while I ran, freezing to death," he said. "When we got back to town, Francis tried to blame me for going over budget. . . . He didn't know that I was pretty close with

Roger . . . [who] didn't believe I was to blame. . . . It had more to do with shooting in Big Sur—and trying something you never do on a Corman picture, which was run cables up from the rocks into the mountains. Roger's way would be to just shoot from up on the road. But Francis hadn't worked with Roger that much so he hadn't had that disdain for any kind of production expense burned into him yet."[45] Nicholson asked if he could have a crack at directing a scene after the company returned to L.A. "It's simple shooting," he told Corman, who agreed for the actor to work one day as a director, gaining invaluable moviemaking experience. Other Corman protégés also directed scenes, but they didn't "exactly *mesh*," Corman admitted. Nicholson added, "I believe the funniest hour I have ever spent in a projection room was watching the dailies for *The Terror*." Peter Bogdanovich, future director of *Paper Moon*, recalled, "When I watched *The Terror*, I remember thinking, Gee, I hope Jack makes it as a director or writer because he's not much of an actor here."

Sam Arkoff threw a wrap party on the set, and his wife and sister-in-law brought Jewish delicatessen. "Roger had these actors he always used and they were always hungry," said Arkoff. "I think they never ate between his pictures." After the film's release in 1963, critics dismissed it as "faux Poe." Curtis Harrington later "ran into Jack at the Los Feliz movie theater," the director recounted. "*Films and Filming*, in reviewing his performance as a vapid young man, wrote, 'Jack Nicholson is the most wooden thing this side of Epping Forest.' I quoted it to Jack when I saw him. This was long before he became famous. He had a wonderful sense of humor, and laughed it off."

In 1963 Nicholson was in the running to portray Robert Kennedy in a proposed film version of RFK's book *The Enemy Within*, but Kennedy preferred Paul Newman (and never forgave Newman when he turned down the role).[46] That summer, just as

Nicholson was preparing to leave for location shooting in Mexico for his second major-studio film, *Ensign Pulver*, he learned that his mother, June, whom he still regarded as his sister, had cervical cancer. Accompanied by Ethel May, Lorraine, and his pregnant wife Sandra, he visited her in Cedars of Lebanon Hospital the night before his departure. After years of disparaging his acting efforts, June was glad to see him making money at last—$350 a week, SAG minimum—and urged him to go to Mexico and fulfill his Warner Bros. contract. Though only forty-four years old, she looked like an old woman, her weight having dropped from 120 to 80 pounds.

"Shall I wait?" she asked him. He interpreted her meaning to be, "Shall I try to fight this through?"

"No," he said, in effect releasing her from further suffering. Later, going down in the elevator, he slumped to the floor and started crying hysterically. In Mexico, he filmed throughout July on a Navy cargo ship anchored off Puerto Marques, near Acapulco. On July 31, 1963, June died without ever telling Nicholson she was his mother. He missed June's funeral mass at the San Fernando Mission Cemetery. Ethel May, the woman he still regarded as his mother, was also ill, having contracted a progressive muscular disease.

On the day he returned from Mexico, September 13, 1963, his daughter Jennifer was born. "I knew life had changed," he said. "It really was a eureka experience. Through whatever self-delusion, I thought I had solved some of life's problems—and then complete vulnerability again, through the child. . . . It is [a child's] death that's under all your fears all the time."[47]

Unable to afford a babysitter, he and Sandra took Jennifer along when they attended a party at the beach home of Robert Walker Jr., star of *Ensign Pulver* and the son of the late Robert Walker, who appeared in such World War II films as *Since You Went*

Away and *See Here, Private Hargrove*, and Jennifer Jones, Oscar winner for *The Song of Bernadette*. As Walker Jr. served his guests 1959 Lafite Rothschild, Nicholson walked around with his baby daughter in his arms. "You just loved to hang out with Jack," Walker said.

Other new friends included Tuesday Weld, Larry Hagman, and Samson DeBrier.[48] Curtis Harrington, director of the underground Dennis Hopper film, *Night Tide*, remembered, "Jack was married to Sandra Knight when he came to the home of Samson DeBrier, who ran a kind of salon in Hollywood on Barton Avenue, off Vine Street, near Santa Monica Boulevard. Sam had been raised in Atlantic City and went to Paris when he was nineteen years old after having written André Gide some fan letters. Gide opened the door and grabbed him and pulled him in and they had a slap and a tickle. Later, Sam received letters from Gide, and Sam played the lead in *The Inauguration of the Pleasure Dome*, which Kenneth Anger filmed at DeBrier's house.

"Sam DeBrier never slept until the wee hours, waking at 2 P.M. and having open house to his friends all night long." Stanley Kubrick dropped in, as did James Dean and Anaïs Nïn. According to Nicholson, DeBrier liked to turn out the lights and read from his memoirs. "I didn't know many people who had been André [Gide's] lover, so it was very exotic to me," Nicholson said, calling DeBrier "one of the great Hollywood puries, someone very expressive of the L.A. culture, the Hollywood electric whiz-bang kids."[49] James Dean arrived one night with John Gilmore and a one-legged woman, who told Nicholson, somewhat cryptically, that one of the guests at the party was responsible for her handicap. Dean was eager to talk about Anger's *Pleasure Dome*, and launched into an intense conversation with DeBrier. When Gilmore attempted to introduce Nicholson, Dean appeared to snub him, but it was nothing personal, according to Gilmore, who

later explained that Dean's hearing and eyesight had been temporarily impaired as they'd ridden their motorcycles to the party in a strong wind.

In the late summer of 1964, Nicholson, who'd never left the continent before, sailed from L.A. to Manila, where his next two films, *Backdoor to Hell*, a WWII adventure, and *Flight to Fury*, a plane-crash survival yarn, were shot on location, for $80,000 each. One of his costars, Jimmie Rodgers, had scored a No. 1 hit recording with "Honeycomb" and was attempting to become an actor. Rodgers described Nicholson as a "needler," someone who liked to provoke trouble and then laugh it off as a joke.[50] Monte Hellman, who directed both films, observed that Nicholson "likes to lose his temper, because it's a high. . . . He's nervous when he's not in the spotlight." Nicholson would not hesitate to throw a temper tantrum if it was the only way to reclaim "the center of attention," Hellman added.[51]

Manila was "prostitute heaven," recalled movie executive Jack Leewood. "We were screwing the same dames. It was fun and games."[52] One night, as Nicholson was making it with a Filipino hooker in a motel, she shrieked, "The Terror strikes!" just as she reached her climax. Nicholson, who wasn't even aware *The Terror* had opened in the Philippines, was too startled to continue, and surrendered to coitus interruptus.[53]

Returning to the U.S. mainland in October 1964, he attended a Christmas party at Jimmie Rodgers's large house in the San Fernando Valley, where a band was playing in the backyard. The decor inside the house represented affluent L.A. ostentation at its worst, including a $6,000 inlaid glass coffee table. Rodgers noticed Jack "standing there, looking around the room. . . . The look on his face was, 'So this is what it's like.'"[54]

Nicholson and his wife were experiencing marital difficulties. "The scene in *The Shining* comes out of this time," he said,[55] re-

ferring to the sequence in the 1980 movie in which a writer scolds his wife for interrupting his work. "My beloved wife [Sandra Knight] walked in on what was, unbeknownst to her, this maniac," Nicholson recalled.

"Even if you don't hear me typing," he told her, "it doesn't mean I'm not writing. This *is* writing."

His work days stretched to eighteen hours when he and Monte Hellman, bankrolled by Corman, formed their own companies in December 1964 and filmed two "thinking man's Westerns," *The Shooting* and *Ride in the Whirlwind*. He acted in both and contributed the screenplay for the latter. His old friend from Corey's class, Carole Eastman, wrote *The Shooting* under the pseudonym Adrien Joyce. Nicholson coproduced both pictures for $85,000 each and called them "exploitation pictures, but you could sneak some quality into them." Raising money, producing, acting, writing, directing—such multitasking fervor left him virtually no time for Sandra and Jennifer, and he later described himself as "this young kid who's trying to sort of dive sideways onto the screen, sort of hurl himself into a movie career. All I see is this kind of fearful, tremulous, naked, desperate ambition. Which is pathetic."[56]

Inevitably the unhappy Nicholsons drifted apart. "We were becoming a burden not only to each other, but to our child," he said. Helena Kallianiotes was a guest at Nicholson's card parties, where other players included Ethel May, who often came by to be close to baby Jennifer. "We'd come to Jack's with our pennies in our socks and play," Kallianiotes recalled. Sandra "got turned on. . . . She fell in love with God," Kallianiotes added, "and Jack couldn't compete . . . Jack cheated a lot."[57] Nicholson blamed "the secret inner pressure about monogamy" and professional rivalry. He felt that his "increasing celebrity" intimidated Sandra. "You can't turn the celebrity off to save the relationship," he said.[58]

The day they decided to end their marriage, he was "out on the

lawn with John Hackett and we were doing a brake job on my Karmann Ghia . . . this massive undertaking to save fifty dollars, and that day I got two jobs. One to write a movie [*The Trip*] and one to act in one [*Rebel Rousers*]."[59] When Nicholson and Sandra dropped acid while he was researching and writing *The Trip*, she had a frightening hallucination. "She looked at me and saw a . . . totally demonic figure," he said. "For whatever reason, either because it's true about me, or because of her own grasping at something, it was pretty bad. But there were lots of reasons for our growing apart. I was working day and night, and I couldn't take the arguments: they bored me."[60]

Although Nicholson's LSD trip stirred fears of homosexuality and penis amputation,[61] he continued using the drug,[62] becoming a part of Peter Fonda's turned-on social circle in the Hollywood Hills. Referring to Nicholson, Fonda said, "There is a real deep hurt inside; there's no way of resolving it, ever."[63] Their marriage crumbling, Sandra finally told Nicholson to leave,[64] and in the spring of 1966, he leapt at the opportunity to go to France with Don Devlin to see if he could sell foreign rights in his Westerns. "European critics consider them classics," Nicholson claimed.

At the Cannes Film Festival on the Riviera, his B Westerns accrued a modest underground following. Carrying the prints in hatboxes, he worked hard at making contacts, meeting Tony Richardson, Nestor Almendros, and New York Film Festival director Richard Roud. "I was a festival rat," he recalled. "I ran around with Bernardo [Bertolucci]."[65] He listed his main influences as "Roman Polanski, [who became] a friend of mine, and Milos Forman. I met Milos hanging around the film festivals; his *Loves of a Blonde* was playing." With Nicholson's cocky manner, he approached everyone as if they were old buddies, and managed to dispose of distribution rights in the Westerns to the Netherlands and West Germany.

"Jack Nicholson was in Cannes trying to sell two pictures that cost $4,000 between them," recalled Robert Evans, Paramount production head. "He starts talking to me, and I don't understand a word he's talking about." But every time Nicholson smiled, Evans found he couldn't take his eyes off him, and decided to make him an offer. By Evans's estimate, Nicholson had never received more than $600 for any picture he'd made to date.

"Listen, kid, how would you like to play opposite Barbra Streisand in *On a Clear Day You Can See Forever*? I'll pay you $10,000 for four weeks' work."

"I just got a divorce, and I've got to pay alimony. I have a kid. I have to pay child support. Can you make it $15,000?"

"How about $12,500?"

"I love you," Nicholson said, enveloping Evans in a bear hug. "I'll never forget you as long as I live."[66]

Nicholson's official separation from Sandra, who was aware that he played around overseas, was announced April 1, 1967. In divorce papers on file at the Los Angeles County Courthouse, dated August 8, 1968, Nicholson was accused of "extreme cruelty," and the decree specified that both partners be "mutually restrained from annoying, molesting or harassing the other."[67] Sandra got possession of four-year-old Jennifer and also took the 1959 Mercedes, leaving Nicholson his Karmann Ghia and a court order to pay $300 per month child support and $150 monthly alimony. He was worth $8,000 in cash at the time and owned stock securities. Sandra soon moved on with her life, remarrying, and raising their daughter.

Taking along his manual typewriter and looking forward to some uninterrupted writing time, Nicholson moved in with Harry Dean Stanton, later remembering, "Harry Dean I found very easy. He'd already been living in his place at the bottom of Laurel Canyon a year or two when I moved in, and he still hadn't un-

packed his boxes. The living room was completely barren. I wrote *The Trip* over in the corner at a desk. Bare floor with a record player on it, and I used to dance around, then go back and write like a fiend." A rural mountain community near West Hollywood, Laurel Canyon was home to rock legends Carole King, Jimi Hendrix, John Lennon, Michelle and John Phillips of the Mamas and the Papas, Jackson Browne, and Frank Zappa, as well as herds of deer and packs of coyotes. The steep boulevards winding up from the Sunset Strip were lined by oak, eucalyptus, and pine, and quaint cottages perched on the brink of drop-offs. Immortalized in the Crosby, Stills, Nash, and Young song, "Our House," Graham Nash and Joni Mitchell's love affair took place in their Lookout Mountain greenery, and Jim Morrison wrote "Love Street" about Rothdell Trail. "Laurel Canyon is an inspiration," said Tim Mosher, a former punk musician. "You can write. It's quiet. You can be alone with your thoughts."[68]

Unfortunately, as *The Trip* would prove, Jack Nicholson's literary efforts were only a notch or two above Jack Torrance's "All work and no play makes Jack a dull boy," the endlessly repeated sentence that constitutes the totality of the novel Torrance writes in *The Shining*. So far in his career, Nicholson's work had been restricted to "the kind of trash only a mother or a *Cahier* critic could sit through and love," Rex Reed wrote in the *New York Times*, and more trash was on the way.

HELL'S ANGELS ON WHEELS

In 1967 Nicholson filmed *Hell's Angels on Wheels*, playing a sensitive grease monkey turned biker. Researching the role, he went to Oakland to meet Sonny Barger, the Hell's Angels honcho, who'd sold the rights to the Angels name to AIP and was cooperating in

the making of the film. "A toke for a poke?" Barger said, offering Nicholson a joint. When the latter took it, Barger hit him in the stomach, and Nicholson bent over, choking and coughing. As promised, he'd received a poke for a toke—the Hell's Angels idea of humor. "Jack mixed right in," Barger remembered. "He carried himself very well as far as we were concerned." The incident explains the origin of Nicholson's famous "shit-eating grin," which, according to director Richard Rush, was first seen in this film. Rush volunteered to cast Nicholson's girlfriend, Mimi Machu, a flower child and former dancer with long brown hair, in the role of Pearl. She appeared under the alias I. J. Jefferson. Their affair would go on for four tempestuous years. According to Sonny Bono, he'd once had an affair with Machu. Sonny's illegitimate son, Sean, was born in 1964.[69]

Successful at the box office, the film failed to win critical approval, apart from László Kovács's photography, which caught the severe beauty of California's highways and desertscapes. As for Nicholson, *Variety* wrote that his performance consisted of "variations on a grin," and the *New York Times* critic thought he looked "rather dazed." In 1967 Nicholson went straight into another biker epic, *Rebel Rousers*, appearing with Harry Dean Stanton, Bruce Dern, and Diane Ladd, and sporting the wool mariner's cap that would resurface the following decade in *One Flew Over the Cuckoo's Nest*, anticipating a punkish fashion fad of the 2000s. *Time's* reviewer wrote that Nicholson "looks like an all-night coach passenger who is just beginning to realize he has slept through his stop." Nicholson accorded it the dubious distinction of being "the only movie of mine I've never seen."

He wrote and starred in *The Trip* in 1967 for Roger Corman, later recalling, "Roger knew I had taken acid and we were both serious on the subject. Roger was my whole bottom-line support then. I had done the Westerns but I had pretty much given up as

an actor. I really didn't have much else going then, kind of a journeyman troubleshooter. He knew he couldn't get a writer as good as me through regular ways. I was happy to write it and make a more demanding picture out of it."[70] In Nicholson's screenplay, he drew on his disappointments in marriage and career, as well as his encyclopedic knowledge of the psychedelic hangouts on the Strip. His protagonist, a part he expressly tailored for Peter Fonda, was a director of television commercials who feared he'd sold out, and whose marriage was breaking up; attempting to make sense of his life, he took LSD, had a bad trip, which his best friend—a juicy role Nicholson created for himself—helped him survive.

"Look, if 'Dernsie' can play it, I owe him, man," Corman told Nicholson, referring to Bruce Dern, the star of his most successful film, *The Wild Angels*.[71]

Corman wasn't convinced that Nicholson was star material. "I had used Jack successfully in leads, but I began to wonder why other people weren't also picking him up. . . . I just assumed my judgment was not shared by older—and wiser—minds."[72] In *The Trip*, Dern costarred with Fonda, Dennis Hopper, Susan Strasberg, Salli Sachse, and Luana Anders. Despite Nicholson's disappointment over having failed to make the cast, he maintained his friendships with Corman and Bruce Dern throughout the shoot, which took place over three weeks in the summer of 1967. More significantly, he established strong ties with Fonda and Hopper. The picture earned $6 million and was featured at the Cannes Film Festival, where it played to a packed house.

In Corman's lame gangster saga, *The St. Valentine's Day Massacre*, Nicholson delivered his small part in a strange, choked gangster voice, later used by Marlon Brando in *The Godfather*. Bob Evans put Nicholson up for the role of Mia Farrow's husband in *Rosemary's Baby*, but director Roman Polanski deemed Nicholson too sinister in appearance, and cast John Cassavetes instead.

Packaging his next film, *Psych-Out,* for himself, Nicholson wrote the original script and played a psychedelic rock 'n' roller named Stoney. Mimi Machu haunted the set, monitoring her boyfriend's bed scenes with costar Susan Strasberg, who sensed that Nicholson was uncomfortable and possibly working out some sexual hang ups. Critics found the film "less than compulsive" and dismissed it as a "meretricious effort."

At his lowest ebb—having failed to break into the mainstream as actor, writer, or director—Nicholson was strolling down Wilcox south of Hollywood Boulevard one day, some manuscript papers stuffed under his arm, and wearing scruffy clothes and worn-out shoes, when John Gilmore drove by and offered him a ride. "Everything's all fucked up, man," Nicholson said. "I want to write. I'm through with acting. . . . Parts are shittier and pictures are shittier."

Reminiscing five years later, Nicholson demolished his entire AIP oeuvre with the remark, "I never dug them. I'm not a very nostalgic person. They were just bad."[73]

These failures did nothing to diminish his passion for the art of cinema, and he remained an inveterate moviegoer. At a Writers Guild screening in 1966 or 1967, he jumped up after a movie that had impressed him and started clapping and screaming. The others remained in their seats except for director Bob Rafelson, who also stood up and cheered, and then went over to Nicholson.

"We obviously both liked the picture," Rafelson said, "so let's go out and get a cup of coffee."

It was a turning point in the lives and careers of both men. After conversing with the ardor of new best friends, Rafelson told him, "We're like Colossus, we bestride two worlds: art and industry. Which should get us a big pain from the stretch."[74] Their synergy would shortly make movie history and help create the New Hollywood.

Bob Rafelson had a wiry body, a softly contemplative and friendly voice, and curly hair. A New York hipster and Dartmouth dropout who'd gone west to work in television production, he'd once thrown a chair at a Universal executive. Together with Bert Schneider, a rich Beverly Hills brat whose father Abe had headed Columbia Pictures and whose brother Stanley currently ran the studio out of New York, Rafelson produced the rock band/TV show *The Monkees*, a huge hit. Both Rafelson and Schneider immediately adopted Nicholson, recognizing his potential and undertaking his initiation into the higher reaches of hip Beverly Hills. At "Bert and Bob's," the next generation of actors, rockers, and writers were then converging and networking. In the Spanish-style Beverly Hills home Rafelson shared with his wife Toby, on Sierra Alta above Sunset, Nicholson, who was usually with Mimi Machu, mingled with Dennis Hopper, Brooke Hayward, actor-writer Buck Henry, and Bert and Judy Schneider. Schneider's brother Harold once remarked, "Bert would fuck a snake." Nicholson concurred, warning a friend, "*Never* bring a woman that you're serious about around Bert or Bob."[75]

After Rafelson and Schneider formed Raybert Productions, with offices at Columbia Pictures on Gower Street, they hired Nicholson, for substantial money, to write a film, *Head*, based on their *Monkees* TV show. Nicholson, Rafelson, and Schneider went to Ojai for several days of brainstorming with the four Monkees— Peter Tork, Davey Jones, Mickey Dolenz, and Michael Nesmith— and during script conferences, Nicholson acted out all the parts. Although Nicholson no longer wanted to be an actor, focusing instead on directing, Rafelson and Schneider were so impressed that they decided to cast him in some future film, over Nicholson's protests. "I can't get a job," he told them. "It's all B-movie parts, C-movie parts. I've given up." Rafelson disagreed, feeling Nicholson "had this amazing talent. . . . great teeth . . . funny eyebrows.

And as we walked through the park at lunchtime he'd do these great animal impersonations. I thought, I can make capital out of this man. I told him we were going to make a movie and he would be the star. What was more, we were going to make a movie every two or three years and it would cover our entire life together."

Monkee Davey Jones said they killed "a ton of dope"[76] while tape recording their idea session. Structurally, Nicholson's concept for *Head* was nonlinear, in the fashion pioneered by *A Hard Day's Night*. Later, Nicholson and Rafelson repaired to a desert retreat and put together the script, which was filmed in February 1968 with Victor Mature, Annette Funicello, Carol Doda (the first topless dancer), Sonny Liston, Frank Zappa, Helena Kallianiotes (as a belly dancer), and Teri Garr.

To stir up publicity, Nicholson and Rafelson decided to create a happening on the streets of Manhattan the day *Head* was to open at Cinema Studio, putting up posters featuring the head of literary agent John Brockman. They accosted a policeman in front of Bonwit's on Fifth Avenue and Fifty-sixth Street, where Nicholson tried to stick a poster to the cop's helmet. He was handcuffed and thrown in jail with Rafelson, who later recalled, "Finally, we managed to get out and didn't make one line of news."

As he worked on *Head*, Nicholson was also seeing his friends Fonda and Hopper and listening to their dream of making the great American biker movie, one that would transcend the Hell's Angels baloney they'd all dished up in Corman's *The Wild Angels*, *Hell's Angels on Wheels*, and *Rebel Rousers*. Hopper envisaged a film that would tell young people not to be afraid of the increasingly oppressive U.S. government and would embolden them to change the nation's prowar, antidope policies. "Learn to protect yourselves," he wanted to tell them. "Go in groups, but go. When people understand that they can't tromp you down, maybe they'll start accepting you."[77]

In trying to hammer out a deal for the movie, Fonda and Hopper had difficulty agreeing on terms with Roger Corman and AIP, and took it to Nicholson, who smelled success, remembering how profitable *Hell's Angels on Wheels* had been for Corman. He agreed to intercede with Bob Rafelson because "neither Dennis nor Peter knew how to present an idea." Nicholson advised Rafelson and Schneider that *Easy Rider* "would make endless amounts of money," and they agreed to take a meeting. Suddenly, all the stars were in alignment for Nicholson's breakthrough.

Chapter Three

THE BIG WOMBASSA

EASY RIDER

Nicholson wasn't in the original cast of *Easy Rider*. Rip Torn had the role of George Hanson, the pot-smoking ACLU lawyer with one foot in the counterculture and the other in the establishment. When Torn asked for his part to be better written, Dennis Hopper said, "Screw you,"[1] and Torn quit, saying, 'I'm not going to do your shitty film."[2] In February 1968, as the first scenes were shot in New Orleans, Nicholson was still in L.A., working at Raybert on *Head* postproduction and in preproduction for another project, *Drive, He Said*. On location, violent conflicts erupted between Fonda and Hopper. "This is *my* fucking movie, and *nobody* is going to take it away from me," Hopper shrieked.[3] On speed and wine the day the graveyard scene was filmed, Hopper reduced costar Karen Black to tears, humiliating her in front of the entire company.

"They had gone down to film Mardi Gras live before they even finished the script," Nicholson recalled. "They had some problems down there between the partners." On March 1, after six days in the Big Easy, cast and crew returned to L.A., and Fonda told Bert Schneider that he couldn't continue to work "with Dennis in such a megalomaniac-like routine."[4] Schneider went straight to Hopper and said, "I want to tell you about your friend Peter Fonda. He told me, 'Hopper's lost his mind, he's obviously crazy.' Peter and your brother-in-law Bill Hayward tried to get you fired. So you're not confused about who your friends are."[5]

Schneider decided to try a new tactic, and assigned Nicholson as troubleshooter on *Easy Rider*. When Nicholson joined the company on the road, he found the production in chaos, and it was clear to him that Hopper and Fonda were still reluctant to accept him, but at least valued him "as a consultant because I had done some drug-related films."[6] Although everyone "wanted to kill one another," Nicholson later recounted, he set out to solve the production's problems. "I got them Leslie Kovacs," he recalled. "They changed casts. I got them my production manager, who put a new crew together. By this time, Bert was a little uneasy, so he asked me to take this role [of George Hanson, recently vacated by Rip Torn] largely because of the fact that I knew production, knew this crew, I knew this situation."[7]

When offered the role by Schneider and Rafelson, Nicholson said, "Yeah, I can play this part easy,"[8] and later recounted, "I jumped at the chance. Acting is a vacation for me." Hopper, who had inflexible ideas about casting, was not thrilled when Schneider told him, "Use Nicholson." He was afraid Nicholson "would ruin my movie," Hopper recalled. "I had my mind set on Jack Starrett, who became a director. . . . I'd never seen Jack do anything like that. I saw him as a Hollywood flasher, not as a country bumpkin."[9] Fonda later wrote, "Hopper resisted my notion of Nichol-

son taking over. He said that Jack was from New Jersey, and he wanted an actor who was a Texan like Torn was."[10] According to Nicholson, neither Fonda nor Hopper wanted him for the part:[11] "I had to beg them for the role."[12] Hopper and Fonda viewed him as hopelessly mired in B crap but tolerated him as a troubleshooter in order to take advantage of his proven ability to get good nonunion people to work cheaply. Finally, Schneider told them to "shut up" and rammed Nicholson's casting as George Hanson down their throats, telling them he was "going to be a star."[13] At last, Hopper told Nicholson, "Great, go do your number."[14]

By the time the company got to Taos, New Mexico, Nicholson "had joined us," Fonda recalled, "and we did a few days of riding shots." Nicholson took the passenger seat on Fonda's bike, and it couldn't have been dicier as they sped over wooden-planked bridges, which were full of gaps. "With Jack as baggage the whole thing became impossible," Fonda said. "Whenever the front end got railed, Jack clamped his thighs together. I have several cracked ribs that Jack could sign."

Before Nicholson had arrived, the company had occasionally tangled with local rednecks, but with Nicholson on board, it was easier going. "Once I agreed with Schneider that he should do the part he turned out to be great all around," Hopper admitted. "I thought he had more natural charm than anybody I'd ever met. He has this great personality and an innate sense of diplomacy. He'll walk away before he'll escalate any tangle, and he would never harm another person. Jack is a great, loyal friend and a wonderful man."[15]

During seven weeks of filming, Fonda and Hopper always made sure Nicholson was stoned on pot before calling "Action," and Fonda advised him "to hold the hit in his lungs a little longer. . . . He was letter perfect, and very stoned, a pro."[16] But as everyone who has seen the movie knows, Nicholson was hardly

letter perfect in his famous, rambling UFO speech in front of the campfire, during which he blew a line. "Den-Den *wanted* Jack to be stoned for real," Fonda continued. "Jack's 'going up' was part of really being stoned, forgetting what you were talking about, losing the thread, as it were. And the laugh was so genuine, so true to the grip of reefer madness. . . . Dennis left the moment just as it was shot."[17]

Nicholson too recalled the difficulties of the campfire scene. "Each time I did a take or angle," he said, "it involved smoking almost an entire joint. We were smoking regular dope, pretty good Mexican grass. . . . Now, the main portion of this sequence is the transition from not being stoned to being stoned. . . . an unusual reverse acting problem. And Dennis was hysterical off camera most of the time this was happening; in fact, some of the things that you see in the film—like my looking away and trying to keep myself from breaking up—were caused by my looking at Dennis off camera over in the bushes, totally freaked out of his bird, laughing his head off while I'm in there trying to do my Lyndon Johnson and keep everything together."[18]

During the campfire scene, the most memorable one in the film, Fonda and Hopper realized Nicholson was walking away with the picture. "Those guys killed him off because he was stealing the picture," Bruce Dern said. "They'd had enough of watching Jack in the daily rushes."

Bert Schneider was not reassured when he came to Taos to check on the progress of his investment. "Dennis threw a shit fit," Fonda recalled. Even worse, the key grip pulled a gun and "shot at the executive producer."[19] Luckily, he missed. While still in Taos, Nicholson dropped acid with Hopper, who later described it as "a wonderful trip."[20] The two were driven to the grave of D. H. and Frieda Lawrence at a mountain ranch commanding a view of several states. They tripped at the tomb for hours, lying in front of the

shrine and later bathing naked in nearby hot springs with a beautiful girl, then running back down the road as the girl followed in a truck, keeping them in the headlights. "We're geniuses, you know that?" Nicholson told Hopper. "We're both geniuses. Isn't it great to be a genius?" Nicholson was under the impression when he returned to the village that their motel was under imminent Indian attack.

His role completed, he left the company in Dallas in order to do "post" on *Head* in L.A., as well as participate in the editing of *Easy Rider*. He told Rex Reed, "I got to edit my own part, so I picked the best shots and everything."

All the forces had now come together to bring Nicholson to the pivotal point of his life: Corman, Fonda, Hopper, Rafelson, and Schneider all had a hand in it. Nicholson, Fonda, and Hopper would go on to superstardom, Rafelson and Schneider to major power.

In 2003, Harry Gittes said, "I saw a very early screening, and Jack just jumped off the screen. He stole the movie. I was extremely happy for him, and extremely sad for myself, because I knew he was gone."[21] Gittes blamed Schneider and Rafelson for advising Nicholson to get rid of his "lame-o" pals from his B-picture past.[22] Without his old friends, who were not afraid to tell him the truth, he would be surrounded by sycophants and in danger of losing touch with reality. "He was no longer going to be [the same]," Gittes lamented.[23] Schneider and Rafelson "brought out his mean side, the hardball side of Jack."

Even prior to *Easy Rider*'s U.S. premiere, there were signs that something seismic was happening to Nicholson's career. In the spring of 1969, accompanied by Mimi Machu, and schlepping film cans of *Easy Rider*, he went to the Cannes Film Festival. "Cannes is where I met all the people I know in the film business," he said. "Of course, you were freer to get loaded back then, so it

was more rockin' than today [2002]."[24] In France in 1969, the air was full of revolutionary zeal; the nation had virtually closed down the previous year due to rioting and strikes. In Cannes, Nicholson, Fonda, and Hopper, looking very hip, created a small stir when they arrived at the Palais and ascended the red-carpeted stairs, Fonda sporting a Union Army uniform, signifying that America was engaged in another Civil War. Nicholson later described the screening: "I'm one of the few people who was actually present at the moment I became a movie star. I could actually sense it in the audience. The film was going along, they were giving it its due, appreciating its . . . new imagery, the fact that Dennis was doing a beautiful job. And then my first scene came along, and the audience just went sssssssss— It was great."[25]

Hopper won the 1969 Cannes Film Festival award for the best movie by a new director; very likely the only reason Nicholson wasn't singled out was because Cannes did not have a category for supporting players.

Easy Rider opened at the Beekman Theater in New York on July 14, 1969. Made for $501,000, it recouped the investment in one week, in one theater. An unusual sight on the fashionable East Side, barefoot hippies thronged the theater and turned the toilets into dope dens. The film came at precisely the right moment—the end of the tumultuous sixties—and enraptured the public by expressing the disillusionment and estrangement of the boomer generation that had witnessed Vietnam, the Cold War, and the assassination of its democratic leaders. There was a feeling throughout the film capital and the press that Hollywood had at last portrayed what the contemporary world was really like, forging a bond with young people in the process. *Life* defined the "style of a New Hollywood [as] love beads . . . and blow[ing] grass."

The film made Nicholson the front man of the hippie revolution, and at last gave him, at thirty-two, a viewpoint and philoso-

phy as an actor. Henceforth he would try to choose roles in which he could both reflect and shape the contemporary personality. He called it riding the sociological wave, sometimes cutting back as he surfed the curl, always in harmony with the generational developments of his time. From now on, he wanted to play "cusp characters. I like to play people that haven't existed yet, a future something, a cusp character. . . . Much in the way Chagall flies figures into the air—once it becomes part of the conventional wisdom, it doesn't seem particularly adventurous or weird or wild." In much of his future work—*Five Easy Pieces, Carnal Knowledge, The Last Detail, One Flew Over the Cuckoo's Nest, The Shining, Batman, Terms of Endearment, As Good as It Gets, About Schmidt*—he would be ahead of his time, challenging, iconoclastic, trailblazing.

There were also the purely practical considerations of maintaining his hard-won stardom, and he adopted a rule that guided him in choosing scripts: "If there are two really good scenes [for the leading man] it means that the part's probably pretty good."[26] These ideas help explain what would become one of the most relevant—and enduring—careers in the history of film. His role in *Easy Rider* was one of his two signature portraits of the defeated rebel, showing what happened to the Beats, Kerouac, Brando, Dean, Ken Kesey, and Clift as they passed from rebellion to despair. The other would be *One Flew Over the Cuckoo's Nest*, which illuminated the predicament of the fallen angel and became a metaphor of the human condition.

He nailed the character of George Hanson by going back into his own past and finding gestures and props that would galvanize the character and the movie. He wore the same glasses that his grandfather, John J. Nicholson, had worn. "Not literally," he said, "but the same. I needed age for that character. I was considerably younger than what I was playing."[27] A fallen angel, his grandfather was an alcoholic who destroyed his early promise and came to a

brutal end, though Nicholson always appreciated his kindly nature. Those are the qualities that shine so endearingly from George Hanson. Nicholson made them real by seeing the world through the eyes of the man whom he still thought of as his father.

The critics, many of them seeing Jack Nicholson for the first time, since exploitation films were rarely covered by the press, loved him on sight, and considered the picture to be "the focal film of the late sixties."[28] Even those who had reservations about the picture recognized Nicholson's talent; the *New York Times* reviewer Vincent Canby wrote that *Easy Rider* was a routine biker potboiler until "a strange things happens. There comes on the scene a very real character. . . . As played by Nicholson, George Hanson is a marvelously realized character . . . the only person in the movie who seems to have a sense of what liberation and freedom are. There is joy and humor and sweetness. . . . *Easy Rider* never quite recovers from his loss." Stanley Kauffmann of the *New Republic* wrote, "There is a crazy sweetness in Nicholson that is pathetic without ever asking for pathos." On Nicholson's home ground, the *Los Angeles Times*'s Charles Champlin threw him the ultimate accolade: "One of the consummate pieces of screen acting."

Even more thrilling than the rave reviews was a telephone call from Stanley Kubrick.

"I want you to play Napoleon for me," said the director of *2001*.

"Fine," Nicholson said. "When do I start?"[29]

Later, Kubrick executive Jan Harlan explained that Napoleon fascinated Kubrick as a "worldly genius who fails. How could someone so intelligent make so many mistakes?" Like many other directors, Kubrick was fond of "battle analogies," Nicholson said. In battles, as in movies, "anything that goes wrong causes catastrophe." Though Kubrick had lined up 5,000 Rumanian cavalrymen, his financial backers withdrew their support when an-

other film about Napoleon, starring Rod Steiger, opened to little business.

Praise from critics and such living legends as Kubrick went straight to Nicholson's head, and suddenly, despite his dislike of politics, he felt capable of anything. Arriving in a restaurant for an interview, he drew stares from the executive lunchers, who gaped at his thick beard, long hair, bellbottom jeans, white-striped red T-shirt, and antique brown-and-white shoes. "I really feel obligated to do something like run for the presidency," he told the reporter, who later wrote, "I can think of worse choices. . . . To watch this fellow appear on the screen is to discover a truly unique individual, a man of infinite raffish aristocratic charm and an acute sensibility."[30] Unlike many stars, Nicholson didn't bother to feign modesty, nor did he despair over loss of privacy. Like the true exhibitionist he was, he thrived on notoriety. "We all seek attention in the first place," he said, "and you don't get to complain about it after you get it."[31] Henry Jaglom thought he went too far, fueled by "his arrogance at the expense of his reason and suddenly he's going to be president of the United States. He has delusions of grandeur in those areas."[32]

In New York in the summer of 1969 to promote *Easy Rider*, Nicholson was staying on his expense account at the posh Regency Hotel when he learned that Ethel May was in a New Jersey hospital, and he later referred to her as a "charity patient."[33] Being a movie star didn't necessarily confer immediate wealth. Ethel May did not always recognize Nicholson when he paid her several visits over the following months, nor did she release him from the big lie of his parentage. She was, however, aware of his success, and happy that his years of struggle had paid off.

One day, Nicholson was scheduled for a press interview at Downey's Steak House at noon, but at five o'clock that morning, he received a call telling him that Ethel May had had an attack.

Getting to Neptune to her bedside proved a harrowing experience, beginning with car-rental companies who refused to give him a vehicle because he didn't have a credit card. "It's always a mistake to try and do anything with cash," he complained. "Nobody trusts cash anymore." Finally he prevailed on a friend who had a credit card to make arrangements with Avis, but then he faced another hassle with Manhattan traffic and the daunting bridge-and-tunnel routes to Jersey. "I was thinking I was going to have to cope with a dying mother," he recounted, "and the problems of just getting around in the city seemed overwhelming." When he arrived at the hospital, Ethel May's voice could be heard in the corridors, screaming his name, but her condition improved, and he was able to return to Manhattan for his interview.

Arriving at Downey's late, the bearded actor struck the reporters as totally frazzled, and he explained that he'd been up all night. The interview was continued the following day in his luxurious Park Avenue hotel suite, and a reporter later noted "the incongruity in the very idea of a bearded underground type just being at the Regency." More journalists turned up every few minutes, and Nicholson's phone never stopped ringing. Slouched on a divan, surrounded by reporters, he enjoyed his position to the hilt, taking calls from the top directors of the decade—Kubrick, Mike Nichols, Roman Polanski, and Michelangelo Antonioni—all of whom were pursuing the latest new star.[34] Despite the obvious impact of *Easy Rider* on his career, he was as reluctant as ever to acknowledge any help from outside, remarking, a few years later, "People think *Easy Rider* changed my career around, which I guess is true, but since *Easy Rider*, I've taken no new work. Everything I've done—*Five Easy Pieces*, *Carnal Knowledge*, writing and directing *Drive, He Said*—I was scheduled to do before *Easy Rider* was released."[35]

During the Regency interview, he elaborated on these and

other projects. "Bob Rafelson's been writing something for me for several months. I've been kind of not wanting to know what it's about. It takes place on a train for the most part. Essentially, the guy is returning to his home town, escorting a coffin back. In *Easy Rider* I left; in this one I go back [Rafelson lost interest in the project, but Henry Jaglom's script, *Tracks*, was eventually filmed with Dennis Hopper in the role originally crafted for Nicholson]. In January I'll direct a film . . . *Drive, He said*. . . . Then I've been talking to a few people. Talking to Mike Nichols about his next picture, the one he's writing with Jules Feiffer. And to Larry Peerce about *The Sporting Club*. It's about two guys in their 30s in upstate Michigan. The members of the club are the elite people in the area. Membership is passed on only to eldest sons. There's this annual 'do' they have and they open up a 100-year-old time capsule. And then . . . anyway, it's really loony [he never made the film]. I had to pass up Dick Rush's college picture, *Getting Straight*. I guess I've lost my standing with him. Now I've got more work than I can handle, and this is a guy I've done my last three pictures with."[36]

Yet another project, but one he failed to mention, was *On a Clear Day You Can See Forever*, the first film he shot after *Easy Rider*, though he and Bob Evans had been discussing it ever since Cannes. He played Barbra Streisand's stepbrother Tad Pringle. In November 1969 he told reporter Harry Clein, "I took the job for the money."[37] Elsewhere he claimed he accepted the role to avoid typecasting, and yet Tad Pringle was, like George Hanson, a well-to-do hippie.

Though Bob Evans finally gave him the role at the Sherry Netherland,[38] Nicholson characteristically declined to thank Evans publicly, telling a reporter, "I was hired off *Psych-Out*, which they were looking at for the lighting effects. 'That's the guy we want,' they said. I wasn't so sure, though, and I turned it down five

times before accepting it. . . .[39] They kept offering me more money."[40]

He'd had to audition for the role—"just me and [director Vincente Minnelli] in the room, *a cappella*, me singing 'Don't Blame Me' to Vincente Minnelli. . . . It blew my mind." During filming, Minnelli gave him little guidance until Nicholson at last said, "Look, Vincente, I don't *mind* being directed." The underappreciated actor was restive throughout the shoot, seeing so much that was wrong and wasteful in big-studio productions. Despite his conviction that he'd already learned everything about filmmaking, and despite the way his ideas had always been readily accepted on Poverty Row—the industry's term for minor studios—he found himself being treated like a tyro by the mainstream pros on the set of the Streisand picture. "I've only done that one big-budget 'A' film," he said in November 1969, "and I wouldn't be in the movies if that's what making movies is like. . . . Roger Corman, Dick Rush [gave me] a very free sort of position. If I have an idea, normally it gets implemented. On *Clear Day*, my ideas were not implemented for this character. They rejected those shoes [pointing to his spectator wing tips]. If I had dressed the character, he would have looked right. . . . I did please Vincente Minnelli—because in my own theory of acting, I must please the director, and I think Minnelli is good—but each night I was unhappy."

He felt he could have produced *Clear Day* for $2 million instead of the $12 million it cost, had he been in charge. They overspent on the set, which had a bad scrim, and he claimed he could have shot his scene better "and for nothing" on the roof of a Manhattan apartment house. In 1969—still decades away from the millions he'd collect from *Batman*—he complained of inflated superstar salaries, saying, "The fees are too high. Not just Streisand, [who] sets the standard for everybody."[41] Much later, when he

ascended to Streisand's pay bracket, he would become one of the most outspoken defenders of huge Hollywood salaries.

He liked working with the pop diva, later telling Rex Reed, "Streisand treated me great, man. I don't think she saw *Easy Rider* . . . so it wasn't because of that. She tried to help me in scenes, you know? She was always telling me things to do."[42] Reed thought him naive for failing to realize Streisand was a well-known control freak. In a later interview he revised his estimation of her only slightly, remarking, "I know what people say about Barbra but it has lots more to do with themselves than with her. She figures she's carrying the movie and wants to do her best. She was helpful and encouraged me in my singing."[43]

On a Clear Day You Can See Forever was an abysmal flop. *Time* said Nicholson had taken "a giant step backwards from *Easy Rider*,"[44] and *Newsweek* wrote, "Nicholson seems to have forgotten how to act." Obviously he was in danger of being written off as a one-hit wonder, but when the 1969 awards season rolled around, he was nominated for an Oscar and a Golden Globe for *Easy Rider*, and the prestigious New York Film Critics Circle and the National Society of Film Critics both voted him best supporting actor of the year. On his first night in New York for the awards, he chose to see *Citizen Kane*, rather than make use of comps for a rock concert at the Fillmore East.

Rex Reed interviewed him in his suite at the St. Regis just before he went over to Sardi's for an award presentation. Reed found him fidgeting and roaming around the hotel room as he munched on a chicken sandwich, downed a Coke, and chatted with a publicist, an agent, and the ubiquitous Mimi Machu. "He has surprisingly tiny features, soft hands, and thinning hair, and looks like a slightly seedy Eagle Scout who is always being stalked by a battalion of slightly aggressive field mice," Reed wrote. Machu burst into laughter when Nicholson told Reed that the only reason they'd

brought Terry Southern into *Easy Rider* was because no one would have financed it with Dennis Hopper as director; without the prestige of Southern's name, it would have been viewed as just another "Peter Fonda motorcycle flick."

When it was time to leave, Nicholson asked, "Will they let me in at Sardi's without a tie?" Machu assured him that as a winner he'd have no trouble, and he took off his tie and tossed it on a chair.

"Will I have to give a speech or anything? I think I'll just say, 'I accept this award in the name of D. H. Lawrence.'"

Machu giggled. Reed told her that her name reminded him of a boat, and Mimi said, "Or a mountain." Then, when Reed asked Nicholson if success was going to spoil him, he said, "Anybody in the world can get me on the phone."

"Some people called up last night from downstairs wanted autographs," Machu said. "I wouldn't let them come up."

"I went down when she wasn't looking," Nicholson said. "The main difference now is money . . . I go for whatever's fair. Only at this point *fair* is a little bit different."

He and his entourage took the elevator downstairs and hopped in a waiting limousine. Arriving at Sardi's for the New York Film Critics Circle's party, he was relieved to see that Jon Voight, the best-actor winner for *Midnight Cowboy*, also wore no necktie, striking an antiestablishment stance at an event at which everyone else was dressed to the nines. Meeting columnist Earl Wilson, Nicholson said, "This is my lady Mimi." Later, dining at Trader Vic's, "she got to kissing [Nicholson's] fingers," Wilson reported in the *New York Post*, "and I kept wondering what there is in the Revolution that can make a girl want to kiss your fingers. This lad Nicholson's pro-pot and has used LSD. . . . He looked at me and said, 'I wish you would say you met a guy whose values you disagreed with but you liked him.'"[45]

The 1969 Oscar nominations were announced on February 16, 1970, and everyone seemed to favor Nicholson, *Newsday*'s critic writing, "If Jack Nicholson doesn't win this year's Best Supporting Actor Oscar, there's no meaning to the awards at all."[46] Still in his early thirties, Nicholson jauntily proclaimed, "If I get an Oscar, I won't feel like I've stolen anything."[47] On another occasion, he quipped, "I'm voting for myself though I don't expect to win." His competition was not particularly impressive: Rupert Crosse for *The Reivers*; Elliot Gould for *Bob & Carol & Ted & Alice*; Anthony Quayle for *Anne of the Thousand Days*; and Gig Young for *They Shoot Horses, Don't They?* Both Fonda and Hopper were passed over by the Academy for producing and directing *Easy Rider*, but at least they received a nomination, together with Terry Southern, for original writing.

At the Oscar ceremony, held on April 7, 1970, at the Dorothy Chandler Pavilion in the Los Angeles Music Center, Nicholson asked Dennis Hopper if he could meet Michelle Phillips, the stunning blond singer in the pop-folk group the Mamas and the Papas, known for their cool, lush harmonies in "California Dreamin'," "Monday, Monday," and "Go Where You Wanna Go."

"Oh, you'd like to meet her? You'll probably be living with her within three months," Hopper said.[48]

Easy Rider won no Oscars that night. Hopper and Fonda lost to Bill Goldman for *Butch Cassidy and the Sundance Kid*, and the old guard preferred veteran supporting actor Gig Young over newcomer Nicholson."[49] Perhaps the most obvious omission from the nominees was László Kovács for his innovative cinematography in *Easy Rider*; the winner in that category was the conventional *Butch Cassidy*. The Old Hollywood wasn't ready to bow out yet.

Money continued to pour in from *Easy Rider*, and Schneider and Rafelson transformed Raybert into a larger company, BBS— Bert, Bob, and Steve—the latter being Schneider's high school

friend Steve Blauner, an intimidating, red-bearded, bead-wearing, three-hundred-pound businessman who was added to the partnership when the details of running the company began to bore Schneider.[50] Nicholson was virtually a fourth partner at BBS, which was about to help revolutionize the motion-picture industry. In the four-story BBS building at 933 North La Brea, which included a fifty-seat screening room, the executives compared penis sizes and called one another "babe" and "doll." According to one staffer, the BBS males "took a macho pride in fucking the same women at different times, from the starlets right down to the typists."[51] A dope peddler regularly made the rounds of offices, as did acid king Timothy Leary, counterculture warrior Abbie Hoffman, and the Black Panthers' Huey Newton. More significant than its role in the fleeting sixties style of radical chic, BBS was an avatar of change in a then-moribund movie industry. A unique communal feeling at BBS spelled the end of the dominance of the producer and rise of the auteur—not to mention a more equitable sharing of profits. Though nothing much of a material nature had yet changed in Nicholson's life, he was definitely in for a percentage, however minuscule, of *Easy Rider*'s epic gross earnings, reported to be $30 to $45 million. Film historians disagree about who was responsible for such retroactive largesse; David Thomson credited Bob Rafelson, but the equally authoritative Peter Biskind said it was Schneider who gave Nicholson points. Schneider also assigned minute percentages to photographer László Kovács, editor Donn Cambern, and location manager Paul Lewis.

For all their air of flower-power purity, the BBS gang "were the meanest people I'd ever met in my life, brutal, inhumane inflicters," said Harry Gittes.[52] "Whatever your weakness was, Bert would be on it like stink on shit. . . . I have never forgiven Jack for getting involved with these guys." Nothing, however, could long come between Gittes and Nicholson; they were friends for life. In

2003, Gittes recalled, "I had left L.A. and gone back to New York and become successful. Jack used to come out and visit, and this was the time in our lives when I was way ahead of him. For years I was more successful in the ad business than the movie business. He was still very much a struggling actor, and he was always trying to get me back to L.A., back into the movie business, because he liked my brand of creativity."

Long before Nicholson became rich, Schneider assured the actor his financial future was so bright he could afford to purchase property in L.A. Following his advice and accepting his loan, Nicholson let Schneider help him look for a place, and bought an $80,000[53] house on Mulholland Drive in 1971—two stories, eight rooms, four bedrooms, three baths, the obligatory L.A. swimming pool, and a black Jacuzzi that had been gouged into rock, where Nicholson was soon enjoying twilight dips. "I borrowed everything," Nicholson said.[54] He later acquired the guest house, and his idol, Marlon Brando, owned the third house in the compound, originally built by Howard Hughes, and purchased by Brando in 1958.

The hilltop compound was situated in a private canyon in the mountains between Beverly Hills and the San Fernando Valley. Eventually, both Warren Beatty and Bob Rafelson moved to Mulholland Drive,[55] which Nicholson compared with Manhattan's Fifth Avenue as the most desirable parcel of real estate in L.A. Access to the compound was unimpeded, a driveway of several hundred feet winding up from Mulholland before dividing into a fork, the right prong leading to Nicholson's house, and the left to Brando's.[56] By the following month, experiencing classic housebuyer's remorse, Nicholson had nightmarish visions of sudden unemployment, inability to meet his house payments, eviction from Mulholland, and ending up back in the flats of Hollywood. "This

week I can pick and choose what I do, but we know people in this business forget very quickly," he said. "I'm already into the problems of my personal life—the auguries of the ultimate demise of everything—and [afraid of being] back in a one-room apartment on Fountain." But he didn't pull out of the deal; it was just his imagination of disaster working overtime.

His combination of overweening ego and cringing self-doubt had not abated with the advent of worldwide adulation. "The Big Wombassa," his nickname for stardom, didn't alter the way he felt about himself. Fame and fortune he defined as "what you think you're going to get but don't get when you get what you want. . . . I find myself apologizing for being a film star if I'm interested in a person socially."[57] Quincy Jones, the multitalented musician-producer whose Laurel Canyon residence included a tennis court, became a new friend—and frequent tennis partner. "When we finished playing tennis," Jones recalled, "we'd start to question each other about our present states and our old ladies. . . . Jack's whole gang came up together and took over the business at the same time."[58]

A few years later, attending the 1973 wedding reception of Quincy Jones's daughter Jolie at the patrician Hotel Bel-Air, "Jack dropped somebody's 'coke' spoon in the toilet," Jones recalled, "and he asked the maitre d' for a monkey wrench. . . . There is Jack, in a white jacket, underneath the toilet, trying to unscrew the big bolt there to get the coke spoon out. . . . There are now six broads in the men's room, watching the action. And when Dick Zanuck hit the room I could see his eyes drop out of his head. I don't think he'd seen too many scenes like this before."[59]

Up on Mulholland Drive, Nicholson and his neighbor Marlon Brando were soon "sharing women," according to Brando's girlfriend Pat Quinn, who played the title role in 1969's *Alice's Restau-*

rant. Quinn found Brando to be an experienced and sensitive lover. "Once Jack moved in next door," she recalled, "Marlon was going after his women, and it became another Hollywood game."[60]

Now that Nicholson had a place of his own, he decided to live as a nudist, so he could overcome self-consciousness about his body. "I was nude no matter who came by. . . . Roger Corman didn't like it much. I wasn't throwing my wang around . . . but it startled him nonetheless. My daughter [Jennifer, born in 1963] understandably didn't like it. . . . Harry Dean Stanton loved it. He couldn't wait to come over and be nude." At the end of his three-month experiment, he felt "very comfortable" being naked in front of others, but admitted in a 2004 interview, "It didn't last."[61]

In January 1970, Ethel May lay dying in a charity bed at the Geraldine L. Thompson Medical Home at Allenwood, New Jersey, of Deamato myositis and chronic myocarditis, complicated by diabetes and osteoporosis. Why, one might wonder, was the mother of an Oscar-nominated actor, at whom producers and directors were flinging scripts, reduced to charity? Despite his new fame and critical accolades, Nicholson was not in the elite circle of such high-earning actors as William Holden and Elizabeth Taylor, nor would he be for some time to come. The purchase of his Mulholland house was accomplished only with the help of a loan. "I lived in this house when I didn't have a nickel," he said. As for his promised percentages, those can be very slow in coming. The longer the middleman—whether a movie studio, book publisher, record company, or agent—hangs on to an artist's money, the longer the middleman can collect interest on it. The polite term for this widespread practice is "slow pay."

Ethel May finally expired, at age seventy-one, on January 6. "I felt the grief, the loss," Nicholson remembered. "After I asked at a

certain point for everyone to leave, when she was in the funeral home for what they call the viewing, I stayed for an hour or so sitting next to the casket." She was buried January 10 at Monmoth Park in New Shrewsbury, New Jersey. For all he knew, she was his mother, for she had died without setting the record straight. He felt "no hidden grievances," he said, since he and Ethel May had never hesitated to air their differences. When he finally learned the truth several years later—that his real mother had abandoned him—he recalled an old, drug-induced episode in which "I got back to the terrible realization I had as an infant: that my mother didn't want me."[62]

Clearly everyone wanted him now. He worked steadily throughout 1970 and, in his personal life, in addition to his tempestuous affair with Manchu, he was seeing other women, including Candice Bergen. Bergen confided in Nicholson after her breakup with Terry Melcher, Doris Day's son, who once considered recording and filming Charles Manson. Melcher was a member of Nicholson's wide circle of friends from the music world, including Phil Spector, Quincy Jones, and Lou Adler. When Manson, a devil worshiper, was later tried for mass murder, Nicholson appeared in court among the spectators and took notes, explaining, "I just wanted to see it for myself."[63] Actually, anything having to do with demonics seemed to intrigue him. He lapped up the writings of Nietzsche, and years later he'd become the personification of evil in such films as *The Shining* and *Batman*. In the latter he'd say, "Ever dance with the devil in the moonlight?" and another signature line was George Hanson's "Did ya ever talk to bullfrogs in the middle of the night?"

It was through Nicholson that Candice Bergen met her next lover, Bert Schneider, who struck her as "charming, sweet, persistent, overpowering, and smart." According to an employee of BBS, Nicholson helped himself to groupies on his film sets and to girls

he met at parties: "When Mimi wasn't there, it was any girl he could find." Though passionate, the relationship with Machu was not viable. "We were two maniacs who couldn't live together or apart," she said. Her days with Nicholson were numbered. Not the least of the Big Wombassa's charms was that, soon, he could have anyone and anything he wanted.

Five Easy Pieces

During the filming of *Five Easy Pieces* in the winter of 1969–1970, Nicholson seemed perversely compelled to perpetuate the identity fabrications and deceptions that had been visited upon him by his family.

It all started when Bob Rafelson had an image of Nicholson in a shot that was as bizarre and original in its way as the famous sequence in *La Dolce Vita* of the religious statue being hoisted onto the Vatican by helicopter. "I have this vision of Jack out in the middle of a highway, the wind blowing through his hair, sitting on a truck and playing the piano," Rafelson said, and told Eastman to write a movie about a concert pianist.

Filmed in the course of forty-one days in Bakersfield, California; Eugene, Oregon; and British Columbia, Canada, *Five Easy Pieces* was essentially built "around me," Nicholson excitedly told another member of the cast. It was every actor's dream: to play himself in a major motion picture. Actually, Eastman based the protagonist only partly on Nicholson, also drawing on the life of her brother, who "drifted almost mysteriously from place to place," and on Senator Ted Kennedy, "whose position as the youngest in his own celebrated family suggested the kinds of competitive feelings and fears" she wanted to explore. The original script, before it

was altered by Rafelson, had the hero plunging off a bridge, Chappaquidick-style, and dying.

Five Easy Pieces presented a new kind of male in American cinema, one who deconstructed not only the usual he-man stereotype of masculinity but, cutting closer to the bone of contemporary reality, unmasked the counterculture rebel, showing him as a far more intriguing creature than Brando, Dean, or Dustin Hoffman—or, for that matter, Peter Fonda and Dennis Hopper—had ever envisaged. Again, Nicholson was riding the sociological curl, giving a watershed performance not only in the history of films, but of acting itself. Rafelson's spare, precise direction and Eastman's quirky genius were indispensable components in his achievement, which, in effect, brought the artistry of British and European cinema—the Angry Young Men, Italian neo-realism, and the nouvelle vague—home to America. Drugs were also a component; on the set, Rafelson served as pharmacist as well as director, and coproducer Richard Wechsler recalled, "He'd say, 'Do you think we should give Jack some grass or some hash for this scene?' "[64]

In the prophetic opening shot, as the credits rolled to the strains of "Stand By Your Man," a shovelful of dirt was dumped in the viewer's face, as if bearing out Nicholson's often-stated promise to challenge the audience—in this case, with everything that was wrong about America in the seventies. "Dirt," said one of the characters. "How did this place get so dirty?" The lead role, Robert Eroica Dupea, a California oilfield rigger living in a trailer, was a wasted pianist. The title *Five Easy Pieces* derived from a child's piano-lesson book. After "auspicious beginnings," Dupea had turned his back on performing and hit the road. Alienated from his father, he yearned for the stability of an emotional commitment but was never able to settle down. Though a good pianist,

he was not special enough for a concert career. As a man, he was also incomplete, incapable of sustaining a relationship with another human being. Dupea was another of Nicholson's cusp characters, a self-destructive artist, a fallen angel, someone who didn't yet exist but, in the troubled society of the time, was morphing from late sixties idealist into early seventies nihilist—from rebellion to despair.

Anyone who was over thirty in the Nixon years knew what Nicholson was saying in *Five Easy Pieces* and his next two films, *Carnal Knowledge* and *The King of Marvin Gardens*: frustration with the status quo and estrangement from the mainstream of contemporary, oppressive, warlike society had led to a chilly nihilism: down with everything, it seemed to say—the state, law, order, and all institutions, for all had been irreparably corrupted. Freedom would only be possible if the idea of God were destroyed, along with morality, marriage, family, property, justice, and civilization. Rebuild the world from scratch, letting personal pleasure be the only guide.

Bobby Dupea lived with a pretty but pathetic girl named Rayette Dipesto, played by Karen Black as a sexy, clinging, cloying mess. Rayette longed to be a country singer; like Dupea, she was good but not exceptional. Dupea took her with him when he drove to visit his family in the Pacific Northwest after his father suffered a stroke, and en route they gave a lift to a couple of Lesbian hitchhikers, Palm Apodaca and Terry Grouse. One of the girls was played by Nicholson's friend Helena Kallianiotes. Palm Apodaca was on her way to Alaska, where she hoped to escape the greed and pollution sinking America. "Crap, filth. . . . People are filthy," Palm said. "They wouldn't be as violent if they were clean. Filth— that's what starts maggots and riots. I don't even want to talk about it." George Hanson's discontent in *Easy Rider*—"This used to be a

great country—what went wrong?"—had turned into national self-loathing.

Palm's screeds became an oddball tour de force as delivered by Kallianiotes, a martial-arts expert who'd previously played the roller-derby nemesis of Raquel Welch in *Kansas City Bomber*. Kallianiotes was in the famous "no substitutions" scene in *Five Easy Pieces*, Nicholson's battle with a waitress, who symbolized brutish institutional authority. He asked the waitress for a side order of wheat toast with his entree, a plain omelet. When the waitress informed him with a touch of sadistic satisfaction that wheat toast was not one of the precise combinations on the menu, and he'd have to accept a muffin or a coffee roll, he cleverly out-argued her, ordering a chicken-salad sandwich on wheat toast, without butter, lettuce, or mayonnaise. "Now all you have to do is hold the chicken, bring me the toast, give me a check for the chicken-salad sandwich and you haven't broken any rules."

"You want me to hold the chicken, huh?"

"I want you to hold it between your knees."

"You'll all have to leave. I'm not going to take any more of your smartness and sarcasm."

The scene ended with Dupea knocking everything off the table and walking out. It was the first instance, though certainly not the last, of Nicholson's famous coiled inner spring, an unexpected eruption of violence as shocking as Brando's table-clearing explosion at Blanche DuBois's birthday party in *A Streetcar Named Desire*. But in *Five Easy Pieces* the gesture became a resonating metaphor of the individual's fight against the network of insane rules that govern society, a theme that would be further developed in *One Flew Over the Cuckoo's Nest*. Henry Jaglom claimed credit for the restaurant sequence, saying that Rafelson had asked him to write a movie for Nicholson, *Tracks*, which included such a scene,

though it was cut in the Dennis Hopper version. "Carole thinks she wrote it," said Jaglom. "I think Jack is convinced he wrote it. Bob Rafelson is convinced he wrote it. It's all *Rashomon*."[65]

Nicholson called Dupea "an extraordinary person posing as a common man." It was indeed a remarkable role, one that summed up, as in no other movie ever made, the contradictions of the American male, torn between the creative impulse and redneck virility, between Pouilly-Fuissé and Bud, Chopin's Prelude in E Minor and Tammy Wynette's "D.I.V.O.R.C.E.," elitist women and earthy waitresses. In creating Bobby Dupea, Eastman drew on fifteen years of shared experience with Nicholson, including his confrontation with the snotty waitress in Pupi's pastry shop in Hollywood when he was still an unknown, and his sad relationship with his grandfather John J. According to Nicholson, *Five Easy Pieces* was "a life mixture of all our lives."[66]

The "secret" to his character, he explained, was "the fact that I was playing it as an allegory of my own career. . . . 'Auspicious beginnings,' "[67] i.e., the bright Jersey boy who skipped college to become a beatnik. He constructed the Dupea characterization from "that time in my life, which Carole knew about, well before *Easy Rider*, when I was doing a lot of TV and [B] movies. . . . So in playing the character, I drew on all the impulses and thoughts I had during those years when I was having no real acceptance." In the script, the words "auspicious beginnings" occurred in the scene between the protagonist and his stroke-crippled father, who was unable to speak.

When they shot the sequence, there'd been a tense morning on the set. Nicholson was in conflict with Bob Rafelson, who felt the actor wasn't emoting enough, that his toughness would turn the audience off.

"Hey, I want you to cry in this movie," Rafelson said.

It went against Nicholson's grain as an actor; he never ap-

proached a scene that directly, and later recalled, "This is the last kind of direction you want to hear." Finally, he wrote his own speech, trying for as little verbiage as possible. "And that 'auspicious beginnings' is what I thought the guy was all about," Nicholson related. "On take one, away I went." Bobby told his father:

"I don't know if you'd be particularly interested in hearing anything about my life. Most of it doesn't add up to much that I could relate as a way of life that you'd approve of. I move around a lot, not because I'm looking for anything really but because I'm getting away from things that get bad if I stay. Auspicious beginnings, you know what I mean? I'm trying to imagine your half of the conversation. My feeling is I don't know that if you could talk we would be talking. That's pretty much the way it got to be before I left. Are you all right? I don't know what to say . . ."

Suddenly, thinking of the yawning void in his own life where a father should have been, Nicholson at last began to sob as he delivered the rest of the soliloquy.

"We were never that comfortable with each other to begin with. The best I can do is apologize. We both know that I was never that good at it anyway. I'm sorry it didn't work out."

Later, Nicholson said, "I think it was a breakthrough, for me as an actor, for actors. I don't think they had this level of emotion really, in almost any male character until that point." Good as Nicholson was, he was by no means the first male actor to go all the way emotionally. Just to name three, Gary Cooper in *Meet John Doe*, James Stewart in *It's a Wonderful Life*, and Clark Gable in *San Francisco* were all as memorable in their tears as Nicholson.

"I've been asked whether I was really thinking of my own father and his tragedy during that scene," Nicholson said. "Of course I was."

At one point while still on Vancouver Island, Nicholson fell in love—or maybe it was only, as with Dupea and Rayette, lust. One

cold night, the cast members were in a forty-two-room seaside mansion, passing around a steaming container of vegetable soup. Nicholson noticed that after each person took a sip, she or he passed it on, and the next person wiped the cup where the other's lips had been. But when Nicholson handed it to the girl next to him, a leggy, toothy blonde who'd been in *Hair* on Broadway, she not only failed to wipe the cup, she licked the place his lips had touched, catching a bit of carrot he'd left.

"You're not an intellectual," he said. "You're a sensualist. A fucking sensualist like me."[68]

Twenty-four-year-old Susan Anspach was five feet four inches, blond, blue-eyed, and had a perfect pink-and-white complexion. "I first met Jack in the summer of 1969 through the audition process for *Five Easy Pieces*," she said. "I already had a one-year-old daughter, whom I'd named Catherine after the heroine in my favorite book, Emily Brontë's *Wuthering Heights*. Jack and I were lovers during the shooting of [*Five Easy Pieces*]."[69] With her short, curly hair, her air of independence and strong will, she was very much the new woman of the dawning seventies, which would see the advent of Gloria Steinem, *Ms.* magazine, and women's liberation. Freedom, Susan had already learned, was not without its price; her rich grandfather had disinherited her when she'd married a blue-collar worker.

Nicholson confided in her that "he had wanted Dusty's [Dustin Hoffman's] part in *The Graduate*."[70] So had just about every other actor of his generation, including Robert Redford. When Nicholson, still mired at the time in potboilers like *The Trip*, had read in *Variety* that the hangdog, forlorn, but stubbornly courageous Hoffman had scored the role of the decade, he'd cursed and then gone out and tied one on.[71] In 1967, *The Graduate* made an instant star of Hoffman, while Nicholson had to endure two more years of obscurity. Candice Bergen, who read for the role

Katharine Ross finally won, would have to wait for decades, and television's *Murphy Brown,* for stardom.

Two other cast members in *Five Easy Pieces,* Karen Black and Sally Ann Struthers (as she was still known before *All in the Family*), also had crushes on Nicholson. "I felt like this girl from Illinois," Black said, "but he'd tell me I was fine— 'just the way I want you, Blackie. You're the best.'" One night, Black dressed up to go out to dinner with him, putting on perfume, and he said, "Blackie, you're real uptown tonight." They liked to listen to music and dance, and she called him "a wonderful dancer." She had "quite a crush on Jack, but he couldn't see me as the girl for him. You have to be eighteen and skinny . . . I was just a little too earthy."[72] And Anspach was just a little too prickly, according to Black, who said, "He used to cry after breaking up with his girlfriend [who] was blond and wore overalls a lot."[73]

But he continued to prefer Anspach, whom Rafelson had originally wanted to play Rayette. Anspach had worked in the legitimate theater, which would win her no points with Nicholson, who had no interest in the stage. "The actor's technique that I follow is to eliminate the audience," he said. "[In the theater] the audience is there. I wish they weren't. I like it in the movies."[74] Anspach recalled, "He said that I was pretentious on the set of *Five Easy Pieces* because I mentioned I'd worked on the New York stage with Robert Duvall, Jon Voight, and Dustin Hoffman. How was I to know he had wanted Dusty's part in *The Graduate?*"[75]

Anspach was viscerally opposed to Rafelson's concept of Rayette as a submissive, lovable anachronism. "I could never play Rayette as cute and sympathetic," she told the director. "I would have to show a lot more rage and pain. As I don't want to argue with you on the set about it, I'll pass on this one." The still-unknown Ellen Burstyn was considered for the role of Rayette before Karen Black was finally cast.

Anspach's was the kind of guts and integrity Rafelson wanted in another character in the movie, the concert pianist Catherine Van Oost. She was finally cast in the role despite, not because of, Nicholson, who wanted Lauren Hutton as Catherine. Carole Eastman wanted Jeanne Moreau. In the end, Rafelson prevailed, and Anspach got the part.

To give Anspach her due, she captured the equanimity of a mature artist as Catherine Van Oost and projected the quiet assertiveness of the new brand of liberated woman just then beginning to appear on the American scene. But, watching the film today, one longs for an actress less diffident, more powerful, and can only imagine what Jeanne Moreau would have done with the role, turning Catherine into a figure of mystery and allure. In contrast, Karen Black made an unforgettable impression with her colorful, poignant, precisely etched Rayette, and *Five Easy Pieces* would turn her into the highly visible and popular (if short-lived) star of *Portnoy's Complaint, Cisco Pike, The Great Gatsby, The Day of the Locust, Nashville,* and *Come Back to the Five and Dime, Jimmy Dean, Jimmy Dean*—a status Anspach would never attain, though she would continue to work as an actress for many years.

Nicholson was both drawn to and repelled by this "avant-garde feminist," as he called Anspach, "who—when I met her—was proud of the fact that she already had a child whose father no one knew."[76] It was around this time that he also remarked, "Sometimes I think all women are bitches."[77] Anspach once said, "The women's movement was about everybody being independent and fair," and she admitted that she "used to fight all the time" with Nicholson, adding, "I like people I can fight with."[78] Years later, she'd reflect, "I feel I am mom personified in his life and the target of an anger he had toward his mother or his grandmother or women in general. If he can spew all his rage at me, he will have

conquered Mother . . . I know he does tend to think of himself as a victim."[79]

She remembered that Nicholson often spoke of how Mimi Machu was tearing him up, throwing parties in his absence on his credit card and warning him that she was thinking about dating a man known as a great lover. Anspach also had issues with Nicholson, feeling they were "not totally trusting each other's way of life. . . . I didn't trust his relationships with women based on what I'd observed and I don't think he was very secure with me because of my straightforwardness."[80]

Understandably, as Anspach fell in love with Nicholson, it became increasingly "painful," she recalled, when he kept talking about Machu. "It bothered me to see somebody I cared about putting himself through that kind of thing. . . . And seeing Jack so upset about it, rather than angry, really sad and loving this person who was treating him this way, upset me, too. . . . We had a very strange relationship. . . . If the world were an island and we'd been totally alone we'd have been very much in love."[81]

She wanted to get pregnant again, and, as Joe Eszterhas would later write in *Hollywood Animal*, "Jack Nicholson never wears condoms." Susan recalled, "He knew very well that I was planning to have a baby, but as it didn't seem to interest him I left it at that. I got pregnant in December [1969]. . . . Everyone involved in the movie suspected that Jack was the father."[82]

One day, Rafelson shot thirty-nine takes of a sex scene between Nicholson and Anspach. "Jack had one toot [of cocaine] every six takes," she said. "He frequently left the set to snort cocaine."[83] She concluded, "His drug-taking is an indication of his lack of happiness."[84] Coproducer Richard Wechsler agreed, commenting, "Jack takes drugs for the same reason I did—it made me feel better."[85] Marijuana had become a beloved habit—"I'm a so-

cial smoker," he said,[86] and added, "I guess I'd be called an old pot head."[87]

After watching the dailies, Nicholson told Anspach, "Ansie, you should see this film—we are gonna be rich. We're gonna be rich!" But as screen lovers they were not destined to follow John Gilbert and Greta Garbo, Clark Gable and Claudette Colbert, or Spencer Tracy and Katharine Hepburn; whatever chemistry they had in bed together did not carry over into their work. As actress Geena Davis would observe in another context, many years later, "Don't ever sleep with your costar. It'll ruin the sexual tension." Eventually Nicholson and Anspach had "a really bad falling out," Anspach said.[88] There were disturbing parallels between what happened in the movie and in reality. On screen, Bobby Dupea asked Catherine Van Oost to become his mistress, despite the fact that she was engaged to his brother. Drawn to him but disgusted by his amorality, she called him "a person who has no love for himself, no respect for himself, no love of his friends, family, work, something—how can he ask for love in return?" The other woman in his life, Rayette, was cruelly dumped by Dupea, who abandoned her at a gas station on a bleak, rainy day, hitching a ride with a trucker and not even saying good-bye. In real life, Nicholson left Anspach while she was pregnant.

Back in L.A., Nicholson and Machu fought over his dalliances. When he learned that Anspach was pregnant, he attempted to set up a meeting, but she stood him up and, in 1970, while she was still pregnant, married Mark Goddard, an actor who played Don West on TV's *Lost in Space*.[89] Described by Susan as "drop-dead-good-looking," Goddard was willing to take care of her and the expected child.[90] In September 1970, Susan "couldn't make the New York premiere of *Five Easy Pieces*," she recounted, "because I was about to give birth." Caleb Goddard, named after James Dean's character in *East of Eden*, and surnamed after his

stepfather, was born in Los Angeles on September 26, 1970, six days after *Five Easy Pieces* was released. According to Anspach, Nicholson said "there was no need for him to have a blood test or tissue culture to confirm his paternity."[91] He attempted to visit the mother and baby, but, by then, Anspach had already been married to Mark Goddard for three months, and her new husband understandably wanted no part of Nicholson.

Even before the premiere of *Five Easy Pieces*, it was clear that BBS had another hit, one that would further enhance Nicholson's reputation. The film was flown up to Vancouver, where Nicholson had returned for location shooting in Jules Feiffer's *Carnal Knowledge* under Mike Nichols's direction. Feiffer had at first objected to casting Nicholson in the lead role, but after seeing *Five Easy Pieces*, he agreed with Nichols that the actor was going to be a bigger star than Brando. Nicholson's sister Lorraine later attended the screening of *Five Easy Pieces* at the New York Film Festival and remembered, "Except for the pounding of my heart, I could not hear a whisper in the audience. When the last scene was over, there was an instantaneous explosion of applause and cheers. Then a standing ovation for the performers. Tingling with pride, I watched Jack rise to acknowledge the tribute. It was a marvelous moment. But I also felt a surge of pain and regret. If only Mud had lived four months longer."[92]

Released the following day, just four months after the National Guard fired into a throng of students at Kent State University in Ohio, killing four, and Nixon's invasion of Cambodia, *Five Easy Pieces* opened at the Coronet in New York, and the public embraced it, feeling that shock of recognition that accompanies a work of art when it's truly new and relevant. Though the ensemble acting was brilliant, the film's highest achievement was the writing; Eastman and Rafelson poetically captured the grave, soul-searching zeitgeist of early-seventies America—ambivalence to-

ward the counterculture in the wake of the 1968 student riots in Paris; the repression of the yippies at the Chicago Democratic National Convention; and the Hell's Angels savagery at the Rolling Stones concert at Altamont. The movie was as dark and bristling with change as the time that spawned it.

Richard Schickel wrote in *Life* that Rafelson, Eastman, and their "exquisitely subtle" cast "create a texture, a complex and ambiguous set of human relationships that will not, I think, ever fade from memory." Nicholson, the critic added, was "one of the few truly gifted movie actors we have." Pauline Kael wrote in the *New Yorker* that *Five Easy Pieces* describes "as if for the first time the nature of the familiar American man who feels he has to keep running because the only good is momentum. . . . Nicholson plays him with a bitter gaiety." *Time* observed that "the role allowed Nicholson not only to turn on his own bursting temper but to flash the charm that has its greatest single emblem in his smile." *Vogue* said Nicholson was "superb."

With regard to his aesthetic and sociopolitical convictions, Nicholson once said, "I think if what you are doing is too naked, you will alienate those who disagree and the people who already agree will fall in line with you."[93] Accordingly, *Five Easy Pieces* did not address specific societal issues, creating, instead, an allegory of the bleak American predicament in 1970, when the nation had not yet decided, after the revolutionary tumult of the past decade, whether it would become a dictatorship under Nixon, with severe restrictions on personal and press freedom, or continue as a democracy. The hippie and yippie leaders had failed as dismally as Nixon, and a deep and bitter cynicism for both the left and the right set in. When Bobby Dupea disappeared at fade-out, heading for the frozen north, it was an act of nihilism: he was following in the tracks of the rattled Lesbian Palm Apodaca, who hated everything. The next stop for Dupea was perhaps the loony bin, just as

one of the next stops for Nicholson, as an actor skilled at interpreting the battered modern psyche, would be *One Flew Over the Cuckoo's Nest*.

In the following years, critics would discern even deeper levels of meaning in *Five Easy Pieces*, viewing it as the universal tragedy of the hero who attempts to respond "to the imposition of identity or class conditions from without," which results in "existential aporia . . . a timeless, archetypal conflict between seemingly irreconcilable cultures and subjectivities."[94] This insight, expressed by critic Colin Gardner in his essay on "Deconstructing the Anti-Hero in *Five Easy Pieces*," dovetailed with Bob Rafelson's statement, "If my films have anything in common, it's that they tend to focus on characters who are struggling to overcome the burden of tradition in their lives."

Dennis Bingham, in his book *Acting Male: Masculinities in the Films of James Stewart, Jack Nicholson, and Clint Eastwood*, went even further, suggesting that Nicholson was a deliberately self-conscious or absurdist Brechtian actor who was more complex than the relatively monodimensional Dean and Brando, simultaneously embodying and critiquing the characters he played by assuming a series of masks. Bobby Dupea, for instance, was a talented musician assuming the identity of a roughneck, but he wore any number of other masks. In the bowling-alley scene, in which he flirted with two girls, played by Struthers and Marlena MacGuire, he was a cultivated pianist pretending to be a redneck pretending to be a television car salesman. "[Nicholson] excelled in roles that posed the male as not so much a player of the game as a player of parts," Bingham wrote. "He made a masquerade of masculine conformity, revealing a character's confident male identity as an unconscious oedipal identification with monstrous paternity."[95]

On February 22, 1971, Nicholson received his first Best Actor

Oscar nomination, along with George C. Scott (*Patton*); Ryan O'Neal (*Love Story*); James Earl Jones (*The Great White Hope*); and Melvyn Douglas (*I Never Sang for My Father*). In the Best Picture category, Rafelson and Wechsler were up for Oscars as coproducers of *Five Easy Pieces*; Karen Black was nominated as Best Supporting Actress; and Rafelson and Eastman (again under the pseudonym Adrien Joyce) were nominated for Best Story and Screenplay. Rafelson had already won the New York Film Critics Circle's directing award.

Nicholson somehow intuited that he was going to lose, "and deservedly so," he said, announcing his intention to vote for George C. Scott. Although Scott let it be known that he would refuse the award if he won, the Academy voted him Best Actor, since, according to the *Los Angeles Times*'s Paul Rosenfield, "the powers that be in Hollywood want what they can't have."[96] In retrospect, it seems incredible that, when the awards were presented at the Dorothy Chandler Pavilion on April 15, 1971, Scott's impressive but retro Patton won over Nicholson's coruscating, hip Bobby Dupea; that insipid Helen Hayes (*Airport*) defeated the heartrending Karen Black; and that Francis Ford Coppola and Edmund H. North won Best Story and Screenplay for *Patton* over Rafelson and Eastman. In their history of the Oscar, *The Academy Awards*, Gail Kinn and Jim Piazza called *Patton*'s win over *Five Easy Pieces* in the Best Picture category a "sin of omission," adding that *Five Easy Pieces* was "a landmark film for its—or any—time."

After attending the Oscar ball with Nicholson, Michelle Phillips called him "a fun date. This was early in his career when he was a star, but not yet a megastar. He was very charming arm candy for me that night. Jack never wanted to look like the penguin in the tuxedo. He was always a bit edgy in the way he dressed, and he kind of started that hip men's style of dressing where you didn't just wear a white shirt with a little black bow tie. He would

not conform to something like that. We had a good time [with Leigh Taylor-Young and Ryan O'Neal, who was nominated for Best Actor in *Love Story*], lots of fun, lots of drinking, but I did go home alone. Jack dropped me off at my house."[97]

In the 1970's, the decade of California rock, Michelle Phillips, the Mamas and the Papas meltingly lovely blond sex symbol, was the essence of Hollywood hip. Arriving in L.A. in the summer of 1965, Michelle, her husband Papa John Phillips, Cass Elliot, and Denny Doherty became the warm-up band at the Whisky A Go-Go, a club that, along with the Rainbow Bar and Grill, the Troubadour, and the Roxy, formed the center of the newly interacting worlds of film and rock. Nicholson's best friend, record mogul Lou Adler, a handsome charmer who dated Britt Ekland, Ann-Margret, and Shelley Fabares, produced the Mamas and the Papas' debut album. Before their marriage ended in 1968, Michelle and John Phillips led the rock invasion of Bel Air, where their home became party central for Janis Joplin, Art Garfunkel, the Lovin' Spoonful, Jim Morrison, the Beatles, and the Rolling Stones. Candice Bergen remembered, "By sandal and sole, Bentley and Rolls, they came to the Mamas and Papas high on the hill . . . swallowing Librium like Life Savers, 'windowpane' acid, maybe mescaline."

Lou Adler owned the Roxy, where Nicholson hung out in the ultraprivate upstairs room On the Rox with such other Adler pals as Ryan O'Neal, Cher, Warren Beatty, Michael Jackson, Cheech and Chong, and Michael Douglas. "You couldn't get more inside," Cheech said. The waitresses at On the Rox were the prettiest girls in town. "That was like fishing in a hatchery," Cheech added. "Oh, baby."

Nicholson, Beatty, and Dennis Hopper caught Ozzy Osbourne, Elton John, and Rod Stewart at the Rainbow Bar and later partied at the exclusive VIP haunt Over the Rainbow. The Eagles,

Fleetwood Mac, and Dan Fogelberg played the Troubadour; Adler booked Neil Young, Graham Nash, and Cheech and Chong into the Roxy, where *The Rocky Horror Show* premiered with Tim Curry and Meatloaf; and Johnny Rivers, Frank Zappa, Sonny and Cher, Van Halen, Mötley Crüe, and the Doors held forth at the Whisky. It was the hey-day of the L.A. stoner culture, and Nicholson was in the middle of it, and of the punk and glam-metal scenes that followed. Recalled Slim Jim Phantom, the Stray Cats' drummer, "Jack Nicholson was in the audience dancing in the front row getting pushed around by all the rockabilly kids."

According to author Jim Harrison, who'd later write *Wolf* for Nicholson, "Lou Adler and Nicholson . . . handled L.A. as if it were their own personal birthday cake. Going to the [L.A.] Lakers basketball games drew you away from the quarrels of meetings, in addition to just seeing splendid basketball, which never quite works on television. Jack and Louis had seats on the floor next to the visitor's bench where the game was improbably visceral and the subtlety of the moves detectable."[98] When Adler's son Nicholai was born, Nicholson became his godfather.

Five Easy Pieces predictably fattened Nicholson's bank account, appealing to everyone across the social spectrum from rednecks to eggheads. "Since *Five Easy Pieces*, I am a primary gross participant," he revealed.[99] Costing $876,000—very inexpensive for a major feature—it didn't take long for his percentage points to click in.

It was in 1970–1971, the time of *Five Easy Pieces* and *Carnal Knowledge*, that Nicholson gained his reputation as one of the all-time swingers, bringing it on himself by telling *Newsweek*, "I've balled all the women, I've done all the drugs, I've drunk every drink."[100] He became cafe society's stud du jour. During a party in

a Manhattan brownstone, several women followed him into a bedroom, where he stretched out on a king-size bed, willing to take on all comers. Iman, the high-fashion model who later married David Bowie, was all over him. "So I'm sexy," he told a reporter. "Is that a crime?"[101] Whatever it was, intimacy wasn't a part of it. His habit of giving everyone he met a nickname was a way of both holding people at bay and making them feel special, "a sign of affection and disaffection at the same time," according to "Curly" Rafelson. Bob Evans was "Mogul"; Mike Nichols "Big Nick"; Art Garfunkel "Art the Barf"; Candice Bergen "Bug"; Harry Gittes "Wonderful Harry"; Steve Blauner "Blautown"; Monte Hellman "Bomber." Rafelson observed, "It keeps him in an authoritative position, keeps the relationship a little distant."[102] Bob Evans had the same habit, calling Nicholson "Irish."

Despite Nicholson's distaste for actors who engaged in active politicking, in 1972 he let Warren Beatty talk him into campaigning for Senator George McGovern, the Democrat who opposed President Nixon the following fall. At the Oscar ceremony on April 10, 1972, at the Dorothy Chandler Pavilion—the night Jane Fonda won for *Klute* and Gene Hackman for *The French Connection*—Nicholson sported an Op-Art shirt and a McGovern button, sans jacket, heralding a heretical decade full of political, moral, and fashion breakthroughs. Beatty also enlisted support for McGovern from Asylum Records' David Geffen, the power behind the Eagles; Linda Ronstadt; Joni Mitchell; and Laura Nyro. Geffen introduced Nicholson to Mitchell, and a short if intense relationship began. Nicholson, Mitchell, Geffen, and Beatty together went to a benefit concert featuring Barbra Streisand, Carole King, James Taylor, and Quincy Jones that raised $300,000. Later, Beatty called on Nicholson to serve as a celebrity usher, along with Julie Christie, Ryan O'Neal, Candice Bergen, Jon Voight, Goldie Hawn, Gene Hackman, Lee Grant, Paul Newman,

and Dustin Hoffman, at a Madison Square Garden rally in New York, where the concert featured Peter, Paul, and Mary, Dionne Warwick, Mike Nichols and Elaine May, and Simon and Garfunkel. As an usher, Nicholson was a bust, shrinking from the huge crowd, but he was demonstrably affectionate with supermodel Veruschka when, wearing a white suit, he attended an après-concert dinner at the Four Seasons restaurant with a group that included Hawn, Voight, and Shirley MacLaine.

The six-foot-one-inch-tall Veruschka was the Countess Vera von Lehndorff, whose East Prussian father had been executed in World War II for trying to assassinate Hitler in the famous 1944 officers' plot. At eighteen she started posing for photographers like Helmut Newton and Richard Avedon and gracing *Vogue* covers. After her appearance in Antonioni's *Blow-up*, such movie stars and rock musicians as Nicholson and Mick Jagger, who'd traditionally hooked up with actresses or singers, looked to the runways of Seventh Avenue, London, Milan, and Paris, and to fashion-magazine covers, for their girlfriends and wives.

Nicholson, Newman, Hoffman, and the rest of the celebrities Beatty assembled for his January 1972 Madison Square Garden concert raised $400,000 for McGovern. The Hollywood troglodytes supporting Nixon included Jack Benny, John Wayne, Cesar Romero, Charlton Heston, Dorothy Lamour, Jane Russell, Bob Hope, and Debbie Reynolds. The election, one of the most crucial of the century, would pit the young and hip against the old and square. The nation had a chance to renounce the corruption of war and Watergate and get back on the track of moral progress it had tasted under President Kennedy.

In the fall presidential election, Nixon's landslide victory over McGovern "left a bitter taste not so much about politics, but about

American social life in general," Nicholson said.[103] Actress Coco d'Este, who later married David Carradine, recalled, "During the McGovern election era in Hollywood, Jack and Warren Beatty were always the hot guys who went to the Troubadour on Santa Monica Boulevard. They were the big political guys then and they had all the little chickies around them. Jack dated a waitress at the Troubadour who was heartbroken after it was over. She should have stayed away from him. Ha! She was a petite blonde with curly hair. He was there every night, became a permanent fixture, as did Tommy Smothers and Cheech and Chong. It was the most fabulous era. Don Henley had just become an Eagle, and they were beginning their rehearsals."[104]

The freewheeling scene at the Troubadour was nothing compared with some of the sexual stunts Nicholson would pull as director of his first mainstream Hollywood feature, *Drive, He Said.*

Chapter Four

THE CASTING COUCH

DRIVE, HE SAID

A brazen instance of Hollywood's sexually exploitive casting practices occurred when Nicholson was putting together *Drive, He Said*, his first major directorial effort, released in 1971. Eternally horny, he interviewed scores of girls for the film's nude scene, asking them to disrobe, but ended up hiring none of them, knowing from the outset that he was going to use a professional actress. It was the wildest casting call since MGM producer Arthur Freed exposed his genitals to eleven-year-old Shirley Temple, while L. B. Mayer, in an adjoining office, hit on Shirley's mother.[1]

Auditioning for *Drive, He Said*, one woman arrived for her appointment at BBS, which she described as "a cartoonist's idea of what a production office should be. Everybody is running around in freaky clothes, yelling 'Babe' and 'Doll.' . . . There must have

been a hundred of us all willing to do anything for this 'ferkockta' little part." Nicholson was in his office with three other men, who eventually drifted out, and then some secretaries and assistants joined him during the audition.

"Are you willing to do nude scenes?" he asked the girl. "You know, I have to see this actress undressed first. Are you willing to do that?"

She took all her clothes off "in this roomful of people," she recalled, "but I was really just undressing for him. He looked me over, smiled, and then said—so help me— 'Thank you, we'll let you know.'" Later on, she and Nicholson got together. "I was an intermission between Mimi Machu and Michelle Phillips," she said.[2]

A friend of Machu's, June Fairchild, a professional actress Nicholson had worked with in *Head*, got the role. Nicholson soon discovered that the cost of fame was high for a womanizer. "A couple of years ago, I told a reporter that for years I'd balled all the chicks I'd wanted to," he said. "Well, man, every chick I ever related to really resented that statement. . . . She doesn't want to be in a pussy parade. I mean, no chick wants to be part of some band of cunts."[3] On another occasion, he complained, "I can't go around picking up stray pussy any more." Nor could he frequent the Troubadour—to catch James Taylor or Cat Stevens—or Barney's Beanery without fans accosting him. Michael Gotovac, a bartender at Dan Tana's restaurant on Santa Monica Boulevard in West Hollywood, remembered, "Jack had a table directly behind the bar. He never sat at the bar. He was always at his own table with his own group of people. He was coming there regularly for a couple of years and then he just disappeared and never came back. This had to be in the early 1970s. Always a big table behind the bar. There's a lady, she was in his movie *Five Easy Pieces*. She used to come in there with him all the time. Helena. She was Greek. Big long Greek name [Kallianiotes]."

With his seventies crowd—Sally Kellerman, Warren Beatty, Bob Towne, Harry Dean Stanton, Harry Gittes, and Lou Adler—Nicholson liked to hang out at the Roxy, listening to rock 'n' roll. The men dressed in the prevailing style—satin baseball jackets and jeans—but Nicholson, ever the nonconformist, switched to tailored sport coats acquired at Maxfield Bleu of West Hollywood, where Giorgio Armani and Basile were just catching on. "I brought the suit and tie back," he claimed.

For all its drawbacks in terms of loss of privacy, fame certainly had its compensations. Most of the actors he'd studied with at Corey's were now in their midthirties and reduced to doing television, if they were lucky. "Now, as it is, I might get to work in this area [feature films] until I'm forty, rather than being a has-been at thirty, which can totally wreck your life, as it has for most young successes," Nicholson said. "You can scoff at the Troys or the Tabs or the Rocks or whatever, but you're lucky you're not him. . . . Those guys are all under forty and they've had to call on instincts that men usually use to meet their psychological dilemmas with when they're seventy."[4] In retrospect, we know that he was underestimating his lasting power in Hollywood, and that he's still, in his midsixties, a bankable star. Through it all, he has remained almost alone among actors in eschewing television talk shows, because he is "enamored with mystery for an actor. . . . The more the audience knows about you as a person, the harder your job as an actor becomes."

Though he directed, coproduced, and cowrote *Drive, He Said*, his only appearance in the film was limited to mooning his backside. Harry Gittes, one of his coproducers,[5] recalled in 2003, "In *Drive, He Said*, the guy's getting a shot in the ass with a hypodermic needle. Jack has a great ass, so he let his ass be the one that took the needle."

As a director, he was a splendid teacher, at least for the actors,

though the crew would have harsh reservations. "A question you always ask in acting is, Where were you going if this scene didn't interrupt the movements of the character?" he said, and he always advised beginners to follow every impulse, "no matter how wrong it seems . . . because we're not on a stage. It might be something, and if it ain't—take two." Expounding on his directorial philosophy, he told a reporter, "I try to tell them where the freedom lies, rather than the restraint. This is where unpredictability comes from, this is where the fortunate accident comes from."[6]

Though it looks simple on the screen, movie acting is difficult. Some directors ask their actors to memorize as many as fifty moves when blocking out a scene. It's very important where the body is and where it isn't when working with a camera, and there are also tight lighting marks that have to be observed—when to flow and to what rhythm. The actor must somehow absorb all this without overloading, so she or he's still able to improvise and be creative. Nicholson urged his actors "to encourage your full organism and subconscious to engage and become expressive. Part of that dynamic is to look as much as you can at who you are inside, and become at peace with it. I'm more comfortable seeing that I'm a hideous liar, a coward, an exploiter of everyone. I'm comfortable with seeing those things about myself because I know everyone has them. It's part of a whole human being just as the beast is in the human being. There's a common fantasy and fear that people have. . . . I read [about it] only once, in [Thomas] Pynchon's *Gravity's Rainbow*. There's a moment where he talks about taking a poker and smashing [an] infant's fragile skull with it. And his face goes through that horror, old father of two little children trying it out, feeling it. An actor has to clear the ground for the subconscious."[7]

BBS's Harold Schneider put together the crew for *Drive, He Said*, using people he'd worked with on a few previous pictures

whom he thought were "terrific and they also think they're terrific." These pros didn't like Nicholson's unstructured way of filming. They'd ask him what they were going to shoot that day, and he'd give them a list of seven shots. "After lunch we had never shot any of the seven shots, but we'd shot something else," Schneider recalled. Nicholson shrugged and said, "What's the problem? The picture is still on schedule."

The real issue was the crew's prudishness. They accepted his decision to have one actress strip nude every time she appeared, "all the time. . . . for no purpose," Nicholson said, but the cameraman refused to shoot Nicholson's planned "symphony of dicks, satirical, long-lensed, out-of-focus shots of all these guys in the shower. I thought it might have been a good title sequence." He was testing how far he could go in challenging the film industry's antiquated censorship strictures.

The crew went to Schneider to complain. "We're only here because of you. Jack is different, and we would have left if not for you." Schneider told them, "You think there's too much swearing, too much sex, whatever the hell it is. That's not what you're hired for and that's not what I'm hired for. It's not our job to judge that. Our problem is to service this and to the best of our ability." But he later admitted, "We did not do that well."[8]

For all of Nicholson's expertise as an on-set acting coach, he wasn't a good director, because, according to *Cosmopolitan* writer Leo Janos, he was too disturbed in his private life for the requisite concentration. Nicholson smoked pot "to ease the private pains," Janos revealed. "He long ago turned to marijuana, openly acknowledging the fact much before it was popular to do so. He used the narcotic to unwind the way others use a few stiff drinks at the end of the day in the privacy of his home."[9] As anyone who's smoked a few joints knows, the drug, apart from its delightful euphoria, confuses the mind, slows it down, and leaves a hangover

that, while less painful than alcohol's aftermath, involves grogginess. It's not the best condition for doing any kind of serious work.

Filmed for $800,000, *Drive, He Said* exemplified Nicholson's obsession with cusp characters; the story dealt with college revolutionaries teetering between rebellion and riotous self-will (and sometimes insanity). It also combined his interest in directing and his passion for basketball, and the film's basketball sequence "is considered by many aficionados to be one of the finest ever filmed," according to the *Los Angeles Times*'s Deborah Caulfield.[10] Principal photography started at the University of Oregon in Eugene, where Nicholson filmed an actor running nude across the campus. Predictably, the local police showed up, and Nicholson, on a whim, stripped naked for his interview with the local constabulary. The state of Oregon took out an injunction to prevent *Drive, He Said* from being shown in the state.

In casting the male leads, Nicholson proved to be anything but a star maker. Schneider wanted Richard Dreyfuss for the role of Gabriel, the student radical, but Nicholson insisted on Michael Margotta, an actor who resembled Nicholson in appearance and attitude. Little was heard of Margotta after *Drive, He Said*. For the role of Hector, campus basketball star, Nicholson wanted William Tepper, who'd played the game in high school. Schneider didn't like the actor, but Nicholson assured him that Tepper, "probably the best actor of his generation," was bound for stardom. No such thing happened.[11] Also in the cast were such Nicholson cronies as Robert Towne, Karen Black, Bruce Dern, and Henry Jaglom. In the end, the film was X-rated, "which we successfully fought," Nicholson later recounted. "The censors were even crazier then. . . . If you suck a tit, it's X. If you cut it off, it's PG."[12]

While Nicholson slept with groupies in Eugene, Mimi Machu, inhabiting his L.A. house, was sleeping with his friends and telling them Nicholson wasn't much of a lover.[13] Machu came

up to Oregon to do a cameo and was rumored to be having sex with one of the actors Nicholson was directing. Machu and Nicholson yelled at each other in front of cast and crew, and Machu stormed off, returning to L.A.

Depressed when she blew him off and moved to Oregon, he said, "I had been with her for three years, in love. After she left I couldn't even hear her name mentioned without breaking out in a cold sweat." Afraid he was cracking up, his friends rallied round, and one of them recalled, "Jack will always pick a woman who's going to shit on him. And when she leaves him, he goes to pieces, he's pulverized."[14] Henry Jaglom observed, "He deserves better than he's had. I feel it would be frightening for him to be with a woman who might demand the very most from him."[15] Nicholson, a self-described "walking cliché" of the predatory male, was dazzled by "skunks": such unobtainable, aloof goddesses as high-fashion models, rock stars, and glamorous actresses. Machu definitely fit into this category, and their stormy relationship had miraculously survived for several years. Later, she got involved with his friend, director Hal Ashby.[16]

Nicholson went into psychotherapy for "first aid," he said, citing as the cause "women. . . .[17] It ended before I was ready to be out of it. She felt that it wasn't worth her time; she'd had it. It was all very sudden, very abrupt, and I was unprepared. I couldn't cope with all that emotion that was released as a result of being cashiered." Reichian therapy helped him release his sexual energy, he told Susan Strasberg, who remembered that he distilled it all down to: " 'You fuck better.' " Later, he confided to journalist Chris Chase, "I'm interested in sex. I'm preoccupied with sex. I love it. But, you see, most sex is about non feeling. People are afraid of their feeling in this area. . . . The world fears the sexual animal. The only therapy I've ever been in is Reichian, and Reich says we

form our personalities, our families, our governments around this neurotic armor. We're all victims, victims of the furies. You can feel the difference when you make love and there's love there, and when you make love and there's not love there. . . . Repression and fear of freedom are the problems."[18]

Required to take off his clothes to be analyzed naked, he recalled, "It worked with me like this," snapping his fingers. Cocaine also helped; quoting Erroll Flynn, he told *Playboy*, "Putting a little cocaine on the top of your dick [might act] as an aphrodisiac." He also confided to the infamous stroke magazine, "Chicks dig it sexually. . . . The property of the drug is that, while it numbs some areas, it inflames the mucous membranes such as those in a lady's genital region. That's the real attraction of it."[19] He kept two qualities of cocaine around: a downstairs stash for acquaintances, and an upstairs supply for sex partners.[20]

Screening *Drive, He Said* at the Cannes Film Festival, where it was one of three official U.S. entries, he assumed he had the Best First Director award sewed up—after all, Hopper had won it for *Easy Rider*—but instead it went to Dalton Trumbo's *Johnny Got His Gun*. The *New York Times* speculated that the French were offended by *Drive, He Said*'s "unglamorous handling of the sex scenes." The counterculture and the student left were outraged by "schizophrenic people" representing the movement, as if the only persons drawn to protest were "crazy . . . freaked-out rapist[s]," wrote the alternative weekly *Village Voice*'s correspondent, Mike Zwerin, from Cannes.

On June 16, 1971, the picture opened at Manhattan's Loew's Tower East. "Jack Nicholson's first crack at directing is a thudding disappointment," wrote the *New York Daily News*. Everyone assumed the rebel star of *Easy Rider* had done an "about face," wrote the *Village Voice. Time*'s Jay Cocks called it "a bush-league disaster

that might have passed unnoticed, and perhaps unmade, but for the participation of Jack Nicholson." *Newsweek* was more charitable, calling it a "serious but ultimately flawed film."

Just as Dennis Hopper had predicted, Nicholson began an affair in 1971 with Michelle Phillips after she left Hopper, with whom she'd appeared in the expensive flop, *The Last Movie*. Their violent marriage lasted only eight days. Both Nicholson and Michelle Phillips were dejected when they met, the former still reeling over Machu and the latter in shock over Hopper, one of Nicholson's best friends. He rang Hopper in Taos immediately and told him he was in love with Michelle. "Best of luck, man," Hopper said. "It's over between her and me anyhow."[21]

Nicholson and Phillips would become models of the sexual revolution. With the long-overdue demise of the Victorian era, people were beginning to look at their own sexuality and consider options that were newly respectable. Nicholson had become a hero to hippie males and their *Playboy*-reading beatnik antecedents, who were now running the establishment. Michelle Phillips, world-class beauty and career girl, was very much the protofeminist woman with a life of her own. Treasuring her independence, she began her affair with Nicholson on "agreed terms" that neither was the stereotypical homebody. She did not want to move in with him because she had her five-year-old daughter Chynna to think of, and Nicholson was too "set in his ways." He moved her into the third house in the compound he shared on Mulholland Drive with Brando "to try to save their relationship," said Bob Towne. Helena Kallianiotes also moved into the little house. After *Five Easy Pieces*, Helena's acting career was minuscule, but she remained in Nicholson's life for years, as his "totally platonic companion," secretary, housekeeper, and Girl Friday. "If he liked something," said Kallianiotes, "he'd bring it home, whether it was a lampshade or a

person. Two or three house guests were around in any single month."[22]

Anne Marshall, Nicholson's full-time secretary, was the daughter of actor Herbert Marshall and a former girlfriend of John Phillips. In typical sixties *Bob & Carol & Ted & Alice* fashion, Marshall—or "Staff," as Nicholson called her—was an intimate of Phillips's ex-wife and Nicholson's current girlfriend, Michelle Phillips. In the Nicholson household, Anne Marshall's "job is to watch me while I'm working," Nicholson said.[23] In reality, she kept his appointment book and protected him from outsiders. Years later, he'd toss Marshall a small part in *The Two Jakes*.

According to Bob Towne, Michelle Phillips "seemed to be wanting to get out of the affair—a few of us had seen it coming— so Jack thought that by having her own place she could retain her independence. He was trying hard to keep her, but I could see it wasn't going to work." Nicholson proposed marriage to Phillips, but she wasn't interested. "Jack was always peering in the windows to see what I was up to," she complained. Nicholson wanted her, but wanted his freedom even more, saying, "As my feeling for Michelle deepened I told her up front, 'Look, I don't want to con- stantly define the progress of this relationship. Let's keep it in- stantaneous.' "[24]

CARNAL KNOWLEDGE

Nicholson worked on *Drive, He Said* a year and a half, and it over- lapped with the far more important *Carnal Knowledge*, which started filming in September 1970 in Vancouver, where Nicholson and costars Candice Bergen and Art Garfunkel took over a large house. Nicholson called Garfunkel, the former singing partner of

Paul Simon, "a born actor," though the pop-rock star's truncated acting career would hardly bear him out. Bergen's torrid affair with Bert Schneider was still going on, Schneider playing Svengali to her Trilby, but it'd soon lose steam, after Schneider introduced the subject of what he called "sexual nonexclusivity."

"What do you mean by that exactly?" Bergen inquired.

"Where two people feel secure enough and free enough to explore sexually with other people."

"What do you mean . . . 'explore sexually'?"

"I'm sorry it's so threatening to you, Bergen, but you have to understand that I'm a love object for every woman who walks into my office. . . . Start dealing with that—it's time you began growing up."

Schneider had given the same kind of advice to his wife Judy, telling her to sleep around, and even advising one of his pals, "My wife really likes you, I'm going out of town, why don't you take her out to dinner?" Predictably, Judy kicked Schneider out and they never got back together. Much later, Schneider kicked Bergen out when he heard rumors she was having an affair with William Holden.[25]

The atmosphere on the set of *Carnal Knowledge*, at $12 million a very expensive picture for the time, was so volatile that director Mike Nichols told everyone to stop smoking pot for the duration of the shoot, for more "vitality."[26] Despite the failure of his heavy-handed 1970 flop *Catch-22*, the still very hot Nichols had *The Graduate* and *Who's Afraid of Virginia Woolf?* to his credit and was going for the triple crown with *Carnal Knowledge*, an unproduced Jules Feiffer play originally titled *True Confessions*. An insider connected with the production recalled, "Mike read the play and called Jules and said, 'If they walk out during intermission, they'll never come back to their seats. Let's do it as a movie.'"

Feiffer's play made a strong statement about men that was edgy, unsentimental, and chilling.

Carnal Knowledge was supposed to confirm Nichols's position as the leading director in Hollywood and Nicholson's as a superstar, and it was also expected to make a major star out of Bergen. It would do none of these. Instead, it marked the beginning of Nichols's precipitant decline, which would not be reversed until *Silkwood* in 1983. For Nicholson, it was a setback, and for Bergen, further proof that, despite her tantalizing debut as an aloof Lesbian in *The Group*, she was headed nowhere in Hollywood.

But during filming, everyone involved was convinced they were on a rocket to success, and at one point the company threw a joint party with the *McCabe and Mrs. Miller* company, which was also on location in Vancouver, and whose glamorous stars, Warren Beatty and Julie Christie, were romancing. When Jules Feiffer introduced Nicholson to Beatty, Nicholson said, "Now, *that's* what a movie star is supposed to look like." They were friends from that day on, allegedly competing to see who could conquer the most women in a given period of time.[27] They "pass[ed] dazzled females to each other," wrote *Marie Claire*. "They called models, including Apollonia von Ravenstein, Lauren Hutton, Veruschka, and Kelly LeBrock and flew them in for the night. Nicholson [even] tried on strongwoman Lisa Lyons."[28] The latter, who was photographed by Robert Mapplethorpe, went from Harry Dean Stanton to Nicholson, and ultimately to Rafelson. Nicholson also dated models Zou Zouk and Jude Jade.[29] A person who was present during the shooting of *Carnal Knowledge* recalled, "Jack Nicholson was charming, absolutely seduced everyone with his charm and attractiveness. He had wonderful lips."

Carnal Knowledge was "a picture about men's hatred of women," Jules Feiffer told playwright Lillian Hellman, adding, "all

heterosexual men hate women." Having had considerable experience with heterosexual males, ranging from former husband Arthur Kober, who cowrote the book for Harold Rome's Broadway musical, *Wish You Were Here*, to friendships with Dashiell Hammett and Warren Beatty, Hellman attempted to correct Feiffer, saying, "You're talking about homosexuals."

"No," Feiffer said. "Homosexuals love women. And heterosexuals hate women."[30]

Feiffer had always had it tough as an American male. "In high school, at James Monroe in the Bronx, I had a deep sense of inadequacy," he said. "I was physically slight, never good at sports, and also because I skipped a grade in grammar school, I was younger than everyone else. In our gym class, where we swam naked . . . I was the one without pubic hair. . . . I saw myself as a failure as a boy."[31]

Carnal Knowledge was about the rage men experience when they realize women can't make them feel like men, because that conviction can only come from inside, and how they punish women for this perceived failure.

Lavishly produced and directed by Nichols, the film traced the sexual history of two Amherst College roommates from upbeat youth through embittered adulthood. As Sandy, Garfunkel represented the gentle, positive side of the American male, Nicholson, as Jonathan Fuerst, the dangerous, mean-spirited sexual predator, for whom Feiffer wrote the line, "Guys don't really like girls."[32] When Sandy fell in love with a Smith coed, Susan, played by Bergen, Jonathan betrayed his roommate, seducing Susan and calling her "a good piece of ass." Sandy and Susan began an unsatisfactory, short-lived marriage, and Jonathan became involved with the love-starved, suicidal Bobbie Templeton, played with wrenching pathos by Ann-Margret. When Bobbie hinted at marriage, Jonathan snapped, "I'm already taken—*by me*." According to a

Hollywood source, Jules Feiffer's then-wife, Judy, later an editor, motion-picture executive, and author of the 2004 Random House novel *My Passionate Mother*, was "a little bit Candice Bergen's Susan and a little bit Ann-Margret's Bobbie."

In the end, Jonathan, now impotent, was barely able to achieve an erection despite the expert oral manipulations of Louise, played by Rita Moreno, who later revealed that fellatio with Nicholson required twenty takes. "He was considerate," she said, "knowing it was a hard thing to do."

The problem of both of the men in the film, Jonathan and Sandy, was that they were stuck on an impossible vision of perfection, symbolized by a graceful figure skater they used to watch at the Woolman Rink in Central Park. "In a casual conversation with me," Nicholson said, "you could have a certain difficulty in separating my sexual stance from Jonathan's." Indeed, many called it typecasting, especially after Nicholson admitted, "I've had days in my life . . . when I've been with more than four women. I found that to be an internal lie. You're just not really getting it on past a certain point."[33]

Another of his cusp characters, Jonathan Fuerst, a disenchanted Don Juan, came at exactly the right moment to be culturally relevant in America: writers like Gay Talese, Erica Jong, Alex Comfort, Linda Lovelace, and Xaviera Hollander were gearing up to document the decadence of the seventies. Again Nicholson was ahead of his time, surfing the sociological curl that would bring the sex revolution, as well as its tragic aftermath, AIDS. Nicholson occasionally attempted to disown any autobiographical parallels between himself and the character he played in *Carnal Knowledge*, telling *GQ*, "That was really Mike Nichols and Jules Feiffer," but an insider who was present throughout the production said, "Mike, Jules, and Jack were all misogynists, and all had a high on this movie." Nicholson said he "knew that women weren't going

to like me for a while, that was a given."[34] Mike Nichols was impressed with the actor's willingness to take on unsympathetic characters like Bobby Dupea and Jonathan Fuerst, commenting, "Over and over, Jack plays a character that ends up with more specific gravity than anyone would have guessed from reading the screenplay. . . . One of the things that makes it weigh so much is that generosity—that throwing away of vanity . . . with both hands."

Ann-Margret, who'd heretofore played sex kittens in fluff like *Bye Bye Birdie* and *Viva Las Vegas!*, was nervous on the set until Nicholson, attempting to relax her, scared her out of her wits. "Jack just went out of his way to be helpful," she said. "I actually got frightened of him. I thought he was going out of his mind. It was just so unselfish of him to help me like that." Bergen, who'd met Nicholson right after *Easy Rider*, also found him encouraging, calling him "the most lucid, the most generous, the most helpful and supportive actor to work with. He has this laserlike intelligence that's used with you instead of against you." He nicknamed her "Bug," and she called him "the Weaver" because "he just weaves these magical sentences, totally original, very powerful, and completely his." When a journalist asked Bergen if she and Nicholson had been lovers, she said, "If I had been, I certainly wouldn't talk about it."[35] Referring to old flames, Nicholson once said, "You know, I'm still good friends with Faye [Dunaway]—not romantically, you understand, and with Candice, well there's another helluva girl. I think we were crying on one another's shoulders, both having experienced bad emotional scenes. . . . Oh, it happens to us, too. We're just as vulnerable."[36]

The harshness of Nicholson's performance in *Carnal Knowledge* was entirely deliberate and premeditated; nothing less than exposing Jonathan Fuerst as a complete prick could drive home Jules Feiffer's point about the emptiness and heartlessness at the core of

the masculine mystique. It took guts for an actor to make himself so hateful, but Nicholson had come to regard the craft of acting as a way to change the world for the better, by "press[ing] on the nerves" of mankind. If he was never as overtly political as Brando, Shelley Winters, Warren Beatty, Shirley MacLaine, Jane Fonda, Jon Voight, or, later, Martin Sheen, Susan Sarandon, Richard Gere, and Sean Penn, it was not because he was less passionate or committed, but because he was convinced that he could bring about more profound change through art. "Jeff Corey used to say that all art really can only be a stimulating point of departure," he recalled. "You can't change the world, but you can make the world think."[37] Nicholson would put this advice to particular use in his depictions of gender conflict in such studies of male-female relationships as *Carnal Knowledge* and, later, *Heartburn*. "Artists are not politically involved," he insisted. "I believe, as did Nietzsche, their job is to undermine that, and to defy the conventions."[38]

Critics appreciated Nicholson's performance in *Carnal Knowledge* and the picture's overall aura of hipness, but few pretended to like it. "Cold, superficial, manipulative," wrote *Life's* Richard Schickel, and *Newsweek's* Joseph Morgenstern scorned Nicholson's "treating [his] women as objects and moping through half a life-time of self-ignorance." David Denby accused Feiffer and Nichols of "male chauvinism," *The Atlantic* called it "harshly accusatory," and Paulene Kael wrote, "This movie doesn't just raise a problem, it's part of it . . . how we use each other sexually as objects . . . cold, slick. . . . [Nicholson] acts up such a tormented, villainous squall that even his best scene—a well-written monologue about the perils of shacking up—-seems to be delivered in a full voice against cliffs and crashing seas."

The film also had some champions, notably the discerning Hollis Alpert, who wrote, "A cruel film, perhaps, but an essentially honest one. . . . If you thought Jack Nicholson was good before,

you will find him superb on this outing. . . . True, Jack seems a bit weathered as an Amherst undergraduate in a few of the early scenes, but the spirit is accurate and he displays astonishing power as he advances." The most controversial movie of the year, it was also one of the most commercial, coming in at number six among 1971's top-ten blockbusters.

Like a good wine, *Carnal Knowledge* aged well. In 1977, *Variety* listed it among the "all-time rental champs," and in 2001, *Vanity Fair* called it "the wittiest, smartest, and most acutely entertaining product of masculine self-loathing ever minted. . . . Nichols's film still lacerates . . . wedding . . . precise direction . . . [Feiffer's] stiletto-funny script, and a quartet of withering, revelatory performances."

In view of all these successes, Nicholson couldn't have been short of cash, but producer Steve Tisch recalled an odd incident that occurred in 1972. "I was working for Columbia Pictures and had been out here about four months. I was in my early twenties. A security guy from the lobby of the studio in the Administration Building gets me on the phone and says, 'Do you have a second to talk to Mr. Jack Nicholson?' I was a huge fan of *Easy Rider* and I was very aware of who Jack Nicholson was. I got very excited and said, 'Sure.' I didn't know why he was calling, but I was so thrilled with the chance of talking to him. He gets on the phone and says, 'Who is this?' I said, 'Steve Tisch.' He said, 'What do you do?'

"I said, 'I'm the assistant to Peter Guber.' He said, 'Okay, I need to borry twenty bucks.' So I went down and gave him the twenty bucks. I haven't seen my twenty bucks, or the interest on it, in about thirty-one years. We kid about him every once in a while. Do I think he'll ever pay me back? No."

Rarely seen, then or now, Nicholson's next picture, *A Safe Place*, produced by Bert Schneider, costarred Orson Welles and Tuesday Weld, and was the brain child of Nicholson's *Psych-Out* costar, the

bearded Henry Jaglom, who'd also helped edit *Easy Rider*, appeared in *Drive, He Said*, and belonged to the BBS set. Critically, the film was greeted as a bit of ineffectual whimsy in which Weld wandered through Central Park, trying to decide whether to fall in love with a mustachioed Nicholson, who represented the bohemian life, or Philip Proctor, a symbol of the establishment. "I improvised the entire part," Nicholson said. "My stuff was great." Film historians write it off as a favor for his friend Jaglom, and perhaps Nicholson was trying to dispel the guilt he'd felt after the first flush of stardom, when he neglected old friendships. "There was a time soon after *Easy Rider*," he said, "when I was rude to friends—didn't return phone calls as promptly as I should."[39] In order to film *A Safe Place*, he turned down *The Great Gatsby* and *Day of the Jackal*.[40] Later, he regretted having rejected the former and said he could have done a better job than Robert Redford, who accepted the role in the Robert Evans remake, which was stylish but lacked the power of the terse 1940s production with Alan Ladd, Betty Field, and Shelley Winters.[41]

Screened in the Vivian Beaumont Theater at the New York Film Festival in October 1971, *A Safe Place* opened at Manhattan's Columbia II on October 29. Vincent Canby of the *New York Times* wrote, "In fits and starts, *A Safe Place* is almost as moving as it wants to be, as when Nicholson drops in at 4 a.m. to chat and make love."

Despite this misfire, there was no dearth of scripts and attractive offers piling up for him throughout the early seventies. For a while, Stanley Kubrick's Napoleon biography was on again, and Nicholson recalled, "I raised the money for the project—it took me a day—and then he changed his mind and did *A Clockwork Orange*. He [would use] a lot of the Napoleonic material in *Barry Lyndon*."[42] A few years later Nicholson revealed, "The Kubrick project is a dead issue. It was something that I liked very much and was very flattered that he considered me for, but I think he's lost cre-

ative impetus on it."[43] The actor couldn't give up the notion of playing the Little Emperor, and a decade later was still dickering with the idea.[44] He paid $250,000 for the rights to a book entitled *The Murder of Napoleon*,[45] a whodunit about Napoleon's poisoning on the island of St. Helena.[46] Nicholson never decided whether he wanted to play the lead, or just launch the package as producer and director, with Bob Towne writing the screenplay. "I sort of look at it like Shaw [and] Nietzsche, who consider[ed] Napoleon *the* man," he said. "I got a feeling of autobiography about it—again, in terms of poetics—in the sense that he was a man who conquered the world twice. And became a symbol for the devil. That's the way they described him in England. But he was ultimately the man who overthrew feudalism, after all. . . . Up until that time, it was all about family. And now, after him, you could just be who you are."[47]

Now that Nicholson was prospering, he started sending money to his half-sister Pamela Liddicoat, though they weren't speaking for a while after Pamela sold pictures of Nicholson and Sandra Knight to the tabloids. She lived in Georgetown in Northern California, where, following her grandmother's example, she opened a beauty parlor, financed by Nicholson. Marrying a man named Doug Mangino, she had a daughter, Kristi, who was introduced to Nicholson as his "niece." As sex driven as her half-brother, Pamela had a dangerous proclivity—drinking too much, picking up strangers in bars, and bringing them home to party. Nicholson continued to send her money throughout her sad and sometimes violent life.[48]

He was outgrowing his low-budget pals at BBS. Bert Schneider was good at keeping expenses low—including actors' salaries—and profits for himself and Rafelson high. The upstart wunderkinds of BBS would strut the stage of the New Hollywood for less than a decade, victims of early burnout, which was also the fate of cocaine-addict Julia Phillips, who won an Oscar in her twenties for

producing *The Sting*. But Nicholson's fascination with Bob Rafelson was so strong that he continued to pursue Rafelson, always asking what he was up to. Rafelson recalled, "We shared a motel room on *Five Easy Pieces* and we finally got a partition when we did *The King of Marvin Gardens*."[49] The latter was their next picture, and just before they started it, Rafelson taught him how to play tennis. Within two years, Nicholson was mopping up the court with him. "We compete," said Rafelson. "We compete about athletics. We compete with our intellects, we compete with women." It was an affable, relaxed one-upmanship, not the hostile competitiveness of, say, John Huston and Errol Flynn, who beat each other to a pulp over Olivia de Havilland. "Jack's the smartest actor I've ever met," Rafelson added. "He has an intellectual curiosity, a great feeling of irony, and he doesn't conceal anything."

Hoping to continue to make art films with BBS despite the company's decline, Nicholson turned down the lead in *The Sting*. Studio chiefs wanted him, Warren Beatty, or Dustin Hoffman for the role of Michael Corleone in *The Godfather*, but director Francis Ford Coppola successfully fought to sign relative newcomer Al Pacino. Had Nicholson marshaled his power in Hollywood to secure the Corleone role, he might have won it, but later told reporters, "Creatively, [*The Sting* and *The Godfather*] were not worth my time. . . . I wanted to put my energies into a movie that really needed them."[50] Such a movie, he felt, was *The Exorcist*, and he actively sought the part of Father Damien Karras, as did Paul Newman. "Nicholson actually came to me and said, 'I want to do it,'" director Billy Friedkin related, "but I had this idea it should be a new face, someone you had never seen before."[51] The author of the novel and screenplay, William Peter Blatty, had his heart set on Brando, but Friedkin cast an untried actor, Pulitzer Prize–winning playwright Jason Miller, who turned in a remarkable, Oscar-nominated performance.

When Nicholson's next-door neighbor Marlon Brando won the Best Actor Oscar for his performance as Don Corleone in *The Godfather*, Nicholson made a congratulatory telephone call to him at 2:30 A.M., March 28, 1973, according to one of Brando's biographers, Peter Manso. Nicholson's call failed to rouse Brando from his stupor as he sat slouched in front of two or three television screens in his bedroom, where, earlier, he'd watched Native American activist, Sacheen Littlefeather, an Apache, accept his award, explaining that Brando was snubbing the Academy because the film industry's portrayal of American Indians was "hostile, savage, and evil." In the audience at the Dorothy Chandler Pavilion, Clint Eastwood wondered aloud about "all the cowboys shot in John Ford Westerns over the years."[52]

THE KING OF MARVIN GARDENS

Conceived by Rafelson in the spring of 1971, *The King of Marvin Gardens* sprang from a story conference—held in the giant redwoods of Big Sur—between Rafelson and writer Jacob Brackman, a critic for *Newsweek* and *Esquire* and a fringe member of the BBS circle. Just as *Five Easy Pieces* had started with a single image of Nicholson, again all Rafelson had in mind was the longest close-up in movie history: Nicholson rapping. Rafelson and Brackman decided that Nicholson and Bruce Dern would play brothers, but this time the typecasting would be switched; Dern would be the madman, Nicholson the intellectual Jean Shepherd–type late-night radio DJ and failed novelist David Staebler, who was drawn into his con-man brother's cockeyed scheme to buy a Hawaiian island and turn it into a resort.

At some point, Rafelson changed his mind about using Nicholson, perhaps because he was becoming a big star no longer

affordable by BBS. But when Rafelson mentioned the movie to Nicholson, the actor seized on it and wouldn't let go. "I didn't really want him to be in the picture," Rafelson said. "I thought the character was not the slightest bit charming and completely wrong for him . . . but he kept insisting he wanted to know what I was working on, wanted to see a script. Finally I showed it to him, and he argued for a long time until he convinced me."[53] Rafelson also cast newcomer Ellen Burstyn, who was still disappointed over losing the role of Rayette in *Five Easy Pieces*.

They filmed in the winter of 1971–1972 in Philadelphia, Atlantic City, and along the Jersey Shore. On Burstyn's birthday, Nicholson, Dern, and Rafelson all took off their clothes and sang to her in the nude. Usually, Michelle Phillips was much in evidence on and off the set. During breaks in filming, Nicholson took her to Manasquan High School football games, flaunting his rock-star lady in front of former classmates.

When Michelle didn't get her way, she would explode, calling Nicholson an Irish mick. During their fights, it was usually she who got the upper hand. In February, her car broke down and she wanted the movie company to have it fixed so she could drive into Philadelphia, "coming on like a star's lady," said Harold Schneider, BBS's Doberman-like enforcer, whose job was to protect the budget. Schneider informed Michelle "she was a guest of the company and we didn't have to do fuck-all anything for her and we weren't about to stop making a picture to take care of her car." Then he went looking for Nicholson and found him on the beach at 4:30 P.M.

"I want you to know I just had a run-in with Michelle and if there are going to be some repercussions I thought I'd let you know in front. Whatever you have to do, you have to do. Maybe I should have handled it better and I'm sorry it happened."

"Hey, man, don't worry about it, and thanks for telling me."[54]

Schneider never heard about the incident again.

Nicholson was content to stay at Howard Johnson's, where he could have fun with "Dernsie" and "Curly," but Michelle, accustomed to grand rock-'n'-roll perks, found them an oceanfront mansion for the nine-week location shoot. Nicholson put his foot down, and Phillips returned to California in a huff.

The drug of choice for the party at the end of filming was the trendy 1970s downer Quaalude, which provided an ecstatic, highly sensuous trip.[55]

The BBS movies were all made for under $1 million each. For *Five Easy Pieces* and *Marvin Gardens*, Nicholson, who could easily have commanded $500,000 per picture, a huge sum in the early 1970s, received only scale plus his "primary upfront gross position." Obviously, he was not yet motivated by money but by "social responsibility," he said. "Now I think that the actor's responsibility, more than supporting a candidate, is to support a film like *Marvin Gardens*, which otherwise simply wouldn't get made. This is an actor's way of influencing the system; it is what he can do to help in educating people, which, as we all know, is finally the most important way of affecting society."[56]

Screened at the New York Film Festival, the movie was greeted with excitement mingled with perplexity, and *Life*'s Richard Schickel, usually a champion of both Nicholson and Rafelson, wrote, "[The moviemakers] are so damned aware of the whole tradition of modernist despair, so smugly pleased to be allowed to be joining in even if they are (or were) just humble commercial movie people, so proud to match the essential bleakness of their vision with all them fancy writers." *New Republic*'s Stanley Kauffmann complained, "It's quite a negative achievement to flatten Nicholson, but this picture does it." *Time*'s Jay Cocks took the opposite stance, writing, "It does not give him the chance to do what is easy

for him—display sudden rage, ruthlessness, a casual, cunning kind of cool. Here, wearing a slowly unraveling cardigan and squinting nervously behind a pair of glasses forever smudged with finger-prints, Nicholson invests David with real turmoil and vulnerability." Comprehending Rafelson's true purpose in making the film, Arthur Knight of *Saturday Review* called it a "superb metaphor for the American dream—the dream of getting rich quick, with a minimum of effort and a maximum of manipulation."

Viewed today, the movie has a tired, minor-key quality, rather like what was happening to BBS at the time. "I was watching a company start to come apart," Dern said. "Bert didn't give a shit." Schneider was hopelessly preoccupied with radical politics. During a promo tour, Nicholson had to nag BBS for a limousine to take him to interviews, while Schneider was squandering $300,000 on the Black Panthers,[57] one of whom, a coked-up Huey Newton, became a freeloading fixture at Schneider's home. Later, along with Schneider, Jon Voight, Elizabeth Taylor, Jane Fonda, Candice Bergen, Warren Beatty, and Peter Fonda, Nicholson attended a Black Panther fund-raiser organized by Donald Sutherland's wife Shirley. On another occasion, Nicholson hobnobbed poolside at Schneider's with Newton and Beatty.[58] "Left-wing politics in and out of Hollywood was about pussy and/or drugs," said Buck Henry.[59]

With Schneider sidetracked by radical chic and Bob Rafelson's reputation for being arrogant, difficult, and hostile,[60] BBS's days as a creative haven and force in the industry were quickly coming to an end. *Drive, He Said, A Safe Place*, and *Marvin Gardens* were all BBS, and all flops. "We didn't give a fuck-all," Rafelson said. "I was burned out."[61]

The Last Detail

In November 1972 Nicholson read Darryl Ponicsan's antiauthoritarian novel *The Last Detail*, the story of the final binge that two aging, hell-raising shore patrolmen impose on their prisoner, an apprentice seaman they're transporting to the brig. Making this picture would be like old-home week; Nicholson's friend Hal Ashby was directing, Bob Towne was writing the script, and Nicholson played Billy "Bad Ass" Buddusky, who, like McMurphy in *Cuckoo*, undertook the sexual initiation of an innocent, Larry Meadows, the prisoner who was facing eight years' confinement for having stolen forty dollars from a polio donation box. Budgeted at $2 million, the comedy-drama had to be postponed due to Nicholson's busy schedule, and Peter Guber of Columbia wanted to dump him and cast Burt Reynolds, Jim Brown, and David Cassidy in the leads, as well as replace Towne, who was balking at cleaning up the script, which included 342 "fucks" in the first seven minutes. Moreover, Hal Ashby was in trouble because of a marijuana bust while in Toronto scouting locations. In the end, Nicholson, Towne, and Ashby stayed in the picture, and, according to Guber, "Nicholson's fierce loyalty to Hal made a big difference."[62]

Before the director made the final decision on casting the role of the geeky misfit Larry Meadows, Ashby invited Nicholson to his house to meet Randy Quaid, who'd heretofore only appeared in BBS's terrific *The Last Picture Show*. Ashby lived in a seedy two-story Spanish-style rental in Laurel Canyon, on Appian Way. His neighbors in the hippie enclave included Steven Spielberg, roommates Don Simpson and Jerry Bruckheimer, Alice Cooper, Mickey Dolenz, and Fleetwood Mac. The rooms in Ashby's house were connected by archways and painted different pastel colors, and the Best Editing Oscar he'd received in 1967 for *In the Heat of the*

Night was used as a doorstop. "Jack was going to give the final approval on my casting," Quaid recalled. "I took to him right away."[63]

For the role of the other guard on the trip, "Mule" Mulhall, Nicholson wanted his friend Rupert Crosse, a black, but Crosse couldn't begin filming immediately due to cancer. "Most movie companies drive the wagons right over the grave," said Nicholson. "Hal delayed the start of *The Last Detail* for a week so an actor could come to terms with the knowledge that he had a terminal illness." Crosse's cancer proved incurable, and Otis Young got the part. Principal photography at last began in November 1972, in Toronto, Washington, D.C., and other locations along the Atlantic coast.

While filming in Boston, Nicholson and Quaid went to a Celtics game and later visited the locker room. Nicholson told the Celtics that "their penises [came] up to his eye level," Quaid said. Nicholson always referred to Quaid as "Randall" because, Quaid explained, "that's my real name, but I'd never used it. At first I didn't like it but now I do." On the set, before filming began each day, Nicholson pep-talked the crew and joked with them. "When you're feeling better I guess you work better," Quaid said, "and he made everybody feel good." But when Nicholson didn't like someone, he could be cruel. In New York, a fan wanting to impress his girlfriend brought her up to Nicholson, who didn't know the man from Adam, and said, "Hey, Jack, remember me? This is my girlfriend. Dear, this is Jack Nicholson."

"I've never seen you before in my entire life," Nicholson said. Unfortunately, the man was one of the biggest backers of *The Last Detail*.

Sometimes he was operating under the influence of drugs, according to Quaid, who said, "Like so many other things Jack does, his use of drugs is over-excessive. It would be interesting to see

how he would function if he didn't take anything for two months."[64] Recalled a press agent, "I had to go see him on the set once to write a feature, and he was so stoned all the time I had to make it up."[65] While shooting on location, Nicholson, who was always ready to display his backside, surrendered to a compulsion "to drop his pants and make a moon at a passing commuter train," *People* reported.

In the film, Bad Ass Buddusky made sure Larry Meadows savored a full taste of "the wonderful world of pussy" before his incarceration. From a raw, vulgar sailor, Nicholson transformed Buddusky into a magnificent, multifaceted character, all tough cop on the outside and compassionate heart on the inside. In Ponicsan's novel, the two Navy guards went AWOL in the end, and Nicholson argued that Towne's screenplay should remain faithful to the original. Towne disagreed, and at fadeout Bad Ass and Mule, having delivered Meadows to the brig, returned to their base. Nicholson felt the movie would have had greater box-office success with a more dramatic ending, but "Towne felt that was a cheat [AWOL being too convenient an ending], so I went along," Nicholson said.

When *The Last Detail* was previewed in San Francisco, later opening at the Bruin in Westwood, Los Angeles, in December 1973, most of the critics loved it. Vincent Canby called it "big, intense, so full of gradations of mood," and added that Nicholson "establishes himself at the head of a line that includes Al Pacino, Dustin Hoffman, James Caan, and Robert Duvall." The *Washington Post* hailed Nicholson as "the greatest American film actor of his generation." Pauline Kael praised the actor's "satirical approach to macho. . . . Buddusky is the best full-scale part he's had." Virtually alone among detractors, *Esquire's* John Simon denounced Nicholson's "impasto of smugness."

Despite tanking at the box office—Columbia's David Begel-

man badly botched the release after almost shelving the picture—
Nicholson was voted Best Actor at the Cannes Film Festival, and
when Oscar nominations were announced on February 19, 1974,
he received his second Best Actor nod, for a career total of three
nominations, including Best Supporting Actor for *Easy Rider*. "A
nomination for the Academy Award still blows my mind," he said.
His competition was Robert Redford for the role Nicholson had
turned down in *Butch Cassidy and the Sundance Kid*; Jack Lemmon
for *Save the Tiger*; Marlon Brando for *Last Tango in Paris*; and Al
Pacino for *Serpico*. At the Oscar presentations on April 2, 1974,
Nicholson lost to Lemmon. Nominated in the Best Supporting
Actor category, Randy Quaid lost to John Houseman for *Paper
Chase*, and Robert Towne, nominated for Best Screenplay, was
trumped by William Peter Blatty for *The Exorcist*. "Not getting our
own Academy Award hurt real bad," Nicholson said. "I did it in
that movie, that was my best role. How often does one like that
come along, one that fits you?"

There were personal disappointments as well. After a couple
of years with Nicholson, Michelle realized that she could never
compete with his workload. He tried to make a movie star out of
her by involving her in *Three Cornered Circle*, Metro's planned re-
make of *The Postman Always Rings Twice*, but the studio, not sur-
prisingly, kept wondering why it should waste the Lana Turner
classic on a group singer who'd never made it as a solo act. Nichol-
son refused to accept Raquel Welch, a then-hot property, as his
leading lady, and the project collapsed after MGM and director
Hal Ashby disagreed about Michelle for the lead.[66]

Not long afterward, in the late spring of 1973, life with
Michelle became impossible. One night he was dining with friends
at Dan Tana's restaurant in West Hollywood when she burst in and
started a fight.

"You fucking asshole!" she screamed at Nicholson.

A girl named Leslie Cyril, who hung out in the Troubadour and Dan Tana's five or six nights a week, recalled, "He had obviously done something she was very angry about, but didn't raise his voice, he didn't respond, just sat there, very quiet. He wouldn't allow anybody to laugh or interfere. He didn't defend himself or say anything or tell her to be quiet or shut up. He didn't try to have somebody escort her out. Even when he drinks and he gets plotzed, he's still a nice guy, and there's not that many celebrities you can call a regular guy. Michelle Phillips was with a few girlfriends, who ended up pulling her away. But she was absolutely enraged, and it wasn't long before their relationship was over."[67]

Michelle went on to date the future U.S. senator John Kerry. Nicholson had two other affairs with ex-wives of Dennis Hopper: Brooke Hayward, author of *Haywire*, and dancer Daria Halprin, star of *Zabriskie Point*.[68] "Maybe that's his trip," Hopper mused. "I don't know. It doesn't bother me. I still like him."[69]

Whenever Nicholson was in New York, he participated in the frenetic seventies social scene with gusto, soon becoming a popular figure in the fashion world and the jet set—"the beautiful people," as the *New York Times*'s Marylin Bender christened them. Models were now the favorite prey of the rich and famous, and since Nicholson was a friend of the prominent gay modeling agent Zoltan Rendessy, known as Zoli, he had no problem meeting girls. Zoli ran his business, Zoli Models, out of the lower two floors of his Manhattan town house and hosted parties upstairs for such regulars as Nicholson, Beatty, David Geffen, Al Pacino, David Bowie, Dustin Hoffman, Mick Jagger, Sue Mengers, Robert Altman, Lauren Hutton, and Woody Allen. "All those guys were there for girls," said a Zoli booker. "It was voluntary, but the girls would fall at their feet, of course. It was all about who was gonna get who. The girls were into it. Going to bed with lots of people was what sophisticated people were doing. It was the beginning of the days

of cocaine, champagne, and airplanes. Gays really came to the forefront. You had straight men trying to make people think they were gay. It became fashionable for girls to be gay. Everything was wide open, fun, and accepting."[70]

Zoli's clients included Cheyenne, Christina Paolozzi, Anjelica Huston, Apollonia, Pat Cleveland, and Geena Davis. The editor of *Vogue*, the sybaritic, grotesque-looking Diana Vreeland—gash-red lips, ghostly white skin, hawk nose, and shoe-polish-black hair—took up Nicholson and extolled him all over Manhattan. "Jack believes in pleasure and in beauty," she gushed. "He's easily seduced by anything—object, man, woman—that suggests the possibility of something splendid or grand." Vreeland was at the end of her reign at *Vogue*, which she'd filled with artificial, over-the-top, stiff clothes that no one but models posing for a camera would dare put on. Soon, she was replaced by the antifashion, women's-liberation style of Grace Mirabella, but Vreeland continued as the doyenne of couture from her perch in the costume department of the Metropolitan Museum of Art on Fifth Avenue, and it was she who coined the phrase "killer smile" to describe Nicholson's trademark feature. According to Helen Gurley Brown's *Cosmopolitan*, the actor possessed "two rows of perfect uncapped teeth [that] sparkle like a hundred brilliant suns in a smile as devastatingly charming as John F. Kennedy's."

His new fascination, one that would last for the next seventeen years, was Anjelica Huston, of whom photographer Richard Avedon said, "I've had great friends who were models—Suzy [Parker], Dorian [Leigh], Penelope Tree, Anjelica Huston, China Machado, and now Stephanie Seymour—but these are interesting, feeling women, with good hearts, minds, and, only coincidentally, good bodies. I'd be interested in them no matter what they looked like. . . . You can't fuck and photograph at the same time."[71] On a trip to L.A., Anjelica attended a party at Nicholson's house one

night, and her stepmother, who'd brought her, asked if there was anyone in the room she wanted to meet. The stately, magisterial Huston surveyed the guests and pointed to Nicholson. Later, she recalled, "I wanted him. I told one of my girlfriends what I thought of him." To Anjelica's horror, the friend "went over and told him."[72]

Chapter Five

THE GOLDEN YEARS

The granddaughter of stage and screen immortal Walter Huston, who introduced "September Song" in Broadway's *Knickerbocker Holiday* and won an Oscar for *Treasure of the Sierra Madre*, and the daughter of the dark and fatalistic John Huston, who directed *The Maltese Falcon* and *The African Queen*, Anjelica Huston carried an unmistakable air of pedigree. She was twenty-two when she met the thirty-six-year-old Nicholson, who later recalled, "If you're not a member of a conventionally coupling society—and I'm not—you're going to be around younger women because older women are simply not there."[1]

Nicholson's choice of a girlfriend fourteen years his junior of course had nothing to do with a scarcity of age-appropriate partners. The gap would steadily widen until, years later, he was courting Lara Flynn Boyle, who was thirty-three years his junior. As Boze Hadleigh, author of *Celebrity Lies!* wrote, "When a man

chooses a much younger woman, the youth he is seeking is not so much hers as his own."[2]

Anjelica's father was also a youth-seeker. John Huston was sixty-six, and his his fourth wife, Cici Shane, who brought Anjelica to Nicholson's party, was thirty-one.

When Nicholson first saw Anjelica that night, he thought "cla-a-a-ss, a dark, coiled spring of a woman with long flowing lines." Apart from her beauty, he was drawn to her "mind and . . . literary sense of style, and you better believe she's got imaginative energies. She's absolutely unpredictable and she's very beautiful." What really excited him, according to the actor's friend Sue Barton, "was that she was John's daughter. He was so thrilled that he, from Neptune, New Jersey, could have captured this princess whose father was John Huston."[3]

Although "mortified" that her friend had told Nicholson she wanted to meet him, Anjelica was reassured when she realized that "obviously Jack didn't get put off."[4] She was attracted to his strength and maturity, seeing "an element of my father in Jack," she said. "I've never been attracted to weak men. . . . He's at home with himself, and when you're with him, you feel as if you've come home. You feel he's family."

Born in 1951, Anjelica grew up in St. Clerans, a Galway mansion on an estate that included stables large enough to hold fifty thoroughbreds. House guests sometimes included Jean-Paul Sartre, Carson McCullers, John Steinbeck, and Pauline and Phillippe de Rothschild. Due to John Huston's peccadilloes—he sometimes kept as many as eight women who were in love with him at St. Clerans—his marriage to his fourth wife, Anjelica's mother Enrica "Ricky" Soma, a George Balanchine ballerina, dissolved when Anjelica was seven or eight, and the once exuberant child was devastated. Hoping to restore her vitality, her father shoved her, at age fifteen, into a starring role his 1969 film, *A Walk*

With Love and Death.[5] Critic John Simon called her performance "perfectly blank, supremely inept," and added that she had "the face of an exhausted gnu, the voice of an unstrung tennis racket, and a figure of no describable shape."

A worse blow came in her sixteenth year when her mother was killed in an automobile accident in France, a loss that almost took Anjelica "beyond the realms of sanity," she said.[6] A failed star in her teens, she played bit parts for the next five years, and finally resorted to modeling. She began an affair with fashion photographer Bob Richardson, who later said she turned him on to marijuana on their first date.[7] Although Richard Avedon splashed her across thirty-six-pages in *Vogue*, it did nothing to assuage her lack of self-confidence, nor did Bob Richardson, who left the marriage owing her $10,000.[8] "I thought I was ugly," she said. Cici Huston disliked Anjelica's husband, who "treated her like shit," Cici said. "I told him to go fuck himself."[9] Though a favorite of Diana Vreeland, Anjelica never became a top model in the U.S., where her "big nose," as Anjelica called it, was at odds with the smiling Cheryl Tiegs look currently favored by photographers. Anjelica had better luck abroad, posing for Helmut Newton and doing runway work in England for Halston and Giorgio di Sant'Angelo.[10] Six months after the end of her marriage, she began her affair with Nicholson.

"Jack is very definitely a real man," she observed, "one who gets your blood going."[11] She needed all the reassurance she could get as a woman, later telling Andy Warhol's *Interview* magazine, "It's so easy to become a fag hag if you're a successful model." When Huston succeeded Michelle Phillips in Nicholson's affections, Michelle moved in with his best friend, Warren Beatty. "Michelle and Warren's relationship had nothing to do with me," Nicholson said. "I was going with Anjelica Huston when they got together. . . . Michelle, being the lady she is, took the trouble to call

and ask if I had any feelings about them, which I did: I thought it was fabulous, because I like them both very much."[12]

Nicholson proudly displayed his new, aristocratic catch to his friends, and producer John Foreman said, "Jack does everything but rise when Anjelica comes into a room. She's the center of his life, and he knows her value." Bob Evans also approved: "Her breeding and culture have refined his life," Evans observed. Always insecure, Anjelica did not find it easy to make the transition from the New York fashion world to Los Angeles. "It was hard at first," she said. "Jack has a lot of friends; I didn't really know anyone even though my father is associated with Hollywood. . . . But Jack sensed it and helped me through this period."[13]

Perhaps he helped her too much, for she began to live in his shadow. "I decided I did not want to work for a year, and then it became two," she said. "Before I knew it, I hadn't worked for five years, and I was living with him to all intents and purposes as a housewife without my own center. Not that I didn't have a good time. I traveled a lot on his films, but at a certain point I became thoroughly disillusioned with myself for not having an aim, and this was merely aggravated by the fact that we were surrounded by very motivated people all day long."

Resuming her work, Anjelica arranged modeling assignments in order to accompany Nicholson to location sites in Europe. In the summer of 1973, as a favor to one of his artistic heroes, *L'Avventura* director Michelangelo Antonioni, he appeared in the cryptic *Passenger*, shot in London, Munich, Barcelona, and North Africa. Anjelica looked the other way when Nicholson filmed love scenes with a former girlfriend, Maria Schneider, Brando's nude leading lady in Bernardo Bertolucci's *Last Tango in Paris*.

Another seventies disillusioned antihero, David Locke, the character Nicholson played in *The Passenger*, assumed a dead man's identity, which ultimately led to his own demise. Nicholson always

relied heavily on his directors, but Antonioni, who was more interested in mise-en-scène than actors, offered "no communication," Nicholson said, "no give and take. . . . Antonioni's basic approach to his actors is 'Don't act, just say the lines and make the movements.' "[14] Without direction, Nicholson attempted to match Maria Schneider's unmannered, minimalist, depersonalized acting, jettisoning his intensely individualistic style, with results that were decidedly mixed. "Jack is a professional," Schneider said. "He likes to know what he is doing. I do not."

It proved to be a difficult shoot, at best. "Working with [Antonioni] is the outside pole of film idiosyncrasy," Nicholson said. "He drives you crazy. . . ."[15] With the Italians every morning it was a circus. Michelangelo had two tantrums a week. . . ."[16] They tell me I'm the first actor in twenty-five years he got along with, but that was because I wanted to do an Antonioni movie."[17] Though excruciating, it proved worthwhile; Antonioni had a strong influence on his work. The lessons of the master would be evident in such less theatrical, more laid-back performances of Nicholson's as J. J. Gittes in *Chinatown* and the title character in *About Schmidt*, representing some of his best work. "Jack is a great actor," said Antonioni, "though I tried to control him. He usually [does his customary shtick) in some way. I didn't want that."

By the conclusion of filming in the Sahara Desert, Nicholson had become so fond of the Italian crew that he became "a basket case," he recalled. "I was tears down to the chest."[18]

On *The Passenger*'s release in April 1975, Penelope Gilliatt of the *New Yorker* wrote, "Nicholson's performance is a wonder of insight. How does he animate a personality that is barely there? He does it by cutting out nearly all the inflections from his voice, by talking very slowly, by making random movements. One particular gesture is oddly expressive and impassioned. A slight flapping of the arms, as if he were trying to fly." In the *Nation*, Robert

Hatch wrote, "Since the early performances of Brando, no American screen actor has had Nicholson's almost hypnotic gift of being absolutely present. As with Brando, it is almost impossible to take your eyes off him, even when he seems to be doing nothing."

Some, however, weren't impressed, like flinty Judith Crist of *New York*, who wrote, "What Antonioni does manage to accomplish is to make Jack Nicholson awkward and dull."[19] Probably because of the dearth of action, a coherent narrative, or any noticeable screen chemistry between Nicholson and Schneider—off screen she called him "Uncle Jack," which he didn't "dig," he said[20]—the film was no great success, but in the final analysis, choosing *The Passenger* over *The Godfather* was essential to his development as an artist. Without Antonioni, that magic presence might have remained dormant under layers of flamboyant, eyebrow-arching affectation and clowning. In 2002, British critic Julian Hoxter wrote that Nicholson's performance "stands as his most natural, his least affected, and . . . his most accomplished to date."[21]

CHINATOWN

When Nicholson returned to Mulholland Drive in 1973, Anjelica moved in with him, taking the guest room. According to *People*, "Their L.A. home became an epicenter of the era's drug-soaked social scene."[22] Nicholson called Anjelica "Tootie," and she called him "the Hot Pole."[23] Still traumatized by the brutal murder of his wife Sharon Tate by the Manson gang in Benedict Canyon in 1969, Roman Polanski was a frequent guest at Mulholland Drive, where his reckless drugging was a time bomb waiting to go off, as was his preference for sex with minors.[24]

Rather perversely, both Nicholson and Anjelica's father, John Huston, were cast in Polanski's next film, *Chinatown*, which dwelt,

among other things, on incest. In every role Nicholson played, there was a "secret," he said, one that galvanized his performance. Some of the enigmatic appeal of *Chinatown*, considered by many Nicholson aficionados to be his masterpiece, sprang from the triangular situation on the set, and provided the secret of his role. John Huston played Noah Cross, a character based on L.A. water-supply engineer William Mulholland, after whom the mountainous drive on which Nicholson lived was named. In the script, Noah Cross and his daughter Evelyn Mulwray had an incestuous relationship. Inevitably, the presence on the set of Nicholson's mistress's father contributed an additional frisson to this superb *roman policier*, written by Robert Towne and produced by Robert Evans.

"I had just started going with John Huston's daughter," Nicholson recalled, "which the *world* might not have been aware of, but it could actually feed the moment-to-moment reality of my scene with him." At one point in the story, Noah Cross asked J. J. (Jake) Gittes, the Nicholson character, "Are you sleeping with her?" And then, in the film's fish-luncheon scene between Gittes and Cross, the latter said, "Disturbs me. Makes me think you're taking my daughter for a ride." What could have turned into a tense situation on the set became, instead, the foundation for a lifelong friendship between Nicholson and John Huston. "Jack loved John, really," Polanski said. "He admired him." The two men had similar ideas about women, both having been alternately nourished and lied to by powerful mothers. Huston once said to director John Milius, "Be anything women want. Mold to their caresses. Tell them anything. Just fuck 'em! Fuck 'em all!"[25]

Yet another "secret" method by which Nicholson got a handle on his role was his wardrobe, which he designed in the retro-dandy style of his grandfather, John J., who'd once sported spectator shoes and pinstriped suits on the boardwalk in Asbury Park Easter Parades.

A Chandleresque murder mystery, *Chinatown* was a story of corruption, drawing on a 1930s water-rights scandal in which the leaders of Southern California got rich by betraying the public trust. The plot had nothing to do with L.A.'s Chinatown, but Jake Gittes, the detective Nicholson played, had once been a Chinatown cop, and had fallen in love with a woman there and lost her. The attitude of the police regarding the crime and corruption in Chinatown was, "Do as little as possible," since any investigation by outsiders led to a shadowy labyrinth. It was a perfect metaphor for the United States in the Nixon era, during which corruption seeped into every area of life, and was tolerated for too long. "Chinatown is, symbolically speaking, where we all live today," wrote film historian Douglas Brode.

Nicholson was paid $500,000 plus a percentage of the gross, which would eventually bring him more than $1 million. Although Bob Towne tailored the script specifically for Jane Fonda and Nicholson, Fonda declined the opportunity to be Nicholson's leading lady, Evelyn Mulwray, explaining that he bored her. Bob Evans's wife Ali MacGraw got the job but promptly lost it when she left Evans, who'd discovered he "couldn't fuck her once after our marriage . . . couldn't get it up."[26] Polanski and Nicholson reportedly toyed with the idea of casting Anjelica Huston but decided that it would be altogether too incestuous. Faye Dunaway, whose career had faltered following the splash she'd made in 1967's *Bonnie and Clyde* and 1968's *The Thomas Crown Affair*, assumed the role for the bargain price of $50,000.

When principal photography began on September 28, 1973, fireworks were not long in developing between the temperamental Polanski and his equally volatile stars, Nicholson and Dunaway. One day, Polanski was trying to finish a shot before quitting time, and Nicholson kept darting back to his dressing room to watch a Lakers–New York Knicks basketball game.

"I told you we wouldn't finish this scene," Nicholson said.

"Okay, if that's your attitude, it's a wrap."

Then Polanski stormed into Nicholson's dressing room and trashed the TV set; no more Lakers that day. Dissolving into hysterics, Nicholson tore his clothes off.[27]

"You are an asshole," Polanski fumed.

Later, as they drove home, they encountered each other at a traffic light.

"Fucking Polack," Nicholson said.

Somehow, the two friends laughed it off and got on with their picture, though Polanski, who, in addition to directing the film, played one of Noah Cross's thugs, seemed to take an inordinate amount of pleasure in the scene in which he slashed Nicholson's nose with a knife. For the remainder of the film, Nicholson wore a bandage on his nose, a sadistic touch that no other actor in Hollywood would have accepted from Polanski. In the film Gittes jokingly explained his injury to another of the characters by saying, "Your wife got excited. She crossed her legs a little too quick." British critic Michael Eaton later wrote that with these words, Gittes "concretiz[ed] the phallic symbolism of his wound," which represented the castration of the hard-boiled, pugilistic private eye, and became yet another instance of Nicholson's ongoing deconstruction of stereotypical notions of masculinity.[28]

Polanski used Nicholson's hot temper to advantage during filming, later recalling, "You see how he gets angry in a scene? Unbelievably scary! He cannot stop, he goes into a kind of fit, you dunno whether he is acting any more! . . . take that, you motherfucker. . . . Glands, endocrine or whatever . . . start secreting substances, the blood races. It can be very hard on you physically, it is hard on Jack, but what wonderful results."[29] Nicholson was not as generous, calling Polanski "an irritating person whether he's making a movie or not making a movie."[30]

Polanski's conflicts with Dunaway were equally volcanic. After Nicholson allegedly urinated in a cup, she threw the contents in Polanski's face.[31]

"You cunt, that's piss!" Polanski screamed.

"Yes, you little putz," Dunaway replied.[32]

Referring to his leading lady, Nicholson later said, "She demonstrated certifiable proof of insanity."[33]

Chinatown was released in 1974, and although some critics were puzzled by this neo-film noir's obliqueness, the smarter ones got it. Nicholson was lauded by the *New York Times* for his "air of comic, lazy, very vulnerable sophistication that is the film's major contribution to the genre." *Glamour* welcomed Nicholson to the ranks of "the best actors in America today." In the American Film Institute's list of the one-hundred best films ever made, compiled by industry leaders in the 1990s, *Chinatown* ranked number nineteen (*Citizen Kane* was number one).

As the 1974 award season approached, Nicholson began to win every best-actor prize, from the New York Film Critics Circle (a tie with his own performance in *The Last Detail*) to the National Society of Film Critics. The Academy of Motion Picture Arts and Sciences again nominated him for Best Actor, along with Art Carney (*Harry and Tonto*); Albert Finney (*Murder on the Orient Express*); Dustin Hoffman (*Lenny*); and Al Pacino (*The Godfather Part II*). At the presentation at the Chandler Pavilion the following April, Nicholson made a splashy entrance in tux, shades, and black beret, accompanied by Anjelica, the personification of seventies sexiness in a lean, beaded, soignée gown and natural-looking straight hair, towering over her shorter lover. Despite the drenching downpour, Nicholson appeared confident and even a bit prematurely jubilant. The *New York Daily News* wrote, "Not since Ray Milland guzzled his way to an Oscar in *Lost Weekend* has an actor been such a sure bet as Jack Nicholson."

In the end, the only winner among *Chinatown*'s eleven nominees was Bob Towne's screenplay. When Art Carney won for Best Actor, Nicholson muttered, "Maybe next year I'll be the sentimental favorite." Leaving the Los Angeles Music Center, he shared a car with Anjelica, Evans, and Towne, who "had to practically hide his Oscar under the limo seat," Nicholson recalled. "And then Angelica and I went to the ball and accused her father of being absurdly drunk in front of the whole nation."[34] Later Nicholson took a more philosophical view of his loss, observing, "After you've been chosen one of the five best actors of the year—and there are only about forty thousand—then people come up to you and ask how it felt to lose. One doesn't *lose* an Academy Award."

At least there was some consolation in seeing his salary soar to $750,000 per picture, and becoming the 159th star to put his hand- and footprints in the forecourt of Mann's Chinese Theater. Another consolation was drugs. According to *People*, "He occasionally snorts cocaine and has dropped a good deal of acid." Nicholson offered this qualification: "Drugs are a social thing with me. . . . Nobody's ever seen me slack-mouthed."[35]

In October 1974 he and Anjelica attended a dinner at John Phillips and Genevieve Wait's Stanford White town house in Manhattan's East Seventies. Huston wore an orange satin print dress and seven-league red boots, Nicholson a dark gray pinstriped suit and dark blue shirt open at the neck. Back in L.A., they threw a costume party at Halloween, and Susan Anspach came "dressed as a French whore"; other guests included Warren Beatty, Ryan O'Neal, and Roman Polanski. Nicholson met Anspach at the door wearing a tuxedo, a black T-shirt, and top hat, telling her that his private joke of the evening was on her: it wasn't a costume party after all.[36]

Nicholson and Anspach's son, Caleb, regarded Anspach's husband, Mark Goddard, as his father. Though a busy actress,

Anspach took the family on all her locations as she made films with Woody Allen and George Segal. Dr. Paul Fleiss, a well-known Hollywood pediatrician—he later delivered Leonardo Di-Caprio—said, "Even though she had a major career, they had a very stable home for a long time with Mark Goddard; he was the father-figure in their lives, and Caleb was very close to Mark."[37]

Meanwhile, the social scene at Nicholson's place on Mulholland attracted such family members and A-list friends as Lorraine Smith, Mike Nichols, Art Garfunkel (who had a room named after him), Harry Gittes, Millie Perkins, Bob Rafelson, Carole Eastman, Lou Adler, Bruce Dern, and Bob Evans. Nicholson's New Year's Eve bash became an L.A. tradition, described by Monte Hellman as "hundreds of people and not much communication. He supplies lots of food and drinks, doesn't come to greet you at the door or make a conscious effort to move around."[38]

Helena Kallianiotes continued to occupy the guest quarters after Michelle Phillips moved out. "In the seventies Helena Kallianiotes was running a skating rink," recalled director Curtis Harrington. On Monday nights at Helena's Skateaway, Nicholson sometimes joined the crowd. He was still the weaver and plotter of his immediate circle's social life, organizing trips to Frank Sinatra's opening nights in Vegas, where he also caught the gigs of Mel Torme and Bette Midler, or to concerts in Manhattan, ringside sports events, and skiing in Gstaad, Switzerland, and Aspen, Colorado. "Jack Nicholson comes in on whatever studio corporate jet he can hitchhike a ride on and as soon as he gets on the plane he calls me and says, 'What's shakin' in Aspen?'" recalled professional skier Tim Moone.[39]

He saw his daughter Jennifer, now ten, every week. "We have a real good relationship," he said, "very one to oneish. . . . It's always been easy for us to talk to one another because genetically we have the same emotional tracks."[40] Quincy Jones recalled, "A few

years ago my dog bit his little girl. He took her into the bathroom and while we were worried that she had rabies, he was trying to get her to accept an attitude. 'Well, Jennifer,' he said, 'these are the kinds of things in life we have to learn to get through.'"[41]

When Jennifer went to live with her mother in Hawaii, she often flew back to L.A. during her preteen years to be with her father. He permitted her free run of his hedonistic life in Beverly Hills, taking her to the Playboy Mansion, Bob Evans's house, the Hotel Bel-Air, and anywhere else he was in the habit of partying with Warren Beatty and Marlon Brando. "My mother used to say that she prayed a lot, and I guess it worked, because nothing bad ever happened," Jennifer recalled.[42]

Despite the glamorous trappings of her father's milieu, Jennifer found that she was not altogether happy being the child of a megastar, feeling often misunderstood. She found solace in her greatest enthusiasm, fashion, and learned to use clothes as a means of escape. "It gave me a really different feeling of myself, and made me feel really sexy and cool, like an adult," she said.

Bob Rafelson, who had a place in Aspen, invited Nicholson to visit, and he brought along Anjelica. First pioneered as a resort and cultural center by Chicago philanthropist Elizabeth "Pussy" Paepcke, and as a Hollywood getaway in the 1940s by Gary Cooper and later Jill St. John, Aspen subsequently became a counterculture haven, home to the Eagles, the Byrds, and Jimmy Buffett. An old silver-mining town—population 6,500, swelling to 30,000 in peak season—Aspen was a valley floating in the sky, with flat, gridlike streets hovering beneath the slopes of 11,000-foot-high Aspen Mountain. After witnessing a meteor shower there, John Denver wrote "Rocky Mountain High."

"Aspen is full of freaks, heads, fun-hogs, and weird night-

people of every description," wrote gonzo journalist Hunter S. Thompson, whose rustic Owl Farm lay in the valley of Woody Creek. "I like to wander outside, stark naked, and fire my .44 magnum at various gongs I've mounted on a nearby hillside. I load up on mescaline and turn my amplifier up to 110 decibels for a taste of 'White Rabbit' while the sun comes up on the snow-peaks along the Continental Divide."[43]

In 1973, tragedy had overtaken Rafelson in Aspen, when a propane stove in his house exploded, injuring his ten-year-old daughter Julie, who later died of infections from her burns. "Nobody ever recovers from that," said his friend, Buck Henry, "and it affected everything Bob ever did after that."[44] Bert Schneider had already left BBS, and the now-defunct company was renamed Filmmakers Coop and turned over in 1974 to Henry Jaglom, Barbara Loden, Paul Williams, Carole Eastman, Dennis Hopper, Martin Scorsese, and Penelope Gilliatt. Its all-too-brief glory days were over.

One day in Aspen, Rafelson, Nicholson, and Anjelica took Rafelson's Jeep out for a spin on the mountainside, and "took a little something to enhance the ride," Rafelson recalled. Nicholson and Anjelica loved the experience so much they begged Rafelson to give them another tour. "We took some more," Rafelson said, and while speeding across Taylor Pass—altitude 12,000 feet— Nicholson and Anjelica stood up in the back and held their arms aloft. Suddenly Rafelson lost control of the Jeep, which lunged from the gravel road and started rolling "like a drunken fat lady." Rafelson shot through the windshield, and Anjelica went sailing through the air for twenty feet. When she found Nicholson, she gave him two Percodan to stop his crying. Eventually, he would purchase a green Victorian house in town and another in the mountains with a swimming pool and a beaver pond, and he also co-owned a guesthouse with Lou Adler.

On one occasion, setting out for an Aspen holiday, Nicholson and Anjelica joined a group on record mogul David Geffen's Warner Communications corporate jet that included Cher (Geffen's fiancée at the time); Warren Beatty and his girlfriend Michelle Phillips; and Lou Adler and his lady, Britt Ekland. They all took skiing lessons and went to a party at Jill St. John's house. Cher's costumes, which she changed hourly, were so elaborate that her friends were astonished she could manage to balance herself on skis. Her relationship with Geffen soon ended, "my dad's dick being bigger than his," according to Cher's daughter, Chastity Bono, who walked in on Geffen as he bathed.[45]

While spending time with Nicholson and Anjelica in Aspen and L.A., Bob Rafelson became convinced that their affair, despite the press hype about "the No. 1 couple of the film capital," was headed for trouble. "There was a prevailing sense of hopelessness about it always," Rafelson said.[46] Anjelica's strategy of self-sacrifice wasn't working, and life with the superstar soon palled. His heady L.A. crowd activated all her worst insecurities, and when his friends came to call, "I'd stand in the corner like a schlump," she said. "I'd spend a lot of my time hiding in the bathroom, usually throwing up from nerves."[47] Her too-needy love, instead of nurturing Nicholson, made him feel smothered, and he began to pursue other women. Both products of traumatically broken homes, Nicholson and Anjelica were fearful of emotional enclosure and commitment.

In 1974 he flew to London for one day's work—a cameo role in the Who's rock-opera film *Tommy*—largely because he was curious about the misanthropic director Ken Russell, the enfant terrible of British cinema, whose films included *Isadora Duncan* and *Women in Love*. Russell's fascination with high art, madness, and decay no doubt appealed strongly to Nicholson, who said he did *Tommy* because he wanted to "find out what makes [Russell] tick."

He was paid $75,000 for the day's work, singing a song by Pete Townshend with costar Ann-Margret.

His next assignment, *The Fortune*, was written by Carole Eastman and produced by Mike Nichols and Don Devlin during the troubled Begelman regime at Columbia. A former CMA agent, Begelman cheated his client Judy Garland, and later, as a studio executive, tried to abscond with actor Cliff Robertson's salary. Eventually, Begelman committed suicide. Though *The Fortune* was viewed as a "can't-miss" movie thanks to the teaming of Nicholson and Warren Beatty, it was doomed from the start by a bad script. Filmed in Southern California in July and August 1974, it concerned two cads who tried to rob an heiress—newcomer Stockard Channing—of her money by marriage and/or murder. Nicholson offered Anjelica a part but the proud girl, though she complained about her professional idleness, said, "Absolutely not. I don't want handouts."[48] She was well out of it; a hectic farce wholly lacking in charm and style, *The Fortune* opened at the Coronet in Manhattan on May 20, 1975, and was thoroughly trashed by critics. The *New York Daily News* identified the film's problem as the total incompatibility of Nicholson and Beatty: "Beatty as Nicky and Nicholson as Oscar get all knotted up in their idiosyncrasies. Each is a subtle scene-stealer, and the intensity with which they work at it keeps them from playing off each other with anything like the effectiveness that Paul Newman and Robert Redford had in *The Sting*."

While working on this embarrassing debacle, Nicholson at last discovered the crushing news that his "sister" June was in fact his natural mother, and Ethel May, the woman he'd always thought was his mother, was, actually, his grandmother.[49] Preparing a 1974 cover spread on him, a *Time* investigative reporter told him the facts, which predictably brought on an emotional crisis. "I was stunned," Nicholson said. "Such is the price of fame. People start

poking around in your private life, and the next thing you know your sister is actually your mother."[50] When he received a fifteen-page letter from a man who claimed paternity, and repeated that June, not Ethel May, was the mother, Jack immediately telephoned Lorraine.

"What's this crap this guy's telling me?" he demanded.

"Yes, June is your mother," she admitted. "As far as this man is concerned, I don't know. June dated him, but she dated a lot of people."

Nicholson asked to be spared any further details, and he never brought up the subject again with Lorraine. Alone, feeling violated, lied to, and working with the sketchiest of facts, he had to face some brutal truths: Ethel May, his alleged mother, was his grandmother; John Joseph, his alleged father, was his grandfather; June, his alleged sister, was his mother; and Lorraine, another alleged sister, was his aunt. As for his father, he would never know for sure, only that he bore the stigma of bastard. "I am an illegitimate child," he said. "I never knew my father. I didn't learn the truth until I was thirty-seven years old."[51] Without naming names, Lorraine said that the man who'd written to Nicholson was the younger brother of a boy she'd dated in school, and suspected he was surfacing now in order to cash in on Nicholson's fame and bank account. "I'm not overly curious," Nicholson said. In a sense, he felt he'd had "the most fortunate rearing. . . . No repression from a male father figure, no Oedipal competition."[52]

His glibness—if that's what it was—masked a real and deep hurt. He was so badly shaken in the middle of a film shoot that he told his director, Mike Nichols:

"Now, Mike, you know I'm a big-time Method actor. I just found out something—something just came through—so keep an extra eye on me. Don't let me get away with anything."[53]

Time concealed its findings, and the truth about his family was

deleted from the cover story when it ran in 1974. "A friend of a friend was an editor there, and he said, 'We don't need it,'" Nicholson explained.[54] But Nicholson confided in old friends, weeping and sounding heartsick and bewildered over why June, his mother, had continued to masquerade as his sister, even on her deathbed, and why, even after June's death, Ethel May persisted in lying to him. "He didn't have a father, and some of us knew the story before he did," Harry Gittes said. "He was brought up by Mud, his grandmother, who I knew too very well, and I got along with her immediately. He was brought up principally by her and he calls her his mother. You know, if you can't trust your own mother, who can you trust?"

In 1978, the facts of his background were at last reported by *Parade* magazine,[55] and when quizzed by reporters about the big lie of his lineage, he assumed a compassionate and forgiving stance toward those responsible. "People can't believe I'm not upset by the deception," he said, "but how can I be upset by something that worked? These women were never anything but great with me, and I'm not being sentimental. If I never embarrass their spirit, I did good. Sister. Sister-mother. Just hyphenate it and you know what I'm talking about."

He even claimed he was grateful to all concerned; after all, they'd given him the gift of life. "If June and Ethel had been of less character, I would never have gotten to live," he said. "It was a real feat June accomplished." He even claimed to admire their discretionary skills, commenting, "I'd like to meet two broads today who know how to keep a secret to that degree."[56]

Such gallantry was commendable, but it shrugged off the emotional wounds he must have suffered from the triple trauma of abandonment, mendacity, and illegitimacy, which would occasion agonizing soul-searching in anyone, not to mention revenge, which in Nicholson's life took the form of fathering children with

women he neglected to marry. Hermine Harman, a psychologist and friend of Susan Anspach, mother of Nicholson's illegitimate son Caleb, called Nicholson's "quasi-acknowledgment" of Caleb "abusive," and suggested that Nicholson's repressed rage at Ethel May, perpetrator of the big lie, and June, who went along with it and deserted Jack, was unleashed on "all women" as a way of "getting even for being abandoned as a child by his mother."[57]

In an *Esquire* interview Nicholson referred to the dark side that "every man has . . . buried, hidden, or simmering just beneath the surface. You can never predict what will trigger the thing which we keep carefully locked up inside us."[58] In the coming years, as he continued to portray Ethel May and June as veritable saints, excusing their treachery, he would find it increasingly difficult, in his behavior, to control his hot temper. There would be well-publicized eruptions of road rage and unacceptable conduct at basketball games, as well as a charge of prostitute-bashing. No doubt such incomprehensible violence sprang in part from the emotional beating he took from well-meaning but misguided family members.

"His heart broke, and it blocked things," said Cynthia Basinet, who would later be intimately involved with him. "So he became manic-depressive. Others might put it through their chakras and balance things, but he doesn't get over a grudge. He holds onto it, like this whole beating thing [a road rage incident in the 1990s]. They're always talking about Jack flying off. It's a rage. The same thing happened to [singer] Bobby Darin when the press verified that his mother wasn't his mother; he'd already had a heart condition but it killed Bobby, especially because she had already passed, as Jack's mother had, so he didn't have the ability to confront her. Jack was holding this thing to say to her, for all these years. I used to go to bed and pray that his mom would talk to him in the middle of the night. Like, I'm not even some weirdo religious person,

but I'd wake up twice a night in the morning hours in dripping sweat, my heart pounding, even after I'd left Jack for a year."

After *The Fortune* wrapped, Nicholson and Anjelica vacationed abroad. Though he needed to recover from the mental and emotional shock of a sordid past recently laid bare, Anjelica reveled in a Proustian rerun of her magisterial origins, tarrying at her ancestral home, St. Clerans, in Ireland. The new owners didn't even invite them into the house, but Anjelica had a weepy talk with a gardener, who'd been present when she'd lived there. Nicholson was full of "antifamily" feelings at the time, but Anjelica had never been readier to commit to a relationship and start a family. With the *Time* researcher's revelation still smarting, Nicholson found the notion of marriage less appealing than ever.

They visited Tony Richardson, who owned a quaintly crumbling, cliff-hanging property, Le Nid Du Duc, in the village of La Garde-Freinet in the south of France, where his other guests included John Gielgud, Buck Henry, David Hockney, Michael York, and Schenck/MGM heiress Marty Stevens. "The food was delicious, the company stimulating, and the surroundings sublime," said York's wife, Pat. "Jack, the most contemporary of men, was as at home here in this escapist paradise as in the grittiest of his film milieus."[59]

By the end of their European jaunt, he and Anjelica were on shaky ground and thinking about splitting up.[60] Back in America, his relations with his sister Lorraine were chilly; he felt she should have kept him from hearing the true facts of his background from strangers. Strains also developed between Anjelica and Lorraine, who had previously stayed in Anjelica's room when visiting her children in California. Now, whenever Anjelica was in residence—she moved in and out depending on the state of

their relationship—Lorraine had to find other quarters. Eventually, Nicholson stopped visiting Lorraine and Shorty in Neptune altogether.

On a promotional trip to Manhattan for *The Fortune*, *Tommy*, and other pictures, Nicholson and Anjelica presided over the opulent celebrity suite at the Sherry Netherland, which was on the twenty-fourth floor, commanding a view of Central Park and its bordering skyscrapers. Nicholson lounged around in jeans and a boutique T-shirt, talking to *Newsday*'s Jerry Parker and posing for photographs. "In the course of twenty years, I've been called the young Henry Fonda, the young James Cagney, the new Elisha Cook Jr., and the new Spencer Tracy. I think I've been compared to so many people because I'm not like anyone else." Anjelica haunted Bendel's and Bonwit's, and at night they went out, catching Tom Eyen's Off-Broadway *Women Behind Bars*, which Nicholson called "the best thing I've seen." They dined uptown with Diana Vreeland, and, accompanied by Stockard Channing, took in the Manhattan Transfer at the Bottom Line. They spent an evening with Elia Kazan and Barbara Loden, and went to several Broadway shows, including *A Chorus Line* and the opening of *Chicago*.

One Flew Over the Cuckoo's Nest

Despite wretched overexposure in pointless projects like *The Fortune* and *Tommy*, Nicholson's triumph in *Chinatown* remained so strong in 1975 that he was widely sought after, some even using Anjelica to bring his attention to scripts or offers. Michael Douglas, whose movie-acting career had fizzled after his 1969 debut in *Hail, Hero!*, making him settle for a television series, *The Streets of San Francisco*, controlled the celebrated Ken Kesey novel *One Flew Over the Cuckoo's Nest*, which his father Kirk Douglas had

brought to Broadway, in a version by Dale Wasserman, for a five-month run in 1962, with Kirk Douglas and Gene Wilder in the cast. "Michael Douglas talked to me early on about *Cuckoo*," Anjelica said. "I mentioned to Jack that Michael wanted to see him about it."[61]

Nicholson's *Last Detail* director, Hal Ashby, had recommended Nicholson before Douglas and coproducer Saul Zaentz decided they couldn't work with the secretive Ashby and hired Milos Forman to direct. The leading role of Randall Patrick McMurphy, an inmate in an insane asylum, was first offered to Gene Hackman and then to Marlon Brando, both of whom passed.[62] According to Michael Douglas, Milos Forman was wild to have Burt Reynolds, saying, "He has cheap charisma—perfect for McMurphy." Forman denied it, saying he wanted Nicholson, but the actor was unavailable for months, so he was willing to consider others for the part; in the end, however, he told his colleagues that he must have Nicholson.

Trying to decide whether to accept the part, Nicholson took in a student production of the play at New York University, where the audience stood up at the end and applauded. That was enough to convince him that the movie would be a big hit with the dominant demographic sector—youth—and he cut a deal with Michael Douglas that included a large chunk of the film's $4.4-million budget[63] and a hefty piece of the back end, which was destined to make him very rich when the film became one of the industry's major moneymakers, grossing $200 million.[64]

His involvement in preproduction for *Cuckoo's Nest* meant that he couldn't accept Alfred Hitchcock's offer to star in *Family Plot*, a tongue-in-cheek thriller in which he would have played George Lumley, boyfriend of a phony psychic, a role originally planned for Liza Minnelli but eventually played by Barbara Harris. When Nicholson proved unavailable, Hitch went with his second choice,

Bruce Dern, and also cast Karen Black. Though old and infirm, Hitch was still randy enough to stick his tongue in Karen Black's mouth.[65]

When Nicholson and Anjelica returned from Ireland, he went up to the Oregon state asylum in Salem, in late January 1975, to research his role, observing how electroshock was administered to patients. The role of his leading lady was proving difficult to cast. Lily Tomlin wanted to play Nurse Ratched, which, she later said, would have assured her a more active movie career, but she was committed at the time to *Nashville*, having won the part originally planned (ironically, as it turned out) for Louise Fletcher. Many actresses declined to play Nurse Ratched, including Anne Bancroft, Jane Fonda, Angela Lansbury, Geraldine Page, Colleen Dewhurst, Ellen Burstyn, and Faye Dunaway. Nicholson was disappointed, and blamed women's lib, a convenient scapegoat for the world's ills. "One area where I'm not sympathetic with the feminist movement is as actresses," he said. "They do scream for roles for women—or we do—and here's one of the great roles for women and a lot of people turned it down. They didn't want to play heavies. You would not get that response from actors." It was Fred Roos, now producing *Godfather II*, who finally came up with Louise Fletcher, though Milos Forman had also come across her when viewing *Thieves Like Us* to see if Shelley Duvall might be right for another role in *Cuckoo*.

The filmmakers were looking for an American Indian to play the pivotal role of the huge, mostly mute Chief, but they soon discovered that most Indians are far from gigantic in stature. Michael Douglas had met a man named Mel Lambert who owned Lambert Motors in Portland, Oregon, specializing in selling cars to Indians. Lambert found Douglas a nonactor, a forest ranger, who was physically perfect for the role: Will Sampson. As time would tell, he was perfect in every other way as well. When Nicholson first saw Sampson, he said, "It's him! Chief!"

Forman and Zaentz scouted three asylums before they found the one they wanted, the state institution in Salem. Forman made another inspired decision in casting the hospital's actual superintendent, Dr. Dean Brooks, as the film's John N. Spivey, M.D. Brooks in turn convinced the filmmakers to hire eighty-nine patients as assistants to the crew. Another good casting choice was Danny DeVito as an inmate, because, once they started filming, it was DeVito who managed to spark the improvisations that became the film's impressively authentic group-therapy sessions. At that point in his life, DeVito, like Doc Torrance in *The Shining*, had an imaginary friend he communicated with. A doctor at the institution said that it was fine, as long as you know the friend is not real. Like Nicholson, DeVito was from Neptune, New Jersey, where he'd been born in 1944, and his sister, like Ethel May Nicholson, ran a hair salon. After working as a hairdresser and makeup artist, DeVito became an actor in New York City, and in 1973 was directed by Kirk Douglas, who became his roommate. While performing in summer stock, DeVito met Michael Douglas, and landed in *Cuckoo's Nest*.

Anjelica went to Salem when Nicholson filmed for eleven weeks, beginning in February 1975, at the asylum. "If you really wanted to get into research," he said, "you could always go upstairs before any scene and check it out."[66] He and his mistress spent much of the time arguing, because, among other reasons, working in a mental institution made it difficult for him to change back to his real identity after a day's filming as the psychotic McMurphy.

"Can't you snap out of this?" Anjelica inquired. "You're acting crazy."

He couldn't help it. "Usually I don't have much trouble slipping out of a film role, but here I don't go home from a movie studio," he explained. "I go home from a mental institution."

"I'm no longer certain whether you are sane or not," Anjelica said. "I'll see you when you come back into the real world."[67]

Returning to L.A., she moved out of Mulholland Drive, and over the next few years, that would remain her pattern—moving in and out. It was just as well. He was too involved in searching for the "secret" to his character—finding props and gestures that would convey the inner dynamic of Randall P. McMurphy—to be concerned with Anjelica's comings and goings. "[McMurphy's] a scamp who knows he's irresistible to women and in reality he expects Nurse Ratched to be seduced by him," Nicholson said. "This is his tragic flaw. This is why he ultimately fails. I discussed this with Louise [Fletcher]. . . . That's what I felt was actually happening with that character—it was one long unsuccessful seduction which the guy was so pathologically sure of."[68] At one point, McMurphy bragged, "The next woman who takes me on is gonna light up like a pinball machine and pay off in silver dollars." In preparing for this aspect of his role, Nicholson asked Fletcher what Nurse Ratched's first name was. Although the character had been assigned no first name, Fletcher told him, "Mildred." Weeks later, when Nicholson called her Mildred in one of their scenes together, Fletcher was so completely in character that she blushed, which can clearly be discerned on the screen.

There were times when Nicholson felt McMurphy was saner than the doctors and nurses in the film, the theme of which was not mental institutions, in his estimation, but "life and how people relate to iconoclastic behavior. . . . All progress [as Bernard Shaw pointed out] is made by unreasonable men." Being Jack Nicholson, he could not have failed to respond to the film's documentation of the American male rebelling against domineering women.

All the men in the cast remained in character throughout the shoot, the supporting players living in the asylum dormitory and

taking their meals there, venturing outside occasionally to buy marijuana in the streets of Salem. Eventually the production company made these excursions unnecessary, making bricks of grass available to the cast at street prices.[69] Such enforced isolation "created an ambiance. . . . hard to match," according to Michael Douglas. An intense rapport sprang up between the males, excluding Louise Fletcher, who realized that the actors playing the patients had come to view her as the real Nurse Ratched. To break the spell, she stripped off her clothes on the set one day and stood before them topless, unmistakably a warm, living, breathing woman. "I'm not this monster," she said.

In a reprise of *The Last Detail*, in which Bad Ass Buddusky undertook his prisoner's initiation into the pleasures of life, *Cuckoo*'s McMurphy showed the inmates how to have fun again—watching sports on TV; playing poker; getting Billy Bibbit, the young character played by Brad Dourif, laid; introducing them to the joys of basketball, and telling the tall Indian, in the film's most famous line, "Chief, this is the spot. Raise the hands in the basket. All right, let's play some ball, nuts." Finally, McMurphy sneaked out of the asylum with a group of inmates, hijacked a boat, and took them fishing—an episode to which Milos Forman objected but on which Saul Zaentz insisted. Though it seemed fanciful and improbable, it was quite authentic, based on an experiment of Dr. Dean Brooks, who once chaperoned fifty-one patients of Oregon State Mental Hospital on a two-week rafting trip. The sequence required a full week to film, and during one grueling ten-hour, daylong shoot, everyone, except Nicholson, got seasick. Most of *Cuckoo* was shot in sequence, but the boating scene was filmed at the very end.

In the movie's actual denouement, McMurphy was subjected to a lobotomy, which robbed him not only of his independent spirit but of all vitality, reducing him to a vegetable. McMurphy had al-

ways told the inmates they could break out of their confinement by smashing through the bars with a huge lavabo, which was bolted to the floor and would somehow have to be dislodged. The only patient large and strong enough for this herculean task was the Indian, Chief Bromden. When Chief saw the robotlike condition of McMurphy after his lobotomy, he administered a mercy killing, smothering McMurphy to death with a pillow, and then took the lavabo and smashed his way through the window bars to freedom.

Summing up the film's universal appeal, screenwriter Bo Goldman, who was paid $8,000 for his extensive rewrite of Dale Wasserman's play, said, "How do you describe the Nicholsonian exuberance, that wildness, you know, that wonderful, mad cackle which is really kind of giving the finger to the world, which is in all of us, and which was at the center of the movie? From the moment we're born we're enjoined to become part of the system, and what are we on this earth for except to invent ourselves? McMurphy in his criminality and madness and in his obsession understands that better than anybody. The last scene between the Chief and McMurphy—I remember Saul saying, 'I think he's gotta hug McMurphy, you know?' I was concerned about that; I was concerned about the sentimentality of it and yet, I remember just putting down the stage direction, 'and then he embraces McMurphy,' and thinking, Okay, this is right. Then, what was the Chief going to say? What was the Chief's last line? And I couldn't find it. Milos said, 'What do you think? What is it?' I said, 'He wants to say, 'Let's go.' And Milos said, 'That's it!' It's the best line I've ever written. It told the whole story. They were going to take a trip together, though one of them was going to be dead."

Actor William Redfield, who played inmate Dale Harding, recalled that "one of the actors, Sydney Lassick [who played Cheswick], wept so bitterly watching the rehearsal of this scene

that we had to take him away." Forman got the scene in one take, with five cameras going. When he called, "Cut!" the entire company, cast and crew, erupted in cheers. "As in any great story, there's no deviation from it, no choices," Bo Goldman said. "It has to come out that way. If a man lives a good and honest life, he's going to come out okay, even if his career gets destroyed, he loses his children, if he loses his wife, he'll come out okay because he's written the right script for himself. And that's what McMurphy has done, and Chief recognizes that, and he frees him."[70] Goldman was a minor playwright virtually unknown at the time, but through skillful agenting he adapted *Cuckoo's Nest* and his career soared.

The measure of Goldman's, Nicholson's, Fletcher's, Zaentz's, and Forman's triumph was not immediately apparent to most reviewers. In *Time*, Richard Schickel complained that the film "would rather ingratiate than abrade," and *Newsweek*'s Jack Kroll accused *Cuckoo's Nest* of "simplif[ying]" Kesey and sacrificing "the nightmare quality that made the book a capsized allegory of an increasingly mad reality." Judith Crist called it "naive" and "obvious" in the *Saturday Review*. The customarily astute Robert Hatch admitted his bafflement and dismissed it as a "crowd pleaser" in *The Nation*. In the *New Republic*, Stanley Kauffmann found it "warped, sentimental, possibly dangerous." Oddly, it was the less serious magazine, *People*, that got the message, writing that Nicholson "creates an endlessly mysterious and fascinating portrait of a meat-head Hamlet who wanders the wavy line between sanity and insanity but speaks like a trumpet to the human spirit. . . . the first American actor since Marlon Brando and James Dean with the elemental energy to wildcat new wells of awareness in the national subconscious."[71]

Cuckoo's Nest shot to number one at the box office after grossing $50 million, second only that year to *Jaws*, and eventually became the seventh-highest-grossing movie ever—$320 million

worldwide, including an eleven-year continuous run in Sweden. Nor would time diminish its power. Reviewing the DVD released on the occasion of the film's twenty-fifth anniversary, the *New York Times*'s Lisa Zeidner wrote, "Mr. Nicholson's performance has not aged at all—even his inpatient coiffure is hip enough for MTV Movie Awards night." Much of the film's success she attributed to Nicholson's "seductively confrontational persona [that] had been set with *Easy Rider* in 1969." In 2002, *Sixth Sense* director M. Night Shyamalan called it the "best dramatic film ever made."[72]

When Nicholson went to Oregon to do publicity, he was having major troubles with Anjelica, and a reporter who visited his hotel room found him in a "rotten depression."[73] He felt "bad," he said. "Beat. Like, 'I want my mommy.' I'd like to lie down in a dark corner. Do you know the Philip Roth story called 'Eli the Fanatic'? This guy has a nervous breakdown and they find him in the closet, laid down on top of his shoes. I love that story. I'm an oblivion-seeker when I'm in pain. All my relationships have ended catastrophically. I hate feeling like I'm unacceptable because of who I actually am. I don't tell anyone the total truth. I'm not religious, so I don't have a counselor. I'm not in therapy now, so I don't have that. The idea that two people could totally recognize and expose themselves to each other, that's what we all strive for, but where is it? How often do you see anybody actually succeed?"

Like many of the rifts between Nicholson and Anjelica, this one was short-lived.

The Missouri Breaks

He'd always wanted to work with Brando, but when the two stars finally made a film together, unfortunately it was the lugubrious, dismal *The Missouri Breaks*. The deal was put together by a larger-

than-life producer named Elliott Kastner, a colorful, faux Sam Spiegel–type wheeler-dealer. In June 1975 the thirty-nine-year-old Nicholson signed for $1.25 million for ten weeks' work plus 10 percent of the gross in excess of $12.5 million, and the fifty-two-year-old Brando signed for $1.25 million for five weeks' work and 10 percent of the gross after the first $10 million. The teaming of Brando and Nicholson made it a "can't-miss" film, according to industry observers, and the press swarmed around the Billings, Montana, location, where Brando, who weighed 250 pounds, impishly led a reporter to believe that he and Nicholson were having an affair.[74] Despite being Nicholson's neighbor in their Mulholland Drive compound, Brando was fiercely competitive, and he convinced director Arthur Penn to let him alter the script in his favor and to Nicholson's disadvantage. Author Tom McGuane was annoyed with the script changes, and Nicholson objected to Brando's suggestion that Nicholson play the role of Tom Logan as an Indian.

Anjelica arrived in Montana with her little sister Allegra in tow, and Nicholson put them up with him in a house he was leasing outside Billings. Anjelica "was always cooking chickens," recalled Joan Juliet Buck, daughter of Sam Spiegel's business associate, Jules, and the former editor in chief of French *Vogue*. Brando and his favorite son, the drug-addicted[75] Christian, who on one occasion seduced his father's girlfriend,[76] camped out in a mobile trailer nearer the location site. Christian had spent much of his life at the center of custody battles between Brando and Anna Kashfi, and Brando feared the boy was destined to be "destroyed by his mother's weirdness."[77] Christian tried to steal marijuana from Nicholson's stash, and Nicholson caught him red-handed. Recalled a friend, "Christian laughed when he imitated Jack scolding him in the voice of his character in *Chinatown*: 'You do that again and I'll break your fucking fingers, man.'"[78]

The Missouri Breaks hardly enhanced Nicholson and Brando's relationship. Nicholson objected to Brando's use of cue cards, a lazy actor's way out of memorizing lines, remarking, "Why does he need those Goddamn cue cards?" In their scenes together, it broke Nicholson's concentration every time Brando shifted his gaze to the cue card behind the cameraman. Brando told reporters, "I actually don't think Jack Nicholson's that bright—not as good as Robert De Niro, for example."[79] In the film, Brando insisted on using a "dumb Irish accent," said associate producer Marion Rosenberg, who added, "Nobody had the courage to say, 'Hey, wait a minute, what are you doing?' . . . Behind his back people were saying, 'Is he crazy? We can't use this shot!' But nobody stood up to him."[80] Brando insisted on doing his climactic scene with Nicholson in drag, mounting a horse in a Mother Hubbard dress. The flabby Brando later joked that he donned the dress to conceal his fat, because he didn't want to spoil his "hunk reputation."[81]

Everyone seemed to realize the picture had been a mistake, and a bored Nicholson was overheard sighing, "Another day, another twenty-one grand."[82] He didn't find Tom McGuane cooperative in rewrites and complained to a reporter, "It's not a movie I'm real fond of. I wanted to work with Brando."[83] McGuane said Nicholson "was absolutely full of it,"[84] and added, "Jack always wanted to do his patented blowup. I refused to write it." Robert Towne revised the ending when McGuane proved unavailable.[85] There was no chemistry between Nicholson and his leading lady, Kathleen Lloyd, a militant feminist. "I don't even *like* her," he said. "I wouldn't even fuck her myself. How can I make love to her in this movie?"

His daughter Jennifer, who was now twelve, visited during a school holiday and played poker with the crew. "Jenny thinks more highly of me than she should," he said. "That's sort of a classic situation with children of divorce—she was very young when San-

dra and I separated. But I'm not too worried about Jenny. She is a visibly self-sustained human being, and she's got a lot of class. I've always tried to be open and straight with her, but I don't take much credit for her being the way she is. It's innate. She was even a fantastic baby; she slept the same hours as me. I have a real strong affinity with her."[86] To her father's dismay, Jennifer wanted to be an actress. "What am I gonna do?" he said. "I've told her it's not all it's cracked up to be, but she can be whatever she wants to be. She's a beautiful girl."

Nicholson threw a party at the War Bonnet Motel at which the crew let off so much steam that the lieutenant governor of Montana had to be called in to settle the feud between the filmmakers and the motel's management. Nicholson's one-time girlfriend Lynn Bernay was the costumer, and other old friends in the cast included Luana Anders, Harry Dean Stanton, Frederic Forrest, John Ryan, and Randy Quaid. After filming, when Bernay left Nicholson's entourage to work in another picture, he wrote her off, saying, "You're abandoning me."[87] Years later Nicholson said, "Arthur Penn doesn't talk to me anymore because I told him I didn't like his picture."[88] New friends were replacing old. When author Jim Harrison visited the set to see Tom McGuane—whose Livingston ranch often played host to Harrison, Jimmy Buffett, Warren Oates, Jeff Bridges, and Richard Brautigan—Harrison lent Nicholson his motel room so the actor could catch a hasty bath before watching dailies.[89] Harrison told Nicholson about an eerie experience he'd had in his Michigan cabin that would lead to their collaboration over a decade later. "I rubbed my hand over my face and felt fur on it," said Harrison, "and I felt a snout." Nicholson recalled, "It's neither the most nor the least outlandish thing Jim has ever said to me. . . . He felt he'd been invaded by this spirit." When Harrison turned the experience into *Wolf*, Nicholson optioned the film rights.

A critical and artistic failure, *The Missouri Breaks* was ruined by Brando's antics, according to *New York Times* critic Vincent Canby, who wrote that Brando was "out of control." Nicholson came off a little better, in the estimation of *Newsweek*'s Jack Kroll, who wrote, "Nicholson radiates a new kind of beleaguered innocence, grinning hedonistically amid the moral confusion of our time." But Nicholson was never interesting when he appeared opposite his male acting peers; his most conspicuous failures were with Marlon Brando and Beatty. Not even the Big Silver was large enough to contain such outsize egos.

While still sporting his beard for *The Missouri Breaks*, Nicholson let *Esquire*'s clever cover designer, George Lois, who'd persuaded Muhammad Ali to pose as an arrow-pierced St. Sebastian, talk him into appearing nude in the magazine. Nicholson looked rosy and healthy enough, but his ab-less body was hardly the sort to inspire a poster.[90]

Nicholson proved his friendship with Brando had survived their unfortunate film when, in 1975, he attempted to intervene with the governor of Oregon, with whom he'd become friendly while filming *Cuckoo's Nest*, to help American Indian activist-leader Dennis Banks. While fleeing from Brando's Winnebago, which was loaded with dynamite, hand grenades, and guns, Banks had been apprehended by police. Escaping to Tahiti, Banks was met in Papeete by Brando's wife Tarita and their daughter Cheyenne.[91] Brando's energy would increasingly be leeched by various causes and lawsuits, and his movie career would never fully recover its vitality. His son Christian, with his tenth-grade education, remained a burden, unemployable and prone to drug busts, and Brando called on friends like Nicholson and Jane Fonda, offering Christian's services as a tree trimmer.[92]

In the fall of 1975, while still promoting *Cuckoo's Nest*, Nicholson played a very small part in his pal Sam Spiegel's production of

F. Scott Fitzgerald's *The Last Tycoon*, based on the life of MGM wonder boy Irving Thalberg, who made Metro the dominant force in Hollywood by shaping such classics as *Camille* and *Grand Hotel*. Spiegel and Nicholson had become close friends, and the producer wanted him for the lead. Arthur Miller once called Sam Spiegel "The Great Gatsby," referring to Spiegel's shadowy past—immigration violations, jailings, sharp business practices, and a penchant for living beyond his means, usually deep in debt. As Hollywood wag Billy Wilder once put it, Spiegel was "a modern day Robin Hood, who steals from the rich and steals from the poor." Known as S. P. Eagle until the mid-1950s, when anti-Semitism eased up a bit, Spiegel won three best-picture Oscars for producing *On the Waterfront*, *The Bridge on the River Kwai*, and *Lawrence of Arabia*. By the seventies, as *The Last Tycoon* would demonstrate, he was past his prime.

Although Spiegel saw Nicholson as the Thalberg character Monroe Stahr, Mike Nichols, originally slated to direct, wanted Al Pacino, who rejected his offer, and Nichols then tried to sign Dustin Hoffman. Nichols and Spiegel kept clashing, and finally Nichols threw up his hands and walked away from the $7.5 million project, to be succeeded by Elia Kazan.[93] Nothing came of negotiations with Hoffman, who wanted to meet the screenwriter, playwright Harold Pinter, but was too grand to go to Pinter's office, and Pinter was too stubborn to go to Hoffman's hotel.[94] Kazan chose Robert De Niro, who was of Italian descent, for the lead, though Paramount CEO Barry Diller said he was "miscast. Irving Thalberg was Jewish."[95] Nicholson was offered a small part, as were such other stars as Dana Andrews, Ray Milland, Jeanne Moreau, Donald Pleasence, and Tony Curtis. Agent Sue Mengers speculated that Nicholson accepted the minor role only because "Sam Spiegel was a great host and Nicholson went on his boat [the *Malahne*]."[96] The conscientious De Niro went in for absolute

verisimilitude when he filmed his drinking scene with Nicholson. "Sam was mad that Bobby really got drunk," said Spiegel's young girlfriend Carrie Haddad.[97] None of it helped the picture, and the savvy Barry Diller, after seeing the rushes, said, "This is dead."[98]

Anjelica tried out for the female lead, Kathleen, but Spiegel had a crush on a very wooden model, Ingrid Boulting, whom he found "coltish." Peter Viertel, who wrote *The African Queen* and later brought the Fitzgerald novel to Spiegel's attention, preferred Susan Sarandon, but the inept Boulting got the role, and Anjelica was given a bit part. Advance word was so bad on *Last Tycoon* that the studio had to pad the house with the entire membership of the Actors Studio for the premiere at Avery Fisher Hall in Manhattan's fashionable Lincoln Center, where, according to Lady Antonia Fraser, who was present that night, "people burst out laughing as soon as Ingrid Boulting opened her mouth."

The picture was a flop at the box office, but Spiegel, an expert at creative bookkeeping, managed to make money. After having promised Nicholson a share of the profits, he welshed on the deal. "Sam's attitude was, 'Jack won't sue me,' but he did," recalled Spiegel's New York lawyer, Albert Heit. Spiegel offered Nicholson part of his art collection as barter, but Sandy Bresler said his client didn't want paintings and demanded "a complete accounting" of the film's gross earnings, "not a guestimate," but, as contractually agreed, a legitimate distribution statement.[99] Bresler said Nicholson's points were worth $40,000, and eventually a settlement was paid out of Spiegel's share of the gross domestic distribution. "And throughout the entire proceedings," wrote Spiegel's biographer Natasha Fraser-Cavassoni, "the film star continued to go on *Malahne*."[100]

Though Nicholson was beginning to build his own art collection, he may have been wary of Spiegel's if MCA's Lew Wasserman and directors Joseph L. Mankiewicz and John Huston were

correct in assessing it as some of the worst paintings by some of the world's best artists. Nonetheless, Spiegel's collection, which included Picasso, Manet, Ingres, Rouault, Cezanne, and Bacon, fetched $8.65 million at auction at Sotheby's. Not such bad bartering material, after all—maybe even better than the $40,000 cash payment Spiegel finally settled on Nicholson.

New York's scintillating social scene in the seventies continued to exert a powerful pull on Nicholson, the former bridge-and-tunnel boy from Jersey. He was present the night Andy Warhol met Gary Hart at Ina Ginsburg's, where Warhol carried on about how people in Washington, D.C., were now prettier than Hollywood stars. The handsome, womanizing Hart received an assist from both Nicholson and Beatty when he ran for the U.S. Senate, and Beatty and Hart formed a fast friendship that was based, according to some who worked with them on upcoming presidential campaigns, on Hart's desire to be Warren Beatty, and Warren Beatty's desire to be Gary Hart.

In Manhattan, Regine's elegant midtown disco was a magnet for high seventies celebriciety—an amalgam of Eurotrash, models, debutantes vying for fifteen minutes of fame as Warhol's latest protégés, dashing young pirate kings just in from million-dollar cocaine runs, a sprinkling of Hollywood royalty, and the usual gaggle of designers, decorators, and hairdressers. "Jack Nicholson was there looking a little older and heavier," Warhol wrote, documenting a party at Regine's for French actress Catherine Deneuve. "Warren Beatty was there looking a little older and heavier. Anjelica Huston and Apollonia the model were there. . . . Warren was dating Iman, the black model. Barbara Allen and her beau Philip Niarchos were there."[101] As gorgeous as a young Hedy Lamarr, Barbara Allen caught Nicholson's eye. He must have used one of the oldest lines in the world on her—you ought to be in movies—

because, according to Warhol, she decided not to go to the south of France with her rich lover, Niarchos, "because she had a 'screen test' with Jack Nicholson."[102]

While in Manhattan, headed for a party given by Diane von Furstenberg and Barry Diller, Nicholson and Anjelica were trapped in an overloaded elevator with Ara Gallant, Margaux Hemingway, Apollonia, Barbara Allen, Marisa Berenson, Bob Fosse, Marion Javits, Ahmet Ertegun, Peter Beard, Marina Schiano, and several others, three of whom were certifiable claustrophobics. Finally, they were taken up a few at a time. Other guests at the party included the Henry Kissingers and a phalanx of Secret Service agents. Later, Nicholson, Anjelica, Lou Adler, and Phyllis Summer took in the Norton-Ali fight at Yankee Stadium, where they had trouble getting in, because 500 policemen picketing for more money allowed a Bronx street gang to riot at will, mugging everyone in sight. Nicholson and his party were spared when the rioters recognized him as the star of *Cuckoo's Nest*, and greeted him as a fellow enemy of law and order. After the actor and his party entered the venue via a garage door, the gang resumed its mugging.

Nicholson and Anjelica broke up again in the fall. While she was filming her bit in *The Last Tycoon*, he returned to Manhattan to promote *Cuckoo's Nest*, hang out with Warhol, and shop for paintings. While visiting the J. N. Bartfield Gallery, he purchased William Tully's painting of an Indian camp for his growing collection, which eventually, thanks to his $15-million slice of the *Cuckoo's Nest* percentages,[103] included works by Rodin, Magritte, Tiepolo, Dalí, and Picasso. In a joint acquisition, he and Lou Adler bought thirty-five paintings by *Rock Dreams* artist Guy Peellaert for approximately $100,000. Nicholson paid $430,000 for Matisse's *Woman in a Fur* at Sotheby Parke Benet in New York.[104] He

also collected painter Jiri Sehnal, as did Mikhail Baryshnikov, Twyla Tharp, Robert Altman, and Milos Forman; Sehnal's works bore titles like *Serbs and Croats Cut Each Other's Livers Out.*[105]

Wintering in Aspen, Nicholson wrote a screenplay based on Donald Barry's novel *Moontrap*, hoping to interest Brando in the role of an 1850s Oregon mountain man. Harry Gittes and Don Devlin tried to help Nicholson get the project greenlighted, but there were few takers after the disappointment of *The Missouri Breaks*, and, to make matters worse, Nicholson only wanted to direct the film, not act in it. Potential backers advised him they'd also expect him to star if they were to put up the money for the film's $2- to $3-million budget. He was asking $500,000 just to direct, plus a percentage. United Artists proved the likeliest customer, but the studio insisted that Nicholson later appear in another UA picture, and at less than his $1 million fee. He refused, and tried to cast the leading role with Brando, George C. Scott, Lee Marvin, Jon Voight, or Dennis Hopper, but the studios wanted Nicholson or no one. He hired a writer, Alan Sharp, to work on the script, but after interminable, rambling conferences with Nicholson, Sharp quit,[106] and the project went into limbo.

Nicholson's affair with Anjelica resumed its rocky, on-again off-again course, and she was with him, as was his daughter Jennifer, when he attended the Oscar ceremony on March 29, 1976. The front runner for that year's Best Actor award for *Cuckoo's Nest*, he was convinced he'd never win because he'd spent no time burnishing his image. "The people who vote for these things don't like me much," he said. "I don't spend my time doing charity. And that's very important to the Academy. . . . I don't have the time."[107.] Insiders said he couldn't lose, citing the rather cynical Oscar truism that actors who play mentally or physically challenged persons always win: Ray Milland in *The Lost Weekend*; Jane Wyman in *Johnny Belinda*; Cliff Robertson in *Charly*; and, years later, Dustin Hoff-

man in *Rain Man* and Daniel Day-Lewis in *My Left Foot*. "The only man I deserved to lose to was George C. Scott as Patton," Nicholson said.

At the Dorothy Chandler Pavilion on March 29, 1976, Art Carney came to the podium to present the Best Actor Oscar, and, at long last, Nicholson took the industry's top prize, breaking up the audience by remarking, "Well, I guess this proves there are as many nuts in the Academy as anywhere else." He concluded his acceptance speech with a barbed tribute to his agent, who, "last but not least . . . ten years ago advised me I had no business being an actor."[108] Surprisingly, he failed to mention the name of the one person who was most responsible for his triumph: the creator of Randall P. McMurphy, novelist Ken Kesey, who fumed the following day, "Any one of them could have thanked me for writing the book. . . . It was like pumps trying to say they're more important than the well and the water."

Cuckoo's Nest made Oscar history that night, becoming the first film since *It Happened One Night* forty-one years earlier to take home the five top awards: Best Actor; Best Actress (Fletcher); Best Picture (Saul Zaentz and Michael Douglas); Direction (Milos Forman); and Writing (Lawrence Hauben and Bo Goldman). Fletcher won in a field so weak—Isabelle Adjani for *The Story of Adele H.*; Ann-Margret for *Tommy*; Glenda Jackson for *Hedda*; and Carol Kane for *Hester Street*—that Ellen Burstyn begged the Academy's acting branch to boycott the Best Actress category that year in protest, citing Hollywood's marginalization of women. Fletcher fired back, pointing out that it would have been "nicer"[109] for Burstyn to stage her boycott during one of the years when she was up for an Oscar. In his book *Oscar Fever*, Emanuel Levy called 1975 "the worst year in the history of the Best Actress Oscar."

"I was beginning to think I'd have to die and get an Oscar posthumously," Nicholson said. "Winning it is like making love for

the first time. Once you've done it, you don't have to worry about it ever again." Nicholson could afford to be proud, for he'd won over stiff competition, if for no other reason that it included Al Pacino's *Dog Day Afternoon*.

The day after he received the Academy Award, Nicholson and Anjelica went to the movies with Jim Harrison, who later wrote that Nicholson "was proud that both the entrance to the theater and the popcorn were free," thanks to his celebrity.[110]

With the Oscar now in hand, Nicholson decided to gamble and take a huge leap as an actor, forsaking naturalism for theatricality in his next two films. "I wanted to be bigger," he said. "I wanted to attempt the affectation of style within cinematic acting, which is something the audience heavily penalizes you for because they're stuck at the turn of the century. They're only interested in naturalism. I was trying to set a new standard for myself, pushing at the modern edges of acting. . . . It's harder to do."[111] At midcareer, he found that he was running out of schtick, commenting, "It's easier to give a good or representative performance when you're unknown. The real pro game of acting is, after you're known, to 'un-Jack' the character, in my case. And get the audience to reinvest in a new and specific fictional person. In the early middle part of my career, directors had a little bit feared 'Jackisms' and they wanted to make sure I didn't do this or that. It was an unnecessary fear but I did understand it. In order to keep growing as an actor, you have to learn the devices that keep you from just relying on what works for you." He would utilize his new style—over-the-top histrionics, as detractors would regard them—with varying degrees of success, not very engagingly in *Goin' South* in 1978 but to brilliant effect, and very controversially, in *The Shining* at the end of the decade.

Anjelica, doggedly but half heartedly pursuing an acting career, appeared in a potboiler called *Swashbuckler* in 1976, but in Sep-

tember, despite her father's advice to marry Nicholson, she packed her bags, cleared out of Mulholland Drive, and ran off with Nicholson's buddy, Ryan O'Neal, star of *Love Story* and *Barry Lyndon*. Tired of deferring to Nicholson, she said, "What's good for the gander . . ."[112]

"I didn't blame her in the beginning," Nicholson said. "I didn't like it but I think being my girlfriend has so many things even I couldn't deal with that. I can honestly say I don't blame her, although I was hurt. . . ."[113] When she went off with Ryan, I [felt] possessive rather than jealous. It was a bad time for me, but it was also a time for me to understand other people's freedom. . . . It caused me a great deal of pain and I can't deny it. . . . While I went out with other women, I put my emotions in neutral and my pride was never so wounded that I said I would never take her back."

Before long, Anjelica felt the effects of what she called Nicholson's "great sense of possessiveness." She and O'Neal went to Deventer, a city in the Netherlands, where he was playing General James Gavin in *A Bridge Too Far*. Meanwhile, Nicholson undertook a grueling thirty-five-day worldwide promo tour for *Cuckoo's Nest* with Douglas, Forman, Zaentz, and Fletcher that brought him first to New York—where he allegedly got a hair transplant from Dr. Norman Orentreich[114]—and then to London. He checked into the Connaught in Carlos Place, Britain's most exclusive hostelry, where he could enjoy his favorite breakfast of scones. Playing the field, he dined with Jerry Hall, later Mrs. Mick Jagger, but she was too involved with Bryan Ferry to take him seriously. Anjelica stole away from O'Neal to meet Nicholson in London, admitting that she "felt so crummy abandoning him—men like Jack you just don't find anymore."[115]

O'Neal followed hard on her heels, also showing up in the British capital and staying with her in South Kensington. Anjelica met Nicholson for lunch at San Lorenzo, though they were still

estranged. "I don't want to be mentioned in the same sentence as O'Neal," Nicholson declared. "We are no longer friends."[116] Several years later, he added, "If you told me that some woman could go off and fuck one of my best friends and I'd end up reading about it in the newspapers, and that four years later I wouldn't give a shit, I'd have said, 'You're talking to the wrong guy here.' That's not the way I am now." *Women's Wear Daily*, the bible of the fashion industry and a regular chronicler of Jet Set doings, reported that a party was thrown for Nicholson by Donald Sutherland, and Lyndel Hobbs gave him a small dinner party.

When Nicholson went to the south of France in August 1976, it was Sam Spiegel who gave him the foul news that UA was not going to back his hapless western, *Moontrap*. On the Riviera, aboard Spiegel's 457-ton, teak-decked *Malahne*, Nicholson dropped his pants and mooned the paparazzi and fans awaiting him on the St. Tropez pier, a sight never before seen on the august motor yacht, which had played host over the years to Greta Garbo, Irwin Shaw, Joan Juliet Buck, Lauren Bacall, Arthur and Alexandra Schlesinger, Polly Bergen, U.K. prime minister Edward Heath, Warren Beatty, Kenneth Jay Lane, Margot Fonteyn, Isaac Stern, and Mike Nichols. "Sam told Jack how undignified his behavior was," recalled Willy Rizzo, a photographer and *Malahne* regular. "He scolded him like a son."[117] So did *People* magazine, which termed Nicholson's behavior "lunacy."[118]

Like Nicholson, Spiegel was a notorious womanizer, according to Lady Antonia Fraser, who said he "invited" every woman he met to his bed but added, " 'No' meant nothing to him and, for all I know, 'yes' meant little either." Lauren Bacall, Anouk Aimee, Irene Mayer Selznick, and Afdera Franchetti Fonda (Peter's stepmother) were among the women who resisted his propositions. Another untouchable was Candice Bergen, whom Spiegel had been the first to discover, bringing her to the attention of Colum-

bia Pictures. When glamorous guests on *Malahne* rejected him, he could always turn to the hookers he brought on board, or to his young girlfriend Carrie Haddad, who called him a "kinky weirdo." He had "a foot fetish," according to Salimah "Sally" Aga Khan, a European Jet Setter Spiegel tried to get into movies, but only succeeded in getting her to let him "admire one of my feet." Usually, there was a fifty-year age difference between the seventy-ish Spiegel and his numerous girlfriends. "You could hardly open a door without a floozy jumping out," said Michael Linnit, who came aboard with his client Richard Burton. Spiegel once threw a "semi-hooker" off *Malahne* for accidentally dropping a favorite cushion overboard. "There was a certain amount of thinness and meanness around the edges," said Mike Nichols. "[The hooker] had to leave at the next port of call because of his cushion." While on board, guests could neither place nor receive telephone calls, which amused Nicholson so much that, every time the phone rang, he looked at the other guests and said, "Please God, it's not for one of us." Spiegel's wife, Betty, could be just as promiscuous as her spouse, and enjoyed having affairs with William S. Paley, John Hay "Jock" Whitney, and Omar Sharif.[119] Life aboard *Malahne* was the ultimate in luxury—pâté, caviar, fine wines, and bullshots in alabaster goblets.

According to Mike Nichols, Spiegel was "like the head of the family. Jack, Warren, Anjelica, and me. That's spanning a lot of different kinds of people, careers, and lives." David Geffen, Julie Christie, and Diane Keaton eventually joined Spiegel's inner sanctum.

At the urging of John Huston, who told Nicholson to "be firm with her," Nicholson called Anjelica in the Netherlands, "ordering" her back to the U.S. Three days later Anjelica rendezvoused with him in New York. Left behind in the Netherlands, Ryan O'Neal said, "It ended as quickly as it had begun, which was a pity. I really

loved her—even Tatum [his daughter, who won an Oscar at age nine for *Paper Moon*] liked her."[120] With regard to his reconciliation with Anjelica, Nicholson said, "We are side by side now and that's the way it is going to stay." However, none of their issues was settled. "We didn't discuss it at all," he said.[121]

Back in L.A., Anjelica continued to play Nicholson and O'Neal off against each other, according to Cici Shane, who said Anjelica stayed first with one and then the other. Anjelica brought her sister Allegra to live with her and O'Neal in Malibu and Beverly Hills. According to Cherokee MacNamara, one of John Huston's oldest friends, "Ryan was probably one of the weakest men in the world." Allegra was used as a pawn in the triangular conflict between Nicholson, O'Neal, and Anjelica. Said Cici Shane, "When Anjelica was with Ryan he would pick up Allegra at Marymount High School. Then Anjelica would break up with him and Jack would pick up Allegra. Anjelica and I had a big beef because I accused her of involving Allegra in her sexual life between these guys. I said that I'd take her outside and punch her fucking teeth down her throat if she didn't stop."[122]

Later, Allegra moved in with Cici's parents, and then went on to Oxford University and a career in book publishing, receiving three promotions after her first year at Chatto & Windus.

Having broken up again with Anjelica, Nicholson left for Colorado, expecting her to finish moving out while he was away. Aspen was still abuzz with talk about Andy Williams's ex-wife, Claudine Longet, Peter Sellers's costar in 1968's *The Party*, who shot and killed her lover, Croatian Olympic ski racer Vladimir "Spider" Sabich, as he was on his way to rendezvous with another woman. In a defense seat in the front row directly behind Longet, Nicholson was a daily spectator at her trial in 1977, and his stellar presence, as well as the massive media invasion of the Pitkin County courthouse, were blamed by some for the transformation

of the sleepy village into a celebrity showplace that came to be known as Hollywood's sister city.

Longet's attorney, Ron Austin, was so successful in defending her that she later married him and remained in Aspen.[123] Found guilty of criminal negligence—only a misdemeanor—she served twenty-one days in jail, leaving many Aspenites with the feeling that she got away with murder. "When celebrity walks in the door, justice goes out," said Aspen attorney Frank Tucker.[124] After the trial, the California takeover of Aspen went into full swing, led by Sally Field, Arnold Schwarzenegger, Kurt Russell, Goldie Hawn, Martina Navratilova, George Hamilton, Don Johnson, Melanie Griffith, and a clutch of movie moguls including George Lucas, Marvin Davis, Mike Ovitz, Michael Eisner, Jon Peters, and Peter Guber.

In their wake came chain discos, singles bars, ostentatious boutiques, and the inevitable influx of real-estate agents. Soon, land developers overwhelmed the once funky mountain town, which Hunter S. Thompson aptly renamed Fat City. Nicholson retreated to his "little red house" at the bottom of a thousand-foot cliff, with a stream gurgling by his terrace and a view of snow-capped mountains. Nearby, a neighbor had 100 horses. "I don't allow no movie talk around here," Nicholson said. "This is where I come to heal." Occasionally, he went riding on his Harley-Davidson, wearing his Ray-Bans, and following a road into the wilderness. There was plenty of time to reflect on why he always seemed to choose the wrong women. "They're tough women, some of them, or distorted," he said. "They can be vengeful. And they're more individualistically oriented than relationship-oriented. But I've had the best, most honest relationships. Still, I'm always the one who's been left. I've never left anybody. Yes, I've wondered whether I'm doing something to arrange it that way. But relationships are tough. There's always some problem."[125]

Meanwhile, back at Mulholland Drive, forty-three-year-old Roman Polanski and thirteen-year-old Samantha Geimer arrived one day in March 1977, and Helena Kallianiotes unwisely gave them the run of Nicholson's house, also letting them help themselves to his Cristal champagne. Polanski told the adolescent he'd make her a star by photographing her for *Vogue Homme*, but his real aim was to have sex with her after drugging her on Quaaludes and getting her drunk.[126] He photographed her nude in Nicholson's Jacuzzi, and then they retired to a bedroom near the pool for a session of cunnilingus, coitus, and sodomy.[127]

Anjelica, who wasn't supposed to be in Nicholson's house, returned to get some clothes to take to Ryan O'Neal's, calling out, "Roman, Roman, where are you?"[128]

"We're down here," Roman shouted from the bedroom. "We'll be out in a few minutes."[129]

When he and Samantha Geimer finally emerged, Anjelica asked the child, "Are you okay?"

"Yeah, I'm okay," she said, "but I want to go right home."[130]

After Anjelica and Polanski conferred, Anjelica again asked Geimer if she was all right, and again she asked to go home.

"Roman, are you going to take her home?" Anjelica said, and, according to a later police account, Anjelica appeared to be "really pissed that this had happened."[131] Anjelica then went to Helena Kallianiotes to complain. Polanski packed up his camera equipment and left with Geimer.

"Keep this a secret," he said. "Don't tell your mother."

She didn't, but she told her seventeen-year-old boyfriend, and her sister overheard and informed their mother, who called the police and accused Polanski of rape.[132] Arrested the following day at the Beverly Wilshire Hotel, Polanski was booked on suspicion of raping the girl in Nicholson's home. The police escorted him the next day to Mulholland Drive, where Polanski broke into the

locked compound, leaping over the gate and releasing it from a button inside. Proceeding to Nicholson's house, the police banged on the door.

Anjelica again was present, and the police questioned her privately in the kitchen, where she called Polanski a "freak," evidently attempting to dissociate herself and Nicholson from the director.[133] The police weren't impressed and proceeded to search her purse, turning up some cocaine. Later, hashish was found in the house.[134]

"They've got it," a white-faced Anjelica told Polanski.[135]

Both were carted off in different squad cars to the West Los Angeles police precinct on Purdue Avenue, where the desk sergeant looked Polanski up and down and asked, "What in hell do you think you're doing, going around raping people?" When Polanski went to take a pee, he saw Anjelica and mumbled, "Sorry about this."[136] She shrugged and remained mute. Polanski realized his lame apology "was inadequate," but offered nothing more. Booked on suspicion of possession of cocaine, Anjelica was released on bail of $1,500,[137] but she'd been dragged into the mounting scandal swirling around Polanski's sexual abuse of a minor, one that would soon end his career in Hollywood and drive him into lifelong exile.

Nicholson was still away, skiing in Aspen, when he learned that he'd have to be fingerprinted because of the hashish container that had been discovered in a bureau drawer. He sent his fingerprints to the LAPD from Aspen; fortunately, they did not match the prints found on the container.[138] "I was told, 'Don't talk about it, don't find out anything, don't become involved, since you aren't at all,'" he said. "I spoke with [Anjelica] about it. She's been very wronged. . . . The DA's office wrote her a letter of apology."

All charges against Nicholson and Anjelica were dropped, and she went to live with Ryan O'Neal again. Anyplace must have

seemed safer than Mulholland Drive, but in early 1978 she moved back in with Nicholson. "Ryan didn't treat her so well," said Allegra, who should know, since she'd lived with them in Beverly Hills and Malibu.[139]

According to Polanski, Anjelica ratted him out. "Anjelica had been granted immunity on all charges of drug possession in return for undertaking to give evidence for the prosecution," he said. She could hardly be blamed, but it left Polanski feeling "slightly bitter." Ever the artful dodger, Nicholson managed to come out of the scandal scot-free. The day before Polanski was to be imprisoned, Nicholson attended a dinner party for him given by Tony Richardson, with critic Kenneth Tynan and several others. Afterward, Polanski was confined in Chino Prison for forty-two days of psychiatric assessment prior to sentencing for having sexually abused a minor. In his mug shot, he wore a placard around his neck stating: CALIF PRISON B88742Z R POLANSKI 12 19 77. Inside Chino, his filthy, "tiny concrete box" of a cell was painted baby blue. It had a few pieces of furniture cemented into the wall, a flush toilet, piped-in rock-'n'-roll music, and a slatted window with a view of the watchtower and barbed-wire fence.

Dino De Laurentiis, the flamboyant producer of *La Strada*, *War and Peace*, *Nights of Cabiria*, and *Barbarella*, visited him long enough to fire him as director of *Hurricane*. Polanski received mail from Candice Bergen, Kenneth Tynan, Sue Mengers, and Richard Sylbert. He got out of Chino on January 29. Nicholson visited him just before his court date, finding him in "the best of spirits. . . . [I] kept advising him to show up in court. He would have gotten off because the girl's father had entered the case and taken her out of state. She would not have testified."[140] Fortunately, Polanski did not heed Nicholson's advice. Before Polanski's sentencing, Judge Laurence J. Rittenband said to Polanski's friend, producer Howard Koch, in the men's room at the Hillcrest golf course: "I'll send him

away forever. I can't imagine anything more terrible, more disgusting, more heinous, having sex with a thirteen-year-old girl. I'll see this man never gets out of jail." Rittenband intended to disregard a no-jail plea bargain and give Polanski the maximum punishment under law. Samantha Geimer's attorney, Lawrence Silver, later confirmed this, asserting that Judge Rittenband called him, the prosecutor, and Polanski's attorney into chambers. "The judge was getting a great deal of pressure and he was concerned about criticism in the press," Silver said. "He was going to sentence Polanski, rather than to time served, to fifty years. What the judge did was outrageous. We had agreed to a plea bargain and the judge had approved it."[141]

A friend warned Polanski to clear out of the U.S. immediately. "Hillcrest club pressures mattered more to [Rittenband] than anything else," Polanski recalled.[142] Unaware of the danger their pal was in, Nicholson and Warren Beatty planned a party to celebrate Polanski's release on probation, but the terrified little Pole, once apprized of the certainty of more prison time, told Dino De Laurentiis, "I've made up my mind. I'm getting out of here."

"That judge," De Laurentiis said, "what a prick."

Polanski accepted a $1,000 gift from the producer, who also offered him his job back, and left for the Santa Monica airport, where he planned to rent a Cessna 150 and flee to Mexico, a half-hour away. Then he thought better of it, made a U-turn, and drove to LAX, hopping the next flight to London, leaving in fifteen minutes.[143]

"I am deeply shocked that he has flown the coop," Nicholson said. "It's stupid."[144] Far from stupid, it was obviously the best course of action for Polanski, if he wanted to stay out of prison. Reportedly settling a civil suit with Polanski in Europe for more than $200,000, Samantha Geimer married, had three children, and moved to Hawaii.[145] Nicholson continued to defend his

friend: "The crime for which he was convicted isn't even a crime in his own country. Whatever the age was, it's not underage where he comes from. He always maintained that he didn't feel he did anything wrong." Later, when Polanski had children of his own, he at last admitted his wrong, perhaps realizing he wouldn't like to see his own youngsters sullied.[146]

For Nicholson, the golden years, if not exactly over, were definitely tarnished.

Chapter Six

MIDLIFE CRISES AND CRESCENDOS

GOIN' SOUTH

N icholson at last dropped *Moontrap* for another Western, this one a decided improvement over *The Missouri Breaks*, entitled *Goin' South*, filmed between mid-August and late October 1977 on a $6-million budget, with Nicholson at the helm as director and star. A period comedy set in Texas, the film concerned a cattle rustler/horse thief/bank robber saved from the noose at the last minute by a marriage of convenience, thanks to a peculiar law stating that any single woman in the community could claim a condemned man by marrying him.

After both Jane Fonda and Anne Bancroft turned down the feminine lead, a prim-and-proper pioneer woman, who wasn't looking for love but merely for a slave to help her mine for gold, Nicholson tested Jessica Lange and briefly considered newcomer Meryl Streep. Then he came across an unknown named Mary

Steenburgen in the Gulf + Western offices in the Paramount Building in Columbus Circle in Manhattan, where the twenty-four-year-old waitress had responded to the casting call for *Goin' South*. After reading some pages of the script with her, he flew her to Hollywood for a screen test, after which he told her, "You're on the payroll."

Before leaving for location shooting in Durango, Mexico, in the summer of 1977, Nicholson threw a party, and one of the guests later described "lots of drugs, lots of drinks," and a large bowl with different sections containing marijuana and cocaine. Nicholson was "a very good host," and the guests were not stars but "the people he was hanging out with at the time. The furnishing was Santa Fe–type stuff, comfortable not flash, and there were wood floors and big bleached-wood tables. Apart from some very nice art, there was no feeling of opulence; just lots of people running around having a good time."[1]

In Durango, Nicholson stayed in a large ranch house in the mountains, hosting nightly lasagna chow-downs for intimate members of his circle whom he'd hired to work in the film, including Ed Begley Jr., Luana Anders, Danny DeVito, and Veronica Cartwright, an actress who could drink and party as hard as Nicholson. Though he was involved with Anjelica, he asked Cartwright to spend the night, and she accepted. He was an amazing lover, she later recalled—funny, charming, and capable of maintaining an erection for hours on end.

When Cartwright woke up the next morning, she went downstairs in her robe, and came face-to-face with several cast members, including Christopher Lloyd. Nicholson hugged her in front of everyone, and from then on, they had periodic flings.

Toby Rafelson, the cool and hip den mother from Nicholson's BBS days, was working as art director on *Goin' South*. Her fickle husband, Bob Rafelson, had recently told her to give beauty advice

to the woman he was sleeping with, Sally Field, who'd just come off *The Flying Nun* to star in Bob's *Stay Hungry*, and was afraid she wasn't sexy enough.[2] Finally fed up with Bob, Toby left him. In Durango, she informed Nicholson that their mutual friend Jim Harrison was broke, and Nicholson, exercising his directorial perks, told her to notify Harrison to come on down to Durango. When the author of the esteemed *Legends of the Fall* arrived in Mexico City, Nicholson sent his secretary, Annie Marshall, to pick him up at the airport. Annie's cat Pinky had been airfreighted from L.A., and Annie told the baggage attendants, "Dónde está my fucking gato vivo." That, Harrison later recalled, was his "splendid introduction to the movie business."

In Durango, Harrison drank with the cast and crew, including "Jack's preposterous Uncle Shorty, a railroad worker from New Jersey." Evenings, Nicholson and Harrison conversed about books and cinema, and after a week, just as Harrison was poised to confess his nervousness about what he was supposed to be doing, Nicholson lent him enough money to write for a year. All Nicholson asked was a share in the movie rights in whatever Harrison turned out. Later, when Harrison's income was substantial thanks to numerous screenplays, Nicholson "would accept only the amount of the original loan. Many people can afford to behave this way but very few actually do."[3] It was Nicholson who educated Harrison about what he called "'dead money,' larger overflow that you have neither the time nor the inclination to spend."

Another member of Nicholson's *Goin' South* entourage was *Saturday Night Live*'s John Belushi, who was paid $5,000 for a cameo role. Jim Harrison, who'd spent time with Tom McGuane in Key West, Florida, thought Belushi "didn't seem all that crazy by Key West standards," but Nicholson soon wearied of Belushi's druggy displays and fights with Harold Schneider, who was co-producing with Harry Gittes, and expelled the comedian from the

charmed circle. He advised Belushi that he should never become so spaced out at work that he was unable to "talk shit with the suits." Hopelessly addicted to cocaine, Belushi said, "Jack treated me like shit on *Goin' South*. I hate him. If I see him, I'll punch him."

Belushi's girlfriend, Cathy Smith, a drug dealer, fixed Nicholson up with some of her friends. A *New York Times* reporter who visited the set wrote that Nicholson seemed obsessed with weird things, and talked "of death and of cancer, of macabre philosophies, of sex without much enthusiasm, and of drugs with much more."

Nicholson's spastic, crazed, wired performance in *Goin' South* was influenced by his admiration for such quirky, twitchy character actors as Gabby Hayes and Charley Grapewin, who were old men when they pulled their geriatric antics. In a leading role, such cantankerousness seemed inappropriate, and Nicholson's dumb grins and antsy antics came off as silly. Steenburgen, who turned in a delightfully spirited performance, later acknowledged Nicholson as her "patron saint" when she won an Oscar for *Melvin and Howard*. *Goin' South* was a critical and commercial failure, and critics speculated that Nicholson's judgment had been unhinged by drugs, *Time* noting his "somewhat stoned eyes."[4] As a director, Nicholson lacked both vision and style, and *Vanity Fair*'s Stephen Schiff wrote, "One can hear a persistent, chiming envy whenever [Nicholson] talks about the directorial successes of actors such as Robert Redford and Warren Beatty."

He would have been better off accepting Julia Phillips's offer to star in her UFO classic *Close Encounters of the Third Kind*. Though the avowedly ruthless Julia had already cast Richard Dreyfuss, she was feeling vengeful over the actor's having "extracted" $500,000 "plus five gross points from break." She gave the script to Nicholson's agent Sandy Bresler, who rang her back with an emphatic no. "He said he didn't want to fight the [special] ef-

fects, but he'd sure take the points anytime," Bressler said. Julia begged him to persuade Nicholson at least to meet with director Steven Spielberg, but Bressler refused, though he told her Nicholson "knew it was a hit."[5]

On returning to L.A., Nicholson and Anjelica had dinner with Harry Gittes and his girlfriend Christine Cutty and Lou Adler at Trader Vic's, and Gittes later recounted, "Christine had a very exotic drink, and then she had some chocolate-dipped strawberries, and while we were outside afterward, waiting for our cars, she fainted. Lou Adler, who used to be a medic in the National Guard, ran back inside and came back and put something on her head to wake her up. I kidded her that she was all over Jack because of his star power, which was not the case at all. It was that she'd had too much sugar and she didn't realize it. As we were walking out to our car Jack said, out of the side of his mouth, 'Marry her.' And I did, seven years after we lived together. He's an absolutely unbelievable reader of character. This type of approval from him is extremely important to me. I've known the man forty years."

After *Goin' South* was released in 1978, the first public reference to Nicholson's lineage appeared in *Parade* in an item by Walter Scott, who listed "Donald F. Rose" as his father. Nicholson called Furcillo-Rose in Ocean Grove, New Jersey, and they had a friendly chat. When Nicholson asked him if he needed anything, he replied that he was financially comfortable, with a house in the Poconos, and invited him to visit. Nicholson called one more time, then never again, to Furcillo-Rose's dismay.[6]

Sadly duplicating his nonrelationship with Furcillo-Rose, Nicholson refused to acknowledge publicly that he was Caleb Goddard's father, insisting that Susan Anspach repeat the behavior of Ethel May and June, and protect his dark secret.[7] Anspach and Goddard were divorced in 1977. "I'd been to a couple of parties at Jack's house," Anspach said, "and I called him and told him

Mark and I had split up. It seemed like the right thing for him to take some fatherly interest in his son."[8]

"I don't want to discuss Caleb publicly because I'm illegitimate," he told her, according to Anspach, "but you know I love him; I couldn't love him any more than I do already." In time, his insistence on anonymity became "a sore point with me," she said.[9]

Nicholson's relations with Ryan O'Neal remained so strained that when both men were present at a party or club, the other guests expected a fight to break out. One of them recalled, "Around 1978, one of Warren Beatty's ex-girlfriends, Barbara Allen, almost caused a small fight between Jack Nicholson and Ryan O'Neal at Studio 54. Barbara was trying to get a part in his film *Goin' South*, which went to Mary Steenburgen. Barbara had just broken up with Ryan O'Neal, who was seeing Anjelica Huston. Steve Rubell was keeping Jack and Ryan apart all night long. He asked me to dance with Ryan's teenaged daughter, Tatum O'Neal, who was there with Ryan. An ex of both Ryan's and Jack's, Margaret Trudeau, was there also. Jack was in the basement with Halston and I remember doing cocaine with them; Halston always had the best cocaine. Steve Rubell was running around the club like a madman, saying, 'We got to keep Ryan and Jack away from each other. There's going to be a big fight.'

"[Later] we were sitting upstairs with Diana Vreeland, Tatum, and Steve, and Steve saw Jack come up the stairs. He got all nervous and started pushing me to take Tatum to the dance floor, and I did. I don't think Jack or Ryan ever saw one another that night, because I'm sure, like, Steve Rubell said, there would be a fight and blood because both are hot tempered Irishmen who love to fight, and Jack was mad that Ryan was seeing Anjelica. Today [2002]

Barbara lives in Greenwich, Connecticut, and is married to Henryk deKwiatkowski, a wealthy polo player."[10]

Earlier, as Andy Warhol noted in his diary, Barbara Allen had sent her lover Philip Niarchos away to the south of France, in order for her to do a screen test for Nicholson, and Niarchos had had an affair with Anouk Aimee's daughter, Manuela Papatakis. On his return he admitted it to Allen, and accused her of having sex with Nicholson, Beatty, and Mick Jagger, which she denied.[11] Not long afterward, Warhol wrote, "Barbara was upset because Jack Nicholson gave the part she 'auditioned' for to an unknown girl who did some New York theater things."[12]

Nicholson's 1978 reconciliation with Anjelica came about, he said, because he "made it clear that I still wanted to see her."[13] She settled back in at Mulholland Drive, where, one evening as Nicholson relaxed on the couch and watched the Lakers on TV, Anjelica said, "Jack, why is Larry Bird so pale? I wish he'd get a tan."

"Whaddya mean, why is Larry Bird so pale? Where does he live? Boston, right? What time of year is basketball season? Winter, right? . . . How in hell is he gonna get a tan? I like him just like he is, anyway."[14]

Sometimes, for L.A.'s top A-list couple, they sounded more like Roseanne Barr and John Goodman. They certainly bickered as much, and neither could agree on what kind of relationship they wanted. "Monogamy seems to be a big problem," said Nicholson. "Man-woman relationships just seem to get harder and harder. . . . I propose to Anjel from time to time. Sometimes she says yes and sometimes she says no, so we never actually get around to it. When I'm working she's usually doing nothing, and now that I'm taking time off she wants to work."[15]

Despite the comforts Anjelica offered, he still wanted dalliances, offbeat relationships, seductions, the exotic and new.

Amazingly, he still wanted to have children, telling a reporter, "I'd like to have six more. This year. . . . I've actually proposed it on occasion to women I've known . . . however they'd want to do it— either I'd take the child or they would. If I could redesign the universe I'd make it possible for people to live out that fantasy." Surely he was "crazy," the reporter interjected, to think that he could raise children when he so obviously lacked stability. Missing her point, he replied, "No, I'm not [crazy]. I can afford it, darling. Don't you understand? I'm actually in a position to carry it off."[16]

Nicholson and Anjelica celebrated Christmas 1977 on the Aspen slopes with his daughter Jennifer, Zoli, retailer Jackie Rogers, Andy Warhol, debutante Cornelia Guest, Diana Ross, Barry Diller, Calvin Klein, Jimmy Buffett, and *Playboy* Playmate and *Hee Haw* star Barbi Benton. Looking worried, Anjelica stood at the bottom of Ajax Mountain, waiting for Nicholson, who zoomed down with reckless abandon in army-surplus work clothes. Later, Barbi Benton threw a party, and Jimmy Buffett hosted a bash on New Year's Eve.

When he returned to L.A., Nicholson discussed a horror story, *Fourth Force*, which never came off, with Paddy Chayefsky, who was in town to pick up an Oscar for writing *Network*. Nicholson turned down the Willard role in 1979's *Apocalypse Now*, as did Robert Redford, Gene Hackman, Al Pacino, James Caan, and Steve McQueen, which drove director Francis Ford Coppola into such a rage that he threw his five Oscars out the window, only one surviving. Harvey Keitel got the role, but was fired after a month, and replaced by Martin Sheen. Brando played Kurtz, receiving $1 million for five weeks' work, later collecting $17.7 million for *Superman*. Both Brando and Nicholson were flush with cash, and Brando bought a condo next to one Nicholson had earlier purchased on Bora Bora.[17]

After Robert De Niro was fired in 1975 from the Neil Simon movie *Bogart Slept Here*, Nicholson, James Caan, Richard Drey-

fuss, Tony LoBianco, and Dustin Hoffman were candidates to re-
place him until the project was scrapped. He was also well out of
the ill-fated *1900*, which *Time* wrote off in 1976 as "boring." Di-
rector Bernardo Bertolucci had wanted Nicholson but ended up
with De Niro, whom he later called "neurotic."

Nicholson, Al Pacino, and Sylvester Stallone were all up for
the role of the paraplegic Vietnam vet in *Coming Home*, but Jon
Voight got the part—and the 1978 Oscar for Best Actor. Andy
Warhol wanted to produce a biopic of painter Jackson Pollock star-
ring Nicholson as the drunken genius of abstract expressionism
and Anjelica as his girlfriend Ruth Kligman, who'd just written a
memoir of their love affair. Kligman later told Warhol "she was off
Jack Nicholson . . . and the new he-man screen-man of her
dreams is Bobby De Niro."[18] When Ed Harris played Pollock—to
perfection—years later, the film was based not on the Kligman
book but on Steven Naifeh and Gregory White Smith's biography
Jackson Pollock: An American Saga. Wrote Warhol's biographer Vic-
tor Bockris, "Andy met and, if only briefly, befriended a large
number of Hollywood stars by interviewing them for cover stories
in *Interview*. The only one he really liked was Jack Nicholson." The
pop artist and the actor often encountered each other in Aspen,
and Warhol once noted in his diary, "Met the Dowager of Aspen,
the Grande Dame. Went to her house. Her name is Pussy Paepcke.
She's eighty-two and she's very beautiful, she looks like Katharine
Hepburn. Her house was great, next to Jack Nicholson's and Lou
Adler's."

The Shining

Stanley Kubrick, who'd wanted to work with Nicholson ever since
Easy Rider, called him after reading Stephen King's novel *The*

Shining, the story of a writer, Jack Torrance, who goes crazy while working as off-season caretaker of a huge resort hotel during a snowbound winter of total isolation, and tries to murder his wife and son. "I hadn't read the book but it wouldn't have mattered," Nicholson recalled. "I would have done whatever Stanley wanted." The actor and his agent Sandy Bresler cut a deal for $1.25 million plus a percentage of the gross.

The Shining went into production at Timberline Lodge in Mount Hood, Oregon, in the winter of 1978, and then moved to London for the next ten months. Nicholson lived on Cheney Walk on the Thames from May 1978 until April 1979 in a mansion known as a "raghead" house because it was often leased by Arabs. Nicholson was completing some last-minute work on *Goin' South* at the time, and Kubrick was the first to see the final cut. "He responded very favorably to the film, finding it both good and funny," Nicholson said.[19]

His daughter Jennifer came to visit in 1979, and while in London she became enamored of punk. "I was shocked, but I was totally into it," Jennifer recalled.[20] Clothes that were slashed, safety-pinned, and studded were very much to her taste. Her own distinctly girlie sensibility would later lead her to mix and match, pairing a scalloped baby doll dress with motocross boots and a biker-style jacket in white lace. Clothes continued to be her passion, and there were already unmistakable signs of an estimable fashion designer in the making, not to mention a marathon shopper.

Jim Harrison arrived to discuss his *Revenge* project, which Nicholson wanted to film with John Huston directing (when the clunker was finally made in 1990, the stars were Kevin Costner and Anthony Quinn, directed by Tony Scott). Harrison stayed with the actor in his Chelsea Embankment mansion. "It was serene compared to Hollywood, with very little cocaine," Harrison later re-

called, "though once as a practical joke George Harrison was sent to my bedroom to wake me from my nap with a long line."[21]

Then Anjelica appeared in London with her sister Allegra, who became Jim Harrison's U.K. book editor. Harry Dean Stanton was also in town, filming *Alien*. Nicholson worked daily at nearby EMI-Elstree Studio, where Kubrick took over four sound stages for his massive Colorado resort sets, as well as extensive exterior space. Anjelica and Harrison would visit Elstree in the mornings and then repair to San Lorenzo for leisurely lunches while, at Elstree, Nicholson underwent the rigorous experience of performing for the perfectionist director of *Paths of Glory*, *Spartacus*, *Dr. Strangelove*, and *Lolita*. He found it difficult beyond anything he'd ever experienced. Kubrick told him that what was going on in *The Shining* was largely going on in the head of the character he was playing, and added, "I never know what I want, but I do know what I don't want."

Nicholson was "surprised" that Kubrick chose Shelley Duvall, perhaps the least glamorous of Hollywood leading ladies, to play Jack Torrance's beleaguered wife, Wendy, but Kubrick explained that the actress's "irritating" voice would convince the public "to believe that this man would want to hunt down and terrify his wife."[22] Kubrick wanted Nicholson to live near his home, Childwickbury Manor, near St. Albans, Hertfordshire, a 120-acre park an hour north of London, but Nicholson preferred the city. The reclusive director expected "a full report [of] what we had done the night before," Nicholson recalled. "He used to ask Shelley Duvall questions about her sex life and everything that went on."

On the set, Kubrick offered his actors little direction, putting them through multiple takes until their performances rang true. "They'd come to him for direction, and he'd send them back to work to find out for themselves," wrote Michael Herr, who later scripted Kubrick's *Full Metal Jacket*. According to Duvall, there

were "thirty-to-fifty videotaped rehearsals before we even rolled film." Nicholson's scene with Lloyd, the ghostly bartender, played by Joe Turkel, who delivered the Nicholsonian line, "Women—can't live with them, can't live without them," required razor-sharp changes of mood, and Kubrick filmed it thirty-six times, later saying, "Jack produced his best takes near the highest number." Kubrick believed that he had to exhaust his actors so they'd "lose control of [their] sense of self, of the part of you that was internally watching your own performance," said Nicole Kidman, who later worked with the director in *Eyes Wide Shut.* "Eventually, he felt, you would stop censoring yourself." Kubrick himself had a simpler explanation: "When I have to shoot a very large number of takes, it's invariably because the actors don't know their lines, or don't know them well enough."[23]

One of *The Shining's* film editors, Gordon Stainforth, revealed that the famous long tracking shot in which Nicholson stalked Shelley Duvall up the staircase as she tried to clobber him with a baseball bat was filmed fifty or sixty times. Just as he'd been with Antonioni, Nicholson was happy to have a strong director in Kubrick. "I want to be out of control as an actor," he said. "I want them to have the control—otherwise it's going to become predictably my work and that's not fun." In order to elicit the requisite horror from Nicholson when the rotting hag stepped out of the bathtub in Room 237, Kubrick drew the actor aside, reached into a brown paper bag, and produced graphic photographs of accident victims.

In another bloodcurdling scene, Nicholson and the ghost of the former caretaker, Delbert Grady, played by Philip Stone, who'd butchered his family in 1970, confronted each other in a weird-looking, red men's room, based on an Arizona hotel toilet created by Frank Lloyd Wright. In a voice that was both deferential and deadly, Delbert programmed Torrance to murder his own son.

"Long takes each time," Philip Stone recalled. "We seemed to be in that set forever. . . . The inner concentration and stillness came from working in Pirandello plays, long speeches lightly played, the drama of the mind, but you've got to get your balls behind the lines."

While Kubrick treated Nicholson with deference, telling him, "You're the man, let's do it," Shelley Duvall felt the director was unduly harsh. "From May until October I was really in and out of ill health because the stress of the role was so great and the stress of being away from home—just uprooted and moved somewhere else—and I had just gotten out of a relationship and so for me it was just tumultuous," Duvall recounted.

Shooting the movie's trademark scene, when Torrance tried to murder Wendy, Kubrick accused Duvall of overacting, saying, "Every time he speaks emphatically you're jumping and it looks phony." Since Kubrick was letting Nicholson go over the top, the actress couldn't understand why the director was requiring so much restraint from her. After Torrance hacked his way through the bathroom door with an ax, he stuck his face through the hole and yelled, "Heeeere's Johnny!" Delivered by Nicholson as high camp, the words were destined to become *The Shining*'s most quoted line. "I was so antitelevision at that point I didn't even know where the line came from," Nicholson recalled; neither did Kubrick, who lived in England and rarely watched American TV.[24] Screenwriter Diane Johnson had lifted it from Ed McMahon's introduction to Johnny Carson's *Tonight* show on NBC.

The $13-million budget did not permit Kubrick to recreate the animal-shaped topiary hedges that morphed to macabre life in King's novel, but the labyrinthine maze Kubrick used instead provided the film with its incomparably scary denouement, in which the homicidal father pursued his son, Danny Torrance, brilliantly played by five-and-a-half-year-old Danny Lloyd, through the

maze on a snowy night. Constructed at EMI-Elstree, adjacent to the rear of the Overlook Hotel's facade, the maze was made of pine boughs stapled to plywood and was used only for exterior shots. Inside Stage 1, a duplicate maze was built to accommodate the high-powered nighttime lighting required for the climactic scene, which was filmed with the newly invented Steadicam, enabling the photographer to move more freely than ever before.

So cast and crew wouldn't get lost inside the life-size puzzle, Kubrick had an overhead-view map drawn and distributed, but they all continued to lose their way in the mazes. The snow was created out of dairy salt and pulverized Styrofoam, and the fog was toxic oil smoke, requiring the crew to wear gas masks, while the actors, director, and cinematographer suffered and tried to breathe. Steadicam operator Garrett Brown had to use stilts with Danny Lloyd's shoes nailed to them for the famous shot in which Danny, trying to fool his father, reversed course, backing up in his own tracks. The ruse saved the child's life, and Jack Torrance froze to death in the maze while Wendy and Danny escaped in the Sno-Cat. In the final cut, Kubrick added a scene, deleted after the movie's release, in which the hotel manager, Mr. Ullman, played by Barry Nelson, paid a visit to Wendy in the hospital.

Nicholson's grotesque grimaces during the maze chase came from a toy machine he'd had in childhood, in which "you shoot a bear and it makes horrible sounds," and Torrance's heavy limp he borrowed from Charles Laughton's lumbering hunchback of Notre Dame. Jack Torrance was another of Nicholson's fallen angels, a cusp character presaging the "Me" decade of the eighties. Like two previous Kubrick villains, Peter Sellers's Humbert Humbert in *Lolita* and George C. Scott's General "Buck" Turgidson, Torrance had to be at once sinister and comic, scaring the audience while also winking at it. Nicholson gave the performance of a lifetime, his new, midcareer, theatrical style dovetailing perfectly with

Kubrick's penchant for what Nicole Kidman called "slightly odd, slightly off" acting, and proving that Nicholson had been right to add pre-Method, nineteenth- and early-twentieth-century pyrotechnical histrionics to the more naturalistic style of his early period.

The Shining opened in Manhattan on Friday, May 23, 1980, becoming the most commercially viable film of Kubrick's career, and a much-needed hit for Nicholson. "The biggest opening our company has ever had in New York and Los Angeles," said Warner CEO Terry Semel. On the following Thursday, Kubrick, unable to stop working on the film even after its theatrical release, decided to excise the final sequence—the hospital scene—dispatching editors on both coasts, who rode bicycles from theater to theater and physically scissored out the superfluous scene. "After several screenings in London the day before the film opened in New York and Los Angeles, when I was able to see for the first time the fantastic pitch of excitement which the audience reached during the climax of the film, I decided the scene was unnecessary," the director said.[25]

Amazingly impervious to the film's technical, visual, and aural virtuosity, and its elevation of the horror genre to high art, critics wrote that the characters were unsympathetic, and couldn't forgive Nicholson for abandoning realism. "Jack Nicholson hams atrociously from the outset," wrote John Simon in the *National Review*, and Pauline Kael wrote in the *New Yorker*, "Ax in hand and slavering, with his tongue darting about in his mouth, he seems to have stumbled in from an old AIP picture." One of the film's few champions, *Newsweek's* Jack Kroll, wrote, "Nicholson's Jack Torrance is a classic piece of horror acting; his metamorphosis into evil has its comic sides as well—which makes us remember that the devil is the ultimate clown."

In one of its most flagrant sins of omission, the Academy of

Motion Picture Arts and Sciences accorded Kubrick no nomina-
tions, that year, and also ignored the peerless performances of
Nicholson, Duvall, and Danny Lloyd, not to mention Kubrick and
Diane Johnson's writing, John Alcott's cinematography, Garrett
Brown's pioneering Steadicam work, and Roy Walker's set design
of the Overlook Hotel.

During and after filming, Nicholson had sampled the lively
London social scene, which was still swinging in the late seventies.
He met Margaret Trudeau, former wife of Canadian prime min-
ister Pierre Trudeau, and had what Ms. Trudeau later called a "mad
episode . . . in the back seat of a Daimler."[26] When Anjelica joined
him in London, he blew off Trudeau with the remark, "Guess
who's coming tomorrow?"[27] Trudeau felt "crushed . . . a fool,"[28]
but consoled herself by starting an affair with Ryan O'Neal. At a
party in Hollywood, Nicholson led Trudeau to the men's wash-
room for a private tryst, and she balanced herself on a toilet seat,
hoisting her legs so that no one could see her feet.[29]

Earlier, at the film's premiere party in a New York club, Nichol-
son spotted a *Playboy* centerfold model in the VIP room and asked
Diane von Furstenberg to introduce them. In a few minutes, as he
chatted with Zoli, Mick Jagger, and willowy Texas model Jerry
Hall, von Furstenberg approached them and said, "Jack, I think
you might want to meet this girl."

"Heeyyy!"

"Hi! I'm Bebe," said Bebe Buell, who'd had sex with some of
the best—Iggy Pop, David Bowie, Todd Rundgren, Jimmy Page,
Ronnie Wood, Rod Stewart, Elvis Costello (her favorite because
he possessed "femininity without being gay"), and Aerosmith's
Steven Tyler, with whom she'd had a daughter, future movie star
Liv Tyler.

"Hey, Beeb!" Nicholson said. "Thank you, Diane. Sooo, Beeb,
what do you do? Let me guess. You're a model?"

"Well, unfortunately you're right."

"Well, what do you mean by that?"

Mick Jagger began to tease her, insinuating that Bebe acquired her "juuuicy lips" not from blowing Todd Rundgren, "famous for his huge penis," but from Jagger. That seemed unlikely. Keith Richards "was the member of the Rolling Stones who was particularly well-endowed," Bebe later revealed, adding that his erections were impervious to drugs, and that Bill Wyman also "grabbed honors in this department."

"Stay away from Jack," Mick warned her. "He's naughty . . . a womanizer."

Nevertheless, Mick, Jerry, and Bebe all ended up in Nicholson's Pierre Hotel suite for champagne and games. The girls donned Nicholson's "very clean, very white men's briefs," fell to the floor, and began to leg wrestle in front of the men, who threw money down, betting on who'd win, the six-foot Jerry or the five-foot-ten Bebe (the former won). Then Rachel Ward arrived, and promptly disappeared into the boudoir with Nicholson. Bebe left with Mick and Jerry, and Jerry wanted to see her "titties," but Bebe refused to go to bed with them.

The following morning, Nicholson called Bebe, and to make amends he took her to dinner with Mick and Jerry at an Italian restaurant in Greenwich Village, where Jerry kicked a girl flirting with Mick so hard her legs crumpled. Then they went to Mick's house, and Nicholson and Bebe had "very normal sex," she later recounted, "wholesome back seat sex." She rated Nicholson, Jagger, and Warren Beatty in a class by themselves as "perfect practitioners of love. God put them on this planet to make love to women. They really take pride and pleasure at being skillful. . . . You know you weren't going to walk away from it unsatisfied." The next day, Nicholson sent flowers and asked Bebe to call him "Jeke." He was so fond of her that he even rang her mother in Virginia.

"Your daughter is fantastic," he said. "You did a good job, Mom."

He flew Bebe out to L.A., where she stayed with a girlfriend nearby, off Mulholland, and Nicholson drove over in his "cover car," the old Volks.

"Mick tells me that you're gonna hurt me," she said.

"Well, I might, but you'll have a damn good time before I do."

With agent Sue Mengers, they took in *The Shining* in Westwood, and he asked Bebe for the "female point of view."

"She might be right for *Postman*," Mengers said, referring to a forthcoming Nicholson project, *The Postman Always Rings Twice*.

"She's a rock 'n' roll kind of girl," Nicholson said. "I don't think Hollywood and the Beeb would mix."

Later, he and Bebe parked high up on Mulholland Drive and he showed her the lights of L.A. before dropping her off at her girlfriend's, where they did it up against the Volks, Bebe hiking her dress up and Nicholson keeping his trousers on and just opening his fly, "high school demure" style. She found it all "very sexy."

"My butt was going fifty miles an hour," Nicholson told her.

When Bebe subsequently put together a rock band, the B-Sides, and played the Ritz in New York, she wrote a song, "Normal Girl," with a Nicholson-inspired lyric about about how good it was to make out in the car on a starry night. For a while, she and Nicholson continued "fooling around," which upset her lover, rocker Stiv Bators. According to Bebe, at CBGB one night, during a coke-and-booze-fueled set with his band the Dead Boys, Bators received oral sex from a member of the audience and later tried to hang himself from an overhead steam pipe. Bebe broke up with Bators, and she and Nicholson kept seeing one another intermittently.[30]

* * *

Nicholson was in Aspen on June 1, 1979, when Janie Buffett gave birth to Savannah Jane at 7 A.M., "and I cracked the champagne at 7:30," recalled Jimmy Buffett. Nicholson joined the party and remained until ten that night—a fifteen-hour jamboree. Back in L.A., Buffett was a regular at the Troubadour, singing his hit songs "Come Monday," "Margaritaville," and "Why Don't We Get Drunk?" Nicholson returned to Aspen in 1981 to begin a year of rest and recuperation after the rigors of working with Kubrick. "I want to get out of that cycle for a while," he told his guest, writer Tom Cahill. "Let the reservoir fill up." Another friend, *60 Minutes*' Ed Bradley, bunked with Cahill in Nicholson's Aspen town house, while their host occupied his larger Aspen retreat. Nicholson began every day looking at slides of fine art, particularly German expressionists, and then, with the other members of the Crack of Noon Club—Anjelica, Jimmy Buffett, and Bob Rafelson—he breakfasted with Bradley and Cahill before skiing. "The way Jack skied was straight downhill, as fast as he could go," said Cahill. "He wasn't doing sissy hills, either—all upper-range intermediate." In the evening, "we partied pretty hard," Cahill added. "He's the quintessential guy's guy, but a kind of Renaissance guy's guy."[31]

His next film was hardly of the Kubrick caliber: Metro's long-delayed, and wholly unnecessary, remake of the John Garfield-Lana Turner noir classic, *The Postman Always Rings Twice*, James M. Cain's story of a Depression drifter and a sleazy waitress who plot to kill her husband for his cafe and insurance money. The picture reunited Nicholson and Rafelson, whose erratic directing career hit a bombastic low when he apparently threw something—perhaps his fist, perhaps a piece of furniture—at a Fox executive who visited the set of *Brubaker*, where Rafelson had been directing Robert Redford in Columbus, Ohio, in April 1979. The executive had been attempting to pressure the director to work faster and spend less.[32]

Nicholson's big mistake in making *Postman* was that he thought he could still play a sexy hero, perhaps deluded by Meryl Streep's promise to do nude scenes if he'd cast her as his leading lady. "He wasn't so keen on that," she later joked.[33] Mercifully, the film included no bare middle-aged bodies, but Nicholson was determined, he said, to "come down the middle with the fast ball about sex. . . . The whole reason for that movie is sex, and that's why I wanted to do it." While filming with leading lady Jessica Lange, Nicholson wanted to do a love scene with "a full stinger because they'd never seen that in the movies." He tried to fluff himself up for forty-five minutes but couldn't manage to raise an erection "because I knew everyone was waiting down there to see this thing."[34]

Anjelica managed, with Nicholson's help, to score a small role as Madge the lion tamer in *Postman*, exposing her backside. "It was in my movie *The Postman Always Rings Twice*," he said, "that she had her first good part, a short but flashy role that I knew would do what it did for her.[35] Anjelica also worked as a part-time secretary for his friend Helena Kallianiotes, but mostly she was vegetating.[36] She completed her bit in *Postman* in Santa Barbara in May 1980. The following week, she was driving to Helena's fashionable roller rink, Skateaway, going down Coldwater Canyon to the Valley, when an inebriated sixteen-year-old boy in a BMW hit her head-on, sending her through the windshield and breaking her nose in four places. She was not wearing her seat belt. "I remember being ejected and then coming back into my seat and seeing nothing," she said. "Blackout. And feeling my face to see if my eyes were there. Then my hands traveled down my face and I knew that my nose was no longer where it once had been. There was a lot of blood. I ran out of the car. That's when the police came. I kept asking, 'Do I have lacerations?' You become very pinpointed in those moments."

Knowing she'd require the best plastic surgery, she told the police to call Annie Marshall, Nicholson's secretary, who rushed to the scene and whisked Anjelica to Cedars-Sinai. The surgeons did such a superlative job that she later joked that friends accused her of having the wreck on purpose to improve her looks. She was back in Nicholson's house on Mulholland three days later, still quaking from the shock of the accident and trying to discern some meaning in it. "It made me aware that life is fleeting and tenuous," she said. "And that I really wanted to work." The accident had the effect of switching her priorities from her relationship with Nicholson to her neglected career, and she began by moving out of Mulholland Drive and into her own place on Beverly Glen above Sunset, reflecting, "I had a good life with Jack, but it was necessary to remove myself from the entourage a career like his engenders. I needed to get back to myself and find out what exactly it was *I* wanted to do. Not just in acting. I had never lived alone. I didn't even know what color I liked my coffee in the morning. I didn't know what *I* was like. I needed to draw away, to know that when the phone rang it rang for me."[37]

She studied acting with Peggy Feury and took small roles in local theater, movies, and television. In the early eighties she appeared in Universal's *Frances*, PBS-TV's *A Rose for Emily*, Faerie Tale Theater's *The Nightingale*, Embassy's *This Is Spinal Tap*, and MGM/UA's *The Ice Pirates*. "It was neither her father nor her friends but I who backed her," Nicholson said. "I'm the one who directed and encouraged this undisciplined young woman to take serious acting classes."[38]

After Nicholson completed *The Postman Always Rings Twice* in the spring of 1980, he went to the south of France for the summer with Sam Spiegel. Shortly thereafter, the legendary producer died of a cerebral hemorrhage at the age of eighty-four on St. Martin in the French West Indies. When his body was discovered

in the bathtub of his cottage at La Samanna hotel, Peter Ustinov, who was also on the island, was asked by the manager to give Spiegel a kiss of life. "Alive or dead, I would not kiss Sam Spiegel," quipped the actor.[39] Another guest at the hotel suggested a woman had been with the producer when he expired. Later, in Beverly Hills, where Nicholson was dining at Chasen's with Anjelica and Mike Nichols, Nicholson raised his glass and said, "Let's drink a toast to Sam. I miss him so much." Both Nichols and Anjelica burst into tears. "Sam's lesson to me was always to go for quality," Nicholson said. "I lost three of the really great men in my life this year—Sam Spiegel, Orson Welles, and Shorty Smith. They just happened to be three older dudes who I got along great with for a long, long period of time."[40]

When *The Postman Always Rings Twice* was released in 1981, critics were eager to see if Nicholson and Jessica Lange had managed to surpass, or at least equal, the work of Garfield and Turner in the original version. "They haven't pulled it off," wrote *Newsweek*'s David Ansen. "Jack Nicholson . . . is a bit too old for the part." In *Commentary*, Stanley Kauffmann came down even harder, writing, "He looks a good deal of the time as if he hadn't recovered from the *Cuckoo's Nest* lobotomy."

Attempting to rationalize his failure, Nicholson said he'd brought these attacks on himself by telling the press, following *Last Detail* and *Cuckoo's Nest*, they'd "overly praised" him. "I said that for two pictures and they got up my ass for five years in a row. . . . The result was that people started applying a different standard to me and thinking, 'Yeah, this fucking guy is overpraised. Let's attack the living shit out of him!' And they did. For instance, if I had done *The Missouri Breaks* during the sixties, it would have been perceived as something with some excellent work in it and some flaws. . . . The same thing with *Postman*: I think it's a superior movie that's made a lot of money—mostly in Europe."[41]

Doing films back-to-back, he was working too hard, and it began to show in his behavior. In 1980 he started freaking out at Lakers basketball games. "His greatest performance at the Forum," wrote one reporter, climaxed with "finger-pointing, abuse-hurling dialogue" with officials from his courtside perch.[42] In the fall, when he filmed *The Border* for director Tony Richardson in El Paso, Texas, Richardson said, "I don't think Jack enjoys acting as much as he once did. Jack wanted to return to the style of acting of his earlier performances." Eschewing the theatrics of *Goin' South* and *The Shining*, he played a decent, honest man who eventually, under pressure from his materialistic wife, portrayed by Valerie Perrine, gave in to the temptation of bribery, smuggling illegal immigrants across the Rio Grande. Critic Pauline Kael loved Nicholson's "modulated, controlled performance, without any cutting up . . . the first real job of acting he has done in years," but the public turned thumbs down on this listless, stale film.

His small but important role in Warren Beatty's *Reds* was undertaken because he liked the way it dealt with the onset of American bohemianism, which challenged Victorian morality, and because it tackled real issues, unlike such spineless "high-concept" eighties trendsetters as *E.T.* "They're not making contemporary films," he said. "Nobody's talking directly to the issues of the moment." Nor did he care for the new breed of conglomerate dealmakers who were trying to "cut my prices," and he predicted the imminent downfall of all cinematic art. The old studio bosses at least had gambled on pictures; "they weren't making market shares with backoff sales and cross-financing and cross-collateralization. There's nobody that gambles now. Everybody's going for the big whamola all the time." When the cineplexes came in with their tiny screens and thin, unsoundproofed walls, he said, "I miss the Big Silver, I really do. The world is going to miss the moviegoing experience. . . . The moviegoer's life has been degraded."

When a reporter asked if he was in love with *Reds'* leading lady, Diane Keaton, despite her affair with Beatty, he replied, "During the production, that's the way it began to feel. . . . 'My God, I've got a real crush, and this is my best friend and his girlfriend.'" In the end, nothing was permitted to disrupt his symbiotic relationship with Beatty; they were more important to each other than any woman had ever been to either. The Academy of Motion Picture Arts and Sciences nominated both Nicholson and Beatty for Oscars, the former in the Best Supporting Actor category, and the latter for Best Actor, Direction, and Writing. "It's fabulous for the Pro," Nicholson said, referring to Beatty, but he was not optimistic about his own chances, saying, "I'm petty sure Sir John Gielgud will win for *Arthur*—and that's jake with me. I like a nice relaxed evening. . . . I'm hoping for a win for Warren Beatty." He flew from Aspen to attend the awards ceremony and returned to the Rockies immediately after Beatty won an Oscar for Direction, Maureen Stapleton won the Best Supporting Actress Oscar for her role as radical organizer Emma Goldman, but Nicholson, as he'd foreseen, lost to Sir John. However, critics liked Nicholson again, *Time*'s Richard Corliss writing, "Under Beatty's direction Jack Nicholson proves how resourcefully sexy an actor he can be."

In June 1981, Nicholson flew to Hawaii for his seventeen-year-old daughter's graduation from high school. "I was always on the fringe," Jennifer said, flashing a devilish grin not unlike her dad's. An incorrigible clothes horse, she purchased her first designer piece while in high school—a black, wrapped Azzedine Alaia dress. "It made me feel better," she said. Clothing became for her a kind of armor plating, providing a longed-for sensation of belonging and normalcy in a sometimes cold world.[43] At the time of her graduation, her father said he was "happy. . . . I'm acting not only in films but in life as well, so I'm always having a good time." Jennifer subsequently enrolled in the University of Southern Cal-

ifornia, where she majored in art and joined the Kappa Kappa Gamma sorority.

For Nicholson, it was time for a sabbatical. "I'd worked every day for three years," he said. "I did *Goin' South*, *The Shining*, *Reds*, *The Border*, and *Postman*—one right after another. At that point, I knew I was tired. I don't get tired that often. So I took the time off, and I filled up and I feel great." Timely replenishment had arrived in the foxy form of Bebe Buell after he flew her to the Coast in 1981 and put her up in neighbor Warren Beatty's house, where her host played the piano, serenading her with classical selections, while "a lot of women [came] in and out."

Nicholson, who'd had a "bad breakup" with Anjelica that left him depressed, stuffing food, overweight, and "cry[ing] all night," gave Bebe a rented car, told her to disband her rock group, the B-Sides, and create her own sit-com, assuring Bebe she was "a classy piece of ass." Offering to introduce her to his impresario buddy Lou Adler, he welcomed her into the Jack Pack and accepted her as one of the boys, even when a bevy of starlets joined them one night for dinner, during which everyone scarfed ribs and brew while watching TV, "like a bunch of rednecks."

Moving from the table to the hot tub, Nicholson immersed himself in girls. They were "all over" him, Bebe noticed, and added, "I bet he fucks every one of them and still comes back for seconds." Later, he climbed into Bebe's bed, to no avail. "There was no way I was going to have sex with him after he had sex with six women," she explained. Eventually returning to her band, she recorded *Covers Girl* for Rhino and began an affair with Richard Butler of the band Psychedelic Furs.[44]

After a rapprochement with Anjelica, Nicholson flew to Aspen to spend Christmas 1981 with her and Jennifer. Later, in Manhattan to promote *The Border*, he told a reporter he'd been skiing for the past four months, "basically alone, me and my cook. And

when you ski all day you go home and eat and go to bed. You don't realize that certain layers of skin drop off when you're not out there in society. Now I've returned here, to the city of my birth, and I'm supposed to work, and what I really want is to play around in New York."[45]

Interviewing Nicholson in L.A., an interviewer noticed that he looked "fit, or as fit as he's ever likely to look." When another journalist remarked on Nicholson's "midriff bulge liberally looping over the elastic waistband," Nicholson told him, "I don't care about it when I'm relaxing. Same with my double chin. No point in trying to pretend it isn't there. . . . When I'm working, then it matters." Despite love handles that contributed their share to his forty pounds of excess weight, his secret, middle-age wish was to play Fred Astaire in a musical, directed by Astaire. He also wanted to portray the evil emperor Caligula as a man who led a double life, one as a woman operating a bordello and having sex with men.[46]

Meanwhile, his sabbatical continued, "and I mean I really took off, didn't talk about movies for a couple of years," he said. "Those two years proved to me that I don't have to act. . . . I loved being out of the movie business. I like almost 95 percent of the people in the movie business, and I don't like what they're doing an equal proportion of that time. I call it the Hollywood Virus. You can't get out of town, can't stop making calls, and can't really focus on what it is you want to do."

He was scheduled to appear in *Roadshow*, an epic of a modern-day cattle drive, at MGM in 1983, with Diane Keaton—later replaced by Mary Steenburgen—and Timothy Hutton, but Metro dropped the film after a change in management, leaving the actors, who'd turned down other jobs, out of work. Nicholson "resolved matters" with the studio, and Steenburgen settled for an undisclosed sum, but Hutton took MGM to L.A. Superior Court. Both Nicholson and Steenburgen testified during the month-long trial,

as did Sue Mengers. The jury voted eleven to one to award Hutton $2.25 million in compensatory damages and $7.5 million in punitive damages. Metro, which was owned by Turner Broadcasting, denied Hutton's contentions and intended to "seek a further review," said a Metro attorney.[47] The parties later settled for an undisclosed amount.

It was just as well for Nicholson that *Roadshow* fell apart, because it left him free to do one of his most successful films, *Terms of Endearment*.

Chapter Seven

THE MODEL WARS

In the winter of 1981, Jack Nicholson walked into the VIP room at Xenon, a popular Times Square disco in Manhattan, with Ara Gallant, a hairdresser turned photographer, and model Gia Carangi, better known in the Seventh Avenue fashion industry as "Sister Morphine."[1] Nicholson had first met Gallant, who worked for Andy Warhol's *Interview* magazine, when Nicholson reported on the New York Film Festival for *Interview*. Gia Carangi, who was beautiful in a boyish, edgy way, loved to detach pins from the fabrics being draped on her during fashion shoots, and stick them in Gallant's leather cap, which he always wore with his ubiquitous black leather pants. Apart from Nicholson, Gallant's two best friends in Hollywood were Anjelica and Warren Beatty. Once again, Nicholson was surfing the sociological cusp. Just as he'd set the sixties style of hip rebellion in *Easy Rider* and the uneasy liberation of the seventies in *Five Easy Pieces*, now, in his life, he was overseeing the merger of show business, high fash-

ion, and drugs that would characterize the years of sybaritic overkill leading up to and immediately following the millennium.

One of the principal scene makers of the time, Ara Gallant was a little man with a small, pinched face, and he gave off a distinct impression of sadomasochism; his apartment was black from floor to ceiling. Nicholson and Gallant's companion that night, Gia Carangi, grew up in the meanest part of northeast Philadelphia. A tough, switchblade-toting bisexual, addicted to cocaine and heroin, she was madly in love with a woman makeup artist. "I can count the number of guys I've fucked on one hand," Carangi said. "And then it was only because I needed drugs." By the time Nicholson met her, Francesco Scavullo and Chris von Wangenheim had made Carangi's sultry allure a trademark of disco madness. "She was my best girlfriend," said Beatty's frequent companion, Bitten Knudsen, a luscious blond model and hard drugger. "She pushed the borders right to death."[2]

Carangi would die of AIDS in 1986, but at Xenon that evening in 1981, she followed Nicholson and Gallant as they made their way to Christina Onassis's table, where Nicholson began to chat with a former model who had a European title. "I'm so attracted to him," she told Onassis.

"You can't be serious about Jack Nicholson," Onassis said. "He's a womanizer."

"I don't care," she said. "I like him."[3]

Onassis started to sulk. Earlier, in L.A., while visiting Muriel Slatkin, owner of the Beverly Hills Hotel, Onassis had had a fling with Nicholson, more out of mutual curiosity than lust. She was a fairly attractive Levantine, though she had bad teeth, a big nose, dark pockets under her eyes, and was overweight. After Nicholson, she'd gone on to Warren Beatty, who dumped her after one night. "No call, no postcard, nothing," she complained. "Why are men so terrible?"[4]

After Onassis stormed out of Xenon that night, Nicholson stayed until 4:30 A.M. and finally left with the model, who took him to her apartment on the Upper East Side. They played around until 10 A.M., and then he returned to L.A. Later, she told a friend, "He's so much fun to be around, much more amusing than my old boyfriend Peter Sellers." Her friend, a public-relations account executive for a liquor company, added that she instructed him, "Send a case of vodka to Jack's home in L.A." Thereafter, she and Nicholson continued to talk on the telephone frequently, and then, about a month later, they saw each other again.

The occasion was a party for Nicholson that was thrown by Gallant, who made sure that Nicholson's new model friend received an invitation. Also on the guest list were Andy Warhol and Nicholson's friend Alan Finkelstein, owner of a Madison Avenue boutique, Insport, but mostly the party was wall-to-wall models, including Bitten Knudsen; Esme Marshall, who worked for both Calvin Klein and Perry Ellis; Janice Dickinson, the savage-looking *Vogue* beauty who'd first coined the term supermodel; Patti Hansen, the Calvin Klein jeans model and Keith Richards's girlfriend; Kelly Emberg, who worked for John Casablancas's then-hot Elite agency; Tara Shannon, a modeling virtuoso from Denver who joked about being pursued by such "*top* model hounds" as European playboy Umberto Caproni, owner of Model Ring agency in Milan, who said, "The dream of every Italian guy is a beautiful American model in our bed"; and Winnie Holman Sullivan, who was married to Tom Sullivan, a romantic, good-looking young drug dealer who'd blown into Manhattan with $2 million in cash.

Nicholson was civil if a bit cool with the titled European model, because he was preoccupied that night with Winnie Holman, who was pretty enough to have once been Miss Denmark. She was now an Eileen Ford model, she told Nicholson, and added that she was in the process of divorcing Sullivan,[5] who was cur-

rently dating an old girlfriend of Nicholson's, Margaret Trudeau. Sullivan had been seen "fucking Margaret in the balcony at Studio 54," according to Warhol,[6] and heiress Catherine Guinness also had a crush on Sullivan,[7] whom Warhol described as "the cute guy with the burned hand [disfigured in a Florida plane crash]." At a luncheon for Isabella Rossellini, Sullivan and Bianca Jagger "were practically fucking against the wall," Warhol related.[8] After another luncheon at Warhol's, this one for the queen of England's lawyer Mark Littman, Warhol confided to his diary, "Tom Sullivan pissed on some paintings for me and left." While starring in the film *Cocaine Cowboys* at Warhol's home in Montauk, Long Island, Sullivan became a cocaine addict. "He's so free with it, it's not like a dealer, he gives it away like it's candy," Warhol said.[9]

Winnie Holman wanted out of her relationship with Sullivan, and said she was glad to meet Nicholson and hoped to get to know him better.[10]

A few years later, Andy Warhol made a sad entry in his diary after attending a party given by Jimmy Buffett in Aspen: "Said hello to Jack Nicholson and Anjelica. And in yesterday's paper Margaret Trudeau talked about her affair with Jack, and her new book is out where she talks about her cowboy Tom Sullivan and she doesn't even say that he died."[11]

Increasingly in the seventies and eighties, models were stepping into the vacuum created when Hollywood, for decades the groomer of the world's sex goddesses, turned its back on glamour, beginning with Glenn Close, Meryl Streep, and Jody Foster, whose stardom was built not on physical beauty but on solid talent. The end of old-fashioned movie sex appeal personified by Jean Harlow, Rita Hayworth, Marilyn Monroe, and Elizabeth Taylor led directly to the rise of the supermodel. From 1970 until roughly 1990,

every male celebrity and semicelebrity seemed to be involved with a mannequin, including Nicholson with Anjelica; Bob Evans, John McEnroe, and Tommy Lee Jones, at different times, with Lisa Taylor, a star of the Eileen Ford agency who trod the runways for Calvin Klein; Christian Slater, Jason Patric, and Edward Burns with Christy Turlington, the Eternity fragrance girl, who made $1.7 million a year;[12] David Copperfield with $50,000-per-day Claudia Schiffer; Roxy Music's Bryan Ferry and Mick Jagger with Jerry Hall (Jagger also dated Vanessa Newmann, Jane Ratlich, and Carla Bruni); Billy Joel with blond, blue-eyed California girl Christie Brinkley; Richard Gere with Cindy Crawford, Revlon's contract face; French photographer Gilles Bensimon and Warren Beatty with Australian swimsuit goddess Elle Macpherson; *The End of the Game* author and photographer Peter Beard, hockey's Ron Duguay, tennis's Vitas Gerulitas, George Hamilton, Christopher Reeve, and Gregory Peck's son Tony with Cheryl Tiegs, who had her own line of clothing at Sears and a $1.5 million contract with Cover Girl;[13] Lakers star Spencer Haywood and David Bowie with Iman Mohamed Abdulmajid, a native of Nairobi pulling down $100,000 for a single fashion show; the Average White Band's Hamish Stuart with Elite's Tara Shannon;[14] Guns N' Roses frontman Axl Rose, Elite owner John Casablancas, musician Tommy Andrews, Warren Beatty, and polo player Peter Brant with Stephanie Seymour;[15] Robert De Niro, Mike Tyson, Eric Clapton, and U2's Adam Clayton with Naomi Campbell, a black from London's Syncho agency;[16] Johnny Depp, Primal Scream vocalist Bobby Gillespie, and publisher Jefferson Hack with Kate Moss;[17] Leonardo DiCaprio with Kate Moss, Wilhelmina's Vanessa Haydon, Muscovite Alyssa Sourovova, L.A.'s Kristin Zang, and Brazil's full-bosomed (36-24-35) Gisele Bundchen, who posed on the cover of Victoria's Secret's *Christmas Dreams & Fantasy Catalogue* in a $15 million bra made of rubies

and diamonds;[18] and Liam Neeson and Sylvester Stallone with Janice Dickinson.[19]

As Nicholson once said while watching a Gucci runway presentation, "I eschew fashion of the young men so that I can follow fashion of the young women, which is much more interesting."[20] Nicholson's friend Jim Harrison wasn't enthusiastic about accompanying him to a fashion show "until I learned that our seats would be backstage where the ladies changed outfits," Harrison recalled.[21] It was perhaps inevitable that Nicholson would eventually end up in bed with the mother of all supermodels, the unruly, loudmouthed hedonist, Janice Dickinson. Ford agent Bill Weinberg called Dickinson "a trashy little street kid," like Gia Carangi.[22] According to photographer Peter Strongwater, 1978–1982 were the "zenith" drug years in modeling. "We fucked a lot, took a lot of drugs, and worked a lot. . . . I had the time of my life."[23] Later, he paid for it in rehab.

Nicholson met Janice Dickinson at a party at Ara Gallant's, which was also attended by Beatty, Dustin Hoffman, and Robin Williams. One of the preeminent matchmakers of the disco era, Gallant had been instrumental in getting Jerry Hall and Mick Jagger together. According to Patti Hansen, Jerry Hall was soon "busting [Jagger's] balls to get married." She finally succeeded, and their union lasted until Jagger fathered a child with Brazilian model Luciana Morad.[24] Later, when Janice Dickinson met Nicholson at Gallant's all-black apartment, she sized up Nicholson as "too much of a wolf," but she couldn't resist his Cheshire-cat smile, finding him "irresistibly funny," and went home with him to the Carlyle Hotel, "much to Warren [Beatty's] chagrin," she later revealed. Room service provided lobster, rare steak, and champagne as Nicholson, studiously attentive, drew her out. A typical modern mannequin, she was full of shame, guilt, and insecurity from an abusive childhood, during which her father, whom

she described as "tall, slim, handsome, with gunmetal gray eyes," tried to play "the lollipop game" with her, saying, "This is Daddy's dick. . . . *Open your mouth*," and when she refused, he told her, "Some day you'll be on your knees begging guys to suck them off for a few bucks." He also said he'd kill her if she ever told what he tried to do to her. Before she was eleven, he sucker-punched her and stood on her stomach until she urinated. In adulthood, suffering from "repetition compulsion," she sought relationships that duplicated her traumatic childhood, hoping to undo the injury by reenacting it in a healing way.[25] Bitten Knudsen said that despite Dickinson's wild reputation, "there was a very nice, exposed child inside." Tara Shannon found her dangerous but irresistible, "like a flame, and you're the moth. You've got to go to her, and you get burned, you can't help it. . . . She has a chemical imbalance [but] she's a brilliant model, the best ever."[26]

After Nicholson and Dickinson had sex in his suite at the Carlyle, she said, "You were okay, Jack. Really. And you can take that any way you want." But he "pissed [her] off" the following morning by insisting on the same kind of secrecy that would later make him keep Cynthia Basinet and other girlfriends under wraps throughout their affairs.

"Don't tell anyone you've got star cum inside you," he said.

While she went into a slow boil, he lay beside her naked, grinning, and basking in conceit. Later that day, when she reported to Richard Avedon's studio to pose for photographs, Ara Gallant had obviously told everyone, including Perry Ellis and Way Bandy, that she'd gone home with Nicholson.

"So how was he?" Gallant asked.

"Yes, it's true," she said. "I've been up all night fucking Jack Nicholson. And I don't think he'll be getting an Oscar this time out."

Nicholson tried to see Dickinson again, but she was "tired of that same old daddy-thing," and besides, she had collegial feelings

about Anjelica, a sometime Zoli model and regular at Gallant's parties. Not long after Dickinson's fling with Nicholson, she took up with Beatty, leaving another Gallant party with him and Bitten Knudsen. Beatty wanted to know if Dickinson was as "bad" as the press had been making her out to be, and she assured him that she was "*much* worse."

The following night she went to Beatty's suite at the Carlyle, which "was even nicer than Jack Nicholson's. . . . I guess those two were always competing. Probably still are." He kept her waiting as he juggled two telephones, with Diane Keaton on one line and Mary Tyler Moore on the other, making both of them feel "deeply loved." Later, it was Dickinson who kept Beatty waiting, for weeks, until she finally decided she wanted to go to bed with him, calling him at the Carlyle to make sure he was not with Knudsen, Keaton, or Moore. Like Nicholson, Beatty treated her to a room-service dinner before bedding her. "He was great," she revealed. "He knew where everything was and what to do with it." But when she woke up, she found him admiring himself in a mirror, arranging his hair for "that just-been-fucked look." That didn't stop her from dating him for the next eight months. "He was a nice daddy," she said.[27] Janice admitted, "I took drugs like everybody else." After bombing out as a singer in an impromptu performance at Studio 54 in 1982, she went into rehab at St. Mary's in Minneapolis "to recharge my batteries."[28] In L.A., she and Nicholson got together again. "We'd make love on the terrace, on the lawn, in the pool, even in the backseat of his parked car," she said, evidently more pleased with his performance on the West Coast. "Jack got off on playing love games with me and two other women at the same time."[29] In 2002 she published a sizzling memoir and the following year landed a steady gig as one of the judges on the TV show *America's Next Top Model*.

While Nicholson's interest in models was, with the possible ex-

ception of Anjelica, confined to simple lust, his friend Alan Finkelstein made a profession out of being Esme Marshall's boyfriend, much to the ire of her booker at Elite, Bernadette Marchiano, who found him intrusive. "He told me what Esme should be doing," she complained. "She was a child with no self-esteem, and this guy dazzled her." Marshall made $2,000 a day working for Calvin Klein, and soon she was sharing a Greenwich Village duplex with Finkelstein, who convinced her that Elite's John Casablancas should be focusing more on her career. Predictably, Finkelstein took over Marshall's representation himself, starting his own agency, Fame Ltd., helping to kick off the so-called model wars, during which Lisa Taylor left Elite, Christie Brinkley left Zoli, and Beverly Johnson left Wilhelmina, all signing with Ford, and Terri May and Nancy Decker joined Fame.

After working with Esme Marshall, photographer Alex Chatelain complained about Finkelstein. "The drugs were so out in the open. Finkelstein was friends with everyone who was in. If they were famous, he was with them. Esme was in love with him. He took her everywhere, and you'd see her getting hyper and thinner, and at a certain point I couldn't use her anymore. She was too thin. Finkelstein had destroyed her." Eventually he dissolved Fame Ltd. and, according to Janice Dickinson, started beating Marshall up.[30] To get rid of him, Marshall gave him everything she had, dropped out of modeling, and married a professional volleyball player. Finkelstein then hitched his wagon to Jack Nicholson's star, handling messy jobs for him, and eventually they went into business together. "He's a partner in my whole life," Finkelstein said. "He's a partner in everything I do."[31]

In the early eighties, the severe illness of Nicholson's friend Zoli marked the beginning of the end of Zoli and Ara Gallant's wild party scene, once the glittering magnet of Manhattan models—and the actors, rockers, photographers, designers, and

millionaire sugar daddies they attracted—after which the fast lane shifted to Miami's South Beach and to Hollywood. All the partying and pimping at Zoli's New York town house had taken its toll by 1982, the year Zoli died at the early age of forty-one. "There are no records saying it was anything but cancer," said Barbara Lantz, who kept Zoli Models going with a partner, Vickie Pribble. "It certainly sounds like AIDS. But there was never a diagnosis." At that early stage of the AIDS crisis, such celebrities as Tony Perkins, Rock Hudson, Arthur Ashe, Queen's Freddie Mercury, and *Midnight Express*'s Brad Davis suffered in silence and secrecy, though Hudson finally came out of the closet and admitted he was dying of the disease. Later, when Nicholson's beloved Lakers star Magic Johnson tested positive for HIV, Nicholson was "stunned, brokenhearted," he said. "[Magic] was twenty when he came here. I've watched him evolve."[32]

AIDS curtailed Nicholson's sex life, but didn't entirely end it. "You can't get AIDS jerking off in the bathroom," he said.[33] There was also an affair with Denise Beaumont, who described herself as a socialite and artist when interviewed in 2003, just before she opened a show of large pictures—using a photographic style she invented—in four galleries, including the River in Rancho Mirage, Palm Springs. She was a stunning brunette in her early twenties when she started seeing Nicholson in the 1980s. "I met him at Bob Evans's house," she said. "Bob and I were really good friends. I lived at his house for about four years. He's the best. We didn't have anything romantic, I just kept *The Cotton Club* together for him in New York for about a year. . . . I used to date Warren Beatty and Jack Nicholson at the same time. That was the period of free love and all that. Warren and I were seeing each other for years. I used to go to Warren's house and then to Jack's house on the same night. Yeah, they live right down the street from each other. We were crazy.

"It really wasn't that significant with Jack. It was more of a life with Warren, not Jack. I was way in love with Warren. We just really had a good sex life, Warren and I. That was pretty much the basis of our relationship. I was never really in love with Jack. Jack and I had more of a party thing together, but not a *relationship* relationship. I had a year with Jack, but not 100 percent. He had other girls, and whatever. But he was always at my birthday parties and always at my parties and the ones that Bob Evans used to throw for me."

Asked if Nicholson spanked her as he later did a girl named Karen Mayo-Chandler, Beaumont laughed and said, "Well, he did a little of that." And was he a good lover? "Well, he really *was*. No doubt in my mind. . . . When Jack wants to go there, he's very charming. He can be very charming. He's [also] very intelligent. He collects fine art. I think he's a little bit scattered, but as a human being, he's very nice. We hung out mostly at Bob Evans's house. We watched a whole lot of movies there and then we always just went up to his house and stayed up all night, talking and having fun. We pretty much were together—not with other girls. It wasn't like a big threesome with us."[34]

But threesomes, according to a Hollywood socialite who spoke with Nicholson biographer Peter Thompson, was precisely Beaumont's specialty. Beaumont brought girls to Evans's house to "break them in for three-way sex. . . . She knew Warren Beatty and Jack Nicholson very well—the regulars over at the house. . . . Evans was the glue that held it all together because he had the house. Warren did eventually buy a house near Jack up on Mulholland Drive, but for years he lived in the penthouse at the Beverly Wilshire. Jack's not the kind of guy who wants people up at his house, and he doesn't have a screening room. Evans's was always *the* place. He had the screening room . . . he had the girls . . . because he was a big motion picture producer."

An actress who lived with Beaumont for two years recalled that when Beaumont got wind of the fact that Evans, Beatty, and Nicholson were all bragging about how many times they'd had sex with her, she decided to play a practical joke. One evening, she had sex with Evans, then went over to see Nicholson, and had sex with him. Finally she went to Beatty's, "and after Warren had oral sex with her, she began to laugh and told him that Bob and Jack had just been there. At first they were all mad at her, but then Robert Evans thought it was funny, and it became the big joke of the group."[35]

On a trip to Paris, Nicholson stayed at the Hotel George V, and as he stepped out onto the sidewalk one day, the stunning model Tara Shannon spotted him and said, "Jack, what are you doing in Paris?" She was with another model named Lisa Rutledge, and Nicholson told them, "Uh, ladies, I'm going to a little party if you'd care to join me."

They went around the corner to Roman Polanski's apartment, which was full of fourteen-year-old blondes. Joints were being circulated, and girls were passing out, so Shannon and Rutledge headed for the elevator. "What are you doing?" Nicholson asked them. "So we kidnapped Jack Nicholson," she later recalled. Like most models of the time, Shannon hit "bottom . . . drinking and drugging," but, unlike Gia Carangi, she got into recovery.[36]

Despite plenty of action with such gorgeous, if doomed, creatures, Nicholson continued to fret about getting older. Reflecting on the aging process, he told the *New York Times*, "I gain extra weight and I wonder if maybe this time I won't lose it again. There are dark circles under my eyes that may not go away. My hair is going away." On recent film shoots, he'd felt "a loss of . . . powers," and on some days was too tired to do his best work. "We all have an anxiety about growing old," he added, "about being excluded. Thinking, 'Am I the wrong age now for this kind of behavior?'"[37]

He was no longer up for fun and games with friends like Nick Nolte, who "stopped by Jack's house . . . just goofing around," Nolte recalled. "The whole street's locked up. I punched the button on the big iron gate. Lights came on, cameras started to roll, a voice came out. 'Who are you? What do you want?' I said, 'Is Jack there?' The voice said, 'It's four o'clock in the morning, pal.' I said, 'Oh, oh, okay.' The cameras were still going when I left."[38] Later, Nicholson offered to direct Nolte in *A Strange New World*, a road picture by Becky Johnston, who wrote *The Prince of Tides* screenplay for Streisand and Nolte, but studios weren't interested in backing a romantic comedy budgeted at $25 to $35 million.[39]

Veronica Cartwright—"one of the best and most underrated," according to her *Alien* costar Tom Skerritt—showed up unexpectedly at Mulholland one night, creating a minor crisis. She and a girlfriend had been at the Raincheck bar in West Hollywood, where they got tipsy. Veronica insisted that her friend drive her up to Nicholson's house, although it was after 1 A.M. "When you pull into the property, there's an intercom with three different buttons," she recalled. "One was for Marlon Brando's house, one for Helena Kallianiotes, and the other for Jack." Cartwright started pushing the buttons, and finally, after the third try, a voice answered. It was Anjelica, sounding not too pleased and demanding to know who it was. Cartwright said, "Oh, shit!" and the two girls "peeled out of there." Later, Nicholson told her that Anjelica had "figured out" who she was, but he "thought the whole thing was amusing, even though it did get him into hot water for a while."[40] The new fortifications at Mulholland Drive were the result of a break-in at Brando's house in the mid-1980s, after which he ordered the construction of a steel gate weighing several thousand pounds.[41]

Nicholson's situation vis-à-vis his son Caleb remained painfully unresolved. Susan Anspach married her second husband, Sherwood Ball, a rocker with a band called Gumbo, in 1983; she

broke up with him in March 1987.[42] By 1984, the facts about Caleb having been fathered by Nicholson began to seep out, and Nicholson told the press, "Because of the way she's been toward me I've never been allowed a real avenue to find out about it. . . . She didn't mention her second child [Caleb] to me until six or seven years later." Feigning doubt that Caleb was his son, he added, "I guess I like the idea in a certain way . . . if it were true. Hey, I'm ready to meet anybody." Such nonchalance was in marked contrast to his statement: "I've always wanted a lot of children. I'm vitally moved by family. This would be an area where I'd say I haven't done quite what I would like to have done."[43] At one point, Anspach told him, "How can you not want to be a father? Don't you know your son needs you?"

"I had no father," he said, "and I'm a big star."

He finally met Caleb when the boy was thirteen. Just after Caleb emerged from a clinic following an illness in 1984, Anspach suddenly appeared at Mulholland with Caleb in tow, calling from a pay telephone in the neighborhood.

"I'm bringing him up," she announced, "and you can decide whether you open the gate or not."

Nicholson let them in, and when he first beheld his son, he said, "You've got my eyes." Afterward, Anspach sometimes dropped the boy off at his father's. Caleb proved irresistible, as playful, goofy, and intelligent as his dad, and, as if that weren't good enough, Caleb was a basketball fan, though he preferred the Celtics, and Nicholson was a rabid supporter of the Lakers. Soon father and son were going to the Forum for Lakers games. Anspach sometimes spent the day with them, and she began to fall in love with Nicholson all over again. "That's what you're supposed to do," she said, "put it back on the father instead of falling in love with your son. It's a really sane, well-adjusted way to go."

The old spark, first ignited on the set of *Five Easy Pieces*, was

still alive. According to Anspach, she and Nicholson remained "on occasion very intimate" for years after her second marriage, discussing Caleb for seven years before father and son actually met. "Every so often Jack and I would get together, and it always seemed to me that we were okay."[44] Maybe to Anspach, but not to Nicholson, who later testified that he viewed her with "mild antipathy."

Caleb was another matter altogether; over the years, Nicholson regularly sent Christmas cards to his son, who attended Santa Monica's St. Augustine-by-the-Sea, excelling in athletics. "If Caleb needs me, give me a call," Nicholson told Anspach. "I accept him totally." But several years later, Nicholson failed to attend Caleb's graduation from the Crossroads School for Arts and Sciences, a $20,000-a-year college preparatory institution. "What kind of shit is this?" asked Jake Jacobusse, director of the Crossroads Upper School. "It's your own son." Other Crossroads alumni included O. J. Simpson's children Jason and Arnelle; Bob Evans's son Josh; Victoria Sellers; Sony studio chief Amy Pascal; and Jordan Chandler, who settled molestation charges against Michael Jackson. Like Caleb, many Crossroads students had celebrity parents who were caught up in careers and the L.A. social swirl.[45]

TERMS OF ENDEARMENT

In 1983 Nicholson at last came to terms with middle age—professionally, at least—by playing an over-the-hill, drunken astronaut, Garrett Breedlove, who had an affair with his next-door neighbor, Aurora Greenway, in the affluent Houston suburb of River Oaks, in Larry McMurtry's *Terms of Endearment*. The thrust of the film was Aurora's relationship with her daughter, Emma, which ironically blossomed only after Emma was diagnosed with terminal cancer. Nicholson's role, though significant, existed only

on the fringes of the plot. Like the character he portrayed in the film, Nicholson was dealing with his own transition into midlife: "This is probably one of the first really good films in this area. It's very different today than it was when Spencer Tracy did *Father of the Bride*. . . . I don't want to be a man who just past a certain point of physicality, believes it when young women . . . say they actually prefer you this way. It's an image I've always feared. I hope I'm not that vulnerable, but I could be. It's a goofy clownish part; I don't mind acting it, but I don't want to be it."[46]

Professionally, Nicholson was no longer considered bankable, his pictures in the preceding five years having proved box-office duds.[47] If he wanted to stay in the business, he'd need to relinquish some of his star status and settle for such supporting roles as Garrett Breedlove, which Paul Newman had rejected. Making the concession quite painless was Nicholson's fee of $1 million plus a percentage of the profits.

The movie rights to *Terms of Endearment* were owned by Jennifer Jones, who saw it as a possible comeback vehicle. When the rights passed from her, one of Hollywood's most distinguished careers—she'd won an Oscar for *The Song of Bernadette* and burned up the screen in *Duel in the Sun, Ruby Gentry*, and *Love Is a Many-Splendored Thing*—came to an end. James L. Brooks, a staff writer for television's *The Mary Tyler Moore Show* and creator of *Taxi*, chose *Terms of Endearment* as his first movie. Casting the role of Aurora Greenway, he interviewed "everyone over fifty" before Sue Mengers suggested Shirley MacLaine.

For the role of Aurora's daughter Emma Horton, two actresses turned Brooks down, and he "begged Debra Winger, who was a huge star." Winger finally accepted the part, and Emma's fickle husband, Flap Horton, was played by New York actor Jeff Daniels, who'd been up for *The World According to Garp* but lost out to Robin Williams. "The role [of Flap] kept him in the movies," said

Brooks. "He was about to leave." In casting Aurora's astronaut lover, Brooks auditioned several astronauts; offered the role to Paul Newman, who decided it was too marginal; and finally cast Nicholson, who "was a friend of Debra's," Brooks said. "We rescheduled the whole movie around Lakers games so we could get him to do the movie." Although Brooks referred to Nicholson as "Debra's great friend,"[48] Nicholson and Winger would have no scenes together in *Terms of Endearment*, apart from a brief meeting in Aurora's driveway.

In constructing Garrett's characterization, Nicholson drew on his memory of his stepfather, Murray Hawley, a daredevil test pilot in World War II who became an alcoholic, and his high school friendship with future astronaut Russell Schweikert. The role, though different from anything he'd done before, performed in midlife without makeup—or even a corset to conceal his pot belly—was an essential link in Nicholson's oeuvre. Garrett Breedlove, the grounded astronaut, was literally a fallen angel, caught between enchantment and disenchantment.

Cameras rolled on March 14, 1983, in Houston. Totally daunted by Nicholson, James Brooks was surprised when the superstar told him, "You can say anything you want to me, don't worry how you put it, don't worry about sounding stupid." The director "took him at his word," Brooks recounted. "This was my baptism." As had so many directors before him, Brooks found that the legendary actor had "total trust" in his director. "Jack came up with his own jokes sometimes," said Brooks, who considered Nicholson "the great actor of my lifetime. He has a novel approach. To do a drunk scene, he gets drunk. . . . Jack is the greatest actor because he could play either part in *The Odd Couple*." Nicholson gave Brooks "daily report cards" on his directing, saying, "You want to know what the best direction you gave today

was?" and "You want to know what the worst direction you gave yesterday was?"

Aurora Greenway had many suitors, but Brooks decided to "collapse the suitors down so we could concentrate on Jack," keeping only a few, including Vernon Dahlart, played by Danny DeVito, a colleague of Nicholson's from *Cuckoo's Nest* and of Brooks's from *Taxi*. The picture was budgeted at $8.5 million, and was greenlighted by Michael Eisner, then of Paramount, who said, "Go kill 'em." To save money, many subsidiary roles were cast in Texas, the first of three location shoots.

Brooks soon found himself laboring under the "strain of temperamental stars." There was a "strange dynamic between Winger and Shirley," he said. "Debra messed with Shirley." Brooks told Winger to "look at all Shirley's old movies like *The Apartment*— she'd had all the great female roles. Debra was crazy/smart, tried to break Shirley."[49] One day MacLaine walked off the set, but one of the producers, a woman, stopped her by throwing herself on the car. MacLaine wanted to use a Texas accent but Brooks said no. She insisted. Brooks finally won by adding a line to the screenplay stipulating that Aurora originally came from Boston.

MacLaine "loved working with Jack," Brooks recalled. "When he'd done the chicken-salad scene in *Five Easy Pieces*, it had changed her whole attitude toward acting." While filming the Gulf Coast sequence in which Aurora and Garrett drove to and from their luncheon date, Nicholson proved to be "a great driver," said Brooks. The actor kept the Corvette precisely in tandem with the cameraman's car, which was speeding along beside him. Later, when Nicholson and MacLaine fell in the surf, although it appeared on screen to be a beautiful, sunny day, it was cold and rainy, and the actors shivered as they frolicked in the water and a tornado hovered on the horizon. Nicholson quipped, "I've always wanted

to get Shirley all wet." Originally, the script called for the sequence to be filmed on a country road, but Brooks opted for the gulf. "They were so cold but having fun," he said. "The picture needed that pickup."

After having put Garrett off for years, Aurora decided at last to have sex with him, calling him on the phone, inviting him over to her house, and telling him that if she didn't answer the doorbell when he rang, he should come on in, adding that "the back door is open." According to Brooks, "Jack turned it into a joke" by repeating the line and making it a sexual innuendo. Nicholson was not ashamed to reveal his middle-aged body in several scenes. "What size do you want my belly to be?" he asked Brooks, who later recounted, "He'd show me various sizes." At one point, Winger devised a practical joke, getting under the covers with Nicholson and MacLaine in the scene in which the latter said, on the phone to Emma, "I'm in bed with the astronaut." Although Winger's antics distracted the performers, "Jack looked like he was enjoying it," Brooks said.

The comedy of *Terms of Endearment* turned dark when Emma Horton discovered she was dying of cancer. To get the cast in the proper mood, Brooks suggested they visit the Mark Rothko museum and look at the somber paintings of Rothko, who committed suicide. Brooks recalled, "Jack went and sat in the Rothko museum, the only one who did."

"Come to laugh, come to cry, come to *Terms*," invited the ad for the movie. The review press was generally ecstatic, David Ansen writing in *Newsweek*, "Nicholson takes daring farcical chances with this character and pulls them all off." A smash hit, *Terms of Endearment* ran for six months in its initial release, becoming one of Paramount's top fifty worldwide grossers, coming in at number forty-four, with earnings of $165.8 million.[50] Nicholson's percentage by 1984 amounted to $9 million.[51] One

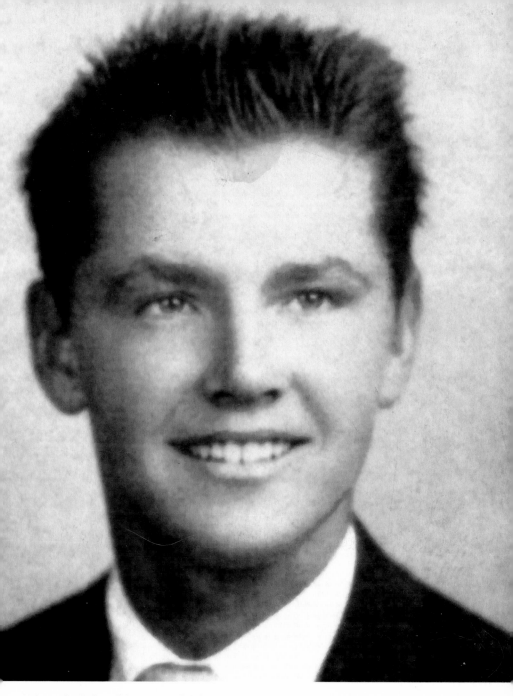

1954 yearbook photo, Manasquan High School, where Jack Nicholson was known as Nick, "jolly and good-natured . . . enthusiastic writer of those English compositions . . . his participation added to our plays. Blue and Gray (the school newspaper) 1, 2, 4; Rules Club President 1, 2; Football 1; Basketball Manager 2; Study Club 3; Junior Play 3; Table Tennis Club 3; Senior Play 4; Class Vice-President 4." © BETTMANN/CORBIS

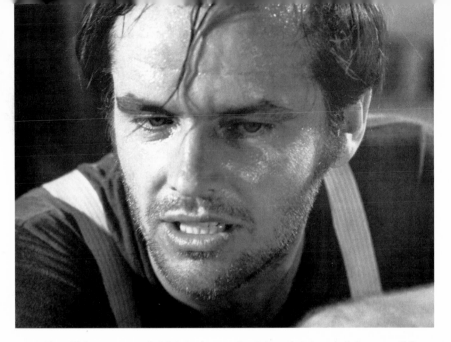

1969: Easy Rider *was not only Nicholson's career breakthrough; it launched the most wildly creative decade in the history of movies, one in which the lunatics ran the asylum. They called it the New Hollywood.* © BETTMANN/CORBIS

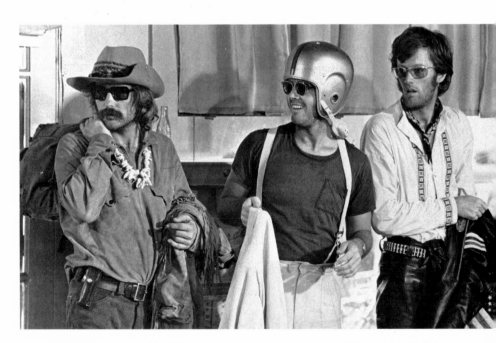

Originally hired as a troubleshooter by the movie executives behind Easy Rider, *Nicholson eventually replaced Rip Torn in the role of George Hanson, despite the objections of Dennis* Hopper (left) *and Peter Fonda* (right). © BETTMANN/CORBIS

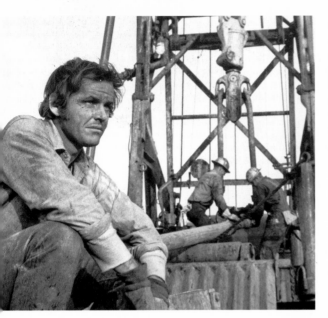

1970: As Robert Eroica Dupea, classical pianist turned oil field roustabout, Nicholson deconstructed conventional notions of masculinity and redefined the modern hero. © BETTMANN/CORBIS

1971: In Carnal Knowledge, *costarring Art Garfunkel and Candice Bergen, Nicholson was "press[ing] on the nerves" of mankind, portraying the dark, misogynistic side of the American male.* © JOHN SPRINGER COLLECTION/CORBIS

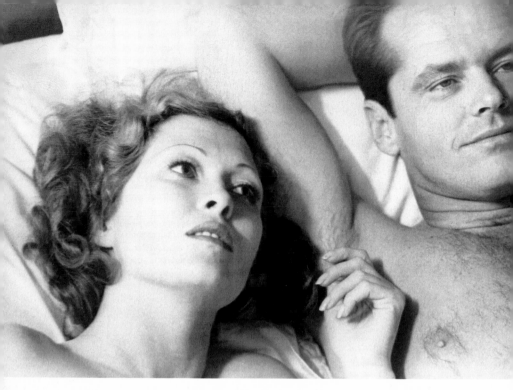

As private eye J. J. Gittes, Nicholson starred with Faye Dunaway in 1974's Chinatown, *a definitive American film noir generally regarded as one of the best movies ever made.*
© BETTMANN/CORBIS

Nicholson's performance as a rebellious mental patient in One Flew Over the Cuckoo's Nest *in 1975 was profoundly autobiographical, drawn from his own antiauthoritarian instincts. "I have the effect of completely demoralizing whatever unit I'm in," he said, referring to his earlier military service in the Air National Guard. "There's just something about me."*
© PETER SOREL/CORBIS SYGMA

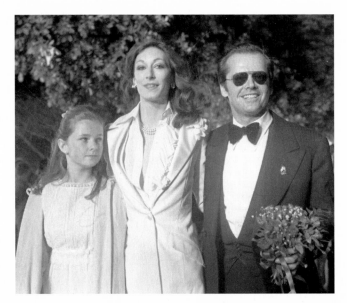

Accompanied by young daughter Jennifer and partner Anjelica Huston, Nicholson arrives at the Academy Awards ceremonies March 29, 1976, to receive the first of his three Oscars (for One Flew Over the Cuckoo's Nest, Terms of Endearment, *and* As Good as It Gets).
© BETTMANN/CORBIS

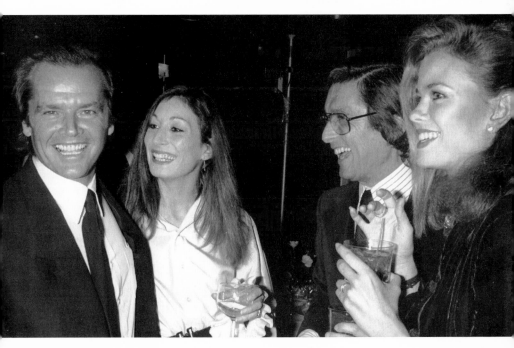

Nicholson with Anjelica Huston, his girlfriend of seventeen years, and pal Robert Evans, producer of Chinatown *and connoisseur of gorgeous girls. Nicholson was fourteen years older than Anjelica.* © CORBIS SYGMA

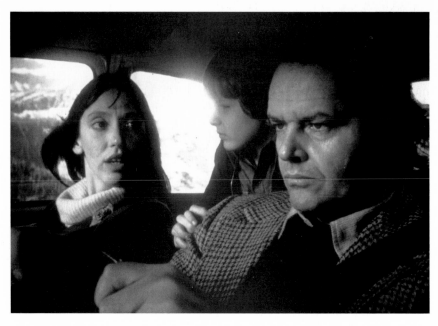

As homicidal Jack Torrance, Nicholson drives his wife (Shelley Duvall) and son (Danny Lloyd) to the Overlook Hotel in 1980's The Shining. *Nicholson's brave, original performance was a theatrical tour de force, one that transcended Method naturalism and electrified audiences.*
© SUNSET BOULEVARD/CORBIS SYGMA

With Cher, Susan Sarandon, and Michelle Pfeiffer in 1987's The Witches of Eastwick, *in which Nicholson played the devil.*
© CORBIS SYGMA

In Paris, France, with Rebecca Broussard, who played Nicholson's secretary in The Two Jakes, *and their daughter, Lorraine, born April 16, 1990. Broussard was twenty-six years Nicholson's junior.*
© B.D.V. CORBIS

Said Adam Sandler, Nicholson's costar in 2002's Anger Management, *"They say if you work with someone better than you, you'll get better as an actor. And, sure enough, as I made the movie with Nicholson, I noticed he was getting better."*
© STEVE SANDS/NEW YORK NEWSWIRE/CORBIS

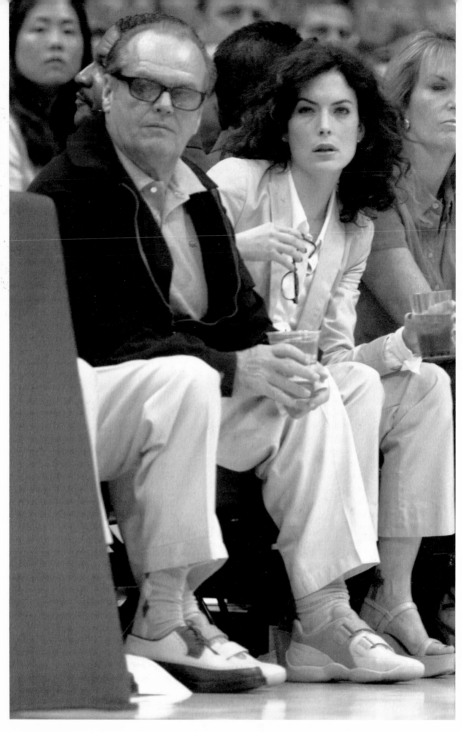

As Nicholson gets older, the girls get younger: Lara Flynn Boyle was thirty-three years his junior. On May 25, 2001, they sat courtside during Game 3 of the NBA Western Conference finals between the Los Angeles Lakers and San Antonio Spurs at the Staples Center in Los Angeles. © REUTERS NEWMEDIA INC./CORBIS

sign of his growing affluence was his four cars: a cherry-red Mercedes 600; a blue Mercedes 45-0 SEL; a white Cadillac convertible; and his fifteen-year-old Volks convertible.

Debra Winger, his *Terms* costar, was his date one night at a Lakers game, and on another occasion he took Daryl Hannah.[52] Referring to Anjelica in connection with the other women he was seeing, he said, "Of course I lied to [Anjelica]. It's the other woman I would never lie to. You only lie to two people in your life: your girlfriend and the police. Everybody else you tell the truth to. . . . Don't think you're going to have a free 'Oh, he's all mine,' because I cannot provide it."[53]

He received his eighth Oscar nomination, this one, like his nomination for *Easy Rider*, in the Best Supporting Actor category. His competition was hardly impressive: John Lithgow, who played Emma's lover in *Terms of Endearment*; Sam Shepard in *The Right Stuff*; Rip Torn in *Cross Creek*; and Charles Durning in *To Be or Not to Be*. "I'd like to win," Nicholson said. "I'd like to win more Oscars than Walt Disney, and I'd like to win in every category. And I've been after this category for a while. Stylistically, I love the Academy Awards. And I'm very fifties Zen—all tributes are false, all is vanity—but I like seeing a Mount Rushmore of 1984 movie stars in a row for the one night, no matter what nut ideas I've got. It's fun. Nobody gets hurt. . . . I'm Mr. Hollywood. I love everybody." Over the years, like millions of others, he'd sat in front of his television set on Oscar night and "talk[ed] about the slime green dress and [said], 'God, if I ever had this kind of breakdown on television I'd shoot myself.' "[54]

On April 9, 1984, Nicholson picked up his second Oscar, going to the podium in sunglasses and tux, raising a fist, and delivering a psychedelic-sounding speech that ended with, "All you rock people down at the Roxy and up in the Rockies, rock on." Plugging the Rocky Mountains in an acceptance speech struck *People*

magazine as one of the odder moments in Oscar history, and their story was suggestively headlined, "Crazy Mountain High."[55] Later, in a more sober mood, he said he'd intended to express his gratitude to his agent, Sandy Bresler, "for selling me his old car cheap—and to congratulate Kareem Abdul-Jabbar. But I got so nervous up there I thought I was going to faint."[56] Shirley MacLaine won the Best Actress Oscar, and said, predictably, "I deserve this." Many disagreed with her, feeling that the winner should have been her costar Debra Winger, who was nominated for the same picture, in the same category. James L. Brooks took home three Oscars, for Best Picture, Best Director, and Best Screenplay Based on Material From Another Medium. As he accepted, sweat pouring from his face, he said, "I feel like I've been beaten up."

Promoting the picture overseas in 1984, Nicholson came to legal blows with the London *Sun* over false statements claiming he'd been arrested in "a string of drug busts," which was untrue. "I said great stuff about the fucking picture, *Terms of Endearment*, and all they wrote about was cocaine, which I didn't even say anything about. I sued, because there you win [court] costs. . . . I felt if you're going to invent what you write, why don't you just write it and not waste my fucking time."[57] His counsel, Desmond Browne, told the High Court judge, Mr. Justice Comyn, "The truth is that he has never been arrested for drugs or any other offenses, either in America or elsewhere. The article quoted Mr. Nicholson as saying that he loved to get high four days a week. The defendants now accept that that was never said." The "unspecified damages"[58] he collected were reportedly "substantial."[59] On paying all of Nicholson's legal costs, Mark Warby, speaking for New Group Newspapers, offered an unqualified apology.[60]

Nicholson hoped for more plum roles, and was counting on making *The Mosquito Coast* with director Peter Weir, but the part

went to the younger Harrison Ford. Not content to wait for desirable parts to come his way, Nicholson bought the film rights from MGM to Saul Bellow's 1950s novel *Henderson the Rain King*, about an archaeologist in Africa. Had the project not been shelved, it would have preceded the coming cycle of such Africa movies as *Out of Africa, I Dreamed of Africa*, and *The English Patient*. Again, Nicholson was ahead of the wave, but no one was willing to finance the picture. Nor could he find backing for a film of William Styron's *Lie Down in Darkness*, an elegant study of neurosis and self-destruction, and the one project that was perfectly suited to bring out whatever directorial gifts Nicholson might have had.[61]

John Belushi, who'd appeared in Nicholson's *Goin' South*, died in 1982, overdosing on a speedball mix of cocaine and heroin. At the request of Belushi's widow, Judy, Nicholson gave an interview for Bob Woodward's book *Wired*, a graphic account of the comedian's decline and death. After the book's publication, Nicholson denounced Woodward, though the integrity of the famous Watergate reporter, one of America's most distinguished journalists, seemed to most impeccable. "The man is a ghoul and an exploiter of emotionally disturbed widows," said Nicholson. "It's the lowest. I talked to him because Judy, John's wife, asked me to because John had always behaved towards me as if I were an uncle. By that I mean he'd say things like, 'Oh not me—I'm not doin' no dope, Jack.' . . . I told [Woodward], 'Look Bob, I don't know what you think, but if you're out here to do a coke/Hollywood sensation book, you don't understand what the karma will be on you.' The guy is actually finished. I believe that."[62] Woodward went on to publish a string of critically acclaimed bestsellers, including 2003's *Bush at War*, which was cited by the *New York Times* for the author's "extraordinary access . . . inside the White House."

In attacking Woodward for writing an honest book, Nicholson had never sounded more arrogant or wrong-headed—a typically

self-serving, press-bashing, harebrained celebrity. Thanks to the tumult stirred up by *Wired*, Cathy Evelyn Smith, who allegedly injected the lethal speedball in the last hours of Belushi's life at the Chateau Marmont Hotel, was hounded down and brought to justice for involuntary manslaughter, receiving the maximum prison sentence of under ten years.[63]

Celebrating their eleventh year as a couple, Anjelica said, "He makes my blood boil."[64] But Nicholson spent the winter of 1983–1984 alone in Aspen while she pursued her acting career in Hollywood. He discovered that solitude was sometimes preferable to companionship, and when asked if Anjelica wanted to get married, he replied, "There's a lot of things Anjelica expresses desire about, but if you begin to produce them, the desire disappears. Children are the primary reason for marriage. . . . I also get furious with her because she makes me feel weak. . . . I let her limit me in ways where I know I'm right. But I've learned as much from her as from anyone in my life. . . . I've changed a lot."[65]

In reality, he hadn't changed at all. Though he said he wanted family life, his daughter Jennifer, now twenty and majoring in fine arts at the University of Southern California, grew up in her mother's home and never knew the daily nurturing of a full-time father. "Jack's got a real hurt deep down inside, and there's no way of resolving it, ever," said one friend, and Candice Bergen had found him "basically unknowable." Yet, despite the deep emotional hurts he lived with, his life and art represented a triumph of the human spirit, and when an interviewer asked in 1984 if he was happy, he replied, "Extremely. I've been on bonus time since I was twenty-eight. . . . I want it the way it is, and, believe me, the way it is is pretty damn good."[66]

His life was always more fun when Bebe Buell popped back

into it, as she did in 1984, showing up at his house pregnant with Elvis Costello's baby. Her delicate condition didn't prevent Nicholson from trying to make out with her.

"Come on, Beeb, let's just have sex."

"I can't," she repeated. "I'm pregnant."

"Yeah, but you're not sure you're pregnant."

"Jack, when your period is two weeks' late, you are pregnant."

"I loooove pregnant women."

Though she permitted Nicholson to climb aboard, she continued to think of Elvis, who was still her favorite lover despite his flat feet and thick glasses. It was her fourth pregnancy with the rocker, and this one, too, ended in abortion. Afterward, Bebe devoted herself to her daughter Liv Tyler's burgeoning career as a model and, later, star of *That Thing You Do* and *The Lord of the Rings* trilogy. After marrying guitarist Coyote Shivers, Bebe suffered a nervous breakdown, but recovered to write a delightful memoir, *Rebel Heart*, with biographer Victor Bockris.[67]

PRIZZI'S HONOR

Nicholson and Anjelica's first costarring vehicle, *Prizzi's Honor*, was filmed in 1985, directed by her father John Huston, who was now seventy-nine and suffering from mammoth emphysema and aneurysm, and a survivor of open-heart surgery. Despite three operations that required over twenty-five hours, John Huston's legendary sex drive survived; "he fucked my brains out," said Cici Shane, but she finally left him after Tony, Anjelica's brother, discovered their father "fucking the maid [Maricela Hernandez] . . . wrapped around each other like two pretzels." According to Cici, John Huston was "drinking like a fish, rivers of vodka . . . and smoking and destroying himself."[68]

Upon snaring the supporting role of Maerose Prizzi, Anjelica immediately started trying to involve Nicholson, whose stardom could not harm the package, hoping he'd play the lead, mobster Charley Partanna. "Often, once they have my involvement, the rest of the pieces come together," Nicholson once said. "That's the way the business works. . . . I am the money."[69] Although he listened to Anjelica sympathetically, he didn't like the role, but he took it, and later complained, "I don't know if Miss Huston actually believes it or not, that I repressed her professionally, but over the years it's become part of her publicity bank." After pointing out that he'd given her a break in *The Postman Always Rings Twice*, he added, "The same thing happened with *Prizzi's Honor* and then on down the line. Then there was my consultation to her. Listen, you can't hire me as a career manager, but believe me, a lot of people would like to." There was something imperious about her that rankled. "She never calls me," he said. "I always call her. During the twenty years I've known her, I probably got a total of eight phone calls that she instigated. It was a facet of the relationship that I maintained the contact. It's just her nature. You can ask any other friends of hers. Anjelica doesn't call people."[70]

At first, Nicholson misinterpreted the script of *Prizzi's Honor*, taking it as a standard Cosa Nostra saga and not grasping its satirical intent. Nor did he understand the role of Charley Partanna, who represented Nicholson's polar opposite: a Johnny-One-Note-type deficient in humor. "The part really put Jack through the wringer," said producer John Foreman. "It forced him to give up everything the public has loved about him in a picture like *Terms of Endearment*—his smile, his charm, his wit, his way of letting you in on the character's naughty secrets. It took great courage to do what Jack did." And no doubt it took all of Anjelica's persuasive powers.[71] According to the *Los Angeles Times Magazine*, "Nichol-

son takes credit for advancing her career . . . by making *Prizzi's Honor* happen by simply agreeing to star in it."[72]

In the story, Charley was once engaged to be married to Maerose, a Mafia princess and granddaughter of a gangland boss. The "secret" that at last unlocked Nicholson's role had to do, he said, with an "observation that I've made about . . . jail mentality, [which] covers like a blanket the mind of the killer. . . . I took . . . intelligence away from the character."[73] To keep Nicholson from using his native intelligence the way he had in every other role, John Huston asked him to wear a "bad wig," but he refused.

By the time principal photography started, Nicholson and Anjelica were living in separate houses. "What the hell, she's only two minutes away," he said, and she added, "If you have a long relationship, as we've had, you go through changes. . . . We see each other when we want to." She lived in a small, Spanish-style house in West L.A., where she kept a dog named Minnie, half Westy and half Lhasa, but she still used a bedroom at Nicholson's place, often dined with him, and spent the night. When they shot *Prizzi's Honor* on location in Brooklyn, they stayed in separate hotels. Astonished at the longevity of their affair, John Huston remarked, "Twelve years! That's longer than any of my five marriages lasted." According to Huston's companion and former maid Maricela Hernandez, "John said that [Anjelica] was a goddamn fool because Jack had proposed many, many times and she just didn't want to get married."[74] When Anjelica, at thirty-five, confided that she wanted to become a mother before her thirty-sixth birthday, Nicholson reportedly asked her to be tested to determine whether she could conceive, but she declined. According to a Huston family friend, she felt the affair had already run its course and Nicholson no longer aroused her.[75]

During filming, Nicholson perfected his "two-ton Tony

Galento walk, with my palms facing backward," and a thug's gaze that he "took from the eyes of my dog when he killed another dog." Anjelica tried to cope with her "fear of disappointing her father again," according to an actor friend. Nicholson helped her burnish her technique, and she went to an acting coach to work out motivation. The film's best-known line was Anjelica's: "Yeah, right here on the Oriental, with all the lights on."

It turned into a dream shoot for all concerned. "Jack and John have always had a remarkable affinity," Anjelica said, adding, somewhat cryptically, "a disturbing affinity." Unlike Kubrick's multiple-take approach, John Huston was confident of what he wanted and went about directing in a decisive manner, becoming, for Nicholson, the first one-take director he'd worked with since Roger Corman.

"Where do I go with this scene," Nicholson asked on one occasion, "am I Pagliaccio, am I hysterical, am I in tears, where am I?"

"Well," Huston replied, "why don't you just clip your nails?"

Julie Bovasso, John Travolta's mom in *Saturday Night Fever* and Cher's employer in *Moonstruck*, taught Nicholson how to speak Brooklynese. Researching the role, he hung out in lowlife dives in Brooklyn, observing Mafia types. "I ate a lot of meatballs, talked under my breath," he recalled. "I'm not the first actor to notice Italians don't move their upper lips when they talk."[76]

Though the public accorded the film only a modest success at the box office, critics loved it, *Time*'s Richard Schickel saluting Nicholson for "one of his boldest performances." Hailing the vigor and originality of the venerable John Huston, Pauline Kael said that *Prizzi's Honor* looked like the work of a dynamic young director. At the beginning of the 1985 awards season, Nicholson and Anjelica went from Aspen to Manhattan to receive their New York Film Critics Circle awards. Later, they dined with Gene Siskel at

Marylou's Italian restaurant at 21 West Ninth Street in Greenwich Village, ordering seafood brochette, and Anjelica told Siskel that being with Nicholson was like having "a good time with your dad."[77] Nicholson hired Marylou's owner Tommy Baratta as his on-location cook, and Baratta also worked as his "accent coach" for *Prizzi's Honor*, in which he played an opera singer. "Jack loved the gnocchi," said Baratta. According to the *Washington Post*, the actor's ever-increasing girth was attributable to Baratta's "good old spaghetti" and hot peppers.[78]

When the Oscar nominations were announced, Nicholson was among the Best Actor nominees, but at the presentation ceremony on March 24, 1986, he lost to William Hurt for *Kiss of the Spider Woman*. Nominated in the Best Supporting Actress category, Anjelica won, walking to the podium in a startling green gown she'd designed herself, and telling the audience, "This means a lot to me, since it comes from a role in which I was directed by my father. And I know it means a lot to him. God, I've got to win another, because then it will be really real, really serious." Discussing Anjelica's triumph, Nicholson said, "I never had a greater moment. . . . We got what we wanted. It was extremely heartwarming, and thank God it came early in the evening—I was legitimately stoned on pain pills."[79]

Despite losing the Oscar, this was a time of high elation for Nicholson, whose beloved Lakers captured the world championship. "This is the first time I've walked into the Bel Air Hotel and everybody hasn't been congratulating me about the Lakers as opposed to this movie [*Prizzi's Honor*]," he said. "Lately the playoffs are where I've been seen by the public. I'm happy for the Lakers, but I'd rather people talked about my movies, you know. I don't really own the Lakers." After the game, he went into the Celtics' locker room and chatted with Larry Bird. "I don't like backstage,

and I don't like locker rooms, but I wanted to congratulate them. Larry Bird is so monomaniacally focused. Bird's like me. . . . Bird don't come to play, he comes to win."[80]

If Nicholson hadn't won his latest Oscar race, he'd at least emerged from the model wars with a stable of thoroughbred fillies. Anjelica's position as his main squeeze became increasingly nebulous. Anything but a conventional woman, she did not depend on him entirely for emotional fulfillment, and was less concerned about his dalliances than the public humiliation that would inevitably follow an exposé of his unfaithfulness, jeopardizing her status as his consort, the unofficial First Lady of Beverly Hills. In her days as a Zoli model on Seventh Avenue, she had complained about the danger of becoming a fag hag, but now, ironically, she became a sort of hetero hag, unwittingly fronting for Nicholson's serial infidelities with other women.

Chapter Eight

DEVIL IN THE FLESH

HEARTBURN

Mandy Patinkin, the original male lead in *Heartburn*, lasted a single day in September 1985 before director Mike Nichols called Nicholson and hired him for $4 million. With only "a couple of days' notice," Nicholson "was working three days after I read the script. . . . I'd always wanted to work with Meryl [Streep]. . . . [It was] a part I might not have done under other conditions."[1] The role of Mark Forman was basically a negative one, a villain based on Washington, D.C., journalist Carl Bernstein, who had an affair with Margaret Jay, wife of British ambassador Peter Jay, after getting his wife, author Nora Ephron, pregnant.[2] Having helped the *Washington Post* win the Pulitzer Prize for exposing the deception and treachery of the Nixon administration, Bernstein and coauthor Bob Woodward wrote the book *All the President's Men*, in the movie version of

which Dustin Hoffman portrayed Bernstein as a hero. In Nora Ephron's roman à clef *Heartburn*, Mark Forman was portrayed as a deadbeat husband, and in the film he'd become another of Nicholson's fallen angels, a disillusioned and dishonored Don Juan precariously perched on the postsexual-revolution, Me Decade zeitgeist.

That Nicholson managed to make the character sympathetic was a testimony to his genius; he was moving in scenes having to do with childbearing and was darkly brilliant when he sang "Soliloquy," Billy Bigelow's fatherhood aria in Rodgers and Hammerstein's *Carousel*. Nicholson and Carl Bernstein knew each other from political events, and when Nicholson later ran into Bernstein at a restaurant, the actor said, "Well, buddy, I sure as hell wasn't going to call you during the shooting—I didn't want to know anything more about you than I already know."[3]

It was Nicholson's fortieth film and his third for Mike Nichols, who said he did not want Nicholson to meet his leading lady until they did their first scene together, so it would be "electric with excitement." Nicholson jumped the gun, unexpectedly appearing at Streep's dressing-room door while she was getting her hair curled "and looking like hell," the actress remembered. "Hi, this is Jack Nicholson," he said. "Can I use your toilet?"[4] It was the beginning of an impressive, if short-lived, screen partnership (they'd later do *Ironweed* together).[5] "She did an *Oprah* in which she called me that lovable old wreck," he recounted, "because she was mad at me. . . . I [had] talked about a genetic innate sweet spot of male-female attraction in an age group. I had to call Meryl up on the phone and straighten that out because I really care what she thinks about me. She's a real smart person and working with her is really a dream. . . . like dancing with a partner that you don't have to do anything with; just get carried along by her and fascinated by it."[6] In *Vanity Fair*, he added, "You do fall in love with . . . certain . . .

creative situations."[7] Streep was married to sculptor Don Gummer, and they had four children.[8]

The role of Mark was the most autobiographical Nicholson had ever assayed: a split personality with a love/hate relationship with the opposite sex, who yearns for marriage and family but proves incapable of the monogamy required for a continuing relationship and effective parenting. Defending the controversial and hotly debated fact that he turned the philandering husband in *Heartburn* into a sympathetic figure, Nicholson argued, "Here's where you press on the nerves. Are we all rotten? Because surely you have friends and you know half of them, say, are capable of this behavior. And I don't think that you think that half your friends are rotten. That's where you press on the nerves. That was what was delicious about the part." With his serial infidelities, it was easy for Nicholson to identify with Mark Forman, who, Nora Ephron wrote, "was capable of having sex with a Venetian blind."[9]

Despite being a rare modern comedy of manners seething in acid-etched portraits of the upper-bourgeois intelligencia, *Heartburn* was mercilessly panned by critics when it opened in 1986. *Vogue* called it "oddly blurry and uninvolving," and *Newsweek* dismissed it as "just another generic story about a suffering wife." Nicholson came in for a few personal kudos, *Time* stating that one could hate him "for his cruelty or love him for his robust grace and fine, sharp humor." Others thought him miscast, the *New Republic* finding him "too old. . . . He seems to be merely making faces."

THE WITCHES OF EASTWICK

A master of the Hollywood brand of networking, Nicholson had professional as well as human reasons for never breaking up with anyone, man or woman. It was at a party at his friend Don Devlin's

home in the Hollywood Hills in February 1983 that producer Rob Cohen first heard of John Updike's novel *The Witches of Eastwick*, and Devlin said it would make a good vehicle for his old roommate Nicholson. "My life is enriched by my friends—Don Devlin, my partner Harry Gittes," Nicholson said. "We've been communicating for thirty years."[10] Unfortunately, the old-buddy network didn't work for Anjelica, who auditioned for *The Witches of Eastwick* but lost the part of Alexandra, one of the witches, to Cher. "I was upset by it because I had won [an Oscar]," Anjelica said. "It made me feel not having to prove myself anymore was an illusion at best."[11]

Although George Miller, the gifted Australian director of *Mad Max*, wanted to cast comedian Bill Murray in the lead, Nicholson won the part, and was paid $6 million to portray the ultimate fallen angel, the devil himself, whom Updike had given the name Daryl Van Horne. Veronica Cartwright, Nicholson's old girlfriend from *Goin' South*, was cast in the small role of Felicia Alden in yet another instance of fortuitous networking. In the eighties, Nicholson would call Cartwright periodically, when Anjelica wasn't around, and Cartwright would drive up and meet him for a tryst. According to Cartwright, his sexual staying power never diminished.

The *Witches* script gave Nicholson one of his signature male chauvinist lines: "You don't think God makes mistakes? . . . So what do you think, women? a mistake, or did he do it to us on purpose? . . . Maybe we can do something about it. Find a cure, invent a vaccine, build up our immune systems." The devil didn't hate women so much, however, that he couldn't confess, "I always like a little pussy after lunch." Filmed in the summer of 1986 in Cohasset, Massachusetts, among clapboard Yankee houses and a quaint church, *Eastwick* was not a happy shoot, according to Miller, who said the film suffered from "too many producers, too

much studio interference and politics." As the most powerful person involved in the production, Nicholson "protected us," Miller added. In the Hollywood pecking order, Nicholson outranked producer Jon Peters, and when Peters attacked him, Nicholson said, "You *can* talk to me this way, but if you keep doing this, I'll turn off. And if I turn off, you'll be in a lot of trouble."[12]

In addition to Cher, Nicholson's costars included Susan Sarandon and Michelle Pfeiffer. "Jack would stir them up and would sit there and laugh," a Warner employee recounted. "He enjoyed seeing the actresses work themselves up into such a stew they were talking about quitting. The more they were quitting, the more fun it was for Jack."[13] Not so, insisted Cher, who said, "[The producers] didn't really give a shit about us. Our only ally in the whole thing was Jack, [who] went head-to-head with everybody."[14] Miller agreed, stating that Nicholson "was great behind the scenes.... He recognized that individual performance is enhanced by the collective quality. Susan Sarandon was best around the third or fourth take, Michelle Pfeiffer best on the first take.... Cher [wasn't] yet technically adept. You never knew when she'd hit it, but Jack never showed frustration. In fact he used it, laughed off her fluffs, and relished it. He worked hard on his off-camera feeds, too."[15]

Premiering in Westwood in June 1987, *The Witches of Eastwick* turned into a $125-million hit despite critic Janet Maslin's pan in the *New York Times* and Richard Corliss's remark in *Time*, "If he was over the top [in *The Shining*], he is stratospheric here." The *Observer* (London) found his performance "dangerously close to self-parody."

James L. Brooks called on Nicholson to do a cameo role in *Broadcast News*, a satirical comedy critical of TV news reporting. Nicholson probably accepted the infinitesimal role as a smug network anchorman because of his deep-seated hatred of television;

he was one of the few actors who consistently refused to appear on the popular late-night talk shows. *Commonweal's* critic admired Nicholson's restrained underplaying, accomplished mostly with his "radar-like eyes . . . far more convincingly egomaniacal than in most of Nicholson's blowhard performances. This is wry without the ham."

IRONWEED

Filmed in the early spring of 1987 in Albany, New York, *Ironweed* had a $27-million budget, from which Nicholson extracted $5 million for a sixty-nine-day schedule, with $70,000 a day in addition for overtime. He played Francis Phelan, a big-league baseball player haunted by death and guilt as he boozed himself through a hobo jungle in Depression-racked Albany. "I would like playing an Irish bum," Nicholson told Hector Babenco, Oscar-nominated director of *Kiss of the Spider Woman.* The actor was able to call on his memories of his alcoholic grandfather in portraying Francis Phelan, who dropped and killed his eighteen-day-old son and never got over his shame. Nicholson wanted his son, Caleb, to play Francis Phelan as a boy, but Caleb evinced no wish to do so. Dozens of boys were auditioned for the role, which eventually went to Frank Whaley.

To make his portrait of a derelict authentic, Nicholson went to great lengths, "lay[ing] down on the floor with his face between the toilet and the wall," Babenco said. "The toilet was very dirty and smelling bad and Jack was squeezed against a corner just like a kid in a fetal position. He fe[lt] like a piece of crap, like a rag."[16] The hard work paid off; Nicholson gave one of the best performances of his career.

There was talk on the set of an affair with Meryl Streep. A re-

porter from the *Los Angeles Herald-Examiner*, Mitchell Fink, arrived to cover the shoot and asked for Nicholson and Streep. A man in neat, freshly ironed dungarees and leather boots pointed to a nearby Winnebago.

"You're kidding," Fink said.

"Nope."

"Really?"

"Yup."[17]

Rumors of a romance between *Ironweed*'s stars "have cost me my goody-goody image," Streep complained. "There's not a word of truth in them." Nicholson's press agent, Paul Wasserman, added, "I'm totally unaware that any of that is going on. People have been talking about Jack and Meryl ever since *Heartburn*, but as far as I know, their relationship is strictly a buddy relationship."

"Well, that's not what we hear," Fink said. "In fact, sources have [said] that whatever is actually going on inside that Winnebago, it's starting to get out of hand. 'Even to the point,' one in the know said, 'where it's embarrassing a lot of people on the set.' And movie people on location, you understand, usually aren't embarrassed about anything."[18]

Babenco was delighted with Nicholson and Streep's "chemistry" in their daily scenes together, citing Nicholson's "intuition" and Streep's "compulsion for perfection. . . . They play together like lovers. They don't feel time passing when they work together."[19] On April 18, Anjelica flew to Albany for Nicholson's champagne birthday party, which was held on the set on April 22. Nicholson still wanted to marry her but she refused. According to Helena Kallianiotes, "Every time someone got divorced, Anjelica would say, 'Look there's no reason to get married.' But Jack wanted to."[20]

A source from the production company told Mitchell Fink, "These are not conventional people, [Anjelica] puts up with a lot of things he does." Fink concluded, "And whatever he does, it's a

great way to turn fifty. Anjelica on one arm, Meryl on the other, and Jack in the middle." On the contrary, it was "no fucking good" turning fifty, Nicholson said. "I don't like it." He despised being "one of the older people in films. Fifty brought me crashing to my knees."[21] When a reporter observed that his senior years would be a good time to write his autobiography, he said, "I definitely know I won't."[22]

After seventeen weeks in Albany, Nicholson returned to L.A., where he dined with Streep and producer Keith Barish in August 1987 at Morton's restaurant. The next day the *Herald-Examiner* wrote, "It's been suggested numerous times by us and scores of others that Jack Nicholson and Meryl Streep are, shall we say, more than just costars, more than just friends, more than a lot of things, if you catch our drift. . . . [Streep] left with Jack. Make of that what you will."[23]

Though *Ironweed* was one of the most uncompromisingly honest, hauntingly elegiac, and powerful movies ever made, critics were cool, *Variety* calling it "unrelentingly bleak," but most of them had good words for Nicholson, *Newsweek*'s David Ansen writing that the actor "commands the screen with the quiet, weathered authority one associates with the great stars of the past—the Bogarts and Tracys. His charisma isn't about glamour, it's about soul."

John Huston died on August 28, 1987, at the age of eighty-one, in Newport Harbor, Rhode Island, after asking Nicholson to take care of Anjelica. Nicholson readily agreed, but on the night prior to the director's funeral at Hollywood Memorial Park, he called a girl he'd met at an Aspen party on February 13, 1986, and invited her to Mulholland Drive. Karen Mayo-Chandler was a twenty-three-year-old British actress who'd briefly appeared in a San Francisco production of Woody Allen's *Play It Again, Sam* and Roger Corman's *Strip to Kill II*.[24] "I had to wonder why he wasn't

consoling Anjelica instead of making love to me," she recounted.[25] "I was trembling like a child when he first carried me up to his bedroom; but he was very gentle, very loving, very romantic. He kept right on kissing me deeply, undressing me all at the same time. We did not sleep a wink that first night. He has amazing stamina and self-control, and we just kept on making love. He's a guaranteed nonstop sex machine."[26]

Somehow, sleep deprivation did not prevent Nicholson from accompanying Anjelica to her father's funeral the following day. "I feel strangely abandoned," Anjelica said, "because I realized that a lot of what I did was for [my father] and to him. . . . He kept us straight."[27] According to Maricela Hernandez, Huston's caregiver and heir to his houses, Nicholson "wept and wept and wept like a little boy. I used to be afraid of him. I thought he was just another goddamn actor. How wrong I was. He's the most sensible, intelligent man."[28] When Maricela asked Nicholson if she could purchase a painting he owned of John Huston posing as an Indian, Nicholson replied, "I cannot sell it to you, and I cannot lend it to you, but you must come and pick it up."[29] Later, he moderated a memorial at the Directors Guild and remarked that he would continue to mourn his idol for the rest of his life.

As awards season approached in late 1987, Nicholson scored the unprecedented feat of winning the New York Film Critics Circle Award for Best Actor in three feature films: *The Witches of Eastwick, Broadcast News,* and *Ironweed.* Both he and Streep were nominated for Oscars for *Ironweed,* and on the night of the presentation ceremony, Nicholson told Bob Evans, who was up to his neck in various scandals, "I want you to be my date. I want to walk in with you tonight." Evans said, "You've got to pick me up in a limousine and you have to have caviar and champagne in it. . . . You've got to promise one more thing. You can't try to fuck me on

our first date."[30] The Oscar eluded Nicholson that night, going to Michael Douglas for *Wall Street*. Also nominated for *Ironweed*, Streep lost to Cher for *Moonstruck*.

Busy with other projects, Nicholson turned down the role of Peter Fallow, the writer-narrator of *Bonfire of the Vanities*, as did John Cleese of *Monty Python* fame. Bruce Willis got the part, and the movie was one of the mega-flops of the decade. One of the mega-hits, *Rain Man*, almost went to Nicholson, but Tom Cruise ended up portraying the brother of the autistic Raymond, a role that garnered an Oscar for Dustin Hoffman.

A girl named Jennifer Howard joined the others in Nicholson's harem in the late eighties and nineties: Anjelica; Mayo-Chandler; Rebecca Broussard (a waitress at Helena's, a nightclub financed by Nicholson and operated by Helena Kallianiotes); Laura Alvarez (a former Vanderbilt wife).[31] At the same time, Mayo-Chandler was harboring fantasies of a longtime commitment, believing Nicholson's "relationship with Anjelica had become merely a friendship thing."[32]

Jennifer Howard was relatively undemanding. A tall, willowy beauty with a quiet demeanor, she had strawberry-blond, shoulder-length hair, and a faint sprinkling of freckles dusted her otherwise clear complexion. A tad bohemian, she was soft-spoken, and chose her words carefully. "I first met Jack at Bob Evans's, whose assistant I was in 1989 when I was twenty-one or twenty-two years old," said Howard, "and Jack was always coming to screenings at Evans's house (he still does). He pops in right at the beginning and then we start it. I used to have to make all the phone calls, back and forth—what does he want to see, what can we get, this is what we've got. I'd call Alan [Finkelstein, Nicholson's friend] and tell him. So they would all come over—Alan and his

girlfriend, Kristen, and Jack and Rebecca [Broussard], the four of them. They came to a number of the movies, so I was friendly with them."[33]

Soon, Nicholson and Howard began an affair. "He's just a great lover—his intimacy, his passion, his control of the situation," she recalled. "He's just very *close*. A lot of men are very distant during lovemaking. He is very oomp! He knows what he's doing. He's sure about it all. It's very comforting. You can just kind of let go. Let him le-e-e-ad the way!"

Despite Howard's charms, Anjelica remained mistress number one, and Nicholson kept Howard under wraps, the same way he would later handle Cynthia Basinet. "He and I never went out together," Howard said, "because we had so many mutual friends; it was something we didn't feel anyone else needed to know, like, 'Oh, let's just keep it quiet.' It would have been just too complicated. [Bob] Evans didn't even know for many years."[34] From Nicholson's point of view, he and Anjelica were still "eternal," he said, adding, "for lack of a better cliché . . . Jean-Paul Sartre and Simone de Beauvoir." In comparing them with the eminent French authors, he was correct in at least one respect: their relationship was full of existential angst and gloom. "Certainly anyone who has ever been intimate with me understands that being an actress does not make that relationship easier," Nicholson said. "My hope is that the roulette wheel would stop somewhere else."[35]

Anjelica's attitude about his other affairs, according to a source, was: "So long as you don't put it in my face, it's cool."[36] After running into Broussard in New York in 1983, Nicholson met her again at Helena's, which, by the late eighties, had become the hot spot in L.A., frequented by Sean Penn, Madonna, Eddie Murphy, Prince, and Warren Beatty. A would-be actress, Broussard was waiting tables and appearing in television commercials to pay the rent. Kallianiotes found her to be "a hard worker,"[37] and Nicholson

thought her "very beautiful . . . a very soulful, loving person."[38] She was so passionate that "the first time Jack Nicholson touched my hand, I almost blacked out," she recalled. No wonder Nicholson called her "a pyrotechnical personality," because the moment they met, she "saw flashes of light," she said, and she realized "something was there." She liked a man to be "exciting and yet insecure," and Nicholson filled the bill.[39]

Born on January 3, 1963, the daughter of a Kentucky engineer, Broussard attended the University of Kentucky for a year, later studying hairdressing in Manhattan. She was a big, lanky Lucille Ball-type, and after a stint at modeling, she moved to California to break into the movies, but became involved with Warner record producer Richard Perry, the force behind the Pointer Sisters, in 1987. His house was famous for after-hours parties attended by Nicholson, Rod Stewart, Sting, and Sylvester Stallone. On July 18, 1987, Perry married Broussard, and she went from being a cocktail waitress at Helena's to being a Hollywood A-list wife, "and with attitude to boot," according to one source.[40]

During the 1987 Christmas season, Nicholson and Anjelica went to a party in Aspen that was also attended by Richard and Rebecca Perry. Later in the holidays, Nicholson and Broussard got together, her husband found out, and the marriage ended on January 12, 1988. "As good a catch as Richard was," said one insider, "Jack was better."[41] Despite this being the era of million-dollar divorce settlements, Perry was protected by a strong prenuptial agreement, and Broussard emerged with a total of $8,100, of which $2,000 had already been dispensed. She moved into a house Nicholson bought for $350,000 on Westwanda Drive off Benedict Canyon.[42]

As with Cynthia Basinet and Jennifer Howard, his affair with Broussard was kept secret, though with difficulty. According to Nicholson, Broussard was jealous; "oh, yeah, God, yeah," he later

said, "breathtakingly powerful, her emotions."[43] His position—juggling so many women—was, at best, delicate, especially after Broussard told him she "wanted to be a mother."[44] In a further complication, Nicholson's twenty-five-year-old daughter, Jennifer, "became very close friends" with Broussard, and Jennifer had long been close with Anjelica.[45] Broussard's tolerance for Nicholson's high-profile affair with Anjelica puzzled many.[46] One Hollywood insider said Nicholson told Broussard, "This is who I am. It's take it or leave it time."[47]

Meanwhile, for four years, Mayo-Chandler continued to press for settling down and having children with Nicholson. Jennifer Howard offered no such problems. "Just being around him all the time, we just bonded and enjoyed each other's company," Howard reminisced. "He was having fun, doing his thing, and I was very young, having fun, too, and not looking for a husband. I did not fall in love with him. I cared greatly for him. He's a great guy. A lot of people don't understand the way he speaks, and at the beginning, I was like, 'Huh? I can't even understand you.' It's the same with Evans, you have to get used to the way he talks. I came to learn Evans-speak and could translate, and it was the same with Jack. By the time we were hanging out and onward, I got it. I actually could follow the conversation. We talked about everything from sports to life, politics, art." His art collection, including the Chagall in the bathroom, was now worth $150 million.[48]

"He's into gadgets he's picked up," Howard added. " 'Oh, look at this, isn't this great?' he'd say. He wants someone to talk to, whether it's world events, the news that's on, or the Lakers game, whatever it is, he'll discuss it. He's very intelligent, full of philosophical thoughts."

Of necessity, their relationship remained "very private," Howard said. "We had Rebecca, Evans, and we weren't taking it anywhere. It wasn't like, 'Oh, maybe we'll get married.' So, why, re-

ally, let anyone know? It's no one's business unless we make it so. It was a quiet thing. I would go up there to his home, we would eat, relax, hang out, talk. He's just a joy to be around. I would leave there on clouds. I would have the best time with him, a heavenly, out-of-time experience. The clock would not turn while I was there. He has a captivating way, a dry sense of humor, charming and interesting. His house is really comfortable, not a bachelor's den, but very much set up for *him*. It's *his* area, with all his little things. It's not technologically advanced—a good bed, wooden furniture, great art. No leather, very simple. I never saw his Oscars. He's not a showoff. He's not like, 'Look what I'm about!' He's about him. And if you don't like him, don't be there. He's very frugal. Who's to say that's not why someone is rich? It's not uncommon that a lot of actors feel that they should get the clothes from their movies. 'You fitted me, so they're my clothes.' [The] production [budget] allows that: 'Okay, you're big enough. Those are yours. We bought them for you.' Everything in the end [a star] get[s] for free. He deserves whatever he gets. He worked his ass off when nobody was paying attention.

"I don't think he's necessarily content, but he's happy enough. He creates his own world to the best of his ability. He can sort of insulate his world and say, 'Okay, this is who I'm putting in, this is what I'm doing.' He has his friends. When I was involved with him, it was a quiet time work-wise for him." She accepted that "he loves women, and has a *lot* of them—and has no problem with them."

But conflict and calamity were not long in developing. Broussard got pregnant, and Mayo-Chandler was considering spilling the beans to any periodical that would pay her $150,000.[49] Others, like Howard and, later, Basinet, kept mum. Howard always felt protective about Broussard, calling her "cute. Rebecca's adorable, You know, a lot of fun. Smiled real natural. She's a little wild one,

just great. . . . They were very affectionate and playful together, and very loving. And the playfulness I always see is such a great thing for a couple; you can't fake it. He was more outgoing with Rebecca around, I felt, than when he was [solo], which was harder. Everything he says is listened to, so it must be a little daunting, the minute you talk. 'Huh? What did Jack say?' Rebecca just accepted him. She wasn't in awe of him like so many others. They had their little disagreements, but she wasn't disrespectful. They had a good relationship."

Nicholson could scarcely have been on thinner ice with Anjelica than he was by March 1988, when she discovered that he'd been skiing with Mayo-Chandler in Aspen. This was not the life Anjelica wanted; "personally," she said, "I'd love to have a child. I'd like to have a husband and a child. It's not something I have immediate plans for because there is simply no one on my horizon, but it is something that certainly has to be considered. And also, I'd like to feel calm and happy."[50] A definitive split with Nicholson was difficult to face. "He is a soul mate," she said, "and I hate to think of a world without him. It would be dismal."[51]

BATMAN

In the midst of personal Sturm und Drang, the sultan of seduction pondered whether to make a comic-book movie, *Batman*, which would mean caving in to the conglomerate-run, bottom-line, high-concept Hollywood he professed to hate. Nicholson had gone on record that he deplored "films with puppets, movies with herpes monsters, and wingdings, buried treasure, cars that talk, [and] Jell-O from every orifice."[52] If he accepted the role of Batman's nemesis, Jack Napier, better known as the Joker, he'd have to eat his words.

He was not the only actor up for the role; the twenty-nine-year-old director, Tim Burton, whose previous films included *Pee-wee's Big Adventure*, preferred Robin Williams, and some of the other candidates were Willem Dafoe, David Bowie, and James Woods.[53] The latter, someone joked, wouldn't require makeup for the white-faced role. Jon Peters, coproducer, and Warner executive Mark Canton both wanted Nicholson, and Tim Burton went up to Mulholland for a meeting. Without committing to the role, Nicholson advised the director, "Don't make this movie bright. Don't let them get you into Happy Time. . . . This was a comic book at night, which gave it that dark thing."[54]

Bob Kane, who created *Batman* in 1939, had wanted Nicholson as the Joker ever since seeing him in *The Shining*, and when the actor and cartoonist finally met, Kane revealed that the character was based on Conrad Veidt's 1927 *The Man Who Laughs*, in which Veidt played a man whose cheek muscles were slit in childhood, causing a perpetual grin. Kane also drew on Victor Hugo's "The Man Who Laughs," the story of a nobleman whose face was surgically altered into a permanent smile by a vicious monarch. After Nicholson's meeting with Kane, the actor was still not convinced he should take the part.

Meanwhile, *Beetlejuice*'s lightweight, unhunklike Michael Keaton got the title role, and Nicholson "outright laughed at me and told me I had to be crazy," Peters recalled, though Nicholson had not yet seen *Beetlejuice*. The studio flew Nicholson to London on the Warner Gulfstream 3 for a look at the Batmobile, based on Chevrolet's Corvette, and the $5-million Gotham City set, which was already under construction at Pinewood studio's ninety-five-acre back lot, where two hundred workers were erecting the largest outdoor scenery built overseas since Elizabeth Taylor's *Cleopatra* in 1960. While still in London, Nicholson partied with twenty-two-year-old model Charlotte Weston.[55] Then he attended a screening

of *Beetlejuice*, and "that's what really sold it to him," said Peters. "It was an unconventional choice and Jack has never run with the Hollywood pack. I knew I had him hooked when we told him about Michael and he said, 'Oh that's interesting.'"[56] Keaton looked exactly like a younger version of Nicholson, with the same steeply arched eyebrows and prematurely receding hairline.

Producer Peter Guber said, "Jack is as difficult a deal to make as any talent deal in Hollywood. . . . You're buying somebody who has an audience from the sixties, the seventies, the eighties, and the nineties."[57] The movie was budgeted at $48 million,[58] and Nicholson received a $6-million salary as well as a percentage of the gross earnings, including merchandizing of black and yellow bat-logo pencil sharpeners, bubble bath, recordings, and Batman outfits. Though Nicholson was not asked to appear in the sequels, 1992's *Batman Returns*, 1995's *Batman Forever*, and 1997's *Batman and Robin*, the deal he cut for the original was so shrewd that he continued to collect royalties on all ancillary rights.[59]

"I like doing something beyond the realm of realism every once in a while," Nicholson said, referring to the Joker, a green-haired, scarlet-lipped monster who terrorized Gotham City by poisoning the air, cosmetics, deodorant, and baby powder. When filming began in October 1988, his costars included Sean Young in the role of Vicki Vale, but some in the cast found her "high-strung," and Nicholson allegedly alerted Warner Bros. that he had some misgivings about her.[60] Young fell and broke a bone while horseback riding with Michael Keaton early in the shoot, and Tim Burton wanted Michelle Pfeiffer as a replacement, but Keaton had just broken off a romance with Pfeiffer, and raised objections.[61] Jon Peters secured Kim Basinger, who flew to London with her then-husband, a hairdresser. Peters, a former hairdresser himself, threatened Basinger's husband for verbally abusing her, and then began an affair with the actress as soon as her husband departed.

Basinger called Peters "my sweetheart hoodlum," and spent nights in his suite at the St. James's Club for the duration of their affair, which concluded simultaneously with the wrap of the picture. Despite her involvement with Peters, Basinger also took note of Nicholson, calling him "crazy, nasty. He's the most highly sexed human being I ever met. . . . He's just the devil."[62]

Nicholson worked fourteen hours a day, including two hours to get into makeup and one hour to get out of it. Some scenes were filmed on location at a 75,000-square-foot abandoned power station in Acton, and the finale took place in a thirty-eight-foot model of a cathedral. As the cathedral scene was filmed, Nicholson and Basinger started walking up the stairs, when suddenly Nicholson stopped and asked, "Why am I walking up all these stairs? Where am I going?" No one could tell him. Peters had ordered the $100,000 cathedral set and then left it to others to figure out what to do with it. Panic set in; Tim Burton called it "the most frightening experience of my life," and speculated that Peters had deliberately created chaos on the set to bring control of the picture back to him, the only person who could "fix it."[63] Finally, the stars were told what to say and do when they reached the bell tower, where Batman finally vanquished the Joker, and the picture wrapped.

Peters and Nicholson decided to reward the crew with top-of-the-line leather Batman jackets, splitting the $10,000 cost. The crew was so numerous that the price tag escalated to $100,000, and Peters reneged on the verbal agreement. Stuck with a $90,000 tab, Nicholson reportedly yelled at Basinger, "Tell that guy whose cock you've been sucking for the past six months that he's an asshole for not paying for the jackets."[64] Finally Warner Bros. absorbed the entire bill.

On his way home from London, Nicholson stopped in New York to meet with Meryl Streep, ostensibly about making another

film together, though at the time she was slated to make *Evita*, which ultimately went to Madonna.[65] Back in L.A., *Batman* opened in Westwood on June 23, 1989, to mixed reviews. "Trash," wrote John Simon, but the critic applauded Nicholson's "inspiredly comic epic performance as the cackling sadist." Pauline Kael found him "too mechanical to be fully satisfying." For all its inanity, *Batman* tapped a new demographic for Nicholson: the young people in sleeping bags who were camping on sidewalks outside theaters, waiting for box offices to open. "The ranks of Nicholson fans have now been swelled by hordes of kids who know little or nothing of his thirty-year career but went wild for what they saw in *Batman*—the face of loony evil for our time," Joe Morgenstern wrote in *GQ*. As usual, Nicholson declined to appear on television to promote the movie, and *TV Guide* called him "the biggest holdout in Hollywood, even during the big publicity push for *Batman*. He equates the act of selling a film on TV with selling out. 'I felt sad when I saw Warren [Beatty] on Barbara Walters,' he said. 'It was an injustice to both of them.'"[66] Nicholson's remarks were hypocritical; he'd already sold out by appearing in *Batman*.

Without the benefit of promotional hype from its star, the film broke all records over the first weekend, taking in $42.7 million at 2,100 theaters. In the first ten days, the figure rose to $100 million; after a month, to $200 million; by 1994, to $251,188,924 domestic[67] and $425 million worldwide;[68] and after seven years, to $2 billion. It was jackpot time for Nicholson, whose earnings have been estimated as high as $60 million.[69] There were rumors that he would parlay this fortune into ownership of the Lakers, with John McEnroe and Johnny Carson as his partners, but instead he bought a sprawling ranch in the Yerba Buena Canyon–Deer Creek area, not far from spreads owned by Bob Dylan, Dick Clark, and Dwight Yoakam.[70] *Life* rated Nicholson "the most powerful actor in Hollywood,"[71] and the Quillan list of major box office stars for

1989 listed him at number one, above Tom Cruise, Robin Williams, Michael Douglas, and Michael Keaton. The film was the commercial hit of the year, and *People* declared, "[Nicholson] stole the film and helped turn it into a $250 million monster that's on its way to becoming Hollywood's all-time box-office champ."

When asked if he'd consider filming a sequel, Nicholson replied, "It depends on the part and the script. I won't do it for the tremendous amount of money. I never did it for that. But it's tempting. And I had a great time working with Tim Burton and Michael Keaton."[72] But two years later he said, "[Warner] didn't even ask me to do *Batman Returns*. Never even came up."[73] As he walked into a Lakers game one night, he snapped at a reporter who inquired about the sequel, "The Joker's dead. Didn't you see the movie?"[74]

Polls rated him the most popular star of 1989, according to Russell Ash's *Top 10 of Film*.[75]

THE TWO JAKES

Exciting new roles were in the offing, and he reportedly entered into negotiations to play creepy Hannibal Lecter, an institutionalized killer, in *Silence of the Lambs*, costarring with Michelle Pfeiffer, Meg Ryan, or Jodie Foster, all of whom were up for the female lead. He was supposed to play Dr. Jekyll and Mr. Hyde in Warner Bros.'s *Mary Reilly* with Emmanuelle Siegner in the title role and Roman Polanski directing, but the package fell apart, and when the movie came out in 1996, it starred Julia Roberts and John Malkovitch, with Stephen Frears directing.[76] Nicholson also wanted to make a biopic about Maria Callas, with Anjelica starring as the incomparable diva. "She could lip-synch while Callas sings," he said. "God, she would be magnificent. . . . I don't know

diddly about opera, but the hair stands up on my neck and arms whenever I hear Maria Callas sing."[77]

But Paramount was at last ready to resume production on the sequel to *Chinatown*, *The Two Jakes*, canceled earlier in the decade, in 1985, when Nicholson, Robert Towne, and Robert Evans fought so bitterly among themselves that Paramount withdrew its support, writing off $3 million. Nicholson had been set to star, reprising his *Chinatown* turn as Jake Gittes, and coproduce; Towne to write and direct; and Evans to produce and costar. "What seems to have been crucial," according to the *Los Angeles Times*, "was Towne's rising doubt about Evans [as an actor] . . . which collided with Nicholson's loyal support of Evans."[78] Another liability was Towne's script, which was undermined by a lumbering, bottom-heavy plot about oil corruption in L.A.

Two years later, when the film was reborn, Bob Evans was out of the cast, and the old friendship between Nicholson and Towne lay in tatters. Biting off far more than he could chew, Nicholson decided to direct as well as act.[79] As director, in charge of the $25-million budget, he brought in many of his cronies, including family, hiring his daughter, Jennifer, twenty-five, as a production-design assistant, and his girlfriend, Broussard, despite her total lack of screen presence, as Gittes's secretary. Droopy-mustachioed Alan Finkelstein, golf partner and longtime sidekick, was billed as associate producer. Small parts and walk-ons went to performers he'd met in acting classes thirty years before. "He doesn't forget the guy he knew before he became famous," said Tracey Walter, who played Bob the Goon in *Batman*. Also on screen were buddies John Herman Shaner, John Hackett, Anne Marshall, Van Dyke Parks, and Bill Tynan.[80] Exercising this kind of power was no doubt a rush, but obsessing on this dreary, downbeat movie was unhealthy for Nicholson in every respect, especially physically. "He looks awful," wrote a *Life* reporter who visited him

on the set. "His face is ashen with fatigue, his jowls are slack, his eyes are dead grapes. He's forty pounds overweight, and he's wearing a dingy sport shirt and drab gray pants that look like elephant legs."

"Couple months ago," Nicholson said, "my cholesterol hit a level where I shoulda been spread on bread." Directing and starring in the movie involved rising from bed at six, starting work at eight, missing lunch to solve production problems, filming until dark, missing dinner due to conferences, and screening the previous day's footage. At midnight, he at last ate supper, returning to Mulholland at two A.M. After studying his lines for the following day, he retired at three, only to get up again at six.

His affair with Broussard consumed what little energy was left over after *The Two Jakes*. "I love Rebecca," said his other girlfriend, Jennifer Howard. "I would not want to hurt her. She may know about me and Jack, but she and I have never acknowledged the fact." Anjelica still didn't know about Broussard, but Nicholson was forced to tell her when he got the twenty-six-year-old Broussard pregnant in July 1989.[81] Anjelica's response "wasn't excessively jagged or negative," Nicholson said. "She's rather like me. Where there's clarity, there is no choice. Where there's choice, there's misery. The fragility of an infant's skull reduces all this talk to gibberish. There was nothing else I could do but what I did." But according to Nicholson's daughter Jennifer, who'd remained close to both Anjelica and Rebecca, "That was really difficult."[82] Anjelica didn't immediately leave him, since the press still wasn't aware of his affair with Broussard, and Anjelica's main concern seemed to be that her own reputation should never suffer because of his peccadilloes.[83]

Nicholson's nerves were so frayed by his domestic situation that he started exploding at the actors on the set of *The Two Jakes*, a far cry from his vaunted bonhomie of yore. "His storied genial-

ity slipped occasionally into outbursts," wrote the *Los Angeles Times Magazine*, and the *New York Times Magazine*'s Aljean Harmetz observed, "With a flick of his voice, Mr. Nicholson can turn boiling water into ice cubes in midair." Principal photography was wrapped in the summer of 1989, and he was well paid for his efforts—$11 million, according to the *Hollywood Reporter*.[84]

Personally as well as professionally, October 1989 was a hellish month for Nicholson. Mayo-Chandler published her "Spanking Jack" account of their affair in *Playboy*, writing, "He's into fun and games in bed, all the really horny things I get off on, like spankings, handcuffs, whips, and Polaroid pictures. . . . his idea of being sexy is dressing in blue-satin boxer shorts and fluorescent orange socks and chasing me around the room with a Ping-Pong paddle. . . . No one, and I do mean no one, can compare with Jack in the sack. . . . He likes a lot of verbal encouragement, too, but the strangest thing about him in bed is his ability to make his hair stand on end . . . as if he had been electrocuted."[85] The way he kept up his stamina after "hour after hour making love," she said, was by taking periodic breaks to consume peanut-butter-and-jelly sandwiches. He was a "noisy love-maker when he gets going, a real grunter."

Enraged, Anjelica struck back, telling *Vanity Fair*, "An article on Jack's sexual prowess at Christmas is hardly my idea of a nice present."[86] Nicholson confirmed that the *Playboy* exposé "did cause me some problems with Miss Huston."[87] He had harsh words for anyone who dared judge him, and also knocked the Reagan administration's pious second in command. "Behind every holier-than-thou sanctimonious Dan Quayle type," he said, "I'll show you a man who pays two transvestites to piss on his face."[88]

October 1989 continued to be a month of bombshells for Nicholson, climaxing when the press broke the story of Broussard's three-and-a-half-month pregnancy. Reporters sought Nicholson

for comment, but he was in the recording studio working on *The Two Jakes* soundtrack with Van Dyke Parks. Anjelica was in Phoenix filming *The Grifters*. His agent Sandy Bresler and press representative Paul Wasserman were suddenly unreachable. Another of his press representatives, Susan Geller, said she knew nothing about it. Broussard retreated to her family in Montana. The media found Jennifer, who refused to let reporters rattle her. "Everybody knows all the family secrets" she said, "so you're not attached to them, and they don't bother you so much. He is a sweet and good man, and he knows how to treat a woman and that includes me. He has always treated me in a very feminine way. . . . He's not crazy, but he pretends to be."[89] Years later, in 2003, Jennifer was more frank about her response.

When Anjelica returned, she stormed into Nicholson's *Two Jakes* office at Paramount and "proceeded to pummel him," according to *Vanity Fair*. "Yeah, I probably deserved it," Nicholson later said. "Let's say I owed it to her, if not deserved it."[90] In either case, their relationship was finally over. On leaving him, Anjelica said, "Be happy," but their relations remained cool, and he complained to a reporter, "Do you know what it was like to pick up *Vanity Fair* and see the headline on the Anjelica story? It hurt. It wasn't realistic. She knew there was another woman and a baby—and then it was just all out there in the public eye, and the privacy and the intimacy were gone. I haven't even had time to think about it with the frantic schedule of *The Two Jakes*. That's what Hollywood does to you. I haven't allowed myself time to grieve."[91]

He had time, however, to call Geena Davis, star of *Thelma and Louise*.

"Geena, when's it gonna happen?" he asked. "You know what I mean."

"We may work together one day," said Davis, "and it would ruin the sexual tension."

"That's bullshit, man," said Nicholson.[92]

In the new decade of the nineties, Nicholson was not the only overweight, besieged resident of the Mulholland Drive compound. Brando ballooned to four hundred pounds, though only five feet ten.[93] Reluctant to be seen in public, he remained closeted on his hilltop with his family and two giant mastiffs. On the evening of May 16, 1990, his thirty-two-year-old son, Christian, shot and killed his half-sister Cheyenne's Tahitian fiancé, Dag Drollet, in the den on Mulholland Drive. Allegedly believing that Drollet had been beating his "little sister," Christian had only meant to "scare him," he later told police, but Cheyenne, in a sworn statement to a magistrate, implied an incestuous motive, stating that Christian did not view her as a sister, but as a "young woman."[94] Subsequently, she added that her father had sexually abused her as a child, and was responsible for Dag's death, charging "autosuggestion. . . . My father asked Christian to bring his gun back home on that evening."[95]

Jacques Drollet, the victim's father, blamed the "morbidly jealous" Cheyenne, who "pushed Christian into it" because she "was losing Dag." Cheyenne's drug addiction and "egoistic" personality flaws had made her "impossible to live with."[96] Jacques Drollet also raised another suspicion: "There were only four people at the house that night: Marlon, Christian, Cheyenne, and Tarita [Brando's third wife]. Among them one is the murderer."[97]

According to Marlon Brando, he went into the den seconds after the killing, "and [Dag] still had a pulse, and I breathed into his mouth, and I called 911."[98] Robert Shapiro, later O. J. Simpson's defense attorney, was retained to represent Christian. In the midst of a worldwide media blitz, Brando sold his life story to Random House for an advance in the $3.5- to $5-million range.[99]

After Christian's arrest, Nicholson and Helena Kallianiotes sent letters of support for his bail hearing at West L.A. Municipal

Court, where the eloquent Brando said, "The messenger of misery has come to my house,"[100] later adding, "I think perhaps I failed as a father."[101] He had nine children,[102] to date, by an assortment of wives and mistresses, and Christian said life at home with Brando had always been "weird and spaced out. I'd sit down at the table some nights and there would be some new addition and I'd say, 'Who are you?' "[103] He was sentenced to ten years in prison and served five, after which he worked as a welder in Kalama, Washington.[104] Cheyenne, a former model, grew obese after the killing and committed suicide in 1995 by hanging herself. Toward the end of the decade, Christian would have a short involvement with Bonny Lee Bakley approximately a year and a half before her brutal killing in May 2001. Her husband, Robert Blake, was charged with her murder, and was scheduled for trial in 2004.

The fallout from violence and broken relationships was all over Mulholland Drive, Nicholson's house included. Anjelica married L.A. sculptor Robert Graham in 1992 and started a family. "I'm much friendlier with Anjelica than Jack is," Harry Gittes said. "They're not enemies, but . . . that was a great loss for me." Elsewhere he said, "Jack's proud of Rebecca. Of course he misses Anjelica, though she seems extremely happy now."[105] Clever enough not to burn her bridges, Anjelica told a reporter in October 1990 she was "grateful" for her years with Nicholson, "but now that's in the past. There may be a misapprehension that Jack in any way thwarted or discouraged my career. This is not true." Journalist Marius Brill wrote in the *Sunday Times* (London), "Seventeen years [with Nicholson] were strained by his drinking and womanizing before they split over the birth of a child—his, by another actress."[106] Huston and Jennifer Nicholson remained friendly.

When *The Two Jakes* opened in 1990, critics savaged it, justifiably, the *Hollywood Reporter* writing, "*The Two Jakes* is no great shakes," and *Variety* calling it "jumbled, obtuse." Nicholson's marks

as a director were equally low, Vincent Canby of the *New York Times* finding him "a competent but not exciting director," and the *Hollywood Reporter* calling his pacing "obsessively slow." Grossing $10,005,969,[107] $15 million short of what it had cost to produce, *The Two Jakes* would prove to be the actor's long overdue swan song as a director. The film "made me think about doing other things," he said.[108]

Now his main issue was what to do about the pregnant Broussard, who, according to Jennifer Howard, wanted marriage. "[Robert] Evans always tried to marry off Jack and Rebecca by trying to help her figure out the way Jack thinks," Howard said. "Everyone knew, Jack loved her, so Evans felt, 'Why not just bite the bullet, since Warren [Beatty] and Annette [Bening] just got married, there's no excuse for Jack not to.' Everyone knew at that point he'd better marry her or he was going to lose her. But he just wouldn't come to that point, no matter what."

Rather than addressing his own relationship issues, Nicholson chose to blame the women's movement, saying, "Women have been hard to please. . . . What have I done to try and adjust? Everything from 'Who's going to cook dinner? No one, I'm buying it' to 'I want to be a movie star. I'm sorry I had a baby.'"[109] Several years later, he told David Thomson, "The havoc in relationships all comes from the militancy in the feminist movement." His male chauvinism did not endear him to Broussard, who later complained to a reporter, "I know I had to leave Jack. Jack comes out with all this man's stuff."[110] Despite their entrenched differences, he would have married her "if she really thought it was important," he told *People*.[111]

Broussard gave birth to their daughter on April 16, 1990, and they named her Lorraine, after Nicholson's sister. The appearance of serene, fulfilled family life that he conveyed in talking to reporters—proud papa, domesticated mate—was very far from the

truth. He never lived with Broussard and Lorraine, or even gave Broussard a key to Mulholland Drive, parking the wife and kid in a house "down the hill" in the San Fernando Valley. "I'm very moody and I shouldn't be around anyone when I think the world is too awful to tolerate," he said. "I need to have a place where no one gets into. . . . It's my office, not my harem."[112] At Mulholland, he passed his days and nights talking or watching sports events with Harry Dean Stanton, Don Devlin, Harry Gittes, John Herman Shaner, John Hackett, and Bill "Reddog" Tynan, but there was also a twenty-two-year-old French actress named Julie Delpy he was seeing. "I never had a policy about marriage," he said. "I've always thought that it's counterproductive to have a theory on that because it's hard to get to know yourself, and, as most of you have probably found, once you try to get to know two people in tandem, it's even more difficult."

He became "eccentric and restless if I have the same scenery all the time," he said,[113] and when he took Broussard and daughter Lorraine for a weekend at the home of *Saturday Night Live*'s Lorne Michaels in Amagansett, Long Island, in 1991, he shuttled between the U.S. Open in Queens, a reception for four hundred on the lawn at the Michaels–Alice Barry wedding, then back to Queens for the finals, 150 miles away. "I think one of the main problems with Jack and Rebecca was not being close enough," said Jennifer Howard. "For him, he doesn't want to live with anyone. That's fair."

He enjoyed hanging out with friends like Jimmy Buffett, Ed Bradley, and Harry Dean Stanton, and one night in early 1991, the four sat around a table at Tosca, the San Francisco restaurant. A big crowd poured in after the shows let out, and Nicholson, feeling expansive, decided to circulate, finally stopping and chatting with some strangers in the front booth. Then he went from table to table, striking up conversations, until the owner, Jeanette

Etheridge, told him, "Listen, Jack, I don't think you should be bothering my customers."

"Jeanette, these are my fans," he said.

"Well, I don't see anybody coming up to you. I've seen you working my room, and I don't think that's right. I'm the only one who can work this room."

"Oh, yeah, well—"

For once, he was speechless. "Pretty soon," Etheridge later recounted, "some people asked him for his autograph, and then it was like, okay."[114] Nicholson decided San Francisco was overrated, calling it "an esthetic Cleveland."[115]

More comfortable in Southern California, he threw a Moroccan-themed birthday party for his daughter Jennifer at her home in Santa Monica in 1992, and invited Jennifer's friend, Victoria Sellers, Peter Sellers's daughter, Cornelia Guest, who had moved to Beverly Hills, and many of the Aspen crowd. Everyone came in costume, and it was like a scene out of the Arabian Nights. Victoria Sellers was an incorrigible party animal, shopping almost every day and playing every night at the Roxy, which her stepfather, and Nicholson's close buddy, Lou Adler, still owned, and for whom Victoria worked. Jennifer partied with her at the Monkey Bar, a popular club Nicholson had established with Alan Finkelstein. During the daytime, she shopped at Neiman's, Saks, and I. Magnin.

In time, Jennifer became a world-class shopper, a tireless collector of designer and vintage clothes, haunting flea markets in Paris, Manhattan, and Hollywood. She owned five hundred pieces by Emilio Pucci, who introduced wacky, garish prints; "twenty or thirty" pieces from Karl Lagerfeld's Chanel period in the early 1990s; countless pairs of Manolo Blahnik shoes; and pieces by John Galliano, Alexander McQueen, and Prada.[116]

Nicholson paid her bills. As he got older, Jennifer was not the

only woman in his life who became more and more expensive. The trouble with Rebecca Broussard started when he sank $6 million[117] trying to launch her acting career, backing and coproducing—with Alan Finkelstein and Richard Sawyer—a mediocre starring vehicle for her called *Blue Champagne*, costarring Jonathan Silverman of *Brighton Beach Memoirs*, *Weekend at Bernie's*, and *The Single Guy*. The romantic story of a jealous woman, *Blue Champagne* was filmed at Nicholson's residence, and also featured daughter Jennifer and Diane Ladd. It wasn't even good enough to get shown at the Sundance Film Festival, despite two tries,[118] and was never released,[119] but at least Broussard got a boyfriend out of it—Jonathan Silverman, born in 1966, who was both younger and handsomer than Nicholson. She also got the promise of a sequel to *Blue Champagne*, which Nicholson would coproduce with Richard Sawyer, entitled *Love Me If You Dare*, the story of a man's affair with an abused girl and a stormy brother-sister relationship.

Though the seeds of their final split had been sown, Nicholson and Broussard had a second child, Ray, who was born February 20, 1992, and named after R&B singer Ray Charles. Nicholson had wanted to call his son Landslide Nicholson, but fortunately Broussard talked him out of it.[120] He introduced Broussard to his sister Lorraine Smith on a visit to Neptune City, and Lorraine later recalled, "She was three months pregnant with Ray and I'd never seen Jack happier. She couldn't take her eyes off him, and he seemed to be younger, more carefree, loving." They still maintained separate residences, even in Aspen, where Broussard and the children stayed in one of his houses while Nicholson occupied another, or drank with his buddies in front of the TV set at the Jerome bar.[121] Without a ring on her finger and no prospect of one, Broussard decided to get married before her thirtieth birthday in January 1993, with or without Nicholson.[122]

The couple went to Barcelona for the 1992 Olympics and then

to the south of France, but by September they fought and separated. "You get to a certain age, your stuff is set," Howard explained, referring to Nicholson's desire to live alone. "You know what you want, you know how you like your life, and you don't want anyone in it, messing it up. For a woman, especially one with children, that was a *big* issue."

On a trip to London, Nicholson felt free to carouse to his heart's content. He stayed at the Connaught, and, often accompanied by Alan Finkelstein, Danny DeVito, and British producer Michael White, partied with such playgirls and supermodels as Amanda de Cadenet, Naomi Campbell, Kate Moss, and Christy Turlington.[123] De Cadenet said, "Power, sexuality, deviance, human gameplay excite me. I know I appeal to men on a primal level. I have tits and an ass. Sometimes you play men as a kind of mental exercise, just to see if you can and because it's so easy."[124] The blond daughter of French racing-car ace Alain de Cadenet, she'd once been married to Duran Duran's bass guitarist John Taylor, and subsequently was engaged to Keanu Reeves.[125]

Michael White, who'd introduced Koo Stark to Prince Andrew, set Nicholson up with girls in London.[126] One night, Jennifer, on holiday with her dad, accompanied him, actress Amanda Donohoe, and Amanda de Cadenet to the Ivy restaurant and then to the club Tramp. With her red hair, and dressed in a silk harem outfit, Jennifer held her own among Nicholson's glamorous entourage. "One woman at a time has never been enough for me," he said. "I've always seen myself as a juggler. You know—having all my balls in the air at once and fearing the painful consequence of dropping one or more."

One ball he was on the verge of dropping was Broussard. "She came back, and finally Jack did ask her to marry him, but it was too late," Jennifer Howard recalled. "She was with someone else." Nicholson had been under the impression that their separation

was "just a silly interlude,"[127] and later told a reporter, "When she left me for that other guy, I realized that by carrying on in my old ways, I was making her insecure. And that wasn't fair, because she's really a very wonderful woman."[128] But for Rebecca, their split had been neither silly nor idle, and she told an interviewer that a thirty-something actor was "a very important person in my life."[129]

"As much as he loved the babies, as much as he loved Rebecca," said Howard, "he took too long to come to the fact that, 'Oh, my God. She does mean that much to me. She *will* leave me.' I don't think he'd experienced anything like that before." Nicholson bought Broussard a ring during the 1993 Christmas holidays.

"I want to ask you something," he said.

"What?"

"I want you to marry me."

"Oh, my God, no! I'm in love with someone else."[130]

On Christmas Day, when he brought together his four children—Jennifer, Caleb, Lorraine, and Raymond—at Mulholland Drive, Broussard was nowhere in evidence.[131] Nicholson held up release of her film *Blue Champagne*.[132] On January 29, he was alleged to have had sex and to have taken drugs with a sixteen-year-old girl at a party given by David Keith, who played the suicidal friend of Richard Gere in *An Officer and a Gentleman* and the arrogant cop in *The Two Jakes* who was forced by Nicholson to suck on a pistol. According to an L.A. private detective, Frank Monte, one of the girls at the party claimed Nicholson had "contributed to the corruption of a minor."[133] There was no further investigation of these claims and no charges were ever brought.

"Broussard has begun seeing an actor (younger than Jack) who she met at a Hollywood party," wrote *People*. "She did this . . . as a reaction to Nicholson's unwillingness to marry her."[134] According to Jennifer Howard, "She and Jack had their breakups but continued for a while. As for Rebecca, when you say to your partner,

'Okay, I'm pretty much in with whatever you want, but if I'm in, having a great time with you, then be monogamous to me and our situation.' My feeling was that they shared what should have been a monogamous relationship. . . . I'm sure that she would have liked that. . . . You love someone, you have children with them, in hopes that maybe he'll change."

But Nicholson would never change, though he expected everyone else to. "I thought I had finally found happiness with a woman who could share my life in ways that I never wanted to share it before," he said. "It's tough accepting that it turned to dust. Even with Rebecca, I told her I needed to maintain a separate house because I need that time to work there and to be myself, so I can think devilish thoughts. I was totally committed to a life as a full-time father, yet we weren't able to work things out between us. *C'est la vie*."[135] Even if he'd been as committed as he claimed, the relationship had been unstable from the start, due primarily—and obviously—to the twenty-six-year age difference between them. He once boasted, "The older I get, the younger the women who are interested in me." When an interviewer asked him to "explain that phenomenon," his reply demonstrated not only his lingering insecurity, but an unfortunate conviction that there must be something wrong with anyone who liked him. "Apparently women are less sensible when they're young," he said.[136]

Obviously, he was caught in a lingering midlife crisis, balking at the passage to the second half of his life. For most men, it hits between thirty-five and forty; for Nicholson, it would go on indefinitely. "Denial is a kind of quest in reverse," wrote Mark Gerzon in *Listening to Midlife*. "We are actually trying *not* to journey. We think our challenge is to stay young, so we pretend that we are still in life's first half, that the transformation isn't taking place. We cling to our youthful selves with all the determination of a shipwrecked sailor gripping a piece of driftwood."[137] For some men,

the driftwood is a Porsche or a hairpiece; for Nicholson, it would be increasingly youthful women who couldn't even keep themselves afloat, let alone an aging Lothario.

In fairness to Nicholson, and despite their peculiar living arrangements, he proved to be an exemplary father to Lorraine, four, and Ray, two, who were shuttled between his house and Broussard's ten minutes away. When the big earthquake hit L.A. at 4:31 A.M. on January 17, 1994—a 6.8 whopper that did considerable damage, especially in the Valley, where Broussard and the children lived—Nicholson was up at Mulholland, where his Tang vases crashed to the floor and his house sustained serious damage. He arrived at Broussard's house in fifteen to twenty minutes. As the mother of Nicholson's children, Broussard would never have to worry about serving cocktails at Helena's again. "I still know her," said Jennifer Howard in 2003. "She has a great new husband now."

Referring to Broussard, Nicholson said, "We have a relationship because of the children, but we have no other relationship."[138] Said Helena Kallianiotes, "It takes a long time for Jack to allow a female into his life. You can actually see it click when it happens. And then he's completely open. So when there's a breakup, the roots are so deep in him—like a tree, really—that it takes years to pull them out."

Despite what *Time* magazine referred to as "zipper control," and despite a scandalous extramarital affair with lounge-singer Gennifer Flowers, Arkansas governor William Jefferson Clinton was elected president of the United States in 1992, generously supported by such donation-rich Hollywood millionaires as Lew Wasserman. Nicholson rooted for Clinton and got to know "Bill and Hillary" during the campaign. "He's going to find you cannot be all things to all people," Nicholson said. "My own political agenda is also more radical than his."[139] Though Nicholson had no political ambitions, he liked the idea of being able to call the pres-

ident by his first name and possibly influence him. Thrilled to have endorsed a winner at last, after years of backing losers like Mc-Govern and Hart, he attended the 1993 swearing-in ceremony at the Capitol and, along with Warren Beatty, Annette Bening, Uma Thurman, and Kim Basinger, the MTV inaugural ball in Washington, D.C.

A Few Good Men

Amazingly, Nicholson continued to work during the emotional dislocations of the 1990s, though, with few exceptions, the films were forgettable. Few would ever want to see *Man Trouble*, *Hoffa*, *Wolf*, *The Crossing Guard*, *The Evening Star*, *Mars Attacks!*, or *Blood and Wine* a second time. *Wolf* was a particularly sad disappointment, because its author, Jim Harrison, and Nicholson were by then such old and companionable friends that they could meet up after long periods and "merely begin the conversation where we left off the last time," Harrison related. "I flew to Paris with the script [of *Wolf*] and met Jack at the Plaza Athénée on his arrival from a vacation in southern France. We had lunch and dinner and then next midmorning when we met for a walk he said he had stayed up late and read the script. 'Let's do it,' he said. We celebrated for a few days and I flew home a bit deranged."[140]

Unfortunately the end product—about a New York book editor who was bitten by a wolf, and subsequently gave in to unspeakably primitive urges—was equally deranged. Part of the fault was that director Mike Nichols, known for witty, urbane social commentary, was out of his element in the horror genre. "From my point of view the project began to disintegrate almost immediately with the choice of director," Harrison said. "There was nowhere to go and one day I quit within what I thought was seconds from be-

ing fired. . . . Jack offered on the phone to back out but I didn't think he should. . . . *Wolf* was essentially the end of my screen-writing career."[141] Twenty years in Hollywood convinced Harrison that the relationship between the movie industry and writers was "basically adversarial. The film business acts as if it wishes it could do without writers but it can't, and it has accepted the fact without grace."

The one exception in Nicholson's early-to-mid-1990s dol-drums was *A Few Good Men*. Budgeted at $40 million, the film was a military courtroom drama concerning a hazing murder. Leading man Tom Cruise received $12.5 million, and Nicholson, in a sup-porting role, pocketed $5 million for two weeks' work. When a re-porter asked Nicholson if it was proper to take so much money for such a small part, he replied, "The minute someone signs a deal with me, they've made money, so what does it matter?"[142] The mass-market economics of Hollywood bore him out; in a few years, Cruise's asking price would soar to $25 million, plus a per-centage, which would bring his earnings from *Mission Impossible 2* to $75 million. George Clooney would score $8 million for *The Perfect Storm* and $15 million for *Intolerable Cruelty*; Colin Farrell, $8 million for *S.W.A.T.*; Renée Zellweger, $10 million for *Chicago* and *Cold Mountain*; Tobey Maguire, $10 million each for two *Spider-Man* sequels; Sarah Michelle Gellar, $6 million for *Scooby-Doo*; and Vin Diesel, $20 million for *XXX2*.

Reporting to work on the first day of *A Few Good Men*, Nichol-son found himself surrounded by Brat Packers Cruise, Demi Moore, Kiefer Sutherland, and Kevin Bacon. "Walking into the first rehearsal and everyone scurrying to their seats when the old guy came in was so strange I felt like the fucking Lincoln Memo-rial," he recalled. "I blushed actually. . . . I think they had to make room for me in the financing of the movie and I think Tom con-tributed to that." The two actors were fond of each other, per-

forming their fierce confrontational scenes together superbly, Nicholson as the villainous Col. Nathan R. Jessup and Cruise as Lt. (j.g.) Daniel Kaffee, the prosecuting officer. At one point Jessup told Kaffee, "What I want is for you to stand there in your faggoty white uniform and extend me some fucking courtesy." At another, Nicholson delivered one of his trademark lines, "You can't handle the truth," in his final scene with Cruise, an unforgettable verbal contest of wills. Though Cruise's Lieutenant Kaffee won the case and had Colonel Jessup arrested, in terms of acting, it was clearly a draw. Even as a tough Marine, Nicholson was still playing cusp characters, for Colonel Jessup was an "iconoclastic anachronism." Physically, Nicholson hadn't looked this good since *The Last Detail.* He'd slimmed down, and his crew cut suited him far more than his customary long, wispy locks.

An immense hit with the public during the 1992 Christmas holidays and for months thereafter, *A Few Good Men* made $237 million worldwide. The *New Yorker* complained of "stale airs of importance," but Nicholson came in for personal raves. "His presence electrifies the film," wrote *Rolling Stone.* The Academy of Motion Picture Arts and Sciences agreed, nominating him for an Oscar in the Best Supporting Actor category, but at the presentation ceremony on March 29, 1993, the prize went to Gene Hackman for *Unforgiven.*

Beginning with the opening of Clint Eastwood's popular Hog's Breath Inn in Carmel-by-the-Sea, California, in 1972, stage and screen actors began to invest in restaurants and clubs. Along with Patrick O'Neal's eponymous restaurant in Manhattan, Tony Bill's 72 Market Street in L.A., and Michael Caine's trendy Langan's Brasserie in London, Jack Nicholson's Monkey Bar, launched in 1992, was one of the first of the actor-owned cafes, followed by

Kelly McGillis's Key West chain; Sylvester Stallone, Arnold Schwarzenegger, Demi Moore, and Bruce Willis's Planet Hollywood; Johnny Depp's Viper Room;[143] Robert De Niro's Ago; Jennifer Lopez's Madre; Ashton Kutcher's Dolce; and Justin Timberlake's Chi in the Hyatt West Hollywood hotel.[144] Nicholson's partner in the enterprise was Alan Finkelstein, long a key figure in the Hogartian Jack Pack.

"I went to the Monkey Bar," recalled director Curtis Harrington, who'd recently been guiding Gloria Swanson through *The Killer Bees* and Shelley Winters and Debbie Reynolds through *Who Slew Auntie Roo*? "It was on Beverly Boulevard, between LaBrea and La Cienaga. I was with Helmut Newton and his wife. Formerly it had been a gay restaurant called the Carriage Trade. Dennis Hopper and Bob Evans were there that night." *Au courant* singles soon flocked to the pink stucco building at 8225 Beverly Boulevard, where three wise monkeys—the hear-no-evil, see-no-evil, speak-no-evil trio—peered from the facade. On June 8, 1995, the *Sun* (London) published an account by its L.A. stringer, Caroline Graham, of a "stunning" young actress who met Nicholson at the bar the previous August, and enjoyed a two-month affair with him, keeping a diary of their meetings and saving his telephone messages. He was twice her age.

The night she met him, he was with Sean Penn, who was directing the actor in *The Crossing Guard*, and she was with a girlfriend. "Our eyes locked," she recalled. She noticed that his nails were manicured and polished and that he was meticulously groomed. He continued to stare at her after they sat down at a table, and she began to chat with Penn, but overheard Nicholson say she was "driving [him] crazy." She returned to the bar the next month and again encountered Nicholson, who told her, "I really want you to come back home with me." Leaving the bar, she followed his limousine in her own car to Mulholland.

Making his guest comfortable, he offered her a drink and selected a Sinatra album before taking her outside for a view of the canyons and the full moon. Then he leaned over and gave her a "strong and tender and loving" kiss. Later, in the master bedroom, she admired his "great body . . . very firm and muscular, with powerful arms, gorgeous legs which he's very proud of, and a lovely hairy chest." The last thing she remembered before having sex with him was that his toenails were as perfectly manicured as his fingernails. As usual, he refused to wear a condom.

"He's a wild man in bed," she recalled. "He was the most passionate, tender, sensuous, and incredible lover I have ever known. He could make love all night long. We didn't sleep a wink. We made love again and again. I stopped counting at seven." Finally, at four A.M., he said, "I'm starving." In the kitchen, the refrigerator was full of pristine white containers holding nothing but fat-free foods. He selected a juicy-looking apple pie, squirting low-fat Readi-Whip on the crust. "He ate the whole thing," she said, "and then we made love again."

It was the start of an unremittingly passionate affair. On their second date, he invited her for dinner and sent a car for her. The table was set when she arrived, and she remembered candlelight, chicken, corn-on-the-cob, and mashed potatoes. Again, he talked about how much he loved being a father of young children, but added he was having "problems" with their mother. He wanted to know if she was seeing anyone and when she assured him she wasn't, he said, "Good. I wouldn't like it if you were."

After dinner, they had sex on silken sheets, and "he satisfied me like no man before," she said. "He was completely unselfish. He was turned on by satisfying me. He was sweet and tender, nothing kinky or weird. He was only concerned with my total pleasure. We made love for hours—I was amazed at his stamina. He was a fabulous lover and extremely well-endowed."

On another date, they went to Bob Evans's house and watched *Natural Born Killers*. Days later, she encountered Nicholson at a fancy-dress Halloween party at the Monkey Bar, where he was dressed as a pirate. In a foul mood, he said he was fighting with Broussard over the children. He left, but later called the Monkey Bar and asked her to come up to his house. She drove there and found him in a much better mood. "We made love again and it was as fantastic as ever," she recalled. The following day, as he dressed for a game of golf, she selected a blue shirt for him. He promised to call, but suddenly, without any sign or warning, it was all over, and she never heard from him again. "I was devastated," she said, feeling "hurt, used, and cheap." A few months later, she ran into him at a screening, and after she pointedly snubbed him, he approached her.

"You really know how to break a guy's heart."

"I don't expect to be treated like that, no matter who you are."

He implored her to come home with him, but she ended it, realizing that he felt they were getting "too heavy," and he had a "fear of intimacy."[145]

Back at the Monkey Bar, Nicholson scored a coup that made the restaurant even more popular, recruiting chef Gordon Naccaroto, who'd recently decided to close his celebrated Aspen restaurant, Gordon's. Studio executives and record moguls who could afford the expensive fare soon joined the models and starlets, and business was booming, the crowd outside sometimes fifty deep, with Mercedes, Rolls-Royces, and Jaguars pulling up and depositing such A-list customers as Nick Nolte, Glenn Close, Mick Jagger, Shannen Doherty, Robert Evans, Harvey Keitel, Don Henley, and Mickey Rourke.

As the Monkey Bar became so popular that one had to be on Nicholson or Finikelstein's list to get in, Nicholson began to do his serious drinking there, and could sometimes be seen "shit-faced

drunk" as he "pissed on the lawn in Harper Avenue," recalled a former habitue.[146] The cramped barroom was only large enough to hold thirty people comfortably, and there was a small portion of the dining room beside the bar, and then a larger room, where Nicholson, on occasion, could be seen dining with his *Wolf* costars, Michelle Pfeiffer and James Spader. It was rather like Helena's, except there was no dance floor. Heidi Fleiss, a regular, often occupied a booth with a pride of high-priced call girls, enjoying Gordon Naccaroto's signature lobster tacos. Sometimes Heidi showed up with Billy Idol or Bob Evans in tow. Her intelligent and kindly father, Dr. Paul M. Fleiss, author of *Sweet Dreams*, a medical guide to a good night's sleep, bought Heidi a $1.6 million ranch house in Benedict Canyon, formerly owned by Michael Douglas, which Heidi was sharing with drug addict Victoria Sellers.[147]

Heidi's formula for success was "If A=success, then the formula is: $A=X+Y+Z$ (X is *work*; Y is *play*; Z is keep your *mouth shut*)."[148] She hosted a birthday party for Mick Jagger in Benedict Canyon, and was a guest at Bob Evans's house. Recalled Paradigm Agency's Ben Press, who worked in the William Morris mailroom in the early nineties, "Bob Evans was known for having great parties. Even Heidi Fleiss was sometimes there. Before one party Bob wanted some scripts delivered. . . . Walking into [his] house is like walking in Dracula's castle. It is otherworldly. . . . It was a classic Hollywood party: Jack Nicholson, Warren Beatty, and Heidi's girls. . . . Later that night Bob said, 'Hey, Ben, come on over here.' . . . He took me into his library . . . pressed a button, and a whole wall moved away, revealing a bubbling hot tub. He said, 'Cindy, come over here,' to one of the girls. He sat her down next to me, and I was in heaven. It was a fun night. Oh, yeah."[149]

Then came "Heidigate"—Fleiss's arrest in 1993 for attempted pandering, money laundering, and tax evasion.[150] "As long as I re-

membered what I had learned, success came relatively easy, but as time went by, I forgot," she recalled. "I got caught up in my lifestyle." One of the reasons for Fleiss's eventual exposure and imprisonment was her brazen behavior in the Monkey Bar, where the girls got into cat fights and came to blows, scandalizing more respectable diners. The restaurant manager, Ron Hardy, defended her, telling the *New York Times*, "She's welcome here any time. She's a pretty cool girl." Years later, in 2003, when a film of Fleiss's life, *Pay the Girl*, was in the planning stage, Nicole Kidman was rumored to be interested in playing the lead, and when talk of that died down, Jamie-Lynn DiScala starred in USA Network's *Going Down: The Rise and Fall of Heidi Fleiss*. The filmmakers got the details wrong, said Heidi, who didn't participate in the project. Mrs. DiScala "is not me," she added.[151] Fleiss self-published a book, *Pandering*; launched a syndicated radio advice show, *Sex Advice With Heidi Fleiss*; and opened an upscale boutique on Hollywood Boulevard named Hollywood Madam, selling lingerie, books, and a full line of Heidi Wear fashions.[152]

The scene on the Monkey Bar's rooftop terrace, which overlooked fir trees and had vine-covered white latticework, was unsavory and contributed to the restaurant's early demise in 1995. Hip Australian guys in Hugo Boss jackets were usually up there, pushing cocaine and heroin, rounding up hookers for late-night parties in the Hollywood Hills, where everyone would end up naked in the swimming pool. Before long, it was this element that dominated, and the influx of hookers and pushers started scaring the elite clientele away. Gordon Naccaroto tried to refurbish the restaurant's image, hosting a fund-raiser for a Catholic church, telling the *Los Angeles Times*, "I wanted to show off the Monkey Bar because we don't get a lot of nuns in here. Since we've been connected with Heidi and her ilk, it was nice having the opposite end of the spectrum to maybe exorcise the demons."

According to Frank Monte, Alan Finkelstein was not the best partner Nicholson could have chosen, calling him "one of the greatest FBI success stories in the seventies when they investigated him while he was running Studio 54 in New York. He calls himself a producer these days and he did get a credit on *The Two Jakes*, but he's nothing but a lackey, and he wasn't a success at the Monkey Bar."[153] After Naccaroto gave up and quit, Eurotrash and San Fernando Valley types—the L.A. equivalent of Manhattan's bridge-and-tunnel crowd from Jersey, Queens, and Brooklyn, the kiss of death for any chic enterprise—started coming in, and fashionable folk went elsewhere. The introduction of live-music acts did nothing to revive the bar's failing fortunes.

One of the singers was the producer Stanley Kramer's attractive, petite daughter, Katharine Kramer, whose mother was actress Karen Sharpe and whose godmother was Katharine Hepburn, star of Kramer's *Guess Who's Coming to Dinner*. Before his death in 2001, Stanley Kramer produced some of the seminal movies of mid-twentieth-century America, including *The Men*, *The Wild One*, and *High Noon*. His daughter recalled in 2002, "I used to beg my dad to introduce me to Jack Nicholson, but he wouldn't, I suppose because he was being protective. I'd always been warned not to get mixed up with bad boys, but I am drawn to them. I knew Warren Beatty before I ever knew Jack, but Warren was like an uncle, a mentor. Jack was different, though I didn't feel any strong attraction to him until after I went to speak to him at his house in 1995 about a project I wanted him to consider, a remake of *High Noon*. Jack really likes Westerns, and I had an idea how *High Noon* should be remade as a contemporary story. I wanted Jack to either direct or play the lead, and he wanted a script. At the time, he was trying to do a remake of his Western, *Goin' South 2*. We talked three or four hours that first day and there were romantic overtures from him, but I basically cut him off, though I fell in love with him.

"We'd talk on the phone—he loves long phone conversations, especially on Sundays. He'd call, and we'd talk about his work, as well as personal things. Then I started spending time with him at his house, and he'd play Frank Sinatra records. He was one of a kind, intimately. He has an innocence to him, though he's very knowing. He was a very good lover.

"I used to go to the Monkey Bar all the time, as I sang there. Jack didn't always come because he didn't want to call attention to our affair. I don't now how many other people he was seeing. Normally, I want to have a man just be true to me, but with someone like Jack, you can't control him. I told Jack that I wanted a more stable life, and he told me he didn't live his life for anyone but himself. He was very upfront about this. I definitely had hopes that if he was ever going to get married, I would be the one. He was having problems with Rebecca Broussard, the mother of his children. I felt a lot of tension. I ran into her a lot, and she knew Jack was seeing me. I think she was jealous.

"I saw him for over a year and a half. We knew all the same people, but we usually were alone together. He kept our relationship very private. One of our best times was dining at Il Cielo restaurant on Burton Way, my mom's favorite restaurant. Jack was very romantic.

"Then things started to get ugly, with a lot of tension around his life. There were a lot of jealous people—so-called boyfriends at the time. They were jealous of Jack, and they tried to create problems for me. Jack's people got involved, and it ended, just kind of drifted off, ran its course. I've always been looking for someone that measures up to Jack. I love him very much. Having known him, it's hard for me to find someone that I think compares with him. That's why I am not involved with anyone."[154]

Chapter Nine

THE BIG MUDDY

Once calling himself "a fool for love," Nicholson's reckless lifestyle inevitably landed him in what Bruce Springsteen referred to as "the big muddy": a series of troubles including paternity charges and criminal road rage. *US* magazine reported in 1994 that he'd been accused of fathering a daughter by a twenty-year-old Hollywood waitress who called Nicholson and said she was going to reveal the situation to the press. "Do what you have to do," he told her. In 2003, the tabloid press claimed that an ex-waitress named Jennine Gourin, now twenty-nine, had become pregnant by Nicholson in November 1993, when she was twenty, and he promised to handle her hospital bills and support their offspring. Their affair had lasted one year. A daughter was born on August 15, 1994, at Mount Sinai Hospital. He fulfilled his promise, sending their daughter to schools in New York and paying her $24,000 tuition. Jennine and her child lived in a New York brownstone in a good neighborhood. "Jack was my first love," she

said. "I thought he loved me. I had the best time of my life with him."[1]

Another paternity issue exploded around the same time, when he discussed his children in *Vanity Fair*, naming only Jennifer, Lorraine, and Ray. Outraged, Susan Anspach wrote a letter to the editor, pointing out that Nicholson had a grown son named Caleb, with whom he had "a very warm relationship, and because Jack loves Caleb, I'm sure he would want me to have you make this correction."[2] On the contrary, Nicholson lived in terror of intimates revealing anything about him. From childhood, he'd told his family, " 'Please, just don't talk about me!' Because they always got it wrong. Always."[3]

That Anspach was telling the truth did not stop him from ringing her, delivering a scalding tirade, calling her a "miserable drunken bitch," and accusing her of exploiting personal affairs to get publicity.[4] In Nicholson's version of the confrontation, he "told Ms. Anspach in no uncertain terms that this is a catastrophic approach to life, making public protestations and all that."[5] Finding little work in Hollywood in middle age, teaching acting and doing some writing, Anspach had requested help from Nicholson when she couldn't meet monthly payments on her four-bedroom Santa Monica house, at 473 Sixteenth Street, for which she'd paid $420,000 in 1979. As security, she'd agreed to a second, $476,000 mortgage to the Proteus Pension Plan, a company operated by Nicholson's manager Robert Colbert. "That's just on paper, it's a tax thing," Proteus told her, according to Anspach, who added that Colbert assured her Nicholson would never foreclose.[6] But after her *Vanity Fair* letter, Nicholson said, "We felt it was time to take the collateral."[7] Proteus billed her for $629,286.97, interest included,[8] and told her to pay up or get out.[9] Had she known Nicholson intended to collect, she would have sold the house in 1989 for

a profit of about $1 million, she said, but Caleb had urged her to keep the family domicile.

"He's trying to ruin me absolutely," Anspach wailed. "I can't have worked my whole life to end up in poverty with my furniture on the street."[10] Twenty-five-year-old Caleb, an employee of CNN, rushed to his mother's defense, saying, "Jack told me [on the telephone] that . . . he never liked my mom. . . . He further said that my mom had tried to use the press against him, that the press didn't matter once you got to court, and that he was not the one going around writing letters to the editor of *Vanity Fair*." *People* magazine reported that the case "marked the first time, according to Caleb, that Jack Nicholson had ever called him his son."[11]

Ironically, Anspach's boarder in her Santa Monica house was Anjelica Huston's brother Tony, now a screenwriter, who rented Caleb's room on the ground floor after Caleb departed for Manhattan to pursue a career as a producer-writer. Directly across the street lived Nicholson's daughter Jennifer and her infant son Sean in a $2.475-million house. Sean's father, Mark Norfleet, a surfer whom Jennifer had met at the Punahou School in Honolulu, had temporarily left Jennifer, a month before she was to give birth, for another woman (they later reunited and married, only to divorce several years later).[12] Though Nicholson had been generous with Anspach over the years, now that she'd broken his code of silence with the press about Caleb, he was merciless, saying, "Why should I pay Susan's rent just because I'm the father of her child? Well, Lawrence of Arabia is here, and I take no prisoners."[13] When she heard his crack, Anspach commented, "It wasn't Lawrence of Arabia who said 'Take no prisoners.' It was Attila the Hun."[14] Actually, Peter O'Toole had yelled "No prisoners!" in the David Lean biopic.

Anspach filed a $1-million lawsuit in Santa Monica Superior

Court alleging that Nicholson's business manager, Robert Colbert, used the loans to threaten and sexually harass her.[15] As the litigation grew increasingly ugly, both the *Los Angeles Times* and the *Sunday Times* (London) weighed in against Nicholson, the former citing "broken promises, moral obligations, and misplaced trust between a Hollywood god and the mother of his child."[16] The British paper came down on him even harder, calling him "bad and mean . . . self-educated, full of big words, and existential sentences [that were] but another facade, an excuse to behave badly."[17] The reason it was hard for him to acknowledge Caleb in public, the *Sunday Times* continued, was because June, his mother, had never acknowledged him. With an estimated worth of $250 million, the only conceivable reason he could want to bankrupt Anspach, the *Sunday Times* concluded, was because he couldn't stand any of his women making him look bad.

"The case was finally settled," Anspach told *Parade*. "The details are confidential, but I can tell you that I'm still in my home."[18]

On a trip to London, Nicholson had an affair with twenty-four-year-old Christine Salata, a member of the onstage band in the West End sex revue *Voyeurz*, enjoying what Salata called "a memorable night," and seeing her again several days later for an "encore." His parting words to her were, "I'll try to keep in touch," and he sent flowers to her flat with a note reading: "Thanks for everything. Jack."[19]

Unfortunately, not all his assignations were that simple. In the mid-1990s, he was sued for unspecified damages by Catherine Sheehan,[20] who complained that he'd hired her and another woman for sex at his Mulholland home, asking them to wear "little black dresses and no stockings,"[21] and roughed Sheehan up afterward, refusing to pay the previously agreed-upon fee of $1,000 each.[22] Taken to Cedars-Sinai Medical Center, Sheehan claimed she was treated for injuries, and that a silicone implant in her breast

had been ruptured. Later, she filed an official complaint with the LAPD, whose spokesperson Eduardo Funes said a preliminary report "listed Nicholson as a party to the crime."[23] In a civil action filed in Los Angeles Superior Court, Sheehan's attorney, Paul Kiesel, claimed assault, battery, and emotional distress, stating, "Miss Sheehan suffered numerous injuries as a result of this unprovoked assault and she is undergoing treatment for head trauma and other physical injuries."[24]

Though Nicholson paid a $32,500 settlement, Sheehan's attorney Robert E. Reimer filed a suit claiming she'd been coerced into signing the settlement agreement,[25] and added that she hadn't known the full extent of her injuries, and wanted more. "I'm dying from my injuries," she said, adding that pain medication was running her $2,000 a month.[26] She supported her complaint with a doctor's note saying she was suffering from postconcussion syndrome with "deep brain inflammation."[27]

Not referring to any particular lawsuit or controversy, Nicholson has stated that he believes there is a kind of hex on money extracted from him by undeserving people. He told *Playboy* in 2004, "Ill-gotten gains are never good for the person receiving them. . . . So when you're paying an extortionist, there's a bit of diabolical delight and contempt in handing over that check."[28]

Another lawsuit sprang from Nicholson's famous case of road rage in 1994, the result of frayed nerves and grief over the death of his friend Harold Schneider, who'd produced all the films directed by Nicholson.[29] At a San Fernando intersection, the fifty-seven-year-old actor left his car, ran over to thirty-six-year-old Robert Scott Blank's Mercedes-Benz, which had supposedly cut him off in traffic, and struck it repeatedly with a golf club, shattering the windshield and denting the roof, according to police detective Robert Searle.[30] Though Nicholson later admitted, "That was a lapse," he added, "You can bet I felt justified. . . . After all,

he was trying to run me over. . . . I never knew what ticked the guy off."[31]

In his suit against Nicholson, Blank alleged assault and battery and infliction of emotional distress.[32] The case went beyond property damage, said Blank, who claimed minor injuries when shards of glass from the broken windshield struck his face.[33] A witness to the attack, which occurred at a traffic light at Moorpark Way and Riverside Drive in Toluca Lake February 8, corroborated Blank's account, and Nicholson was charged with misdemeanor assault and vandalism, according to the Los Angeles city attorney's office.[34] Each charge carried a maximum of six months in jail and a $1,000 fine.[35] Taking note of the incident, which coincided with her own battles with Nicholson, Susan Anspach said, "That guy was just in the wrong lane. I'm the one getting battered emotionally."[36]

Nicholson admitted he used "the 2 iron. I always have my clubs in the trunk. I use graphite clubs, and I expected the club to break. I didn't expect to have to use it, when I took it. . . . It was just because I didn't know what was going on. I was out of my mind . . . [after Schneider] had died that morning, and I was playing a maniac all night. . . . A shameful experience for me. Painful event. It's a shame. I don't like to lose control or to be angry."[37] Earlier, in 1985, he'd told the *Washington Post*, "I'm liable to take all of the repressed anger of something that's very important to me, and take it out on the ice-cream man. And then I feel like a schnook. And I am a schnook at those moments. I don't think I'm better or worse than anybody else."[38]

The civil suit was settled out of court.[39] With regard to the criminal action, defense attorney Charles R. English was allowed in Van Nuys Municipal Court to put off the arraignment until Nicholson could meet with Blank. Deputy City Attorney Jeff Harkavy said that "due to the degree of violence," his office stren-

uously opposed this type of settlement, and would fight Nicholson's attempt to have the charges dismissed in view of his out-of-court settlement of the civil case. Despite Blank's willingness to testify in favor of a civil compromise, Harkavy said Nicholson had swung the golf club "toward the victim's face" in a deliberate, criminal attempt to injure or intimidate him.[40]

Finally, in May, all charges were dropped after Blank "spoke quite forcefully" in a judge's chambers in favor of the civil compromise Nicholson wanted, and received an undisclosed monetary settlement.[41] According to *Variety*, "The victim told a judge he was satisfied with the actor's apology and terms of the settlement."[42] Deploring the new variety of celebrity justice, the *Los Angeles Times* wrote, "With the flick of a pen on a personal check, [Nicholson] can make things go away. Just like that. Sue him for breaking your windshield with a golf club? There, a little cash ought to cover it. Bye-bye, lawsuit. So long, criminal charges."

Nicholson had invested his time and money wisely over the years in various causes that gave him the status of a solid citizen. He'd always had very good relations with the LAPD, where Mulholland Drive was indulgently referred to as "Bad Boy Drive." There was no talk of replacing him as host of the Twenty-third Police Celebrity Golf tournament at Rancho Park on May 14, 1994, to raise money for widows and children of officers killed in the line of duty, and for cops suffering catastrophic illnesses, though a spokesperson for the Police Memorial Foundation did say, "It caught us off guard and there is some concern."[43] His philanthropic activities—he helped raise $2 million for Paul Newman's the Hole in the Wall Gang Camps for children with catastrophic diseases—became a veritable bank account he could draw on in times of need.[44] The *Los Angeles Times* concluded that the superstar was "someone who seems exempt from the rules that govern life for the rest of us."[45]

According to Nicholson, the victim of his assault wrote him a letter of apology a few years later. "And I accept his apology," he said.[46] His car-bashing spree, together with the O. J. Simpson murder trial and the first Michael Jackson child-molestation case—from which all the principals walked away free—marked one of the sorriest trends of the fame-obsessed 1990s: "One kind of justice for celebrities and another kind for the rest of us," as attorney Gloria Allred put it.

During Nicholson's legal crises over Anspach's house and Blank's Mercedes, the motion-picture industry chose to give the actor one of its highest honors, the American Film Institute's Life Achievement Award, heretofore conferred on twenty-two screen legends, including Bette Davis, Alfred Hitchcock, James Stewart, John Huston, Lillian Gish, Elizabeth Taylor, Gregory Peck, and Barbara Stanwyck. Selected by a board of actors, directors, agents, and studio and TV executives, the award was announced by AFI director Jean Picker Firstenberg, who said, "Nicholson seems to take so many chances and he really pushes the boundaries of an actor."

Flabbergasted, Nicholson, who was vacationing at the beach with his two babies, Lorraine and Ray, sputtered, "Have they spoken to Mr. Brando yet? You could have knocked me over with a feather." The AFI criteria for honorees was the highest: "One whose talent has in a fundamental way advanced the film art."[47] The youngest person ever to receive the award, Nicholson chose to call it "The Prime of Life Award."

There is something profoundly suspect about all show-business award shows, especially those that become television specials, such as the AFI, the Oscars, the Hollywood foreign press corps' Golden Globes, Broadway's Tonys, Nashville's country-music awards, and TV's Emmys. Snaring top talent for free, these pretentious, self-serving ceremonies are basically commercial en-

terprises aimed at collecting huge revenues from prime-time TV advertisers. Actors, being ego-driven creatures, are suckers for the ploy, showing up at interminable, boring programs to pick up cheap trophies. It was probably the only way left to get Nicholson for less than $10 million.

Despite the *This Is Your Life* nature of the AFI ceremony, noticeably absent from the invitation list were Anspach, Caleb, and Nicholson's forty-eight-year-old half-sister Pamela Liddicoat, June's daughter by Murray Hawley. Over the years, Nicholson had sent Pamela many repayable loans, including funds to run a beauty shop. Pamela developed a drinking problem after her marriage to Mansell "Mannie" Liddicoat failed in 1993, and Nicholson urged her to seek professional help. "Jack, I'm trying," she said. "God knows, I'm trying."[48] At the time of the AFI honors, she was "very upset," according to a source, about being excluded, and on February 27, 1994, she went on a binge, hitting most of the dives around her home in Georgetown in Northern California.[49] At the Coloma Club in Lotus, California, a logging town on the American River some forty miles east of Sacramento, she and a girlfriend, twenty-four-year-old Michelle Burns, met a thirty-three-year-old white-water-rafting guide named David Fellows and went to his mountain cabin.[50] The three had sex together, but later Pamela's naked corpse, with several bullet holes in it, was found by the El Dorado County police, and both Fellows and Burns were charged with murder, convicted, and imprisoned.

"Oh, my God, not Pamela. Oh, no," Nicholson said, when he heard the news.[51] Marlon Brando, still grieving over Cheyenne's suicide, comforted him. Phoning Mannie Liddicoat, Nicholson offered to pay for Pamela's funeral in Placerville, California.[52] Subsequently, Liddicoat made the mistake of talking to a tabloid,[53] and Nicholson attempted to recover $100,000 in loans he'd made to Pamela, together with $100,000 interest, and to foreclose on a

duplex he'd given her. It was "just a dump," according to Liddicoat's lawyer, and the disabled Liddicoat was renting it out as his only source of income.[54]

Nicholson didn't attend his half-sister's funeral, but he did show up to collect his AFI award on March 3, 1994. To the strains of Steppenwolf's "Born to Be Wild" from the *Easy Rider* soundtrack, he strode into the International Ballroom of the Beverly Hilton Hotel wearing his ubiquitous Ray-Bans, and immediately realized that everyone in the audience of 1,100, including Bob Dylan, Art Garfunkel, Kareem Abdul-Jabbar, Hector Babenco, Mike Nichols, Tim Burton, Jim Brooks, Dennis Hopper, Peter Fonda, Danny DeVito, Michael Douglas, Michael Keaton, and Sean Penn, was also sporting Ray-Bans. Why did he always wear shades, someone had once asked him, and he'd replied, "I can see them, but they can't see me."[55]

Nicholson took his place at the head table, along with Broussard and his leading ladies—Michelle Pfeiffer, Jessica Lange, Candice Bergen, Meryl Streep, Faye Dunaway, Louise Fletcher, Shirley MacLaine, Ellen Barkin, Ellen Burstyn, Madeleine Stowe, Kathleen Turner, Cher, and Shelley Duvall—and started listening to a succession of tributes. Sean Penn delighted the guest of honor by waving a golf club with an iron chain hooked to a medieval mace. Louise Fletcher quipped, "Jack made being in a mental institution like being in a mental institution," and Cher reminded the honoree, "You could never remember your character's name [Daryl Van Horne]" in *The Witches of Eastwick*. Michael Douglas called him "the only actor more comfortable in front of the camera than in real life." Shirley MacLaine said, "First you steal the money, then you steal the movie."

Introducing Nicholson, Warren Beatty said, "He is every bit as vain as I am." Mike Nichols presented the award, and Nicholson began his acceptance speech, first acknowledging Lorraine, who'd

come from New Jersey, then Jennifer and Broussard, "the mother of some of my children. She changed her mind a lot of the time. She's coming, not coming, coming, not coming. Let's take the babies. Well, you know, maybe she's right. I thought that they were too young to drink. I'm drunk and lucky to be at large." His work motto, he said, was "Everything counts," and his life motto was "Have a good time." Although he called himself a "hick actor," he ended with the promise, "You ain't seen nothin' yet."

Then he went to American Express's party in the L'Escoffier Room, and on to the Monkey Bar, where he was joined by Beatty, Annette Bening, Sean Penn, Robin Wright, Fonda, and Hopper. Later, while his sister Lorraine was still in L.A., he introduced her to her namesake, his four-year-old daughter, and to Raymond, two. "Ray will only have one problem with women," he said, "and that will be an overabundance."[56]

On November 11, 1995, Nicholson attended Leonardo DiCaprio's twenty-first birthday party at the Hollywood Athletic Club, where the pool had been covered and turned into a dance floor. When Peggy DiCaprio, Leonardo's shapely stepmother, spotted Nicholson sitting at a table, she went over to invite him to the private quarters upstairs, where Leonardo was receiving his guests. "Hi, Jack," she said, and the actor promptly seized her and planted a big kiss on her lips. With DiCaprio's triple crown of early nineties triumphs—*This Boy's Life*, *What's Eating Gilbert Grape*, and *The Basketball Diaries*—he'd established his position as the successor to Nicholson as the screen's foremost character actor, and he'd shortly lay claim to leading-man status, and gigastardom, in the most popular movie of all time, *Titanic*.

Nicholson's personal life continued to steam with dramatic affairs, including the model-actress Cynthia Basinet and Lara Flynn Boyle, star of the TV hit *The Practice*. For the rich actor, money was a convenient way to assuage guilt. Jennifer, the daughter he so

often hadn't been present for, and who had given him two grandsons, Sean and Duke, by on-and-off husband Mark Norfleet, was a recipient of Nicholson's largesse. She loved to go shopping, and when she established a fashion business called the Launch, the opening party was costly.

Another issue Nicholson confided to Basinet was how he'd reacted when, years ago, he'd first learned he was illegitimate. "His heart was broken," she said. "His mother wasn't his mother. He'd known it instinctually, but was [lied to] his whole life by a bunch of women. That's a really weird setup, like being molested and not being able to tell, because it's like you're just a kid standing there thinking, This guy stuck his finger here. It kind of feels good."

Basinet felt that if Nicholson were ever to be able to love, "you had to walk him to the issue with the mom." She felt he was still in violent reaction to the trick that had been pulled on him by June and Ethel May, and that his anger over it kept him from living fully. In time, she began to feel as if she were "raising two teenagers, Jonathan, my son, and Jack Nicholson. I was being pulled this way and that, and I wanted to establish myself as a musician, later as an actress, when I finished my acting classes. If he felt threatened by the possibility that I might succeed as a singer, it should have been obvious to anyone that I was putting my career on hold and standing behind him, even though I was pursuing music quietly in the background. That came at some cost. He didn't help me."

In 2003, Basinet added, "I've been doing commercials for ten years, but no one from the commercial world said, 'Whoa. Why don't we kick her a commercial?' Matthew Ralston booked me in Kmart, and that's changing for the better. That's what helped me through. [But] I mean, Jack could have talked to Quincy [Jones] and said, 'Listen, I've got this girl. She sings.' I don't think he believed in my voice.

"I was sitting on his lap and he says, 'You know, I . . . I . . . There's a song I like. I put it in a movie, you ought to record that one ["The Haunted Heart" from *The Two Jakes*]. And I said, 'Well, great. I'll record it.'" She decided to give him her tape of the song for his birthday, but she suspected he was afraid she wasn't right for his image—"a little wacky: look at me, I'm not wearing any underwear. He didn't want that to play down on him. He had a real high criteria of himself."

She didn't pressure Nicholson for large sums of money because "then of course I would have had to move in with him and be manipulated. He waved the carrot; but I had reduced all my expenses to zero, and that's why I could stand up to Jack. I didn't need Jack because I wanted to show up with him for premieres and awards ceremonies; I needed him for basic things: We were hungry. He gave me his golf allowance, his winnings on golf. On one Valentine's Day he gave me a sterling silver and malachite telephone, so I'd call him more. One time, he came back from London, where he'd been with his kids. I was in the bathroom, tinkling, and he came in with a present for me. Maybe he's a weirdo, I thought, like he'd been watching me. So, he goes to give me this box, right?"

"Oh, my God! Butler Wilson," Basinet told him. "That's the costume jewelry place up on Sunset Plaza."

"I got it in London," he said.

"Oh, cool," Basinet said, and later recounted, "I think the flagship store is in London. It was a diamond cross—he's really Catholic—but I knew it wasn't real diamonds."

"They make the best costume jewelry," she said.

"Yeah," Nicholson said, "that's what it is. I buy you paste."

"He was always buying me jewelry, but paste," she related. "He said people helped him pick it out, and he didn't really question them. I think he was testing me to make sure I wasn't after him for gems. He is the cheapest person I've ever known. It's sad, because

he would always have a gift for me, and he does have the best taste, like the time he bought me this beautiful velvet scarf. I figured he had a lot of girlfriends, so I was doing okay."

Not so okay, however, that she was the only girl he was seeing. In the '90s, though pushing sixty, he was also deeply involved with Broussard and Lara Flynn Boyle. "About turning sixty, I don't like waking up sore and tired every day whether I did anything or not," he said, just before his birthday in 1997, "although I do like that it's gone by 12:30 or 1 P.M."[57] By evening, he was still able to behave like "a lightly reined-in voracious beast."[58]

On one occasion when he was with Basinet, he ate an entire box of chocolates in front of her. "Can I have a piece?" she asked. She started to reach for the box, but he shut the lid. He was also drinking a glass of milk, and she asked, "Oh, can I have some too?"

"He was mad," she related, "and he drank it all the way down. He could be the same way about spending. He was beginning to take out all his issues on me. He put me to a test one time, the same as he'd done with Rebecca Broussard. He wanted to see what I'd do if he deliberately left a light on in the closet. Bec [Broussard] had got upset with him for leaving the lights on, and he was upset with her."

Basinet told him, "You are so lucky to have a relationship in which that's all you're fighting about," and later recalled, "I didn't get in there and go, 'Oh, well, you know, of course, she's a bitch.' I looked at it like, 'Honey, having to deal with you ain't easy and if all she's complaining about is the light switch, get over it.' I tried to be honest and fair with him about everyone.'"

Lara Flynn Boyle, glamorous, sexy, thin as a rail, and hard-partyer, came to be referred to by Basinet, when she referred to her at all, as LFB. "I think he gave LFB a cross too, but she wore it on the outside. Every time I see her wear a cross, I want to gag." Nicholson convinced Lara to wear a dress designed by Jennifer.

Lara was scheduled to have a red-carpet interview with Joan Rivers at an awards show and naturally wanted to look her best. She could have chosen any designer but wore Jennifer's dress to appease Nicholson, whom she called "the Chief."[59]

Lara and Nicholson had first met at a party in June 1999 for *The Spy Who Shagged Me.* "He started asking around to see who knew her," recalled a friend. "I don't know who got them together." According to Lara, she did it herself. While looking for a bathroom at the party, she discovered him alone in a room smoking a cigarette, and struck up a conversation. At first, they kept their affair a secret, "perhaps," suggested *People* magazine, "to spare the feelings of Boyle's ex, *Just Shoot Me*'s David Spade." The diminutive Spade's girlfriends included TV series actresses Krista Allen of *Baywatch* and Julie Bowen of *Ed.* The latter called him "my favorite lover."[60]

Thirty-three years Nicholson's junior, Lara played Helen Gamble, the smart assistant district attorney on *The Practice.* Shapely, if on the thin side, she fit Spencer Tracy's description of Katharine Hepburn in *Pat and Mike*: "Not much meat on her, but what's there is cherce." The media considered her one of the beauties of her time, reporting her every move, including her makeup routine. The secret behind her golden glow: She used Devitt's Studio line of cosmetics, including Triple C-weed whipped foundation and loose power, both in light-beige Tanami; Alhena-hued Starbrights lip and cheek palate, brushed for contouring with a dark neutral powder blush in Tralee; for her eyes, pale beige Storybook Cave eyeshadow; for her upper and lower lash lines, Eye Intensifier pencil in Tanzania, and three coats of Hong Kong black water-resistant mascara; and for lip gloss, Pink Starbrights.

Before Nicholson, she'd rapidly gone through affairs with Kyle MacLachlan and Richard Dean Anderson, television series actors who appeared in *Twin Peaks* and *MacGyver*, respectively. Another

ex-lover, David Sherrill, said that making love to her was "like try-ing to jack off a bobcat with a handful of barbed wire. She was too wild for me, bro."[61] She liked Nicholson because he stimulated her "mentally," she said; otherwise, she added, quoting Gloria Steinem, "A woman needs a man like a fish needs a bicycle." On Nicholson's abilities as a lover, she said, "It's not bad sleeping with Einstein." One Hollywood wit likened her to "Tallulah Bankhead on speed," and *Practice* costar Dylan McDermott called her "a throwback to Marlene Dietrich and Bette Davis."[62] Lara said, "I'm a big advo-cate of drink-throwing. I'll toss a drink in someone's face and then just sit there because I'm too lazy to walk out."[63]

The origins of her anger were not unlike Nicholson's. An Irish Catholic, she was abandoned by her "shit father" when she was six, and became dyslexic, growing up on Chicago's North Side, start-ing to smoke Marlboros when she was thirteen. Around the same time, she developed a cyst on her ovaries, which explained her skinny figure.[64] "When I was a little girl going through puberty, I had chicken legs and bad posture, and I was insecure about being small-chested."[65] Boys called her "Pootie Boobless." Her hair turned gray when she was seventeen, and she moved with her mother-manager, Sally, to L.A. just after graduating from high school.

"Look at your name," said Sally, who'd named her after the Julie Christie character in *Dr. Zhivago*. "I had great things in mind for you."[66]

In L.A., she "went on Ortho-Novum birth control," Lara said. "And I got these huge breasts—for me anyway—and they just put some shapely weight on me for about three years. I retained water and became more filled out. Then the cyst shrank, and I went off the pills."[67] Thereafter, she became almost frighteningly skinny, and in a town obsessed with weight control, she was rarely out of work, cast in *Twin Peaks* in her first week in L.A., followed by the

movies *Happiness, Wayne's World,* and *Speaking of Sex.* By the nineties, when she filmed *Baby's Day Out* in Chicago, her father, Michael Boyle, had remarried and had two sons, Mike Jr. and Ethan.[68] "Boyle is my dad's last name," Lara said. "Which I was going to get rid of when I turned eighteen and just go with Lara Flynn. But then I thought, 'Well, he made such a shit reputation out of it, I'm going to make a good thing out of it.'"[69]

Like Candice Bergen—and before her, Milton Berle, Lucille Ball, and Eva Gabor—Lara had a busy if hardly stellar film career—she made thirty movies—but didn't achieve success until she appeared on television, where *The Practice* exposed her to 17.9 million viewers weekly. "Playing [Helen] Gamble is the world for me," she said. "I love it, but I do say to David [E. Kelley, the producer], 'Is she going to get laid this season?'"

At last going public with their affair, Nicholson escorted Lara on September 12, 1999, to the Emmys. David Spade, who was nominated, attended with his mother.[70] Later in the same month, on the eighteenth, Nicholson squired her to the Oscar De La Hoya–Felix Trinidad prizefight in Las Vegas, and on the thirtieth, he took her to Warren Beatty's kickoff speech for the Democratic presidential nomination in Beverly Hills. Telling a reporter why she chose Nicholson for her boyfriend, she said, "You can never beat the best. I keep going back to Jack because he's the most interesting and enthralling man I know."[71] When asked if she was in love with Nicholson, she replied that she was in love with herself—"me, me, me, me"—but found Nicholson's genius "attractive. The battle is to find someone who is up to your speed, who can offer something to you."[72]

In certain respects, she was dissatisfied with their affair, complaining, "Somebody would call me and say, 'I have Jack on the phone for you,' and I would say, 'Tell Jack to call me himself.' I couldn't stand some secretary calling."[73] Her mother approved of

Nicholson, saying, "I'm glad that you've at last found someone who's as smart as you are,"[74] and Lara moved into Mulholland Drive. Then, after they returned from a vacation on the French Riviera, she reportedly found a bracelet he'd bought in France, and he admitted it was for another woman.[75] There was also a report that she caught him cheating with other women, and he was put off by her possessiveness.[76]

She moved out, ending their affair, and stayed with Dylan McDermott and his wife. Later, she was photographed having a tête-à-tête with Harrison Ford in a Manhattan club. The following day, the thirty-year-old Lara and fifty-eight-year-old Ford had dinner together and took a hansom carriage ride through Central Park. They were spotted again at the VH1 *Vogue* Fashion Awards at the club, Lot 61. Eventually, Ford's seventeen-year marriage to screenwriter Melissa Mathison went on the rocks.[77] Despite widespread reports that Lara helped ease Ford's midlife crisis,[78] she denied being a home wrecker. "I sat down in a booth with Harrison Ford . . . for five minutes," she said, then added, "Well, maybe *six*. . . . That's the part of fame that's like *The Wizard of Oz* on acid. . . . There are not too many stars I'd want to fuck."[79]

For a while, Nicholson turned into a recluse, and when an agent brought two attractive women to Mulholland, he asked them to leave, saying, "I've gotta get some shut-eye." Later he told a friend, "I just can't get Lara off my mind."[80] Trying to get her back, Nicholson called her, and thereafter they began having frequent telephone chats, but she was reportedly still seeing David Spade.[81] Not so, said Lara, who denied that she and Spade were "boyfriend and girlfriend."[82]

Despite Nicholson's preoccupation with Lara, Cynthia Basinet continued to hold on to him. "I suspect Jack always thought I was playing him, but I saw such a wonderful vulnerable person from the first time I was with him, no matter what game got played, I

vowed never to hurt him, because I'd never had somebody be so vulnerable in my presence. When I wasn't at home, I'd leave some recorded music on my answering machine's outgoing message, to let him know what mood I was in. He would sing into my recorder as his reply." Sometimes she'd start a song like 'I Get a Kick Out of You,'" and Nicholson would finish it by singing that mere booze no longer turned him on, but he still got a charge out of Basinet.

She gave him a CD that she'd recorded just for friends, and principally for him. "Well, he cried," she recalled. "And it was at that moment that I saw love, for the first time in my life, whether he was acting or whether it was really real." Sometimes he called her his soul mate, and she wondered, "What the fuck's he talking about? I didn't even know what frigging soul mates were." Where had Nicholson come up with his "soul mates" line? "Whoever he was talking to at that moment. They said, 'Well, tell her you're soul mates. She'll fuck you then.'

"When he felt like having a serious discussion with me, he would turn his back and then look over his shoulder. It was very cute. And he could be very spiritual. He had a Bible with a little palm—it was next to his television set, up on his vanity—and he was always talking to me about the sanctity of what was happening between us. Oh, yeah, I thought. I told him exactly how the camera read him when he went out, like, after a Lakers game on TV, I'd tell him, 'You looked really good, you could actually blow it up.' When he wears clear glasses, I say, 'Oh, you must be feeling better,' because that's what it means [when he forgoes the shades]. We wore the same kind of glasses together. He is who I am on the inside, and I am who he is on the outside."

She found that he could be very encouraging at times, but she also sensed that he was afraid she'd become a famous singer and eclipse him. He often brought up the film *A Star Is Born*, the story

of a young woman whose career overshadows her aging husband's. "'That's just a movie,'" I told him, but he kept bringing it up all the time. Jack and I had the same vision. He said he could make me governor in 2008, but he was afraid I'd be successful."

She began to notice that he was repeating some of her statements in interviews, though without giving her credit. When she read his remarks about President Clinton in *Rolling Stone*, she told a friend, "Those are my frigging thoughts, and he's passing them out like frigging cotton candy."

As Good as It Gets

In 1997, Nicholson appeared in another James L. Brooks comedy, *As Good as It Gets*. Holly Hunter turned down the female lead, which was eventually played by Helen Hunt, who was thirty-four. At sixty, Nicholson wondered if he was the right actor for the part. "As a young man I promised myself I wouldn't be one of these old dudes who somehow deludes himself that these people are legitimately attracted to you," he said. "Yet in some marginal way I have done that job on myself." Hunt settled the matter by telling the actor she'd "go out with him like a shot."

When Nicholson met associate producer Bridget Johnson, an attractive Rene Russo type, he said, "You know, Bridget, for your type of broad, you're not bad." On the first day of filming, he told Brooks, "Jim, you might have to help me more on this picture than you're used to." After they'd worked for a while, Nicholson said "some horrible things," he later confessed. "Remember, I've asked for his help, he's giving it to me, and I look at him and say, 'I hear what you're asking for, but all you ever fucking do is ask for something, you're not giving me shit.'"

"I swear to you," Brooks later told a reporter, "that some of the times where he had an idea for doing something a certain way, which I thought somewhat secretly was the worst idea I ever heard, just chilled my blood and I thought would bring the movie to ruin and I know I had ideas that chilled his blood, some of each of those are in the movie, I promise you." Despite disagreements, the synergy between Brooks and Nicholson would again produce box-office magic, just as it had in *Terms of Endearment*.[83]

Nicholson played a writer of romance novels, Melvin Udall, who was racist, homophobic, misogynistic, and, above all, compulsive-obsessive. When one of his readers asked him how he created such credible female characters, Udall replied, "I think of a man, I take away reason and accountability." In another of the film's misanthropic bons mots, he said, "People who talk in metaphors oughta shampoo my crotch." Helen Hunt said that making the movie was "thrilling and fun and brutal and hard, a one-of-a-kind experience." Critics and the public loved it, and it grossed $141.3 million.

Honors were not long in coming, including the Golden Globe and yet another Oscar nomination in a year that included strong competition in the Best Actor category from Matt Damon in *Good Will Hunting*. With a total of eleven nominations over the years, Nicholson set a record, topping every other male actor in the history of the academy. At the beginning of the Oscar show at the Shrine Auditorium on March 23, 1998, host Billy Crystal plopped in Nicholson's lap and sang, "Sit back, relax, forget *Mars Attacks!*" Waiting to hear whether he'd won, Nicholson turned into a nervous wreck, and told his friend Peter Fonda, nominated for *Ulee's Gold*, "I ought to go out into the lobby and take a Val."[84] Fonda remembered, "I'd never seen him that way before or after. Usually he's Mr. Casual Cool." At last, when the Best Actor and Best Ac-

tress awards were announced, Nicholson and Helen Hunt both won. "I dropped about three quarts of water the minute I heard my name," Nicholson said, and, in his acceptance speech, admitted, "I like a career that covers three decades."[85]

When his friend, painter Julian Schnabel, asked whether the Academy Awards "mean something," Nicholson replied, "Of course they mean something. But what they mean is hard to define. I can tell you that I've just always flat-out liked them. It's one of those grand occasions. I asked John Huston about them once, and he said that his attitude was based on respect for those who came before you." Nicholson was among only three performers ever to win three Oscars: Katharine Hepburn had four, and Walter Brennan and Ingrid Bergman, three each.

"When he won the Golden Globe for *As Good as It Gets*," Basinet recalled, "I sent him an orchid and a note that said: 'Keep a smile on your face, love in your heart, and a hard-on in your pants.' He said, 'Oh, you sent that? I couldn't read your writing.' We'd been together about two years, and by now I was taking my music and my determination to make it as a popular singer quite seriously." One night after they'd had sex, they were lounging about, "all romantic and wonderful, and suddenly, unexpectedly, out of nowhere, up come his insecurities. 'You're going to leave me,' he said, and I thought, Eventually comes reality. This person's been in my life longer than any other man ever and he seems to have a great fear of me succeeding in this music thing."

She listened to endless hours of talk from Jack. "James Cagney was his hero as an artist. He liked his 'old black-and-white movie stars.' He liked Jimmy Durante and Frank Sinatra. He imparted so much that was new to me. This was pretty heavy stuff I'm hearing, and he was bringing me out of my own little world and making me listen. My attitude was, 'Okay, you can talk all you want to. Just fuck me.'"

The good times between them became more and more scarce as his life filled up with other romances in the nineties. "I thought, I can't buy into this drama," Basinet said. "Why didn't he save the drama for acting? I wasn't getting paid for this misery, and finally, I had to step away. He was in a protracted midlife crisis; everything around him was changing. Friends like Frank Sinatra were dying. I don't know how close they were. I know he went to the funeral. We discussed Frank when I called that morning, and he was devastated. He'd been up all night crying, but I don't know whether that was related to a friendship with Sinatra, or simply understanding that this was a huge shift in the way Hollywood was about to go, that a great peer had died—*that* was a major shift. Another was, he lost his life with Rebecca Broussard, mother of two of his children. And he had a longtime staff woman who had a stroke. Then an old friend died, and Jack became ever more aware of his own mortality. He began to spout charges at me that I sensed had been made by other people in his circle. I could tell whose mouth it was coming out of, and it wasn't his.

"I was Jack's date for Dennis Hopper's birthday party in the nineties. I had a run-in with Jack that night. More and more, we'd meet each other and start fighting. I tried to show him the gentlemanly way to resolve our differences. We'd make great love and then I'd call in the morning and say that I wanted to break up. He was threatening to get kind of serious, and I really wanted a career in music. At one point he really went off the deep end and I knew he wouldn't be 'coming back' for a good three years. He was putting a lot of pressure on me, and I naturally wondered, Do you really want to allow this person to have control over you?

"I knew that what I was starting with my career as a singer would also take me approximately three years to bring off, plus another year to market myself around Hollywood. Maybe he could have helped me, but I always looked to him for more basic things,

like a hug. I got a little tired of always being supportive of him, only to see him go back to LFB.

"He had become my career, and I had to regroup. I was thirty-five or so, and this person was asking such deep things of me, and we'd got serious pretty fast, with him calling me his soul mate. I'd better be careful here, I thought. Keep building your own career, because he can't take that away from you. That's the one thing he could never deprive me of. I kept leaving him because I knew that this wasn't a life I wanted. I was carrying the weight of whole frigging Hollywood for him, and my friends kept saying, 'Why aren't you a star by now? Why aren't you acting?'

"Our two worlds were not coming together any longer, but he didn't want me to leave him. He left a message on my answering machine: 'You've woken up Rip Van Winkle.' Louis Armstrong had played a song for Jack and Anjelica Houston, and Jack had taped it. Now he played it for me, and I told him, 'That's so cool,' and meant it.

"I needed him; I was a single mom, and I was trying to shift from being a Martha Stewart overachieving homemaker to following my dream. And I had no father for my son. Jonathan wasn't seeing his father at the time. He was a teenage boy, and I needed someone to say, 'Respect your mother.' You know, instead of my son seeing me crying all the time. Jack's name is really John, and he'd always call Jonathan and say, 'Hey, Johnny' to my son. Jonathan could see straight through him." Nothing came of Nicholson's relationship with the boy. He liked kids, but rarely lived with them.

When Nicholson made a trip to Cuba in the nineties, Basinet recalled, "I gave him potpourri, this really cool Japanese incense. I'm thinking, He's going to all these houses of ill repute in Cuba and here I am, giving him incense to burn while he's there." Accompanied by Broussard, Mark Canton, and Jake Blooms, Nicholson took the Jamaica route to Cuba, where he'd been invited for a week by

the Cuban Film Board. He visited with dictator Fidel Castro for three hours, later calling the despot "a genius" without backing up the claim, beyond remarking, "We spoke about everything . . . life, culture—he's in pretty good communication with Ted Turner (they have CNN there). He stays up late, like I do. Yes, he's seen some of my movies. We smoked a few good cigars." On Havana streets, Cubans recognized the star and applauded him as he emerged one day from his hotel. Despite the brilliance he attributed to Castro, Nicholson said, "It was sad to see the buildings crumbling, milk only available for little children." He blamed such conditions on the U.S. embargo and said he was hopeful of a reconciliation between Clinton and Castro. "There's no remaining reason for it to continue," he said, overlooking Cuba's status as a police state. "Castro never wanted to break it off with us," he added, conveniently forgetting Castro's romance with Khrushchev and the sixties missile crisis that brought the world to the brink of nuclear war.

On Nicholson's return to the U.S., Basinet still felt under intense pressure to keep their relationship secret, and even had a code name for him, UKW, meaning "You Know Who." He invited her to a screening at Sony of *As Good as It Gets*, sending her a fax. A neighbor of hers, a light-skinned black model with whom she'd filmed a commercial, was visiting Basinet and saw the fax, which stated that Basinet could bring a guest. "Oh, I want to go," her friend said. Being poor, Cynthia designed her own clothes, and looked stunning that night in a purple-magenta Chinese dress with a high neck—"frigging form fitting with slits up to here"— Calvin Klein caramel mules, and a vintage caramel coat.

It was a miserable evening. Her companion kept complaining about being hungry, while Basinet tried to cope with her own hurt and confusion over being unable to speak to her lover, though he was in the same room, sitting a few rows behind her. The model she was with said, "I thought you knew him better than this."

Basinet at last rebelled over living a lie, and later said, "We were having way too heavy a relationship for no one to know about it." Their affair had become all work with too little reward. "Afterward," she related, "I walked right past him."

The screening party went on to a bar. Basinet wanted to go to a sushi restaurant next door to the screening, but her friend insisted they join Nicholson and the others at the bar. "This girl's on my ass," she remembered, "and I've got this CD by Jack Webb [star of *Dragnet*] to give to Jack, who liked to sing to me. I was hoping that Jack and I would eventually sing a duet together. He has a good voice if he'd work on it—a 'talking' voice. I wanted us to sing that Doris Day song in which Dean Martin prods her about who's she in love with and she says she isn't in love at all. It's just enough singing for Jack to handle. I'd been after him to take care of his throat, to smoke less, and then at the L.A. Lakers, he'd be screaming. Without sounding wifey, I suggested he get some throat-coat tea.

"So he finally shows up at the bar, and the *L.A. Times* was also there. I just sat on a bench, with my girlfriend yapping in my frigging ear. I'm holding this CD and finally Jack shows up and of course he's got to position himself on the wall—he's doing a kind of receiving line, right? Oh, this is so cute, right before he gets to me he like slows down."

"Here's your CD," she said. "I can't stay. My girlfriend wants to go for sushi."

"What? You're leaving?"

"Yeah."

"Well, wait a minute."

Nicholson followed the girls outside. "But his limo wasn't there," Basinet recalled, "and Jack lost his temper. I'm sure he wanted to jump me in the limo, who knows?"

"I got you this CD," she told him, and later recounted, "The limo was gone, and he was swearing and yelling."

"Wait, wait, slow down," she said. "I wanted you to see my dress. It's the whole reason why I wore this outfit. Slow down! You're not looking at the coat. I wore it for you—it's a vintage cattle coat."

"Finally," she later recalled, "he stopped and looked and was darling about it. We wind up in the alley, up against this brick wall. I gave him my CD and made him open it. By now he really wanted the limo, and he was so nice, indulging me. Poor guy, I thought. What if he had done all that work for me and just split [from the bar] because I'm *the* girl? I'm the only one I saw in that room that would have appealed to him."

"Okay," she told him. "I've got to go." She collected her girl-friend and went off to Sushi Row. "He's always testing you to get you out of his life," she said. "He pushed me to make that ultimatum."

Asked why she didn't go public with their relationship at the time, she said, "I knew he really wanted a third Oscar, and I felt that if I had gone public, and he didn't go back to Rebecca, it would change the focus. I wanted him to be focused on how he had done it in the past. He seemed to know what he was doing."

In the late nineties, the yelling started. "I just didn't anticipate having that powerful voice yell at me," she said. "I called Jack one night after my son had run away from home, and Jack was dealing with a lot of things, like fighting with Rebecca. He was lonely, and started taking it all out on me. That was the turning point. I could see we were sliding downhill, but it took a whole year to finally leave him after that. By now I was singing live, and I kept building momentum. Then came the car accident Jack got into."

Nicholson had invited Lara to dinner at El Cholo restaurant in downtown L.A., where they sat in a darkened booth, picked at their food, and flirted.[86] After dinner, they got into an automobile crash, and she left him at the scene, before the police arrived, reportedly because she didn't want David Spade to find out she was

still keeping company with Nicholson.[87] According to a press report, "He smashed up her Mercedes on Mulholland Drive while she was in the passenger seat."[88]

Basinet recalled, "I talked to him the week before, and I was a little shitty with him because I knew he was with somebody else, and I couldn't compete. He was becoming pussified. I heard about it from my Italian bodyguard. I was developing my music, handling a bit of newfound fame, traveling with this bodyguard, who was with me for a long time. He had been my driver, and then I stopped working, but he stayed on as my bodyguard. I'd go everywhere with him and he protected me. He knew Aikido. It was really great; he was totally non-Hollywood; didn't butt in my conversations, kept at a distance."

"Is Jack okay?" the bodyguard asked Basinet.

"What do you mean?"

"Well, I hear he got in an accident."

"When did this happen?"

"'Oh, I heard it from someone in Italy who had seen it on TV."

Basinet called Nicholson, but someone in his house answered the telephone and gave her "the runaround," she later recounted. "I confirmed it through an actor, a friend of Jack's, who was in a limo one night when I was driving somewhere with a friend, and I waved and caught his eye. He got out at the light, came over, and said, 'You have amazing lips.' We hung out that night, and from what he said, I knew there was something going on with Jack. He told me who his friend Jack was going out with, like he was bragging about it. It made me feel like a salvage girl. I decided I wasn't going to spend the rest of my life analyzing this. Because it's too expensive. My friends are major tycoons who were always telling me, 'You're not still with that guy, are you? Well, Cynthia, you should be with a guy that's this and this and this.' Jack knew what he was doing—I'd been wearing used clothes, locked in my house,

driving a shit car. What guy's going to ask me out? So I made this decision to leave him. The reason why I left was that, if it's something you want, he takes it away from you. He hates women, but he falls in love with them, then can't stand it. And the minute he falls in love, he's going to punish you.

"When she [Lara] got caught in the car accident, I could have [told the media], 'Whoa. I don't know what he's doing with her, he's with me.' But instead I just kept my mouth shut, and they went to [an awards show] together. Then I sent him a tape-recorded message, and he went on the retaliation. I tried to get hold of him, and I got the brush off, his secretary kind of interfering a little bit. She's like, 'Well, you know, he has . . . You shouldn't have put all your eggs in one basket.' Well, I didn't want to tell her he's been making me put those eggs in one basket. I used to be a pretty wild chick, you know. I think he took LFB to Europe after that accident. When Jack got back, my son called up there. [Finally] I talked to Jack after he went to a doctor following the accident. He seemed hurt that I'd left him, and I could tell from his voice that he was sensing his mortality, but I was flippant."

"I can get dick anywhere," she told him, and later recalled, "I needed his help but I told him he could do whatever he wanted. 'I'm happy to see you in love, if that's what's going on, but what I was trying to do was walk you down a certain path and I only want the best for you.' I told him what I was trying to do with my own career and the company I was trying to build. I was a little nutty. I sent him a herb basket, and I was made fun of for 'acting wifey.' I didn't cry; I just ran off into the night, without making love with him. I knew I couldn't beat LFB. She had a publicist. She had a TV series. She's a good time girl. She has her own money. When he acts [like a diva], she can act like a diva back. See, I never acted like that. When he hurt me, I said, 'You've hurt me.' I didn't say, 'Don't call me for a week.'"

As Basinet receded in his life, Lara was riding high. Nicholson gave her a $50,000 set of designer earrings.[89] They discovered the similarities in their troubled backgrounds. Like Nicholson, Lara avoided her father, commenting, "I do believe you can pick your company, family included," and, again like Nicholson, even referred to herself as a "bastard," since her father had had his marriage to her mother annulled.[90] In Nicholson, Lara had a father substitute, according to a friend, who said, "She sits on Jack's lap sometimes and he treats her like a little kid. He plays daddy."[91] He even offered her a wedding ring, but she told a reporter, "I certainly don't want to get married at this stage of my life. I want to have fun. I won't let any man change me or tell me what to do. I like to call the shots. I never put up with crap, and I won't cry over any man. There are so many other men out there to play with."[92] Nicholson's relationship with her would proceed along a rocky course for the next eighteen months.

Basinet went into emotional meltdown. "I knew the nights they were together, and I just got drunk and puked. It was like somebody punched me in the middle. His attitude toward me was changing again, especially after she moved in. All of a sudden you have the whole world telling me that I never existed. LFB's so great and this and that and the press saying they're getting married and the wedding bells. All of a sudden he was saying I was a witch, that I had an ulterior motive. LFB got in the thing, and I knew I couldn't guide him along if he was going to choose another lifestyle. Then came the accident when I was trying to sing live, putting on a show. I knew this was going on with LFB and he wasn't going to come see me sing live. Once he got into the accident with her, I thought, This guy ain't coming back—he's talking to me like he doesn't even know who I am. Once he got caught in the situation, about two months into it, it wore off, and he realized what the fuck he'd done. But it was too late. The machine had al-

ready taken on a life of its own. All these people were involved. But I was convinced that if he made another film, he'd sort out his issues in his work. 'Go, do it, do it,' I said. They shot *The Pledge* in Canada. It took care of his anxiety for a while."

He stayed in touch with Basinet, if only by messenger. "That Christmas after the accident in '99 he had somebody come over with gifts. But it wasn't enough. If in there was ten thousand dollars, I would have gone, 'Okay.' [But it was] a thousand for his messenger and a thousand for me."

Nicholson's forgettable 2000 film, *The Pledge*, opened with a scene of a retarded boy, not unlike Basinet's retarded older brother Chris, discovering the body of a dead seven-year-old girl. Coincidentally, Basinet had just been talking about her brother with Nicholson. "All this time I had been writing Jack, I'd been talking about my brother," she said. "It helped me, and in turn helped him. Of all the scripts he'd been shown, why pick that particular subject, at that particular time? And not only that. How would he possibly know what it's like to play a retarded person, if your heart's blocked? You wouldn't even begin to know. I often talked about the major moral issue of whether retarded children can have kids. Then *The Pledge* came out and I thought, This is beyond my parents' and brother's wildest dreams. My constant discussions about a lot of things are a big inspiration to a lot of friends. I was writing Jack every day, urging him to hang out with [the film's director] Sean Penn, because Sean's dad had died, and Jack was close to Sean. I told him, 'This is where I see your persona.'"

Her support of Nicholson during and after their affair was draining. She received no credit for her contributions to their life, little compensation for the sacrifices she'd made to remain in his shadow and keep their relationship secret. She tried to get Nicholson out of her system. "I went out with other men, got engaged. I was really upset. I was very isolated, and I used to go to bed every

night and pray that I would meet somebody." He'd broken her heart, but "more than that, he broke my soul. Most of my girlfriends, all my friends that I've gone through modeling with, who don't look anywhere near as good as I, have half my brain, are all living beautiful, gorgeous lives with tycoons."

A final breakup was inevitable. "He comes to the table with a real poor view of women," she said. "He'd claim that he didn't understand 'women and their games.' I couldn't spend my life trying to change that view. I knew we had to break up, get all this shit out of the way, and maybe just see each other. I kept kind of leaving him because I kept trying to find anything that he would do wrong, and bring it up. More to the point, he was starting to get really depressed. He felt such energy after winning the Oscar for *As Good as It Gets*, and that lasted for about two months. Then summertime came and he didn't have the kids, and when he didn't have the kids he was, like *arrgh*. He asked me about his kids a lot, which again made me 'too wifey.' As a friend, I said, 'Why don't you two get back together,' meaning Rebecca Broussard. I just assumed that they loved each other, and I figured, Look, she's been in it with him for this long. She should have him. She's earned it. Plus, there were children involved. Jack and I were in love, that rare thing, and I felt like Yoko Ono, when she pushed John [Lennon] out on that girl [May Pang].

Basinet and Nicholson broke up on a Tuesday. "I think I tried to see him Sunday night and Monday night and finally got to see him Tuesday, because he knew what was coming. He had me sitting there waiting. He had a couple of people come in; I got the staff and the handyman."

She told Nicholson, "I'm just looking out for your health."

"You need to look out for your own," he replied.

"I will," she said, and then she "walked out and that's the last time I saw him until four months later." On that occasion, they met

at his house. "I'd recorded that song 'Haunted Heart' and gave it to him for his birthday. He calls me up and I don't call him back for a week, because I'm so shocked that he's calling me, even though I'd recorded this song and packaged it." Nothing came of their meeting, but at last she made the tabloids. "The *New York Post* or *New York Daily News* [called me] a Karaoke singer that got dumped by Jack. My songs are Karaoke tracks, so I always kid and say, I'm a Karaoke singer, but that's like calling Pavarotti a barber-shop-quartet singer.

"One day in February 1999, I walked up to his house like a fucking moron. I basically gave him an ultimatum: I needed him to help me pay for a pedicure. 'Well, I'm not your boyfriend,' he said. Three years later, and he's saying, 'I'm not your boyfriend.' He was saying it because he was hurt, because the last time he'd said it, I had dumped him. I think he was testing me to see if I'd say, 'No, you are.' I don't know, but either way I couldn't play that game anymore."

They were standing in his kitchen when Jack said, "Look me in the eyes and tell me you don't love me anymore."

Later, she advised him to take a medication "for his hands for the arthritis. I bought it for him but he wouldn't take it. He won't take anything, like vitamins or pills. He doesn't like to swallow pills. Jack comes from an era in which, instead of a man taking care of himself, he puts the responsibility on a woman, then resents her, because she speaks up and says, 'Whoa, I am drained.' And when you're drained, he finds a new one and you're like, 'Hello, I'm completely drained, bed-ridden, and you're running around with that girl who's dissing me and being mean?'

"I have a little house, and my neighbors knew because he'd come to my house. He drove himself, in his black Mercedes. Guys began to call me and say, 'Oh I heard you're with Jack, but there's this girl on Howard Stern describing his dick doing this and that.'"

Friends and acquaintances kept saying to her, " 'Why doesn't he put you in a movie?' I didn't want him to have that kind of power over me. I didn't ever want to not be truthful. If there ever came a moment in the relationship when I couldn't stand up to him and tell him the truth, who would? Everyone else had bought in. I refused to. We almost started to build the land of Shangri-la between us. So, I'm the one that got burned.

"I got engaged to another man after nine months, because Jack wasn't getting any better. I was talking to Jack and I could tell the discrepancy between what I'm feeling he's trying to say and what's coming out of his mouth. It didn't match. His secretary [also seemed concerned and] asked me, 'Are you guys going to get back together?' Then Lara Flynn Boyle showed up at a basketball game [with him]. Jack and LFB are running around the White House. My son and I are starving. We were getting evicted, going to Food Shelter. The reason we're not together is, he wanted that high again, and I thought, I wanted to show him how to have it organically.

"I asked Jack for little things that meant a lot to me—like a car ride; I like to go for car rides, and he wouldn't do that. It would have meant a lot to me if he had taken my son to a basketball game. Nobody would have known. I mean I just cried for so long that I realized I had to leave him.

"I left him in February, and he said to me, 'I'm not as strong as you.' I wouldn't move in, get married, get engaged. The only reason most men are committed is because they're in such codependent relationships they're too distracted to pursue other pussy. That's their idea of commitment."

Just as girls rose and fell in the amorous saga of Jack Nicholson's life, so did restaurants and bars enter and then drop out of favor

with the fickle public. Even the once-fashionable Monkey Bar lost its cachet, and became as dead as the Brown Derby, Chasen's, and Ciro's. According to private detective Frank Monte, Alan Finkelstein "divested himself of his interest in the club for a very small amount of money, and Nicholson got out as well." With no one to pay the rent, the Monkey Bar closed in the spring of 1996.[93] Finkelstein, still handsome in a Frank Zappa way, resurfaced later in the 1990s as a co-owner of the swank Indochine restaurant on Beverly Boulevard in Los Angeles.

Another brainstorm of Finkelstein's was a credit card with a built-in magnifying glass, which was inspired by Nicholson one day when the two were dining at Abetone's in Aspen. When the waiter arrived with the bill, Nicholson took out his credit card and a plastic magnifying glass that he'd bought in a drugstore.

"What are you doing?" Finkelstein asked.

"I am trying to see the bill so that I can pay the bill."

It immediately occurred to Finkelstein that he could combine the two items—a credit card with a magnifying lens embedded in it, for the benefit of diners who had trouble reading the small print on their restaurant tabs, and it would also be useful in dealing with telephone books and food labels. His invention was backed by the Chase Manhattan Bank, which launched the LensCard at a party attended by Nicholson, Sean Penn, and Michael Douglas.[94]

Like the Monkey Bar, the LensCard caught on, but not for long.

Seventy-year-old Stanley Kubrick died on March 7, 1999, and was buried in the park at Childwickbury Manor. He had just finished *Eyes Wide Shut* with Tom Cruise and Nicole Kidman and never saw the final cut. Both Cruise and Kidman attended the funeral, along with Terry Semel, Sydney Pollack, and Steven Spielberg.

Though Nicholson wasn't there, he and the director had remained in touch over the years since *The Shining*, chatting on the telephone about boxing and the O.J. Simpson trial. "Even before the trial started," Nicholson recalled, "Kubrick sensed corruption in the air and felt that O.J. wouldn't be found guilty. . . . From time to time, Stanley would send me a tape he had made on European TV, a film, a television series from the BBC that I couldn't get in the States, a thing with Brigitte Bardot, or *The Singing Detective*."

The movie industry had ignored Kubrick the last seventeen years of his life, and only a few—Nicholson, Spielberg, Polanski, George Lucas, *Deliverance* director John Boorman, and *The Empire Strikes Back* director Irvin Kershner—kept up their friendship. "In his absence, I was the one who was asked to accept the D.W. Griffith prize awarded by the Directors Guild," said Nicholson, referring to the 1997 award named after the movies' visionary intellect. "Though underestimated, Stanley was number one."[95]

Chapter Ten

ANGER MISMANAGEMENT

When President Clinton had sex with an intern, Monica Lewinsky, in the White House, and then urged her to lie about it, Nicholson said, "What would be the alternative leadership—should it be somebody who doesn't want to have sex? Bill, you're great. Keep on."[1] In the late nineties, largely at the urging of Cynthia Basinet, Nicholson joined Barbra Streisand, Ted Danson, Mary Steenburgen, Frances Fisher, Andrew Shue, Elisabeth Shue, Norman Lear, and Tom Hayden (D–Los Angeles) in staging a gala to prevent the president's impeachment. Basinet recalled, "I don't know if Jack realizes the cost to my psyche. . . . When he came up and did something for Streisand—they're old friends—in support of Clinton, I don't think he would have come out of the closet and been so political about a lot of things had I not encouraged him to use his more political side, whether I support Clinton or not."

Addressing the crowd at the gala, which was attended by 1,000

in front of the Federal Building in Westwood, Nicholson said, "I wanted to come down today because the presidency of the United States is at stake. Both parties could stop this tomorrow morning. I'm just here to wish you all a Merry Christmas and say I hope they do." In Washington, D.C., the House of Representatives voted 228 to 206 to impeach the president for perjury and 221 to 212 for obstruction of justice, but the Senate acquitted him of perjury 55–45 and obstruction of justice 50–50. Conservatives saw it as a "cultural collapse," but people like Nicholson saw it as a long-overdue reaffirmation of the sexual revolution.

In a negative, premature career obituary of Nicholson in April 2000, *Talk* magazine stated that Kevin Spacey had replaced him as "the new king of irony,"[2] though it was not Nicholson, but *Talk* magazine, that was doomed, and Nicholson would go on to out-distance Spacey with an artistic triumph in *About Schmidt* and a box-office bonanza in *Anger Management. Talk*'s Hollywood own-er, Miramax, scuttled the magazine when it became obvious that no one needed both *Vanity Fair* and *Talk*, and the latter's high-profile, party-giving editor, Tina Brown, shortly resurfaced as the hostess of CNBC's talk show *Topic A.*

Nicholson escorted Lara Flynn Boyle to the Michael Douglas–Catherine Zeta-Jones nuptials at the Plaza Hotel in New York and to the New Year's millennium party at the Clinton White House, where Lara lifted a toothbrush holder and a PRIVATE LINE sign. Though she was a Bulls fan, they also attended countless Lakers games together.[3] Then, when thirty-seven-year-old Rebecca Broussard, who married actor Alex Kelly in 2001, moved into Nicholson's house during a crisis, bringing along Lorraine, ten, and Raymond, eight, Nicholson cleared out and sought shelter in Brando's house, announcing, "Heeeere's Johnny!" The seventy-seven-year-old Brando welcomed his friend and compound mate, turning over a whole wing.[4] According to *US Weekly*, Nicholson

now had a total of eight children, Brando, eleven.[5] To an inquiring journalist, Broussard denied that she was planning to file a palimony suit against Nicholson. When he took her and the kids to the opening of the Disney California Adventure theme park in Anaheim in early February, they even resembled something approaching a normal family.

Depicting a fictional scene between the odd couple in Brando's house, *The Times* (London) let its imagination run wild, publishing a skit in which Nicholson wandered into Brando's kitchen around noon, naked except for a pair of designer shades. Brando was tucking into three hamburgers.

"Shit, that was some night," Nicholson said, pouring a Bloody Mary. "Got any Advil? Jeez, those broads last night."

"Why is it that one's never enough for you?"

"Never has been, never will be. It's like you and burgers, Marl."

One of Nicholson's girls entered the kitchen, wearing only a Hawaiian shirt, and he told her, "Marl's really pissed because he didn't get laid last night." She said the other girl was still in Nicholson's bed, and Nicholson made a beeline for the bedroom, leaving her with Brando. When Nicholson returned an hour later, the kitchen was empty, and his shirt lay on the floor. Grinning, he raised his glass in the direction of Brando's wing, and said, "Guess he made her an offer she couldn't refuse."[6]

It sounded authentic enough, but in his younger years, it had been Brando who'd offered to share his girls, or tried to. When actress Pat Quinn arrived at the compound for a date in 1965, the actor was talking with his biographer Bob Thomas. "You know," Brando told Quinn, "you're going to have to fuck us both." When Quinn refused, Brando assured her he'd only been joking, and they went to bed, just the two of them.[7]

In 2001, the bloom was off Nicholson's romance with Lara Flynn Boyle, who'd begun to call him "Jackpot Belly."[8] During a

poolside brunch at the Beverly Hills Hotel, she "dump[ed]" him, according to an inside source. "Lara wasn't into the relationship as much as Jack was," said the insider. "She was in it for the parties and the notoriety that came with being seen with Jack at Lakers games."[9] In 2001, she became involved with a man half Nicholson's age, thirty-two-year-old Eric Dane, who played Dr. Wyatt Cooper on ABC's hit drama *Gideon's Crossing*.[10] According to a friend, Nicholson was in "a rage. . . . He's used to be the dumper, but now he's getting a taste of his own medicine—and he doesn't like it one bit."[11]

There were conflicting reports about the status of the affair throughout May 2001. On the fourteenth, *People*'s Tom Cunneff talked with Lara and relayed the information that she was "still dating" Nicholson. By the twenty-ninth, however, Eric Dane was redecorating his home to please her, replacing his minimalist leather furniture with shabby-chic overstuffed sofas.[12] The following month, she had Dane doing things Nicholson would never dream of, like going shopping and buying her a teddy bear at a toy store.[13] However, when Dane asked her to attend a Lakers playoff game in the NBA finals, she chose to show up with Nicholson in the front row at the Staples Center. Also at the game was *Rush Hour 2* star Chris Tucker, who explained, "If you're popular and you have a hit movie, you get a floor seat easily. . . . But if you ain't hot, you ain't going to be at the game, or you're going to be all the way at the top."[14]

Perhaps the surest indicator of A-list status at the Staples Center was access to the Chairman's Room, presided over by the Lakers' senior vice president, forty-two-year-old Tim Harris. During half-time at an early 2004 game, Cameron Diaz, Justin Timberlake, and Selma Hayek drank beer and ate peanuts while, over in a dark corner of the lounge, Leonardo Di Caprio, Toby Maguire, and Jen Meyer sipped cocktails. Nicholson and Penny

Marshall sank into sumptuous leather chairs in the smoking-friendly Jack's Room, a small chamber that was constructed specifically so Nicholson wouldn't have to go outside to light up. "Jack's Room is really the inner sanctum," said Harris. According to *W*, getting into it "required a degree of clout in the stratosphere."[15] Dyan Cannon, whose floor seat was next to Magic Johnson's, supplied home-baked goodies at half-time; Nicholson liked her banana muffins, while the athletes preferred her brownies. The Staples Center's 140 courtside seats went for $1,900 each; Nicholson had four of them for the entire season, which set him back $15,000.[16]

At the next few games, he brought along his son Raymond, and Lara was photographed smooching with Eric Dane at a Los Angeles car wash.[17] Giving a new meaning to the term on-again-off-again, Nicholson took Lara abroad with him, and in England in July 2001 they attended the men's championship final at Wimbledon's Centre Court, which was won by Croatian Goran Ivanisevic.[18] Then, with his sometime mistress still in tow, he made his first trip to Russia for the overseas release of *The Pledge*. During the junket, he met President Vladimir Putin at the home of Moscow International Film Festival director Nikita Mikhalkov, and, while sitting outside, they were attacked by swarming insects. Nicholson made a reference to "these terrible mosquitoes," and Lara offered Putin a yellow tube of insect repellent. The president stared blankly at her for a moment before declining. Then, when Putin remarked that his favorite Nicholson film was *One Flew Over the Cuckoo's Nest*, the actor said that was what most people told him, especially children.[19] Letting that one pass, Putin presented Nicholson with a white fox scarf. The gift would "remind [him] of the Russian winter," Nicholson said.[20]

Despite these gaffes, *The Times* (London) Moscow bureau hailed the meeting between Nicholson and Putin significant as a

sign that "Russia . . . has joined the modern European democra-
cies . . . and . . . deserves a substantial role in global decision-
making." On the final night of the Moscow International Film
Festival, Nicholson received its first lifetime achievement award,
named for Konstantin Stanislavsky. In a congratulatory statement
read aloud at the Pushkinskaya Cinema, Putin lauded Nicholson's
versatility and stressed the importance of movies as a cultural
force. Accepting the award, Nicholson broke up the audience by
attempting a few lines in Russian, and when the laughter and ap-
plause died down, he reverted to English, saying, "I know how
warm it is tonight, so sit down. Because of this I won't give the very
long and detailed speech in Russian I had planned."

Back in America, the nation was reeling from the terrorists at-
tacks of September 11, 2001. In Manhattan, Nicholson arrived at
Ground Zero in his limousine, and was immediately waved
through by security. As he stepped from his car, recovery workers
shut down the machinery, applauded, and approached to shake his
hand.[21] Then, like the blue-collar character he'd played in *Five
Easy Pieces*, he took the controls of a large crane and helped clear
the wreckage. Over the next three hours, he signed 250 workers'
hard hats, and on leaving, he accepted a six-by-eight-inch cross
made from the ruins of the World Trade Center.

In November, he took Lara to New Jersey to show her Man-
asquan High School. "He was very gracious and signed auto-
graphs," said Lee Weisert, the choral and theater director, who
asked the actor if he'd mind having the school's 500-seat audito-
rium named after him. Nicholson had appeared on its stage in the
1954 senior play, *The Curious Savage*.

"I'm humbled," Nicholson said. "I'm honored."

Forty-seven years after his graduation, Manasquan High es-
tablished the Jack Nicholson Award for outstanding drama stu-

dents. One of the winners, seventeen-year-old Doug Morgan, said, "To think that I shared that stage with somebody as brilliant as him."[22]

Prizes continued to bombard the sixty-four-year-old star. Quincy Jones rang him one morning in 2001 when Nicholson was still in bed, and told him he was to be a recipient of the Kennedy Center Honors in Washington, D.C., for lifetime contributions to American culture. Nicholson was "overwhelmed," he said. "I'm a World War II baby, so I'm very patriotic. I felt proud and humble." President George W. Bush welcomed Nicholson to the White House in December, calling him "one of the true greats," distinguished by "mystery [and] the hint of menace." In an interview with *People*, Nicholson said "it's always thrilling" to visit the White House, "no matter who is the President. But I am a big Democrat."[23]

When CBS aired the Kennedy Center special on December 26, 2001, the *New York Times* wrote, "This year's honorees, Van Cliburn, Julie Andrews, Quincy Jones, Jack Nicholson, and Luciano Pavarotti, are no strangers to attention and adulation, but during the awards gala . . . they ha[d] the look of people in a dentist's waiting room. . . . When Warren Beatty, after a barrage of film clips showing Mr. Nicholson wielding an ax or trashing a restaurant, sa[id], 'He's everyman; he's us'—well, let's hope not."[24]

After appearing in the 1994 psychological thriller *Inevitable Grace*, which flopped, Jennifer Nicholson dabbled in interior decorating, refurbishing her father's Mulholland Drive residence. Her real love was clothes, and in 1998 Maska, an Italian label that used celebrity offspring in its runway shows, agreed to employ her as a model after she sent them a headshot and honestly told them she

was a size fourteen. "But when I got to Milan, they said I was too big and they weren't going to use me," she recalled. "It's not like I lied and told them I was a size six."[25]

In 2000 Jennifer teamed up with Keith Barish's daughter Pamela and designed a fashion line that was sold at Saks Fifth Avenue, but her arrangement with Pamela soured after a year. "We thought our styles would mix better than they did," Jennifer said. In April 2002, the thirty-eight-year-old Jennifer introduced her own clothing line, which the *Los Angeles Times* praised as having "the same devilish spirit as her father's famed grin." Her designs reflected her lifelong passion for vintage clothes, which Jennifer described as "1950s debutante on acid." Ranging in price from $250 to $1,000, her monogrammed waitress shirts and three-quarter-length, trumpet-sleeved jackets with oversize safety-pin fastenings were sold at her Santa Monica store, Mlle. Pearl, on Montana Avenue, and at Saks Fifth Avenue in New York. Also selling Stella McCartney, Fake London, Roland Mouret, and Narciso Rodriguez, Mlle. Pearl gave L.A.'s Westside residents a place to shop for designer clothes without having to make the long trip "into town," Jennifer said, and added, "Proud papa. He loves clothes." Her design studio on Market Street in Venice was in the same complex as the gallery of Anjelica's sculptor husband, Robert Graham.

Jennifer has never revealed what she thought after her father announced, following the birth of his son Ray, "I finally got it right."[26] Nor, for that matter, has his daughter Lorraine, Ray's older sister. Nicholson's faux pas seemed to indicate that he still regarded women as the second sex despite social and cultural advances that had long since made such comments politically incorrect.

Referring to his younger children, Nicholson said, "Oh, we do everything. I'm taking [Ray and Lorraine] . . . to my ranch house.

We have a good time being out there. I took Raymond . . . to the Lakers–Chicago Bulls game—he has fallen under the spell of Michael Jordan. I was so pleased that he never stopped cheering for the Bulls, despite the fact that he had a nervous breakdown when he discovered that I'm a Lakers fan. He never backed off and I was very proud of him."[27] Although the boy had inherited his father's legs, which were "short but useful," he was, at least in his dad's estimation, a future lady killer. "Ray may have a problem with being a little too good-looking," Nicholson said. "Looks exactly like Rebecca. . . . You can't wait to get him into a collar or a shaving commercial."[28] Like his father, Ray was "very, very tough" with "absolutely nothing" to back it up except for a "soft, moochy interior," Nicholson added.[29] Lorraine, or "Liddy Poo," was very feminine, always insisting on wearing dresses, and she'd inherited her dad's elegant eyebrows. When Nicholson visited her in preschool, he sat in the front row. Later, he volunteered to help conduct a cooking class, but after he made a mess of the flour and sugar, teachers advised him to try something else.

Thereafter, he appeared at the school on a weekly basis to read stories aloud, predictably enrapturing everyone.[30] When Lorraine was seven, Nicholson engaged Olympic and *Champions on Ice* star Tai Babilonia to teach her how to skate. "You should have seen the mothers at the rink," Babilonia said. "Jack would come to watch, and they would comb their hair and check their makeup. The world stopped." Referring to her partner in U.S. pairs competition, Randy Gardner, she added, "Jack has tapes from when we won Worlds in 1979."[31]

In early July 2002, Nicholson escorted Lara to East Hampton, Long Island, for a charity benefit gala featuring her film *Men in Black II* and benefiting Bridgehampton's Hayground School, which offered educational support to local Native Americans and African Americans. Taking along his children Lorraine and Ray,

they all stayed with *Saturday Night Live*'s Lorne Michaels, described by a journalist as "Nicholson's World Series ticket–dispensing buddy."

Nicholson skipped the film, preferring to play a round of golf, later joining Lara and the kids Sunday evening at Nick and Toni's on North Main Street, where they sat at a table across the dining room from Steven Spielberg and Barry Sonnenfeld, director of *Men in Black II*. Nicholson wore a baseball cap and puffed on a cigarette. A reporter noted that he "chomped through a hot dog like an aging bear—holding it in a single paw and attacking sideways from the top." Describing his son Ray, the reporter wrote, "Think miniature Jack in baggy black football jersey."[32] Ray and Lorraine would "give her shit," Lara said, for chattering with the press. She further complained that during the filming of *Men in Black II* it had required four and a half hours to get into her leather cat suit, "and once I was in it, I couldn't pee."

Later that month, Lara told *US* magazine, "It is so over with Jack. Now I need to find a good man." That was not always a simple matter, since "they have to like me as much as *I* like me. And sometimes, for a man, that can be a little hard to deal with."[33] One who could deal with it, however briefly, was Harry Morton, the twenty-one-year-old son of Hard Rock Hotel owner Peter Morton, whom she met over a blackjack table in Las Vegas. Eric Dane was still in the running, as was Nicholson, who, attempting to conceal the latest in their ongoing series of reconciliations, sneaked out the back door of Mr. Chow's in Beverly Hills.[34] Some observers felt her secret hold over Nicholson was her mother Sally's homemade potato pancakes, which Sally shipped on dry ice from her home in Chicago to Mulholland Drive. Nicholson paid for the shipping and reciprocated with expensive thank-you presents.[35] Sally's pancakes weren't enough to ensnare Eric Dane, who, after

joining TV's *Charmed* series, began a romance with costar Alyssa Milano.[36]

In the summer of 2002, thirty-nine-year-old Rebecca Broussard Kelly[37] rang Nicholson in the middle of the night, wailing that she was about to be jailed by Canadian policemen on charges of assault and mischievous endangerment of an aircraft. If Nicholson's specialty was road rage, Broussard's was air rage. According to *People*, she "was apparently drinking before she boarded the L.A.-to-London flight," and the "crew refused to serve her any more champagne."[38] Because of her "abusive and disruptive" behavior, she reportedly had to be restrained before passing out,[39] and Virgin Atlantic flight 24, bound for Heathrow Airport, "made an emergency landing in Winnipeg."[40]

"Get your lawyers on this," she said. "I'm the mother of your kids. . . . I need help."

Nicholson gave her a stern lecture. Later, a lawyer said Broussard was "presumed innocent,"[41] and she was released on $15,000 bail.[42]

Lara was on the loose again, and she got chummy with Sugar Ray frontman, rocker Mark McGrath, at the L.A. opening of *Men in Black II*, and at a later party hung out with *Friends* star Matthew Perry.[43] Then, at a Beverly Hills restaurant, spotting David Spade, she went to his table and started to give him a kiss, but Spade jumped up, advised her to keep her distance, and headed for the men's room. His relationship with *Cruel Intentions* actress Selma Blair was apparently going far too well to take any chances with an old flame.[44] "If a man isn't a wimp, he won't run from me," Lara said. "Real men appreciate me for who I am. The really cool guys out there revel in a true dame—a broad."[45]

A pattern developed with Lara: As soon as Nicholson got involved with another woman—in the winter of 2002, according to

one report, it was a twenty-year-old UCLA college student—Lara would come crawling back. At the same time, she was spotted at Baby's nightclub in Las Vegas's Hard Rock Hotel in an "in-your-shirt-up-your-skirt smooch session" with Patrick Whitesell, agent for Ben Affleck, Matt Damon, and Drew Barrymore.[46]

One of Nicholson's oldest friends, character actor and teacher Jeff Corey, died at eighty-eight in L.A. in August 2002. After years on the blacklist, he started acting again in the early 1960s, appearing in 100 movies, including *Little Big Man*, *In Cold Blood*, *True Grit*, and *Butch Cassidy and the Sundance Kid*. Another Nicholson pal, Marlon Brando, was slapped with a $100-million palimony suit by his Guatemalan-born maid Maria Christina Ruiz, mother of his three youngest children—Ninna Priscilla, thirteen; Myles, ten; and Timothy, eight.[47] The lawsuit was subsequently settled for an undisclosed amount.

In December 2002, Nicholson invited Lara to Aspen, though he couldn't stand to be in the same house with her, appealing to Antonio Banderas and Melanie Griffith to put her up in their spacious, luxurious lodge. "Absolutely not, Jack," said Griffith, whose hold on her Latin hunk she was not about to jeopardize by exposing him to a seductive house guest.[48] Nicholson, trying to reason with Lara, said it wouldn't be appropriate to have his thirty-two-year-old mistress under the same roof with his small children, and he checked her into the Hotel Jerome, not even giving her the Victorian house he owned in town.[49]

"I've spent most of my Christmases in Aspen for the last few years, and that's always very beautiful," he said in 2003. "I don't ski as much but my kids are starting to ski." During the holidays, the mountain resort attracted Kevin Costner, Will Smith and his wife Jada Pinkett Smith, Jenna Elfman, Don Johnson and Kelly Phleger, Ben Affleck, Val Kilmer, Christian Slater, Kate Hudson and Chris Robinson, Goldie Hawn and Kurt Russell, and Mariah Carey and

Luis Miguel. In 2002, Costner hosted a luncheon that featured a hockey game on his private lake to celebrate his sixteen-year-old daughter Annie's acceptance by Brown University. Two significant figures from the Clinton years, Monica Lewinsky and Denise Rich, were also in town. Wife of a shadowy international financier who was infamously pardoned by President Clinton in his final days in the White House, Democratic fund-raiser Denise Rich's caviar-and-Veuve-Clicquot-champagne New Year's Eve party was attended by Ivana Trump, Milla Jovovich, and Nicky and Paris Hilton. At Italian designer Miuccia Prada's new shopping chalet downtown, Dustin Hoffman bought presents for his wife and daughter, and Lara purchased a taupe-colored alligator purse and a chestnut-colored ostrich back at the Lana Marks boutique. She was with Nicholson when he rang in the New Year on December 31,[50] but she was also becoming friendly with a Saudi Arabian prince she met at the Aspen Mountain Club. The prince came in handy when she arrived at Nicholson's house one day, following an afternoon of shopping, to discover him with another girl, a dancer. Packing up, she headed back to L.A. on the Saudi's private jet.[51]

Later, in London, she was photographed wearing a jacket with a huge message sprayed in white paint on the back, I'M HAPPY IN SPITE OF YOU, "clearly a knock at Jack," according to an insider.[52]

She faced new challenges on *The Practice* in 2003, including a rumored rivalry with heavyset costar Camryn Manheim. When David E. Kelley left briefly to start another series, *Girls Club*, Lara began to maneuver for more oncamera exposure. Kelley returned to the show after *Girls Club* was canceled, and Lara's on-camera time suffered as Manheim's flourished.[53] The five-foot-four Lara's weight went from her usual 105 pounds to 96; normal for her height was 115. "The more failed love affairs she has, the skinnier she gets," said a friend.[54]

Eventually, Lara was fired from *The Practice*, along with Dylan McDermott, Lisa Gay Hamilton, Marla Sokoloff, Kelli Williams, and Chyler Leigh, in a last-ditch effort to save the faltering series by cutting its $6.5-million-per-episode cost in half.[55] "Lara couldn't believe she'd lost her job," said a source close to the show. "She assumed they couldn't continue *The Practice* without her."[56] Not long after the bloodbath on the series, Lara was seen necking with a sexy, blond, blue-eyed, twenty-something man while out for dinner and ice cream at a West Hollywood deli.[57]

Nicholson continued to add to what had become one of the best private art collections in the United States. Director Curtis Harrington, whose latest film *Usher* was honored at festivals throughout Europe, was, like Nicholson, a connoisseur of paintings, and when he ran into the actor, he said, "I believe you have some paintings by Alma-Tadema," mentioning the Victorian artist, Sir Lawrence Alma-Tadema, whose sensuous depictions of Greco-Roman antiquity and Egyptian archaeology influenced the look of early Hollywood, from the exotic costumes of Theda Bara to the sumptuous sets of D. W. Griffith and Cecil B. DeMille. Harrington asked Nicholson, "Could I see your Alma-Tademas sometime?"

"Come to Aspen," Nicholson said. "They're there."

Nicholson was not always astute in handling his art collection. New York art dealer Todd Michael Volpe swindled him and other clients out of more than $2 million before he was caught and tried for "selling and leveraging valuable works belonging to celebrity clients, including actor Jack Nicholson, and keeping the proceeds for himself," wrote the *Los Angeles Times*.[58] Volpe was sentenced to two years in prison and ordered to pay $1.9 million in restitution to his clients, including Christie's.[59]

Another passion was motorcycles. He'd succumbed to the lure of the open road after *Easy Rider*, not to mention the appeal of the

biker image—part rugged individualist, part bandit, part rebel. Cher was among the celebrities who showed up on Rodeo Drive for Happy Harley Day, and other hog owners included George Clooney, Gwyneth Paltrow, Jay Leno, Arnold Schwarzenegger, and—of course—Dennis Hopper.[60]

ABOUT SCHMIDT

Defying all the rules, Nicholson achieved a late-career resurgence in his sixties. Most stars are over by their forties, but Nicholson cleverly reached out to a new generation of filmmakers, personified by a hot new director named Alexander Payne, and the mordantly funny *About Schmidt*, filmed during the rainy, desolate spring of 2001 in Omaha, Nebraska, was the happy result. He played sixty-year-old Warren Schmidt, a retired widower who experienced love for the first time in his life in the surprising final moments of the film. Producer Harry Gittes said the movie came about as a result of "gossip." Gittes heard about Louis Begley's novel from movie executive Michael Besman, who told him, "Jack Nicholson would be great in this." Begley was also the author of *Wartime Lies*, a 1991 novel about the Holocaust, which Stanley Kubrick wanted to film under the title *Aryan Papers*, but after Spielberg's *Schindler's List*, Kubrick dropped the project.

Gittes read Begley's *About Schmidt*, was immediately interested, and decided to coproduce the film with Besman. Gittes introduced the film's youthful director, Alexander Payne, to Nicholson, and "in doing so," Gittes said, "I introduced Jack to a whole new breed of filmmakers. Lara Flynn Boyle knew Alexander before Jack did. Being younger, she was more aware of these people, and she's one of my faves, by the way. Jack and Lara Flynn Boyle are very interesting together, and I love her, but she's a hand-

ful. And she's gorgeous."[61] Nicholson took a small percentage of his usual $15 million fee.[62]

Commenting in 2003 on his long-standing connection with Nicholson, Gittes said, "We have more than a friendship. We have a relationship, with all that that entails. We go through every undulation that a relationship goes through. We go through periods of being in love. We go through periods of being in hate. We go through periods of cold. We go through periods of jealousy. This has been over forty years. Jack always wanted me to be like Sam Spiegel. That has been the guy that I've been shooting for, to be like Sam Spiegel in *The African Queen*. But producers don't have that huge impact anymore. I can't stand how diminished the role has become. The producer's first on, last off. I'm still here [working on postproduction publicity at the time of this interview in 2003], but Jack has made another movie, Alexander has written two or three others, and I'm here working with the media on *Schmidt*. I'm a throwback."

Nicholson seemed perfect for the role of Warren Schmidt, according to Gittes, because he "had things going on in his life, about his own relationship with his daughter, that I knew nothing about when I first gave him the book. Jennifer's in her thirties and they had a serious—it's almost impossible not to have a strained relationship with a very—what can I tell you?—with a person of Jack's size. It's just impossible."

Gittes lined up Kathy Bates for the role of Roberta Hertzel, a matron who winds up nude in a hot tub with Schmidt. "We were looking for someone who could take Jack on," said Michael Besman. "Kathy Bates immediately came to mind." When Gittes first called the actress, she said, "You have no money. . . . My schedule won't permit—" She listed many reasons why she couldn't accept the part. "Shelley Winters wasn't around anymore," Gittes continued. "There's her and there's a huge falloff to the next choice.

There's nobody else that you can actually think of that could do it, and Jack has the same type of [one-of-a-kind] characteristics." Gittes finally succeeded in signing Bates, and when Payne told her she was going to do a hot-tub scene with Nicholson, she said, "Only if I could be nude!"

"Way to go, baby!" said Nicholson.[63]

According to Gittes, "She got very sick after all the strain of doing this, she was so stressed, but you don't see it in her acting. It wasn't easy." According to Bates, "Jack made it easy. After all, he does appreciate women. I was expecting more of a cutup. But Jack was as focused as a snake charmer. . . .[64] We had a perfect synchronistic playing off one another. He's a real pro. He's respectful of other people's personas and working methods. . . . My favorite Jack moment in a movie would have to be from *Cuckoo's Nest* when he is getting his medicine from Nurse Ratched and he hammers the counter from underneath like he's got a hard-on. I love that moment."

During location filming in Nebraska, Nicholson looked around on the first day and said, "Wow, it's 900 shades of brown." Working in front of a Dairy Queen, he created such a commotion that a local driver crashed into the car in front of him. After work, Nicholson's nocturnal habit of wandering around his house naked, shoveling down pie in the early morning hours, shocked some of his Midwestern neighbors. "Who knew Omahans stayed up so late?" he said.[65]

On the set, Gittes noticed that "it's not as easy for Jack to memorize as it used to be." Brando had been using cue cards for years, and Katharine Hepburn "work[ed] off cue cards," wrote Scott Berg, author of *Remembering Kate*. According to Warren Beatty, "Jack uses them, too."[66]

About Schmidt was a U.S. selection at the Cannes Film Festival in May 2002. Although Bob Evans's biodocumentary *The Kid*

Stays in the Picture was also screened, Evans didn't feel well enough to attend. At the last minute, he hopped a ride on Nicholson's private jet, arriving in time for the screening and a party at Martinez Beach restaurant.[67] The seventy-three-year-old Evans's marriage to thirty-four-year-old model Leslie Ann Woodward ended the following year after nine months.[68]

Top honors at Cannes went to another Nicholson pal, Roman Polanski, who won the Palme d'Or for *The Pianist*. Back in the U.S., Nicholson took Lara to the L.A. premiere of *About Schmidt*,[69] but their date hardly represented a reconciliation. "They're on again," wrote a *Beverly Hills [213]* columnist, but later in the year, Lara was photographed cuddling on Venice Beach with a dark-haired beefcake who had her backside firmly in hand.[70] In a reversal of her situation with Nicholson, twenty-four-year-old Jay Penske, an heir to an automobile fortune, was nine years younger than thirty-three-year-old Lara.[71]

Critics loved *About Schmidt*—as did the public—Stephen Holden writing in the *New York Times*, "Mr. Nicholson brings to his role an awareness of human complexity whose emotional depth matches anything he has done in the movies before." *Newsweek*'s David Ansen wrote, "Jack Nicholson's powerfully contained, painfully funny performance has to rank with the greatest work he's ever done." Despite almost universal praise, the *Los Angeles Times* reviewer hurt the aging star's feelings by referring to his "potato physique." "I thought I was never going to recover," said Nicholson. "I thought, Goddamn, is this it? It was frightening."[72] As physically vain as any of the new breed of metrosexuals, Nicholson pampered himself at Terry Hunter's B2V salon, but he eschewed polish following his dermabrasion hand massage.[73]

At the outset of the 2003 awards season, Nicholson attended one of the least exalted of the awards shows, the Critics Choice, televised on E! He and Daniel Day-Lewis (*Gangs of New York*)

both won in a two-way tie among the three nominees for Best Actor. Accepting his award, Nicholson invited the loser, Robin Williams (*One Hour Photo*) on stage. Williams got Nicholson to remove his sunglasses and danced a jig after delivering a six-minute standup-comic routine.

At the Golden Globes presentation ceremony, Nicholson and Nicole Kidman won for *About Schmidt* and *The Hours*, respectively. Standing next to the statuesque Australian, who was a few inches taller than Nicholson, he kissed her hand and said, "What a body of work. I'd love to work with her." Long an ardent fan of his, Kidman was charmed. Lara showed up at the Golden Globes in a pink tutu—the oddest outfit seen in Hollywood since Björk's Leda-and-the-Swan getup in 2001. "What was she thinking?" asked one observer, and another guest inquired, "Is that Jennifer Love Hewitt?" "No," replied her companion, "Jennifer has better taste."[74] (Both Lara and Jennifer turned up on *People* magazine's "10 Worst Dressed" list, along with Christina Aguilera and Bruce Willis).[75] Lara's tutu was an inside joke, referring to the dancer whom Lara had found Nicholson with during the Christmas holidays in Aspen.[76] A smiling Nicholson told a reporter he found Lara's dress "startling,"[77] but rocker Bono was so beguiled that he asked her to appear in U2's next video. *Beverly Hills [213]*'s Arlene Walsh reported that Nicholson "spent the evening talking affectionately about his gal and her zany pink tutu to anyone who would listen."[78] According to others, Nicholson objected to Lara's new, pumped-up, pouty collagen mouth.[79] Around this time, she started wearing a red top with the words KISS MY ASS emblazoned in white over her breast.[80] "You'll always have the fashion disasters," observed Hollywood style maven Steven Cojocaru, "your Lara Flynn Boyles and Björks, but what works now is safe chic."[81]

Nicholson resumed his relationship with an old flame, taking her to a Lakers game on Valentine's Day, where they were openly

affectionate, holding hands, whispering, and kissing. Later they went to a party and then to Mulholland Drive. The thirtyish model had long brunette hair, was five-feet-eight, and, like Lara, pale and thin. The fashion model was headquartered in New York, but when Nicholson split with Lara, he rang her, and she flew to L.A. He reportedly wanted her to move west and settle down with him.[82]

With his twelfth Academy Award nomination (for *About Schmidt*), he replaced Laurence, Lord Olivier, as the most nominated actor in Oscar history. Among performers, only Meryl Streep topped Nicholson with her thirteenth nomination (for *Adaptation*). The male performances of 2002 made up "one of the strongest fields in recent memory," wrote *People*, whose reviewers picked Nicholson to win over his competitors, Adrien Brody (*The Pianist*), Nicolas Cage (*Adaptation*), Michael Caine (*The Quiet American*), and Daniel Day-Lewis (*Gangs of New York*). *Entertainment Weekly* also bet on Nicholson, citing "his greatest performance since *Cuckoo's Nest*." In *Beverly Hills (213)*, Jack Martin ventured, "Nicholson is a sure bet to cop another Oscar."[83] A notable dissenter was the *Los Angeles Times*'s Kenneth Turan, who wrote, "Ordinarily, a good maxim here is 'Don't bet against Jack,' but once *About Schmidt* couldn't manage a screenplay nomination, the heat behind Nicholson's marvelous performance seemed to dissipate." The winner, Turan predicted, would be Daniel Day-Lewis for *Gangs of New York*.[84]

The Seventy-fifth Annual Academy Awards was scheduled to be held on March 23, 2003, at the Kodak Theater on Hollywood Boulevard and Highland Avenue, but, four days before the diamond-jubilee presentation ceremony, the United States went to war with Iraq, and some of the nominees and presenters, fearful of terrorist attacks, or deeming the Oscar irrelevant when Americans were risking their lives 7,500 miles away, thought of boycotting the event. Presenters Will Smith and Cate Blanchett

pulled out, as did Jim Carrey, Angelina Jolie, Meg Ryan, and *Lord of the Rings* director Peter Jackson.[85] Nicholson telephoned all the other the Best Actor nominees and told them, "Come to my house. I want to talk to you about this whole thing." According to Adrien Brody, "It was like, should we go to the ceremony? Should we not? What's appropriate? Jack wanted to have a consensus. . . . 'Well, you know [Brody said], you guys have all been through this before, but I think I *have* to show up. I kind of *want* to show up.' And so they all did."[86] All of them except for Brody had won Oscars before—Cage in 1996; Caine in 1987 and 2000; Day-Lewis in 1990; and Nicholson in 1976, 1984, and 1998.

The show went on as scheduled, viewed by thirty-three million on television. *Us* magazine later called Nicholson and Cage a "buzz-couple," writing, "Cage—deemed a 'hothead' by [ex-wife] Lisa Marie Presley—hit Oscar bashes with Nicholson. No word on whether he scored *Anger Management* lessons from Jack."[87]

When the program began, host Steve Martin said he was glad the Academy, in deference to the war, had "cut back on the glitz. I guess you noticed there was no red carpet outside. *That'll* send them a message! . . . This year, Jack Nicholson and Meryl Streep made Oscar history. It was backstage, and it wasn't pretty. It's been a big year for Jack. He also got in a hot tub with Kathy Bates. But hey, who hasn't?" A few moments later, Martin said, "A movie star can be straight [close-up of Harrison Ford] or gay [close-up of Nicholson]." As Nicholson good-naturedly stroked an eyebrow, Anjelica Huston and Kathy Bates roared with laughter. The amount of attention lavished on Nicholson in the opening monologue reinforced the impression that he was to be the night's big winner, but the Best Actor award went to dark horse Adrien Brody, who gave the buttery presenter, Halle Berry, a lingering French kiss, later explaining, "It was as if all the things I never had an opportunity to do, in that one moment I was able to do."

Brody's director in *The Pianist*, Roman Polanski, also won an Oscar, but watched the ceremony on live television in France, still facing U.S. charges of statutory rape. Nicholson and Bob Evans had dropped in on him in Paris following the Venice Film Festival a few years previously. In their first reunion in twenty years, the friends stayed up all night, and Polanski said he longed to return to the U.S., but talks with L.A. courts had collapsed in 1997. "It's really our loss," Nicholson said. "There aren't that many world-class directors, and he's one of them. Having children apparently changed him, though. It does change things. It did for me."[88]

At the end of the Oscar ceremony, as Nicholson ducked into his limousine, a reporter called out, "Hey, Jack, Where ya goin'?" "Destination unknown," he said.[89] At the annual post-Oscar *Vanity Fair* shindig at Morton's, sugar cookies and lollipops were printed with the faces of Nicholson, Jude Law, Dennis Quaid, Matt Damon, Brad Pitt, and Tom Hanks, which, as someone joked, made suckers out of them all. Nicole Kidman, winner of the Best Actress Oscar for *The Hours*, showed up at Morton's, as did Ryan O'Neal, Ben Affleck, Jennifer Lopez, Colin Farrell, Nia Vardalos, Julianne Moore, Diane Lane, Jake Gyllenhaal, and Kirsten Dunst. At their table, Nicholson and Kathy Bates dined on caviar and salmon. "He's a brilliant mind interested in a lot more than Hollywood," Bates told a reporter. "He's a voracious reader. After all the fame and money, the craft still captivates him."

Earlier, at the luncheon Nicholson had hosted for the Best Actor nominees, Brody, Caine, Cage, and Day-Lewis agreed with Nicholson that the Best Actor winner would treat the other nominees in that category to a topflight restaurant they'd all choose, perhaps Ago or Crustacean, but when the only nonmillionaire among them, Adrien Brody, won, he begged off, at least until he scored a blockbuster.[90]

Cynthia Basinet regretted that she could not share Nicholson's

critical triumph in *About Schmidt*. She started taking a Chinese homeopathic class, and one day some of her classmates decided to analyze and diagnose Nicholson by watching one of his recent movies. "That's what I mean when I say the universe talks to me about Jack Nicholson," she said. Her friends from the class told her, "We just studied him on video, and he's going to have a stroke with those hands."

Summing up her attitude in 2003, she concluded, "Jack said to my son, 'She kept leaving me, John. I love her very much but she kept leaving me.' I don't think Jack realized what we were losing by making that decision not to come back. Now, we will never get back together, because the person I knew obviously doesn't exist anymore. Well, life goes on. It's hard because every day you're moving on, but moving on to what, when your whole life was driven to a moment. You meet the apex. You meet this person. You dig this person. What if I had met him after all those years and we didn't dig each other? We did. We friggin' did. For a year, I'd break out in sweat, praying something bad wouldn't happen to him, that he'd understand what I was trying to say, and that he would keep working. Because that's what really makes him happy—work."

The month following the Oscars—April 2003—marked the opening of ex-wife Sandra Knight Stephenson's exhibit of fifteen oil paintings, *Self Portraits of a Previous Image: Sandra Knight by Sandra Stephenson*, at Jennifer's retail store, Mlle. Pearl, in Santa Monica. The crowd surging through the shop included Henry Jaglom, Owen Wilson, Sally Kellerman, and Harry Dean Stanton.[91] Later the same month, Jennifer's sixty-six-year-old father appeared on the cover of *Vanity Fair*'s Hollywood issue, sharing the center position with sixty-year-old Harrison Ford, and surrounded by Tom Cruise, forty; Brad Pitt, thirty-nine; Tom Hanks, forty-six; Edward Norton, thirty-three; Jude Law, thirty; Samuel L. Jackson, fifty-four; Don Cheadle, thirty-eight; Hugh Grant,

forty-two; Dennis Quaid, forty-eight; Ewan McGregor, thirty-one; and Matt Damon, thirty-two. During the shoot at Culver Studio's Stage 12, Nicholson called out to photographer Annie Leibovitz, "Annie, you want me to look which way? Over here? 'Cause I'm looking at Tom's crotch—I got the full-frontal!" After posing for an hour, Nicholson left to catch Lorraine's playoff soccer game.[92]

After the death of Katharine Hepburn, it was more or less official that he was the most durable and beloved of Hollywood stars. "If he were here, I'd ask him if I could lick his eyeballs," said Christian Slater.[93]

ANGER MANAGEMENT

From a first-rate film, *About Schmidt*, Nicholson went to a potboiler, *Anger Management*, again putting the lie to his frequent claim of carefully planning his career with an eye to quality and artistic daring. Instead, his career had been the typical movie star's grab bag: genre Westerns; stunts (*Batman*); offbeat indie fare (*The Crossing Guard*); fascinating failures (*Marvin Gardens, The Passenger, Heartburn*); high-concept studio films (*The Witches of Eastwick, Wolf*); feel-good commerce (*Terms of Endearment, As Good as It Gets*); and a scattering of rough gems (*Easy Rider, Five Easy Pieces, The Last Detail, One Flew Over the Cuckoo's Nest, Chinatown, Ironweed, About Schmidt*). Actor Willem Dafoe, who went from the deeply felt *Last Temptation of Christ* to the cartoon-based *Spider-Man*, was more honest when he admitted, "Any actor who tells you he makes choices is absolutely wrong. You find work and work finds you."[94]

Adam Sandler, the thirty-six-year-old *SNL* comic who was now making $25 million per picture,[95] sent the script of *Anger*

Management to Nicholson, who, according to *People*, was making "up to $20 million a film."[96] Sandler and Joe Roth, Revolution Studios chief, had decided Nicholson was the dream choice for the role of an ultra-aggressive anger-management therapist who taught a young man, played by Sandler, to get up the nerve to propose to his girlfriend, portrayed by Marisa Tomei. Nicholson took a month to read and ponder David Dorfman's script,[97] and then invited Sandler to Mulholland Drive. Sandler later described Nicholson's house as "dark, dim, to set the mood." When Nicholson said he'd do the picture, Sandler said, "You're kidding." They talked about the script for "twelve hours in a row," Sandler recalled. After the first four hours, Nicholson decided to take a break.

"I'm going to the bathroom now," he said. "If you touch my Oscars, I'll kill you."[98]

In 2003, Nicholson recalled, "I knew [Sandler], only very slightly. I knew his work, was interested in it, and then I wrote [*Anger Management*] for me. I'm only kidding." But according to director Peter Segal, who'd previously brought *Nutty Professor II: The Klumps* to the screen, Nicholson wasn't entirely jesting. One month before principal photography, Nicholson voiced major reservations.[99] "He was looking for a handle on the character," said Segal. "He wasn't sure if he was supposed to play 'Jack' or some other character." The director spent weeks with Sandler and Nicholson, revising the dialogue. "We didn't have anybody but [Nicholson] in mind for the part," Segal said. "We had put all our eggs in the Jack basket. So we basically customized the part for him." John Turturro played another of Nicholson's patients, and during the first day of filming, he asked the star what the tone of the film was. "There is no tone," Nicholson said. "I'm all over the place. Just do whatever feels right." In the movie's only memorable scene, Nicholson's character stopped traffic on the Queensboro Bridge by conducting a sing-along, getting irate hard hats and

other macho types to warble "I Feel Pretty," Maria's girlish aria from *West Side Story*.

During location filming in Manhattan, whenever onlookers approached Nicholson for money or autographs, he shocked them into silence by asking them for cash or autographs before they could open their mouths. Adam Sandler decided to try the same tactic, running up to indigent and homeless street people and panhandling, though Sandler was a millionaire many times over.[100] Asked if *Anger Management* was fun to work on, Nicholson said, "Yes. I did it to learn something about the kind of comedy they do. I think I had a good time. I learned a lot. The minute that you're not learning, I believe that you're dead." It wasn't always fun for Sandler, who was annoyed when Nicholson left the set at 5 P.M. to watch a Lakers game. Cast and crew waited until 11 P.M. for him to return. Filming finally resumed at 4:30 A.M.[101] Only a bankable living legend could get away with such behavior, and, right on cue, the American Museum of the Moving Image sponsored a three-week series, *The Nonconformist: Jack Nicholson on Film, 1970–1980,* which featured the actor's work from *Five Easy Pieces* to *The Shining*.

There was a parallel between Sandler and the character he played, for Sandler, too, was having trouble deciding to get married to his girl for over three years, actress and model Jackie Titone, even though she'd converted to Judaism for his sake.[102] Nicholson told Sandler that he'd lost Anjelica Huston because, according to a source close to Sandler, "Anjelica wanted to marry, but he kept putting her off. Jack told Adam that he's never stopped regretting losing Anjelica and pleaded with Adam, 'Don't make the same mistakes I made.'"[103] In the film, through the machinations of the character Nicholson played, Sandler and Tomei's characters finally got married.

While pondering Nicholson's advice about his marital quandary, Sandler and Nicholson started hanging together, and *Entertain-*

ment Weekly dubbed them "the year's hottest odd couple."[104] They partied with Sean Penn, Robin Wright Penn, Kevin Bacon, and Kyra Sedgwick at Penn's Manhattan lounge Man Ray, where Nicholson and Sandler stayed until last call, though the others had left at 10:30 P.M.[105] When they returned to the West Coast to film Sandler's attack on a group of monks, Nicholson took Sandler to Charlie O's jazz club in L.A., where Sandler soon became bored. He put on his Walkman earphones and started grooving to rap, which the younger man preferred to fifties jazz. Nicholson saw the earplugs and ordered Sandler to remove them and pay attention to the set.[106] On a more successful excursion, Sandler and Nicholson went golfing in Connecticut with the former's father, Stanley. "They hit it off and talked about how dumb I was," Sandler said. "They say if you work with someone better than you, you'll get better as an actor. And, sure enough, as I made the movie with Nicholson, I noticed he was getting better." A few months later, Stanley Sandler, a longtime smoker, died of lung cancer at sixty-eight.

Though a popular 2003 moneymaker, *Anger Management* belonged in the same trash bin as Abbott and Costello, Francis the Talking Mule, and Ma and Pa Kettle. Despite mixed reviews, it exploded at the box office, thanks not only to Sandler's enormous following but also to Nicholson's irreverence, which appealed to kids. The picture raked in $44.5 million on its premier weekend, breaking all records for an April opening, a season hardly known for producing blockbusters. It was also the biggest opening for a Sandler movie, beating 1999's *Big Daddy*.

As tiresome as the movie was—I was unable to watch it to the end—Nicholson clearly had pulled off another miracle: An old man had emerged anew as a gigantic movie star, sharing the screen with a hot young kid, generations removed from him. For a comparable feat, one had to reach back to the 1950s, when the teaming of a venerable Spencer Tracy and a teenage Elizabeth Taylor

sparked box-office magic in *Father of the Bride* and *Father's Little Dividend.*

Nicholson was an honored invitee at the June 2003 wedding of Sandler and Titone, where all of the 300 guests received boxes of Krispy Kreme doughnuts.[107] "If it weren't for Jack," said a friend of the groom's, "Adam and Jackie might never have wound up man and wife."[108] Nicholson was less effective at managing his own affairs, especially his anger, having allegedly attacked a Spanish television crew in Majorca after they attempted to photograph him as he bathed in the shower.[109] A few years after he pounded a car with his golf club, he was again sued over a traffic incident. Nicholson was driving his Mercedes when he collided with Attila Hegedus and Olga Kharitonovich, who filed a lawsuit for unspecified monetary damages. A salesman, Hegedus said he'd lost "earning capacity" as a result of the accident.[110]

At times, Nicholson was a menace on fairways and putting greens, according to his ex–golfing instructor Ron Del Barrio, who said Nicholson hit a line drive that just missed a man who'd left a club in his way. On another occasion, duffers Dana Carvey and Jon Lovitz were cutting up, and Nicholson snapped, "Hey, do you mind? I'm trying to concentrate on hitting a fucking ball here." Later Nicholson said, "I'm just a freaking lunatic and I love it."[111] Especially volatile at Lakers games, he grabbed the legs of visiting Washington Bullets coach Dick Motta, who told the star, "You touch me again and you won't need a frontal lobotomy."

"You're breaking the rules," Nicholson shouted.

"Say, pal," Motta said, "if you wanna be a coach, buy me a team and I'll make you my assistant. Now sit down."

"Sit down yourself," Nicholson said. "By the way, pal, it'll take somebody bigger than you to make me sit down."

At a Lakers–Boston Celtics game, as Larry Bird dribbled close to Nicholson and his companion, Lou Adler's son Nicky, Nichol-

son told Nicky, his godson, "Hey, babe, bite the son of a bitch." Hearing the crack, Bird just winked at Nicky and dribbled on. A Boston spokesperson called Nicholson "an embarrassment to the game and a nuisance to the players," and some fans started carrying CHOKE ON YOUR COKE, JACK posters.[112] Nicholson once bragged, "The best thing we did was on K. C. Jones, the Celtics coach. He had been giving the officials a bad time, and when they came back down our way, we yelled at the officials, 'Fuck you!' And they called a technical foul on the Boston bench."[113] In $1,900 front-row seats at the Staples Center, Jack Nicholson, Michael Ovitz, Jim Carrey, Penny Marshall, and Denzel Washington all had their feet on the Lakers' hardwood floor, while Dustin Hoffman and Andy Garcia were a few rows up, and Tom Hanks, preferring privacy, relaxed in a luxury suite out of camera range.[114]

In a Staples Center crowd one night that included Jeffrey Katzenberg, Heather Locklear, and Dyan Cannon, sport columnist Chris Erskine noticed that Nicholson was losing control. The Lakers weren't playing well, and "at courtside, Nicholson—possibly the Lakers' most ardent fan—grabs the sides of his silvered head and twirls, spins like that McMurphy character he played in *Cuckoo's Nest*, spins like a madman. 'Look at Nicholson,' I [say to a companion]. 'Where?' And I point out Nicholson in his regular seat along the Spurs' bench, a home-court advantage if there ever was one. Imagine coming in from Cleveland or Memphis and looking over to see Nicholson three seats away, hair jutting out from the sides of his head like crab grass? Imagine what that does to your game."[115]

During a Lakers playoff game in 2003, Nicholson lost his cool when a foul was called on Shaquille O'Neal. Rushing from his seat to the edge of the court, he started screaming at the referee. Officials warned him to sit down, but he replied, "I pay a lot of money for this seat. This is the NBA, you can't tell me to sit down." Un-

like Calvin Klein, who'd wandered onto the court during a basketball game in New York, Nicholson didn't have to be led back to his seat. But it did get to the point that the head of NBA security told the Lakers' Tim Harris, "If he keeps this up, we're going to have to remove him."

"Well," said Harris, "I'm not doing it, and the guys in the red coats sure aren't doing it, so if you're doing it, *you're* doing it." Later, Harris grinned and remarked to a reporter, "Because you just cannot remove Jack. You cannot. Jack is the team's grand marshall." Said Shaquille, "I'm glad somebody sticks up for me. I appreciate it, Jack."[116] But, like Nicholson's earlier road-rage incident, his basketball fiasco was another sign of temper meltdown. In *True Believers: The Tragic Inner Life of Sports Fans*, Joe Queenan wrote, "Being a fan is a lot like smoking, a bad habit you pick up in your early teens and can never quite break. To me, the Phillies and the Eagles are exactly like nicotine: a preposterously noxious semi-hallucinogenic substance capable of giving great pleasure for brief periods of time, but that will ultimately destroy your health." The worst offenders, he added, were fans of the New York Yankees, Dallas Cowboys, and Los Angeles Lakers.

The extent of Nicholson's tendency to rationalize his character defects, which placed him in danger of further, perhaps worse, outbursts, was obvious in his statement, "The biggest misconception about me is that I'm angry and violent. But I'm a real sweetie."[117] One night, he was in the VIP lounge at a Lakers game with Mel Gibson and Kevin Spacey, both of whom were madly reciting Shakespeare, trying to see who could pull off the best "To be, or not to be" soliloquy. As they advanced on each other like two warriors, Nicholson intervened, quipping, "Gadzooks, if it ain't Romeo and Juliet."[118]

Up at the Mulholland Drive compound, there was a new sadness as seventy-nine-year-old Marlon Brando fell ill in 2003 and

required outpatient treatment at UCLA Medical Center.[119] The previous year, he'd survived pneumonia, using a wheelchair and oxygen tanks, and his great weight put him at risk of congestive heart failure. Now his condition was serious enough for him to summon his common-law wife, Tarita, the late Cheyenne Brando's mother, from Tahiti.[120] He was still trying to cope with the $100 million claim by Maria Ruiz, whose lawyer Donald Woldman said, "They became lovers in 1988," and acknowledged that Brando paid support for their three children, but "reneged on his commitment" to support Ruiz.[121]

"We don't hang out much lately," Nicholson said. "We're like the perfect neighbors. We don't go to the bowling alley together, but we watch each other's back." When a reporter suggested that Brando's recent movie performances had been ill-advised caricatures, Nicholson leapt to his defense: "There's nothing ill-advised for Marlon Brando. He is a horse of a different color. He can do what he wants."[122]

Something's Gotta Give

Nicholson, as vital as ever in his sixties, was busy in 2003 filming his seventy-eighth movie, a $75-million romantic comedy, *Something's Gotta Give*, about an aging playboy, one of New York's most eligible bachelors, in love with a twenty-something auctioneer, played by Amanda Peet. While convalescing in her home from a heart attack, he falls in love with her mother, played by fifty-seven-year-old Diane Keaton. When feminists heard that Keaton was playing the "older woman," they were quick to point out that she was a decade younger than Nicholson, and that an older actress—perhaps Vanessa Redgrave or Maggie Smith—should have been cast if the movie were to have a shred of relevance. Frances

McDormand and Keanu Reeves were also in the film, which was shot in the Hamptons, Los Angeles, and Paris.

Explaining the recent predominance of comedic material in his *oeuvre*, Nicholson said in 2004, "After September 11, I held my tongue. All the public positions had been taken. . . . I had nothing more to add. So I thought, Bring in the clowns, you know what I mean? That's why I've done a coupla years' worth of comedies."[123]

Director/writer Nancy Meyers had previously written *Private Benjamin, Irreconcilable Differences, Father of the Bride,* and *The Parent Trap.* "I wrote this movie for Diane Keaton and Jack Nicholson," she said. When she pitched it to Keaton, the actress told her, "I love it. No one will make it. No one will make a movie about someone my age falling in love." While Meyers wrote the script, she relied heavily on Nicholson, who shared his extensive experience of dating younger women. "She got a lot from me," he said.[124]

In the film, Keanu Reeves, Nicholson's doctor, also fell in love with Keaton. Meyers said that it was sheer fantasy to think that the thirty-six-year-old man played by Reeves would be drawn to someone like Keaton and added, "The fact that Jack's character [fell for Keaton]—is that a fantasy? I hope not. . . . Jack's character could surprise himself and fall for a woman his own age. . . . It's probably very relaxing for [older men] to not have to be thirty-five in bed when they are fifty-five, you know?"[125]

Her words proved prophetic. Romantic sparks seemed to fly between Nicholson and Keaton, and in early summer 2003 they were seen dining at Nick and Toni's restaurant in Easthampton. A source close to the production commented, "She's a very grounded, funny, and affectionate person and those are qualities Jack loves in a woman."[126]

During filming in New York City, the set turned frosty one day when Reeves disapproved of Nicholson's behavior with the public. As had happened during *Anger Management,* Nicholson started

harassing beggars and autograph hounds. "See, Keanu," he said, "that's what ya gotta do. It scares them away. The only way to avoid people who come up to you wanting stuff all the time is for you to ask first. It freaks them out."

"I like giving money to the poor and signing my name for fans," Reeves said, "because without them, I wouldn't be where I am today."[127]

Nicholson flouted antismoking laws on the movie set, where he insisted on a chair with a built-in ashtray. Finally, a studio security guard decided he'd had enough and told Nicholson to extinguish his cigarette.

"Oh, yeah, boy, what are you going to do about it?"

"I'm going to write you a ticket for $250."

"Fine, just write a ticket. I make more than $250 every five seconds on this set."[128]

While filming in an Easthampton ice-cream parlor, Nicholson flirted with Amanda Peet between takes and consumed fourteen vanilla ice-cream cones, licking her raspberry sherbet before handing it to her.[129] Later, the actress said, "I certainly don't end up with Jack Nicholson. That's disgusting."[130] During a shopping spree at Gucci in Beverly Hills, she tried to update his fashion sense, suggesting he buy wraparound blue shades instead of his usual black ones. He didn't want to be trendy, he said, because "it's over so quickly," but he compromised, purchasing black shades as well as a pair of wraparounds. "What's next?" he said. "Do I need to pull my pants down so low that my underwear shows? Because that ain't gonna happen."[131] When a reporter asked Nicholson whom he'd rather make love to, Peet or Keaton, he replied, "I would be much more likely to wind up with Miss Keaton than Miss Peet. It's a clear call."[132]

Location filming moved on to Paris, where French unemployed actors picketed the set. Grabbing a bullhorn, Nicholson

told the mob, "I'm with you. I, too, belong to a big trade union called SAG. So please let us work." In broken French, he added, "The struggle continues." The crowd roared its approval, and filming resumed.[133] Despite the glory of French cuisine, he missed Peep's, his favorite L.A. pizza joint, and ordered a dozen pies to be frozen and flown 6,000 miles. In Paris, he defrosted the pizzas, popped them in the oven, and treated cast and crew.[134]

When the picture finally wrapped, Nicholson acquired a St.-Tropez tan on vacation in the south of France with his children.[135] He looked happy in photographs with his kids and Diane Keaton, and the press again reported that he and his costar were "dating up a storm."[136] Back in the U.S., they appeared together at the opening night of the Los Angeles Opera's production of *The Damnation of Faust* on September 10, 2003. When reporters inquired why Keaton was on his arm, Nicholson waved them off with the reply, "We made a movie together." But a friend revealed, "Jack says he has so much more in common with Diane than he did with Lara."[137] Both had young children; Lorraine was now thirteen, Raymond eleven, and Keaton's adopted children were seven-year-old Dexter and two-year-old Duke. In 2004 Nicholson told *Playboy* interviewer David Sheff, "I have had a kind of open affection for Diane . . . ever since I was with her in *Reds*."[138]

He had been alone much of the time since his split with Lara Flynn Boyle, but a friend now commented that he and Keaton were "having the time of their lives, and are happy to wait and see where it all ends up."[139] Describing their love scenes in *Something's Gotta Give*, Keaton said, "He's the original bad boy and that's about as exciting as it gets. For the two weeks we were stuck in bed together, I learned a lot about his love life. He's a sentimental guy, a fool for love." But in 2004, when Barbara Walters asked her if there was anything between her and Nicholson, Keaton replied, "Hey, I'm up for it, but Jack is not ready for me."

"Are you too old?" Walters asked.

"I'm sure I am."

"But if he would, you would?"

"Oh yeah, of course. Jack? Any time."

Keaton confided that she'd never been in love, just infatuated with "these amazing men" like "adorable" Woody Allen, "pretty" Warren Beatty, and "gorgeous" Al Pacino, hoping some of their talent would rub off on her. "Nobody has ever asked me to marry them," she added, citing her "crippling insecurity," the fact that she'd been "in analysis all my adult life," the obstacle that her success might pose to the male ego, and the fact that she'd expect a man to "fit into my life" and "love my children."[140]

Meanwhile, although Lara's boyfriend, Jay Penske, was rumored to be on the verge of leaving her, they were seen canoodling at the bar at Dan Tana's.[141] According to another source, she was "juggling" Penske and twenty-three-year-old Malibu surfer Brian Carsten. "Lara loves to pick up surfers. Even though there's not really much of her to go around."[142] She had Penske's nickname, J Bird, tattooed on her shoulder blade, but rumors persisted that he was ready to cut out, finding her "erratic."[143]

In December 2003 Nicholson attended the premiere of *Something's Gotta Give* with his children Ray and Lorraine, and told reporters that Keaton's kisses were "fabulous" and their love scenes together "incandescently hot."[144] The critical press was divided. The trade paper, *Variety*, wrote it off as "slapdash," so bad it could be compared with Warren Beatty's 2001 Waterloo, *Town and Country*. Equally disdainful, the *New Yorker* reviewer David Denby thought Nicholson and Keaton's "affair horribly self-conscious and less romantic than lewd—*American Pie* for adults," and *Newsweek*'s David Ansen criticized Nicholson for "baring . . . his sagging butt," dismissing the picture as "insultingly perfunctory." But A. O. Scott of the *New York Times* called the film

an "unusually satisfying comic romance," and while he praised Nicholson's "devilish combination of high-spirited rakishness and old-school gallantry," he added, "Mr. Nicholson has the gentlemanly grace to step aside and let Ms. Keaton claim the movie."

The Golden Globes and the National Board of Review accorded Keaton their best actress of the year awards, and she was nominated for an Oscar. In February 2004 she said, "I asked Jack Nicholson to take me to the Oscars, but he turned me down. He's taking Amanda Peet. So I asked my sister Dorrie [Hall]." At the presentation ceremony at the Kodak Theater, Keaton got herself up in drag, appearing as "a dandy English lord," said Ralph Lauren, who designed a morning suit for her. Nicholson, who wasn't nominated, steered clear of the Kodak, opting for Dom Perignon and home cooking *chez* David Janssen's widow, Dani. Keaton lost to Charlize Theron for *Monster*, and in a *People* poll, the public overwhelmingly voted Keaton the worst dressed woman at the show, and the one most in need of a makeover.[145]

Nonetheless, *Something's Gotta Give* was one of the year's top ten grossers, raking in $107,054,327 in its first month, and Nicholson remained the only star of his generation to attract major offers. Tossing a compliment to director Nancy Meyers, he said, "I love working with women directors. They don't mind making you cute."[146] He added in the *New York Times*, "She's a tough director, let me tell you that. She knows what she wants and she's not afraid to get bloody to get it." They sometimes clashed over fine points having to do with wardrobe and male behavior. "She's a Philadelphia girl, I'm a Jersey boardwalk Johnny," he explained. "So you know we're going to disagree about how people behave at the beach, from the shoes on up."[147] During the five-and-a-half-month shoot, he took to calling her "Chief."

In 2004 Nicholson revealed that he might be approaching the

end of his movie career. "At some point I will quit. Maybe now. I don't have any plans to make another movie." But the chances were good that he'd continue to work as long as he was bankable. "I never want to overstay my welcome," he said. "It's always made clear to you in the movie business when your welcome is over."[148]

His children had become the "the joy and focus" of his life, and Ray and Lorraine often showed up at Mulholland before going to school. "Part of me doesn't want to wake up at six-thirty," he said. "I won't do it for a million dollars, or even twenty million, but I'd do it for them. . . . When you have children, you learn about a different variety of love."[149] In late 2003 he attended a runway show for Jennifer's 2004 spring/summer collection at Smashbox Studios in Culver City, posing with his forty-year-old daughter and Sean, his seven-year-old grandson. Jennifer had another son, Luke, four, before her marriage to Mark Norfleet ended in divorce. She lived with the boys, a nanny, a chef, five dogs, a rabbit, and a miniature pony, Little Joe, in a 1911 Santa Monica Colonial-style house she was renovating. "In my new house, my closets are going to be as big as my bedrooms," she said. "I told the architect, anything you've ever seen that you thought was a big closet, times twenty, and that's what I want." Born under the astrological sign of Virgo, she arranged her closets by color, and all her vintage clothes were hung together by designer.

Thanks to a low-carb diet that helped her lose twenty-five pounds, Jennifer looked sleek at her Smashbox fashion show, but she was still a far cry from the standard size-two fashionista. "I'm a little too big," she admitted. Her boutique, Mlle. Pearl, offered her own label up to size fourteen, and she accepted made-to-measure orders, but soon found that buyers didn't order the larger sizes. "When I first started my line, I argued with people a lot about sizing," she said. "I wanted to be able to wear the largest size of my

line and really I'm a little too big to fit into the largest size. . . . And when I'm ordering for the store, I'm really annoyed when people only make up to a size ten. I take it personally; I really do."[150]

With her father's money, she could have spent her entire life shopping and collecting couture classics for herself instead of designing and selling clothes, "but I have to work," she said. "My dad has a really strong work ethic. Since I was eighteen, I've always worked."[151] Her justifiably proud father skipped a Lakers' game—the season opener—and declined to watch it on a television set in the Smashbox office, preferring to flirt with the models backstage. "It's fine," he said, "I've TiVo'd it."[152] At the Staples Center that night his absence was conspicuous in an all-star crowd that included Leonardo DiCaprio; Toby Maguire and his girl, Jennifer Meyer, Ralph Lauren's PR agent and the daughter of Universal chief Ron Meyer; Richie Sambora and Heather Locklear; Dustin Hoffman and son Jake; and Cameron Diaz and Justin Timberlake. Part of the Nicholson legend was that he'd never missed a Lakers' home game.

"I like being Jack Nicholson's daughter and I'm proud of him," Jennifer said, "but people don't understand the pressures that come along with that." When her spring 2004 line garnered favorable notices and she received her first major fashion credit in the form of a Steven Meisel shoot for *Italian Vogue*, she felt she might at last have emerged from the shadow of her famous father. Although Mlle. Pearl, which had opened in April 2002, still hadn't turned a profit, her latest collection appealed to Henri Bendel and other department stores.[153] Slowly and steadily, Jennifer Nicholson was coming into her own.

At the same time, her dad was losing ground, at least with liberals who'd once regarded him as a moral hero. The counterculture par-

adigm who evolved into an iconoclastic anachronism was now simply an anachronism. "This is not the time for civil rights," Nicholson announced in a 2004 *Esquire* article, and an angry reader fired a letter to the the editor calling Nicholson "an asshole," while another welcomed the actor to the ranks of the political right, observing, "You are, indeed, a conservative." An unapologetic *Esquire* persisted in calling him "the coolest man in America."[154] He remained a darling of the media and a favorite of the general public, no doubt because of a trait he'd always possessed: he was lovable. He'd never hesitated to plunge headlong into life, and even if he made a muddle of it, he got married as a young man, fathered children, struggled as best he could with relationships and personal demons, and, above all, risked everything for art.

It was somehow appropriate, at the beginning of 2004, that *Playboy* interviewed him for its fiftieth-anniversary issue, because the actor and the magazine had frequently worked hand-in-hand in promoting the sexual revolution, one of the hallmarks of the previous century. Nicholson used the occasion to make some characteristically insensitive and insular remarks about AIDS, ranking "the publicizing of [the disease] right up there with the atomic bomb as events that impacted our culture for the worse. We were moving toward a more feeling, freer society until AIDS." What he really seemed to mind was that AIDS had made it more difficult for him to get laid. Operating under the insanely reckless assumption that heterosexuals were not in danger of becoming infected unless they were "shooting up or getting fucked in the heinie," he'd tried to carry on his sex life as usual, but had found that "you could not proselytize this view. The facts were almost useless. You couldn't give a woman the facts and have her respond, 'Oh, all right.' "[155] Surely the more salient facts of the AIDS epidemic were that forty million were infected, with 8,000 new cases daily, due largely to "prevention fatigue." Nicholson squandered his turn in

Playboy's bully pulpit, which would have been put to better use disseminating safe-sex information.

In the same interview, he lauded the advent of Viagra and recommended it for senior couples, advising, "Once, twice a month . . . stimulate yourself with this pharmacological solution, go out there and tear Mom up, baby, and everything is fine. It could save many relationships."[156] But he seemed to anticipate his upcoming sixty-seventh birthday with a certain amount of rueful dread. "You don't know what you had until it's gone," he said. "The diminution of a man's powers is very, very humbling. You live on barbed wire and bug juice until you're twenty-eight, and there's no price to pay. After a certain point, you pay for everything."

Epilogue: But Not for Love

Men have died from time to time, and
worms have eaten them, but not for love.
—As You Like It

In one of the most characteristic and telling episodes of his life, related by Helena Kallianiotes, Nicholson ran out of his Mulholland Drive home one day in the nineties, golf bag in hand, pursued by Rebecca Broussard, who was holding their baby and crying. "I've worked too hard for my lifestyle," he yelled. "No female is going to turn it around. No woman is going to change me . . . take me away from my recreation."[1] He sounded exactly like the tragicomic characters he'd played—Bobby Eroica Dupea, Patrick Randall McMurphy, and Garrett Breedlove. But the freedom Jack Nicholson treasured, and had always fiercely defended, did not ultimately make him happy. "I'll be single for the rest of my life—and I don't like it," he said.[2] "I live alone. I have an abiding fear of the dark."[3]

Nor was he particularly pleased to be without faith, devoid of recourse to a higher power. "I can still work up an envy for someone who has a faith," he said. "I can see how that could be a deeply

soothing existence."[4] . . . I'm incapable of believing in anything supernatural. . . . I want to believe. I do pray to something . . . up there. I have a God sense."[5] Instead of faith, the strength that had always sustained him was his work, his art. As Henry James wrote in *The Middle Years*, "We work in the dark—we do what we can— we give what we have. Our doubt is our passion and our passion is our task. The rest is the madness of art." Nicholson's achieve- ments—and they are considerable, on the level of Bogart and Cagney—brought him, over the years, whatever peace he knew, thanks to his Zen-tinged belief that "the next thing you do does not have to be bigger and more spectacular than the last."[6]

As he grows older, with the inevitable attritions of time, in- stant gratification of the flesh—*golf now*—will probably seem less important than the loss of companionship. "I don't really offer the full catastrophe to a woman. . . . You know, the package, children, whatever. . . . The probabilities, knowing my criteria, probably aren't great."[7] Nor had his vast experience of women taught him much about them, as a remark he made in 2004 clearly indicated: "Men dominate because of physicality, and thus have mercy where women do not." Never mind Mother Teresa and the Virgin Mary; meet Dirty Harry, the Terminator, Rambo, and Jack Torrance, the real angels of mercy. Even more chauvinistic was his penchant for blaming the world's ills on women's lib. "There are three times as many single women over forty as single men," he said in 2004. "That's what we got from the women's movement. The chickens have come home to roost."[8] *Oink!*

For this aging libertine, women at long last had lost some of their fascination. "You revise what interests you throughout your life," he said. "Now a lot of interhuman communication is not about gender or sex. It was once."[9] Having spent his prime with younger mistresses instead of taking his place in the cycle of gen- erations, he was apt to end up feeling extinct. "I can't have fun in a

club where everybody's twenty-three," he complained. "I can't do it anymore. When something is over for me, it's over. I can't hang around a schoolyard too long after I graduate."[10]

As for love, a lifetime with young girls, all of whom had now flown to more age-appropriate mates, had left him bereft. Though Nicholson insisted he wasn't wasting any time "sitting around," and added, "I certainly haven't ceased looking for a mate in life,"[11] it seemed unlikely he'd ever connect with a longtime partner who'd be there to take care of him to the end—or to care *for*. Not everyone, after all, is cut out for the many-splendored thing.

ACKNOWLEDGMENTS

Many thanks to Maureen O'Brien, Lindsey Moore, Mark Jackson, Andrea Molitor, and Carmen Capalbo in New York, and to Cathy Griffin in Hollywood.

I am also grateful to my friends Ron Bernstein, George Di-Caprio, Curtis Harrington, Dorris Halsey, Mrs. Joseph Cotten (Patricia Medina), Mrs. Aldous Huxley, Mani Bhaumik, George Christy, Janet Charlton, James Prideaux, Jack Larson, Spero Pastos, Dr. Paul Fleiss, Shelley Winters, Mrs. Edward Dmytryk, Cy Egan, and Stacey Behlmer at the Academy of Motion Picture Arts and Sciences Margaret Herrick Library.

SELECTED BIBLIOGRAPHY

Books

Bart, Peter, and Peter Guber: *Shoot Out*, New York: Putnam, 2002.

Bego, Mark: *Cher*, New York: Cooper Square Press, 2003.

Berg, A. Scott: *Kate Remembered*, New York: Putnam, 2003.

Biskind, Peter: *Easy Riders, Raging Bulls*, New York: Simon and Schuster, 1998.

Bockris, Victor: *Warhol*, Cambridge, Massachusetts: Da Capo, 1989.

Bosworth, Patricia: *Marlon Brando*, New York: Viking, 2001.

Breitbart, Andrew, and Mark Ebner: *Hollywood Interrupted*, Hoboken, New Jersey: Wiley, 2004.

Brode, Douglas: *The Films of Jack Nicholson*, Secaucus, New Jersey, 1986.

Brottman, Mikita, editor: *Jack Nicholson: Movie Top Ten*, London: Creation Books International, 1999.

Campbell, Nancy: *Jack Nicholson*, New York: Smithmark, 1994.

Ciment, Michel: *Kubrick*, New York: Faber & Faber, 2001.

Corey, Melinda, and George Ochoa: *The American Film Institute Desk Reference*, London: Stonesong Press, 2002.

Corman, Roger, and Jim Jerome: *How I Made a Hundred Movies in Hollywood and Never Lost a Dime*, New York: Da Capo, 1990.

Daniels, Bill, David Leedy, and Steven D. Sills: *Movie Money*, Los Angeles: Silman-James, 1998.

Dickens, Norman: *Jack Nicholson*, New York: New American Library, 1975.

Dickinson, Janice: *No Lifeguard on Duty*, New York: ReganBooks, 2002.

Downing, David: *Jack Nicholson*, New York: Stein and Day, 1984.

Emery, Robert J.: *The Directors: Take One*, New York: TV Books, 1999.

———: *The Directors: Take Two*, New York: TV Books, 2000.

Fleiss, Heidi: *Pandering*, Los Angeles: One Hour Entertainment, 2002.

Fleiss, Paul, M, and Frederick M. Hodges: *Sweet Dreams*, Los Angeles: Lowell, 2000.

Fonda, Peter: *Don't Tell Dad*, New York: Hyperion, 1998.

Fraser-Cavassoni, Natasha: *Sam Spiegel*, New York: Simon & Schuster, 2003.

Gerzon, Mark: *Listening to Midlife*, Boston: Shambhala, 1996.

Gray, Beverly: *Roger Corman*, Los Angeles: Renaissance Books, 2000.

Green, Joey: *How They Met*, New York: Black Dog & Leventhal, 2003.

Grobel, Lawrence: *The Hustons*, New York: Scribners, 1989.

Gross, Michael: *Model*, New York: Morrow, 1995.

Griffin, Nancy, and Kim Masters: *Hit & Run*, New York: Touchstone, 1996.

Guiles, Fred Lawrence: *Jane Fonda*, New York: Pinnacle, 1982.

Hadleigh, Boz: *Celebrity Lies!* Fort Lee, New Jersey: Barricade, 2003.

Halliwell, Leslie: *Halliwell's Filmgoers' Companion*, New York: Scribners, 1988.

Harkness, John: *The Academy Awards Handbook*, 2001 edition, New York: Pinnacle, 2001.

———: *The Academy Awards Handbook*, 2003 edition, New York: Pinnacle, 2003.

Harrison, Jim: *Off to the Side*, New York: Grove Press, 2002.

Herr, Michael: *Kubrick*, New York: Grove Press, 2000.

Holden, Anthony: *Behind the Oscar*, New York: Simon and Schuster, 1993.

King, Tom: *The Operator*, New York: Random House, 2000.

Kinn, Gail, and Jim Piazza, *The Academy Awards*, New York: Black Dog & Leventhal, 2002.

Kramer, Stanley, and Thomas M. Coffey: *A Mad Mad Mad Mad World*, Orlando, Florida: Harcourt Brace,1997.

Leaming, Barbara: *Polanski*, London: Hamish Hamilton, 1982.

Levy, Emanuel: *Oscar Fever*, New York: Continuum, 2001.

LoBrutto, Vincent: *Stanley Kubrick*, New York: Da Capo, 1997.

Manso, Peter: *Brando*, New York: Hyperion, 1994.

McGilligan, Patrick: *Jack's Life*, New York: Norton, 1994.

————: *Alfred Hitchcock*, New York: ReganBooks, 2003.

Parker, John: *Polanski*, London: Gollancz, 1993.

Petersen, James R.: *The Century of Sex*, New York: Grove, 1999.

Polanski, Roman: *Roman*, New York: Morrow, 1984.

Price, Victoria: *Vincent Price*, New York: St. Martin's, 1999.

Rensin, David: *The Mailroom*, New York: Ballantine, 2003.

Rodriguez, Elena: *Dennis Hopper*, New York: St. Martin's, 1988.

Rowe, John W., M.D., and Robert L. Kahnk, Ph.D.: *Successful Aging*, New York: Dell, 1998.

Schneider, Wolf: *Jack Nicholson Tribute Book: American Film Institute Life Achievement Award*, Los Angeles: Project Marketing, 1994.

Sheehy, Gail: *New Passages*, New York: Ballantine, 1995.

Shepherd, Donald: *Jack Nicholson*, New York: St. Martin's, 1991.

Shiach, Don: *Jack Nicholson: The Complete Film Guide*, London: B. T. Batsford, 1999.

Sylvester, Derek: *Jack Nicholson*, London: Proteus, 1982.

Terrill, Marshall: *Steve McQueen*, New York: Donald I. Fine, 1993.

Thompson, Peter: *Jack Nicholson*, Secaucus, New Jersey: Birch Lane, 1997.

Thomson, David: *The New Biographical Dictionary of Film*, New York: Knopf, 2002.

Warhol, Andy: *The Andy Warhol Diaries*, edited by Pat Hackett, New York: Warner Books, 1989.

Woodward, Bob: *Wired*, New York: Simon & Schuster, 1984.

Articles

"Actor Nicholson Charged After Attack on Car," *Los Angeles Times*, March 1, 1994.

"Actor's Fingerprints Not Same as Those on Hashish Container," *Los Angeles Times*, April 9, 1977.

"Actor Nicholson's Fingerprints Sought," *Los Angeles Herald-Examiner*, March 31, 1977.

"A Fine Romance '94: Rebecca Broussard and Jack Nicholson," *People*, December 2, 1994.

"A Lot of Jack to Go Around," *Newsweek*, November 6, 1989.

Andrew, Geoff: "Grin Reaper," *Time Out* (London), March 11, 1998.

Angeli, Michael: "Playing Jack's Game," *Esquire*, September 1990.

Anspach, Susan: "Letters: Jack of Hearts," *Vanity Fair*, June 1994.

"Anspach v. *Nicholson"* (re Colbert sexual harassment charge), *Los Angeles Times*, November 3, 1995.

"Arraignment Delayed for Jack Nicholson," *Los Angeles Times*, April 15, 1994.

Atlas, Jacob, and Marni Butterfield, "Odd Man In—Jack Nicholson," *Show*, May 1971.

Attanasio, Paul: "Jack Nicholson Genuinely," *Washington Post*, June 14, 1985.

Bacon, James: " 'Deeply Shocked,' Declares Friend Jack Nicholson," *Los Angeles Herald-Examiner*, February 1, 1978.

Bart, Peter: "Judicious Jack," *Variety*, November 16, 1992.

———: "Nicholson at Nite," *Variety*, March 7, 1994.

Battelle, Phyllis: "Movie Actor Tells of Film Set in Hospital," *Los Angeles Herald-Examiner*, November 21, 1975.

Beck, Marilyn: "Nicholson's Back in the News," *Long Beach Press-Telegram*, October 28, 1989.

Bradberry, Grace, and Charles Bremmer: "Just Wild About Bad Boys," *The Times* (London), March 2, 2001.

Bremmer, Charles: "Why Women Fall for the Rogues," *The Times* (London), March 2, 2001.

Brill, Marius: "Talk of the Devil," *Sunday Times* (London), July 21, 1996.

Brooks, Richard: "You've Got to Be Joking, Jack," *Observer* (London), March 14, 1993.

Brozan, Nadine: "A judge dismissed . . ." *New York Times*, May 7, 1994.

Canby, Vincent: "There's No Doubt—Jack Nicholson Is a Major Star," *New York Times*, February 24, 1974.

Carr, Jay: "Nicholson at Peace—Not Such a Big, Bad Wolf," *Long Beach Press-Telegram*, June 18, 1994.

Case, Brian: "Howlin' Jack," *Time Out* (London), August 17, 1994.

Caulfield, Deborah: "Nicholson on the Matter of His Honor," *Los Angeles Times Calendar*, June 16, 1985.

Champlin, Charles: "Star and Director: Jack, Be Nimble," *Los Angeles Times*, July 9, 1989.

————: "Two Films With an Uncommon Actor," *Los Angeles Times*, July 20, 1975.

Chase, Chris: "The Legend That Jack Built," *Cosmopolitan*, February 1983.

————: "At the Movies," *New York Times*, February 5, 1982.

Christy, George: "The Great Life," *Hollywood Reporter*, March 8, 1994.

Clein, Harry: "Jack Nicholson," *Entertainment World*, November 7, 1969.

Collins, Nancy: "Happy Jack," *Vanity Fair*, April 1992.

————: "Jack the Wolf," *Vanity Fair*, April 1994.

————: "Jack Nicholson: The Great Seducer," *Rolling Stone*, March 29, 1984.

"Cops Want Nicholson's Prints in Polanski Case," *Variety*, April 4, 1977.

"Cuckoo Love Story," *Women's Wear Daily*, March 24, 1976.

Darrach, Brad: "The Father, the Director, and the Holy Terror," *Life*, September 1990.

————: "Jack Is Nimble, Jack Is Best, Jack Flies Over the Cuckoo's Nest—En Route to an Oscar?" *People*, December 8, 1975.

————: "Jack Finds His Queen of Hearts," *People*, July 8, 1985.

Davidson, Bill: "The Conquering Antihero," *New York Times Magazine*, October 12, 1975.

Davis, Geena: Interview with David Letterman, *Late Show*, CBS, July 18, 2002.

Davis, Sally Ogle: "Jack Nicholson: Really Good at Being Evil," *Senior Life*, July 1989.

Denby, David: "Jack Nicholson," *New York*, September 11, 1989.

"Devil of a Joker Is Laughing All the Way to the Bank," *Sunday Times* (London), August 6, 1989.

DeVries, Hilary: "Still Simmering Under the Shades," *Los Angeles Times Calendar*, December 6, 1992.

D.M.: "It Must Be Witchcraft," *Vogue*, June 1986.

Ebert, Roger: "Jack's Back," *Marquee*, February 1984.

Ecker, Diana, and Monica Rizzo: "The Odd Couple: Jack Moves in With Marlon," *US Weekly*, March 12, 2001.

Erickson, Steve: "The Myth That Jack Built," *Esquire*, September 1990.

Farber, Stephen: "Jack Nicholson Comes to Terms With Middle Age," *New York Times*, circa 1983.

Fayard, Judy: "Happy Jack," unsourced magazine article (re: asking actress to remove clothes for *Drive, He Said* audition) in Nicholson file, reference department, Margaret Herrick Library, Academy of Motion Picture Arts and Sciences, Los Angeles.

"Film Institute Honors Jack Nicholson," *Press-Telegram*, March 5, 1994.

"Fin de Smoking," *New York*, April 10, 1994.

Fink, Mitchell: "Page 2: Happy Birthday, Jack," *Los Angeles Herald-Examiner*, April 22, 1987.

————: "Page 2: Streep Scene," *Los Angeles Herald-Examiner*, August 18, 1987.

————: "Page 2: The Joker Is Wild," *Los Angeles Herald-Examiner*, October 26, 1989.

————: "The Insider: Trouble in the House That Jack Bought," *People*, September 28, 1992.

Flatley, Guy: "Jack Nicholson—Down to the Very *Last Detail*," *New York Times*, February 10, 1974.

Fleming, Michael: " 'Anger' Gets Best of Jack," *Variety*, December 21, 2001.

France, Louise: "My Friend Jack the Lad," *The Times* (London), May 15, 1998.

Freedman, Samuel G.: "*Two Jakes* Picks Up the *Chinatown* Trail," *New York Times*, August 5, 1990.

Fury, Kathleen D.: "Jack Nicholson," *Ladies' Home Journal*, April 1976.

Garnett, Daisy: "Life in the Fast Lane," *Talk*, November 2000.

Gliatto, Tom, and John Hannah: "The House That Jack Owns," *People*, July 1, 1996.

Graham, Caroline: "He's Double My Age, but His Stamina Amazed Me," *The Sun* (London), June 8, 1995.

———: "Joker Jack Played the Devil . . . but He Is Evil in Real Life," *The Sun* (London), June 22, 1996.

Gussow, Mel: "An *Easy Rider* With Total Control," *Los Angeles Herald-Examiner*, January 8, 1976.

Haber, Joyce: "Brando, Nicholson," *Los Angeles Times*, June 10, 1975.

Harmetz, Aljean: "Jack Ransacks the Cupboards of His Past," *Los Angeles Times*, March 31, 1974.

———: "The Two Jacks," *New York Times Magazine*, September 9, 1989.

———: "The Joker Is Wild," *New York Times*, June 18, 1989.

Harvey, Duston: "Other Side of Success," *Los Angeles Herald-Examiner*, July 27, 1971.

Hirschberg, Lynn: "Jack Nicholson," *Rolling Stone*, November 5, 1987.

Holdsworth, Nick: "Moscow Applauds Nicholson," www.hollywoodreporter.com, July 3–9, 2001.

Honeycutt, Kirk: "Nicholson's Wild Night Is a Good Time for All," *Hollywood Reporter*, March 7, 1994.

Horn, John: "The Oscar Show, and How It Went On," *Los Angeles Times*, March 24, 2003.

Hurst, John: "Defense Rests in Trial of Miss Longet," *Los Angeles Times*, January 14, 1977, p. 1.

Hutchings, David: "Oh, What a Night!" *People*, April 7, 2003.

Iley, Chrissy: "Relationship of the Week: Jack Nicholson and Susan Anspach," *Sunday Times* (London), June 23, 1996.

"Images," *People*, March 1, 1976.

"Jack 'n' Meryl," *Los Angeles Herald-Examiner*, December 8, 1988.

"Jack and Nancy: What? No Goodnight Kiss?" *People*, May 27, 1996.

"Jack and Warren," *Marie Claire*, February 1997.

"Jack Nicholson" (re: Catherine Sheehan accepting $32,000 settlement), *US Weekly*, May 29, 2000.

"Jack Nicholson Being Pitched for *Home* Lead," *Variety*, October 20, 1976.

"Jack Nicholson: On a New Liquid Diet, He's Sloughing His Love Handles," *People*, January 20, 1992.

"Jack Nicholson Sought for Fingerprinting in Hashish Find," *Los Angeles Times*, September 2, 1977.

"Jack Stages a Comeback," *People*, November 19, 2001.

Jacobs, Jodi: "Peellaert" item in column, *Los Angeles Times*, July 28, 1975.

"People: *Jake's* Helping Out Jack," *Long Beach Press-Telegram*, August 9, 1990.

Janos, Leo: "Jack Nicholson: Bankable and Brilliant," *Cosmopolitan*, December 1976.

Jerome, Jim: "The Reel Deal," *People*, August 12, 2002.

"Just for Variety," *Variety* (re: replacing Mandy Patinkin), July 29, 1985.

Kang, Laura: "Annie, Get Your Guys," *Vanity Fair*, April 2003, p. 128.

Kaylin, Lucy: "Jack Nicholson Has Never Been to an Orgy," *GQ*, January 1996.

Ken Kelley, "Tales From Tosca," *San Francisco Focus*, April 1991.

Kilday, Gregg: "Jack Nicholson's Face Odysseys," *GQ*, March 1981.

————: "Page 2: Jack's All Right," *Los Angeles Herald-Examiner*, May 28, 1985.

Klady, Leonard: "AFI's Nicholson Fete an Evening of Shades," *Variety*, March 7, 1994.

Knapp, Dan: "Jack Nicholson, the Bender of Film Boundaries," *Los Angeles Times*, August 8, 1971.

Lagnado, Alice: "Cuckoo in Starstruck Putin's Nest," *The Times* (London), June 29, 2001.

"Lara Stole Jack From Me," *Globe*, June 20, 2000.

Lester, Peter: "Hollywood Heavyweight Jack Nicholson Unloads on Drugs, Marriage, and Polanski," *People*, July 28, 1980.

Lewin, David: "Jack Nicholson," *US*, March 16, 1982.

Lewis, Fiona: "Jack Nicholson: Both Sides of the Camera," *Los Angeles Times Calendar*, November 6, 1977.

Lewis, Richard Warren: "*Playboy* Interview: Jack Nicholson," *Playboy*, April 1972.

Litchfield, David: "Jack Nicholson and Litchfield," *Ritz*, No. 88, June 1984.

Lyman, Rick: "Nicole Kidman: A Perfectionist's Pupil With a Major in Creepy," *New York Times*, February 22, 2002.

Mann, Roderick: "For Nicholson, Fascination Still Rings With *Postman*," *Los Angeles Times Calendar*, March 15, 1981.

———: "Nicholson: Pendulum on Upswing Again," February 21, 1982.

Markham-Smith, Ian: "Nicholson," *US*, April 4, 1984.

Matthews, Jack: "Jack—Laid-Back," *The Los Angeles Times Magazine*, August 5, 1990

Miller, Edwin: "No Ego in His Act," *Seventeen*, April 1976.

Miller, George: "Jack of All Trades," May 18–25, 1988, *Time Out* (London).

Mitchell, Sean: "As Funny as It Gets," *Los Angeles Times Weekend*, December 25, 1997.

Moore, Booth, and Michael Quintanilla: "Heeeere's Jennifer," *Los Angeles Times*, April 5, 2002.

Morgenstern, Joe: "Remember It, Jack. It's Chinatown," *GQ*, January 1990.

Mrozek, Thom: "Prosecutors Will Fight Nicholson's Legal Move," *Los Angeles Times*, April 27, 1994.

———: "Nicholson Settles Case," *Los Angeles Times*, May 3, 1994.

Murphy, Mary: "Jack Nicholson: Why the Joker's Too Wild for TV," *TV Guide*, August 11, 1990.

"Newsmakers" (re: Polanski), *Newsweek*, February 13, 1978.

"Nicholson Allegedly Golf-Clubs Car," *Press-Telegram*, February 24, 1994.

"Nicholson Anger Management Skills Slip at NBA Game," *Hello!* May 13, 2003.

"Nicholson Diet," *New York Times*, August 24, 1994.

"Nicholson Is Treated Like a Ground Zero Hero," *US Weekly*, December 3, 2001.

"Nicholson Notes" (identifies "Don Rose" as Nicholson's father), *US* May 11, 1982.

"Nicholson's Fingerprints Not on Hashish Container," *Variety*, April 19, 1977.

"Nicholson Settles Suit," *Los Angeles Times*, May 11, 1984.

"Nicholson Settles Suit Over Drug-Use Report," *New York Times*, May 11, 1984.

"Nicholson Speaks Out on Clinton," *The Outlook*, January 30, 1998.

O'Donnell, Rosie: "Through Thick and Thin," *Rosie*, July 2002.

"Of All the Hollywood" (re: Dyan Cannon's brownies), *People*, June 25, 2001.

O'Neill, Ann W.: "The Court Files" (re: Catherine Sheehan case), *Los Angeles Times*, May 14, 2000.

O'Neill, Michael: "Jack the Lad Goes to the Devil," *Observer (London)*, October 4, 1987.

"Ordeal by Cameras for Roman Polanski," *Variety*, April 6, 1977.

Osborne, Robert: "Rambling Reporter" (re: *Blue Champagne*), *Hollywood Reporter*, August 9, 1991.

Parker, Jerry/*Newsday* wire-story manuscript, "1st ADD NICHOLSON," from the collection of Charles Champlin, Margaret Herrick Library, June 25, 1975.

Patterson, Dan: "Jack Nicholson and Roman Polanski Talk About Acting in the Strasberg Institute," *Drama Logue*, June 3, 1977.

Perry, George: "Leader of the Jack Pack," *Sunday Times* (London), April 19, 1998.

Playgirl (re: "triangular affair" between Nicholson, Keaton, and Beatty), December 1979.

"Please Don't Ask," *People*, November 5, 1990.

"Polanski Charged in Rape Here," *Los Angeles Herald-Examiner*, March 12, 1977, p. 1.

"Pop Quiz With Jack Nicholson," *People*, December 17, 2001.

Pristin, Terry: "Hutton Wins $9.75 Million in MGM Suit," *Los Angeles Times*, February 26, 1989.

Raftery, Brian M.: "Perfect Pitches," *Entertainment Weekly*, April 4, 2003.

"Range Rover: Tommy Baratta Cooks Where Jack Nicholson Eats," *People*, December 16, 1996.

Reed, Rex: "The Man Who Walked Off With *Easy Rider*," *New York Times*, March 1, 1970.

"Reformation of a Rogue?" *Time*, August 8, 1994.

Reilley, Rick: "Wild in the Seats," *Sports Illustrated*, November 3, 1986.

Renold, Evelyn: "Entertainer," *Midwest Magazine*, March 28, 1976.

Riefe, Jordan: "Jack's Back," *Tongue*, circa 2003.

"Rock Dreams," *Los Angeles Herald-Examiner*, July 23, 1975.

"*Rolling Stone* Interview," March 19, 1998.

"Roman Polanski's Tawdry Troubles," *Time*, March 28, 1977.

Rosenbaum, Ron: "Acting: The Method and Mystique of Jack Nicholson," *New York Times Magazine*, July 13, 1986.

Ross, Marilyn T.: "Hippie? Hard-Hat? Hero?" *Movie Digest*, January 1972.

Rossell, Deac: "Riders' Silent Sage," *Philadelphia After Dark*, September 24, 1969.

Rozen, Leah: "2003 Oscar Picks," *People*, March 24, 2003.

Sandler, Adam: Interview with David Letterman, *Late Show*, CBS, June 25, 2002.

Schiff, Stephen: "Jumping Jack," *Vanity Fair*, August 1986.

Schnabel, Julian: "Jack Nicholson," *Interview*, August 1990.

Schruers, Fred: "The *Rolling Stone* Interview: Jack Nicholson," *Rolling Stone*, August 14, 1986.

———: "Gentleman Jack," *US*, July 1994.

Scott, Walter: *Parade*, October 11, 1987.

Sessums, Kevin: "Call of the Wild," *Vanity Fair*, February 2001.

Shales, Tom: "Shore Patrol Duty for Jack Nicholson," *Los Angeles Times*, March 1, 1973.

Sheff, David: "Jack Nicholson," *Playboy*, January 2004.

Siegel, Lee: "The New King of Irony," *Talk*, April 2000.

Sillifant, Jeff: "Polanski Sex Charge Arraignment Slated," *Los Angeles Herald-Examiner*, March 13, 1977, p. 1.

Siskel, Gene: "Terms of Fulfillment: Jack Nicholson Talks About His Career," *Chicago Tribune*, June 16, 1985.

Slayton, Richard: "My Style," *Los Angeles Herald Examiner*, June 17, 1985.

Slonim, Jeffrey: "Unforgettable," *New York Post*, July 7, 2002.

Smith, Julia Llewellyn: "Why America Adores Its Jack the Lad," *The Times* (London), March 15, 1994.

Smith, Liz: (Re: shuttles between Lorne Michaels and U.S. Open), *Los Angeles Times*, September 10, 1991.

Solomon, Deborah: "Questions for Jules Feiffer: Playing With History," *New York Times Magazine*, June 15, 2003.

Souter, Ericka: "Chatter," *People*, December 16, 2002.

Stall, Bill: "Roman Polanski Charged With Rape," *Los Angeles Times*, March 13, 1977, p. 1.

Sterritt, David: "Nicholson—Acting Is a Hard Trick," *Los Angeles Herald-Examiner*, April 12, 1976.

"Sued" (re: fenderbender with Hegedus and Kharitonovich), *People*, October 11, 1999.

"*Sun* to Pay Nicholson Damages," *Screen International*, May 19, 1984.

"The Actress Women Love to Hate," *US*, July 15, 2002.

Thomson, David: "Nicholson, King of Mulholland: He Just Wants to Make It Nice," *Playgirl*, April 1981.

———: "Jack and the Women," *Independent on Sunday* (London), March 2, 1997.

Torgoff, Martin: "Jack Nicholson," *Interview*, August 1984.

"People: Tourney's Still On," *Long Beach Press-Telegram*, March 3, 1994.

Townsend, Dorothy: "Polanski Indicted in Rape Case," *Los Angeles Times*, March 25, 1977.

Tusher, Will: "Washburn Scripting *Napoleon*," *Variety*, June 8, 1990.

Variety (re: Nicholson's meeting Cesar Romero), August 29, 1988.

Ventura, Michael: "Jack Nicholson Interview #3001," *LA Weekly*, June 28–July 4, 1985.

Viva, circa 1975 (re: Nicholson "paying a tremendous amount of money for my dope these days" and about campaigning for McGovern and JFK).

Walker, Mike: "All the Gossip," *National Enquirer*, circa April 2003.

Warhol, Andy (redacted by Chris Hemphill): "Andy Warhol Listens to Jack Nicholson," *Interview*, December 1976.

Weaver, Neal: "I Have the Blood of Kings in My Veins, Is My Point of View," *After Dark*, October 1969.

Weisberg, Lori: "Nicholson Uses Humor to Field Flak on New Film," *UCLA Daily Bruin*, May 21, 1976.

"Werewolf in Wonderland," *Observer* (London), July 10, 1994.

Wharton, David: "Down in Front!" *Los Angeles Times Magazine*, October 10, 1999.

Williams, Jeannie: "A House Divided: Nicholson, Anspach," *USA Today*, June 17, 1996.

Wilmington, Michael: "Jack Nicholson," *Playgirl*, August 1985.

Wolf, William: "Jack Nicholson Can Do Anything, Can't He?" *Cue*, July 7, 1975.

Woods, Vicki: "Jack Oozy," *Tatler* (U.K.), June 1984.

Zeidner, Lisa: "Rebels Who Were More Angry Than Mad," *New York Times*, November 26, 2000.

NOTES

M uch of this book is based on primary sources—new interviews with Cynthia Basinet, Roger Corman, Curtis Harrington, Jennifer Howard, Denise Beaumont, Steve Tisch, Veronica Cartwright, Harry Gittes, Leslie Cyril, and numerous others, who requested anonymity. Some of Jack Nicholson's quotations are from his 2003 press conference for *About Schmidt*.

Most secondary sources below are identified in short-form; more complete publishing details may be found in the Selected Bibliography. Most of the secondary-source research was done at the Margaret Herrick Library, Academy of Motion Picture Arts and Sciences, Beverly Hills. Though some of the clippings were incompletely sourced, they are all available at the Margaret Herrick Library for inspection by writers and film scholars.

Prologue: No Need for Viagra

1. Peter Biskind, the respected film historian, writes in *Easy Riders, Raging Bulls*, New York: Simon and Schuster, 1998, p. 118: "For Jack, success meant never having to pay for yourself. He never picked up a check if he could possibly avoid it. His home was filled with freebies he'd hustled, or which had just appeared, unsolicited, manna from movie star heaven—bags of expensive golf clubs, heaps of fine Italian shoes."
2. The interview with Cynthia Basinet was conducted for this book in Los Angeles in 2003 by Cathy Griffin. Earlier, on June 20, 2000, the *Globe*, p. 4, published a story about Basinet, "Lara Stole Jack From Me."
3. Mike Walker, "All the Gossip," *National Enquirer*, no date listed, circa April 2003, p. 12.
4. Brad Darrach, "The Father, the Director, and the Holy Terror," *Life*, September 1990, pp. 70–72.
5. No byline, "Jack Nicholson Uncensored," *Globe*, December 9, 2003, p. 15.
6. No byline, "Are Jack's Playboy Days Over?" *In Touch*, February 23, 2004, p. 80.

Chapter One: The Prince of Summer

1. "I became conscious of very . . .": Richard Warren Lewis, "Playboy Interview: Jack Nicholson," *Playboy*, April 1972, p. 78; other sources for Nicholson's birth and childhood: Norman Dickens, *Jack Nicholson*, New York: New American Library, 1975, pp. 8–10; Marius Brill, "Talk of the Devil," *Sunday Times* (London), July 21, 1996, pp. 10–12; Martin Torgoff, "Jack Nicholson" *Interview*, August 1984, p. 47; David Downing, *Jack Nicholson*, New York: Stein and Day, 1984, pp. 5–13; Patrick McGilligan, *Jack's Life*, New York: Norton, 1994, pp. 32–46. June Nicholson was born November 5, 1918.
2. McGilligan, *Jack's Life*, pp. 39–41, 45,140; Brad Darrach, "Jack Is Nimble, Jack Is Best, Jack Flies Over the Cuckoo's Nest—En Route to an Oscar?" *People*, December 8, 1975, p. 54.
3. Peter Thompson, *Jack Nicholson*, Secaucus, New Jersey: Birch Lane, 1997, p. 255.

4. Paul Attanasio, "Jack Nicholson Genuinely," *Washington Post*, June 14, 1985, p. C1: "It is perhaps from the nature of his upbringing, and the confusion of it, that the patterns of his relationships have emerged. He has been a famous philanderer, known to get in a car with Warren Beatty and go chasing women like a high school boy."

5. Nancy Collins, "Jack the Wolf," *Vanity Fair*, April 1994, p. 124.

6. Thompson, *Jack Nicholson*, p. 220.

7. Darrach, "Jack Is Nimble," *People*, December 8, 1975, p. 54. The quotations, "They were both so afraid," "He grew up," and "Jack has a right" are from Nancy Collins, "Jack the Wolf," *Vanity Fair*, April 1994, p. 166.

8. Thompson, *Jack Nicholson*, pp. 113–114.

9. McGilligan, pp. 51, 410, and Bill Davidson, "The Conquering Antihero," *New York Times Magazine*, October 12, 1975, no page listed.

10. Richard Warren Lewis, "*Playboy* Interview: Jack Nicholson," *Playboy*, April 1972, p. 78.

11. Ibid.; Thompson, *Jack Nicholson*, pp. 76–77.

12. Torgoff, *Interview*, August 1984, p. 47.

13. Darrach, "Jack Is Nimble, Jack Is Best, Jack Flies Over the Cuckoo's Nest—En Route to an Oscar?" *People*, December 8, 1975; Kathleen D. Fury, "Jack Nicholson," *Ladies' Home Journal*, April 1976, p. 185.

14. Collins, "Jack the Wolf," *Vanity Fair*, April 1994, p. 166.

15. Chris Chase, "The Legend That Jack Built," *Cosmopolitan*, February 1983, p. 170.

16. Nancy Collins, "Jack Nicholson: The Great Seducer," *Rolling Stone*, March 29, 1984, p. 17.

17. Ibid.

18. Ericka Souter, "Chatter," *People*, December 12, 2002, p. 170.

19. McGilligan, *Jack's Life*, p. 49.

20. David Sheff, "Jack Nicholson," *Playboy*, January 2004, p. 88.

21. Collins, "Jack Nicholson: The Great Seducer," *Rolling Stone*, March 29, 1984, p. 17.

22. Rick Reilley, "Wild in the Seats," *Sports Illustrated*, November 3, 1986, quoted in McGilligan, *Jack's Life*, pp. 61, 411.

23. Ibid.
24. Dickens, *Jack Nicholson*, p. 13.
25. Ibid.
26. McGilligan, *Jack's Life*, p. 53.
27. 1972 *Screw* article quoted in Dickens, *Jack Nicholson*, p. 109.
28. McGilligan, *Jack's Life*, p. 54.
29. "Jack Nicholson: On a New Liquid Diet, He's Sloughing His Love Handles," *People*, January 20, 1992, no page listed.
30. Jack Nicholson in a 2003 interview in L.A. for *About Schmidt*.
31. No byline, "Jack and Nancy: What? No Goodnight Kiss?" *People*, May 27, 1996, p. 51.
32. Phyllis Battelle, "Movie Actor Tells of Film Set in Hospital," *Los Angeles Herald-Examiner*, November 21, 1975, no page listed.
33. Edwin Miller, "No Ego in His Act," *Seventeen*, April 1976, p. 189.
34. Fred Schruers, "The *Rolling Stone* Interview: Jack Nicholson," August 14, 1986, p. 50.
35. Ibid.
36. Douglas Brode, *The Films of Jack Nicholson*, Secaucus, New Jersey: 1996, p. 236.
37. McGilligan, *Jack's Life*, p. 59.
38. Torgoff, "Jack Nicholson," *Interview*, August 1984, p. 46.
39. Ibid., p. 61.
40. No byline, "Jack and Nancy: What? No Goodnight Kiss?!" *People*, May 27, 1996, p. 51.
41. Darrach, "Jack Is Nimble," *People*, December 8, 1975, p. 51.
42. Collins, *Rolling Stone*, March 29, 1984, p. 20.
43. Attanasio, "Jack Nicholson, Genuinely," *Washington Post*, June 14, 1985, p. C1.
44. Schruers, *Rolling Stone*, August 14, 1986, p. 50.
45. Harry Clein, "Jack Nicholson," *Entertainment World*, November 7, 1969, no page number listed.
46. Darrah, *People*, December 8, 1975.
47. Jack Matthews, "Jack—Laid-Back," *The Los Angeles Times Magazine*, August 5, 1990, no page listed.

48. Schruers, *Rolling Stone*, August 14, 1986, p. 40.
49. June a heavy drinker: McGilligan, *Jack's Life*, p. 73.
50. Kathleen D. Fury, "Jack Nicholson," *Ladies' Home Journal*, April 1976, p. 185.
51. In April 1972 Nicholson told *Playboy* (p. 76) he started smoking marijuana "fifteen years ago."
52. McGilligan, *Jack's Life*, p. 105.
53. Deac Rossell, "Riders' Silent Sage," *Philadelphia After Dark*, September 24, 1969, p. 13.
54. McGilligan, *Jack's Life*, pp. 135–136.
55. Ibid., p. 99.
56. Collins, "Happy Jack," *Vanity Fair*, April 1992, p. 228.
57. Sheff, "Jack Nicholson," *Playboy*, January 2004, p. 88.
58. David Litchfield, "Jack Nicholson and Litchfield," *Ritz*, No. 88, June 1984, p. 19.

Chapter Two: Hip, Slick, and Cool

1. David Rensin, *The Mailroom*, New York: Ballantine, 2003, *passim*.
2. Neal Weaver, "I Have Blood," *After Dark*, October 1969, no page listed.
3. McGilligan, *Jack's Life*, p. 80.
4. Thompson, *Jack Nicholson*, pp. 113–114.
5. Jim Buckley and Al Goldstein in *Screw*, 1971, quoted in Dickens, p. 108.
6. No byline, "Jack Nicholson," *Los Angeles Herald-Examiner*, February 14, 1971, p. G–4.
7. Donald Shepherd, *Jack Nicholson*, New York: St. Martin's, 1991, p. 19.
8. Mike Sager, "Jack Nicholson, 66," *Esquire*, January 2004, p. 70.
9. Shepherd, *Jack Nicholson*, pp. 30–31.
10. Hilary DeVries, "Still Simmering Under the Shades," *Los Angeles Times Calendar*, December 6, 1992, no page listed.
11. McGilligan, *Jack's Life*, p. 98.
12. Ibid., p. 99.
13. Ibid., p. 18.

14. Chris Chase, *Cosmopolitan*, p. 170.
15. www.hollywoodreporter October 22, 2002.
16. Patty Bosworth, "The Mentor and the Movie Star," *Vanity Fair*, June 2003, p. 215.
17. Sager, "Jack Nicholson, 66," *Esquire*, January 2004, p. 70.
18. Dan Patterson, "Jack Nicholson and Roman Polanski Talk About Acting in the Strasberg Institute," *Drama Logue*, June 3, 1977, pp. 9–10.
19. Ron Rosenbaum, "Acting," *New York Times Magazine* July 13, 1986, p. 12; Gene Siskel, *Chicago Tribune*, p. 10.
20. Dickens, p. 24.
21. Ibid., p. 103.
22. Schruers, *Rolling Stone.*, August 14, 1986, p. 50. Cathy Griffin interview with Harry Gittes, 2003.
23. Deborah Soloman, "Playing With History," *New York Times Magazine*, June 15, 2003, p. 13.
24. Frank Rich, "The Rush of the New Rat Pack," *New York Times*, October 19, 2003, section 2, p. 2.
25. Shepherd, *Jack Nicholson*, pp. 26–27.
26. Douglas Brode, *The Films of Jack Nicholson*, Secaucus, New Jersey: Citadel Press, 1987, p. 116.
27. Shepherd, *Jack Nicholson*, p. 27.
28. Dickens, *Jack Nicholson*, pp. 34–35.
29. *Washington Post*, June 14, 1985.
30. The same year, he tried to stop smoking. Nancy Collins, "Jack's Baby Love," *Vanity Fair*, April 1992, p. 166.
31. Beverly Gray, *Roger Corman*, pp. 51, 55, 253.
32. Ibid., p. 254.
33. *After Dark*, October 1969, p. 41.
34. Douglas Brode, *The Films of Jack Nicholson*, Secaucus, New Jersey: Citadel Press, 1987, pp. 42–43.
35. Lewin, *US*, March 1, 1982, p. 46.
36. Tom Shales, "Shore Patrol Duty for Jack Nicholson," *Los Angeles Times*, March 1, 1973, p. 22, part IV. *Variety*, April 13, 1984.
37. *Viva*, 1975, p. 103.

38. Michelle Carouso, John South, Rick Egusquiza, Jim Nelson, and Tim Plant, "Stars on Drugs," *Enquirer*, January 14, 2003, p. 10.
39. Shepherd, *Jack Nicholson*, p. 132.
40. *Vanity Fair*, April 1994.
41. Victoria Price, *Vincent Price*, New York: St. Martin's, 1999, p. 272.
42. David Sheff, "Jack Nicholson," *Playboy*, January 2004, p. 83.
43. Ibid.
44. Sager, "Jack Nicholson, 66," *Esquire*, January 2004, p. 71.
45. Roger Corman and Jim Jerome, *How I Made a Hundred Movies in Hollywood and Never Lost a Dime*, pp. 93–94.
46. Lawrence J. Quirk, *The Kennedys in Hollywood*, New York: Cooper Square Press, 2004, pp. 270–271.
47. Marius Brill, "Talk of the Devil," *Sunday Times* (London), July 21, 1996, pp. 10–12. Lucy Kaylin: "Jack Nicholson Has Never Been to an Orgy," *GQ*, January 1996, p. 94.
48. Lewis, "*Playboy* Interview," April 1972, p. 82.
49. Dickens, *Jack Nicholson*, p. 35.
50. McGilligan, *Jack's Life*, p. 147.
51. Dickens, *Jack Nicholson*, p. 46.
52. McGilligan, *Jack's Life*, p. 164.
53. Dickens, *Jack Nicholson*, p. 46.
54. McGilligan, *Jack's Life*, p. 150.
55. Schruers, *Rolling Stone*, August 14, 1986, p. 50.
56. Stephen Schiff, "Jumping Jack," *Vanity Fair*, August 1986, p. 64; Parker/ *Newsday* wire story, "1st ADD NICHOLSON," from the collection of Charles Champlin, Margaret Herrick Library, June 25, 1975, p. 1.
57. Collins, *Vanity Fair*, April 1994.
58. Dickens, *Jack Nicholson*, p. 49, quoting *Time*, August 12, 1974, and Lewis, *Playboy*, 1972.
59. Schruers, *Rolling Stone*, August 14, 1986, p. 50.
60. Kathleen D. Fury, "Jack Nicholson," *Ladies' Home Journal*, April 1976, p. 186.
61. Peter Thompson, *Jack Nicholson*, pp. 76–77.
62. Shepherd, *Jack Nicholson*, p. 54.

63. "Werewolf in Wonderland," *Observer* (London), July 10, 1994, no page listed.

64. Shepherd, *Jack Nicholson*, p. 54.

65. Geoff Andrew, "Grin Reaper,"*Time Out* (London), March 11, 1998, p. 16.

66. No author listed, "Robert Evans," *People*, November 18, 1996, no page listed.

67. McGilligan, *Jack's Life*, pp. 166, 416.

68. Janelle Brown, "Joni Mitchell Slept Here," *New York Times*, November 28, 2003, p. D6.

69. Joey Green, *How They Met*, New York: Black Dog & Leventhal, 2003, p. 278.

70. Corman and Jerome, *How I Made a Hundred Movies*, p. 147.

71. Rex Reed, "The Man," *New York Times*, March 1, 1970, no page listed.

72. Dickens, *Jack Nicholson*, p. 60.

73. Tom Shales, "Shore Patrol Duty for Jack Nicholson," *Los Angeles Times*, March 1, 1973, p. 22, Part IV.

74. No byline or title, *Washington Post*, June 14, 1985, no page listed.

75. Biskind, *Easy Riders, Raging Bulls*, p. 58.

76. McGilligan, *Jack's Life*, p. 188 ("a ton of dope"). Dickens, *Jack Nicholson*, p. 59 ("Finally, we").

77. Elena Rodriguez, *Dennis Hopper*, New York: St. Martin's, 1988, p. 60.

Chapter Three: The Big Wombassa

1. Shepherd, *Jack Nicholson*, p. 66.

2. Dickens, *Jack Nicholson*, p. 66.

3. Peter Fonda, *Don't Tell Dad*, New York: Hyperion, 1998, p. 254.

4. Ibid., p. 258.

5. Biskind, *Easy Riders, Raging Bulls*, p. 65. ("Hopper's lost"); Fonda, *Don't Tell Dad*, pp. 256–257 (speed, wine, Karen Black's tears).

6. Joan Goodman, "Jack the Lad Goes to the Devil," *Observer* (London), October 4, 1987, p. 37.

7. Dickens, *Jack Nicholson*, p. 66; Harry Clein, "Jack Nicholson," *Entertainment World*, November 7, 1969, no page number listed.

8. Schruers, *US*, July 1994, p. 64.

9. Andy Klein, "The Shades," *Variety*, January 15, 1999.

10. Fonda, *Don't Tell Dad*, p. 259.

11. Bridget Byrne, "Jack Enthralls Festival Fans," *Los Angles Herald-Examiner* magazine *LA Today*, October 20, 1976, p. 1.

12. Joan Goodman, "Jack the Lad Goes to the Devil," *Observer* (London), October 4, 1987, p. 37.

13. Byrne, "Jack Enthralls," *LA Today*, October 20, 1976, p. 1.

14. Rex Reed, "The Man Who Walked Off With *Easy Rider*," March 1, 1970, no page number listed.

15. Klein, "The Shades," *Variety*, January 15, 1999.

16. Fonda, *Don't Tell Dad*, p. 269.

17. Ibid., p. 270.

18. Shepherd, *Jack Nicholson*, p. 69.

19. Ibid., p. 267.

20. Dickens, *Jack Nicholson*, p. 69.

21. Cathy Griffin: Gittes interview, 2003.

22. Biskind, *Easy Riders*, p. 117.

23. Gittes interview, 2003.

24. Harlan Jacobson, "Nicholson Is Riding Easy at Cannes," *USA Today*, May 23, 2002, p. 2D.

25. Chris Chase, *Cosmopolitan* p. 171.

26. Schruers, *US*, July 1994, p. 64.

27. Rob Rosenbaum, "Acting: The Method and Mystique of Jack Nicholson," *New York Times Magazine*, July 13, 1986, p. 16.

28. Douglas Brode, *The Films of Jack Nicholson*, p. 105.

29. Thompson, *Jack Nicholson*, p. 225.

30. Deac Rossell, "Riders' Silent Sage," *Philadelphia After Dark*, September 24, 1969, no page number listed.

31. David Sheff, "Jack Nicholson," *Playboy*, January 2004, p. 284.

32. Dickens, *Jack Nicholson*, p. 161.

33. McGilligan, *Jack's Life*, pp. 199, 417, and *Ladies' Home Journal*, April 1976.

34. Neal Weaver, "I Have the Blood of Kings in My Veins, Is My Point of View," *After Dark*, October 1969, p. 38.

35. *Los Angeles Herald Examiner*, February 14, 1971, no page number listed.
36. Kevin Thomas, "Nicholson Leaves Obscurity in Dust," *Los Angeles Times*, August 28, 1969, p. 19.
37. Clein, "Jack Nicholson," *Entertainment World*, November 7, 1969.
38. Peter Bart, "Judicious Jack," *Variety*, November 16, 1992, no page number listed.
39. Kevin Thomas, "Nicholson Leaves Obscurity in Dust," *Los Angeles Times*, August 28, 1969, p. 19.
40. Ibid.
41. Clein, "Jack Nicholson," *Entertainment World*, November 7, 1969.
42. Reed, "The Man," *New York Times*, March 1, 1970, no page number listed.
43. Thomas, "Nicholson Leaves," *Los Angeles Times*, August 28, 1969, p. 19.
44. Shepherd, *Jack Nicholson*, p. 76.
45. Dickens, *Jack Nicholson*, p. 71.
46. Anthony Holden, *Behind the Oscar*, New York: Simon and Schuster, 1993, p. 274.
47. Ibid.
48. Dickens, *Jack Nicholson*, p. 106.
49. Gail Kinn and Jim Piazza, *The Academy Awards*, New York: Black Dog & Leventhal, 2002, p., 176.
50. Biskind, *Easy Riders*, p. 75.
51. McGilligan, *Jack's Life*, p. 201.
52. Biskind, *Easy Riders*, p. 117.
53. Ibid., p. 116.
54. Neal Weaver, "I Have the Blood of Kings in My Veins, Is My Point of View," *After Dark*, October 1969, p. 38.
55. *Times* (London), May 15, 1998.
56. Peter Manso, *Brando*, New York: Hyperion, 1994, p. 884.
57. Schruers, *Rolling Stone*, March 2, 1984, p 18.
58. Dickens, *Jack Nicholson*, p. 72.
59. Ibid., p. 131.

60. Manso, *Brando*, pp. 604, 734.
61. Sheff, "Jack Nicholson," *Playboy*, January 2004, p. 80. Nicholson told Scheff his naked experiment occurred "in the 1960s" in his Mulholland Drive house, but this seems unlikely, if he moved into Mulholland in 1971. In the next paragraph, the reference to charity bed is from *Ladies' Home Journal*, April 1976, in which Nicholson called Ethel May a "charity patient." Also see McGilligan, *Jack's Life*, p. 199.
62. "My mother didn't want me": Shepherd, *Jack Nicholson*, p. 4, and Darrach, "Jack Is Nimble," *People*, December 8, 1975, p. 54; Ethel May's diseases and burial: death certificate in Shepherd, *Jack Nicholson*, p. 177; Nicholson's feelings at her funeral: *Playboy*, April 1972, and McGilligan, *Jack's Life*, pp. 200, 417.
63. Derek Sylvester, *Jack Nicholson*, New York: Proteus, 1982, p. 48. Melcher and Manson: Grey King: *Sharon Tate and the Manson Murders*, New York: Barricade, 2000, p. 138, and Candice Bergen, *Knock Wood*, Linden Press/Simon & Schuster, New York: 1984, pp. 195, 199.
64. Biskind, *Easy Riders*, p. 119.
65. McGilligan, *Jack's Life*, p. 206.
66. No title or byline listed, *US*, July 1994, p. 65.
67. Rosenbaum, "Acting: The Method and Mystique of Jack Nicholson," *New York Times Magazine*, p. 18.
68. Thompson, *Jack Nicholson*, p. 101.
69. Ibid., pp. 17–18.
70. Ibid., p. 41.
71. Ibid., p. 82.
72. Chase, "The Legend That Jack Built," *Cosmopolitan*, p. 171.
73. No title or byline, *People*, no page listed, November 18, 1996.
74. *Interview*, August 1984, p. 48.
75. Thompson, *Jack Nicholson*, p. 41.
76. Ibid., pp. 99–100.
77. Ibid.
78. Dickens, *Jack Nicholson*, p. 84.
79. Thompson, *Jack Nicholson*, p. 27.
80. Dickens, *Jack Nicholson*, p. 85.

81. Ibid.

82. Thompson, *Jack Nicholson*, pp. 17–18. Condoms: Joe Eszterhas, *Hollywood Animal*, New York: Knopf, 2004, p. 381.

83. Thompson, *Jack Nicholson*, p. 102.

84. Dickens, *Jack Nicholson*, p. 130.

85. Ibid.

86. Ibid., p. 129.

87. Ibid., p. 130.

88. McGilligan, *Jack's Life*, p. 213.

89. No byline listed, "The House That Jack Owns," *People*, July 1, 1996, p. 46.

90. Thompson, *Jack Nicholson*, p. 104.

91. Ibid., p. 18.

92. No byline or title listed, *Family Weekly*, January 7, 1973, no page listed; quoted in Dickens, *Jack Nicholson*, pp. 86–87.

93. Marilyn T. Ross: "Hippie? Hard-Hat? Hero?" *Movie Digest*, January 1972, p. 86.

94. Colin Gardner, "'Alienating Alienation': Deconstructing the Anti-Hero in *Five Easy Pieces*," in Mikita Brottman, editor, *Jack Nicholson: Movie Top Ten*, London: Creation, 2000, p. 49.

95. Dennis Bingham, *Acting Male: Masculinities in the Films of James Stewart, Jack Nicholson, and Clint Eastwood*, New Brunswick, New Jersey: Rutgers University Press, 1994, p. 5.

96. John Harkness, *The Academy Awards Handbook*, New York: Pinnacle, 1994, p. 204.

97. No byline, "Michelle Phillips," *People*, April 7, 2003, p. 105.

98. Jim Harrison, *Off to the Side*, New York: Grove Press, 2002, p. 273; L.A. rock club scene: Erik Quisling and Austin Williams, *Straight Whisky*, Chicago: Bonus Books, 2003, pp. 22, 42, 175, 221, 278, 281, 334, 382; Mamas and the Papas: Candice Bergen, *Knock Wood*, New York: Knopf, 1984, pp. 182–183.

99. Hilary DeVries, "Jack: Always the Kidder," *Los Angeles Times Calendar*, December 6, 1992, p. 76.

100. Thompson, *Jack Nicholson*, p. 108.

101. Ibid., p. 107.
102. Dickens, *Jack Nicholson*, p. 155.
103. *Interview* August 1984.
104. Cathy Griffin interview.

Chapter Four: The Casting Couch
 1. Shirley Temple Black, *Child Star*, New York: Warner, 1988, pp. 322–323.
 2. Dickens, *Jack Nicholson*, pp. 89–90.
 3. Ibid., p. 103. At BBS, according to Peter Biskind, Nicholson referred to women as "puss" and "cunts."
 4. Patrick Snyder-Scumpy, *Crawdaddy*, February 1973, quoted in Dickens, p. 60.
 5. Biskind identifies Gittes as coproducer on *Drive, He Said*, p. 442, but Brode in *The Films of Jack Nicholson* lists Steve Blauner as Nicholson's coproducer, p. 120.
 6. Mark Sager, "Jack Nicholson, 66," *Esquire*, January 2004, p. 71; *Rolling Stone*, August 14, 1986, p. 50.
 7. No byline or title listed, *Time Out*, August 1, 1994, p 22.
 8. Dickens, *Jack Nicholson*, p. 91.
 9. Leo Janos, "Bankable and Brilliant," *Cosmopolitan*, December 1976, p. 181.
10. Deborah Caulfield, "Nicholson on the Matter of His Honor," *Calendar, Los Angeles Times*, June 16, 1985, p. 24; $800,000: Nicholson told Andy Warhol, "Less than a million—I think it was 800," in *Interview*, December 1976.
11. McGilligan, *Jack's Life*, p. 214.
12. Sheff, "Jack Nicholson," *Playboy*, January 2004, p. 80.
13. McGilligan, *Jack's Life*, p. 217.
14. Dickens, *Jack Nicholson*, p. 109.
15. Ibid.
16. Biskind, *Easy Riders*, p. 195.
17. Kathleen Fury, "Jack Nicholson," *Ladies' Home Journal*, April 1976, p. 186.
18. Chase, "The Legend That Jack Built," *Cosmopolitan*, p. 171.

19. Richard Warren Lewis, *"Playboy* Interview: Jack Nicholson," *Playboy,* April 1972, pp. 76, 78. McGilligan, *Jack's Life,* p. 241.

20. Bob Woodward, *Wired,* New York: Simon & Schuster, 1984; McGilligan, *Jack's Life,* pp. 241, 420.

21. Biskind, *Easy Riders,* p. 119.

22. Thompson, *Jack Nicholson,* p. 131.

23. Lori Weisberg, "Nicholson Uses Humor to Field Flak on New Film," *Daily Bruin,* May 21, 1976, p. 1.

24. McGilligan, *Jack's Life,* p., 227.

25. Biskind, *Easy Riders,* p. 178, 129–130.

26. McGilligan, *Jack's Life,* p. 221.

27. Brode, *The Films of Jack Nicholson,* p. 132.

28. "Warren and Jack," *Marie Claire,* February 1997.

29. McGilligan, *Jack's Life,* p. 287.

30. Peter Feibleman, *Lilly,* New York: Morrow, 1998, pp. 26–29.

31. Deborah Solomon, "Playing With History," *New York Times Magazine,* June 15, 2003, p. 13.

32. *Playboy* interview quoted in Thompson, *Jack Nicholson,* p. 113.

33. Brode, *The Films of Jack Nicholson,* p. 133.

34. Rosenbaum, "Acting: The Method and Mystique," *New York Times Magazine,* July 13, 1986, p. 16.

35. Chase, "The Legend That Jack Built," *Cosmopolitan,* p. 171.

36. *National Star,* June 8, 1974, quoted in Dickens, *Jack Nicholson,* p. 112.

37. Rosenbaum, "Acting," *New York Times Magazine,* July 13, 1986, p. 12.

38. Marius Brill, "Talk of the Devil," *Sunday Times* (London), July 21, 1996, pp. 10, 12.

39. Brode, *The Films of Jack Nicholson,* p. 137.

40. Thompson, *Jack Nicholson,* p. 116.

41. McGilligan, *Jack's Life,* p. 234.

42. Edwin Miller, "No Ego in His Act," *Seventeen,* April 1976, p. 189.

43. *Viva,* 1975, p. 61.

44. Schruers, *Rolling Stone,* March 29, 1984, p. 20.

45. Rosenbaum, "Acting: The Method and Mystique," *New York Times Magazine,* July 13, 1986, p. 12.

46. Army Archerd, "Just for Variety," May 17, 1982.
47. Rosenbaum, "Acting: The Method and Mystique," *New York Times Magazine*, July 13, 1986, p. 66.
48. Thompson, *Jack Nicholson*, p. 242.
49. No byline listed, "Intelligence Report," *Parade*, no date listed, p. 15.
50. McGilligan, *Jack's Life*, p. 233–234.
51. Robert J. Emery, *The Directors—Take Two*, New York: TV Books, 2000, p. 255.
52. Manso, *Brando*, p. 775.
53. Dickens, *Jack Nicholson*, pp. 118–119.
54. Ibid., pp. 122–123.
55. McGilligan, *Jack's Life*, p. 233.
56. Dickens, *Jack Nicholson*, p. 120.
57. Biskind, *Easy Riders*, p. 177.
58. J. Hoberman, *The Dream Life*, New York: New Press, 2003, p. 365.
59. Biskind, *Easy Riders*, p. 186.
60. Ibid., p. 187.
61. Ibid., p. 177.
62. Ibid., p.175; $2 million budget: Tom Shales, "Shore Patrol Duty for Jack Nicholson," *Los Angeles Times*, March 1, 1973, p. 22, Part IV.
63. Dickens, *Jack Nicholson*, p. 127.
64. Ibid., p. 130.
65. Ibid., p. 129.
66. McGilligan, *Jack's Life*, pp. 235.
67. Cathy Griffin interview.
68. Hayward and Halprin: McGilligan, *Jack's Life*, p. 245. Phillips and Kerry: Don Gentile, "John Kerry's Secret Life," *Enquirer*, February 17, 2004, p. 34.
69. Dickens, *Jack Nicholson*, p. 106.
70. Michael Gross, *Model*, New York: Morrow, 1995, p. 250.
71. Ibid., p. 110.
72. Dickens, *Jack Nicholson*, p. 111.

Chapter Five: The Golden Years

1. David Thomson, "Jack and the Women," *Independent on Sunday* (London), March 2, 1997 p. 5.
2. Boze Hadleigh, *Celebrity Lies!* Fort Lee, New Jersey: 2003, p. 18.
3. Lawrence Grobel, *The Hustons*, New York: Scribners, 1989, p. 674.
4. Dickens, *Jack Nicholson*, p. 111.
5. Brad Darrach, "Jack Finds His Queen of Hearts," *People*, July 8, 1985, p. 56.
6. Grobel, *The Hustons*, p. 612.
7. Ibid., p. 671: Bob Richardson, in a letter to John Huston after their breakup, said "Anjelica turned him on to marijuana (although later in the letter he admitted to a much more serious drug problem)."
8. Grobel, *The Hustons*, p. 671. In the same letter to John Huston Bob Richardson wrote that "he was going to repay Anjelica the $10,000 she had loaned him," according to Grobel.
9. Ibid., p. 670.
10. Ibid., p. 624.
11. Ibid., p. 674.
12. Schruers, *Rolling Stone*, March 29, 1984, p. 20.
13. *Interview*, March 1974.
14. *Sight and Sound*, Summer 1974.
15. Brode, *The Films of Jack Nicholson*, p. 165; Julian Hoxter, "Presence as Absence: Jack Nicholson in *The Passenger*," quoted in Brottman, editor, *Jack Nicholson: Movie Top Ten*, p. 90.
16. Kathleen Carroll, *New York Daily News*, February, 10, 1974.
17. Brode, *The Films of Jack Nicholson*, p. 165.
18. Carroll, *New York Daily News*, February, 10, 1974.
19. Judith Crist, *New York*, April 14, 1975.
20. Dickens, *Jack Nicholson*, p. 145.
21. Julian Hoxter, "Presence as Absence," *Jack Nicholson: Movie Top Ten*, p. 87.
22. Barbara Leaming, *Polanski*, London: Hamish Hamilton, 1982, p. 116; Samantha Miller, "Jack of Hearts," *People*, December 16, 2002, p. 103.
23. Sidney Skolsky, *New York Post*, August 24, 1974.

24. Miller, "Jack of Hearts," *People*, December 16, 2002, p. 103.
25. Grobel, *The Hustons*, p. 641.
26. Biskind, *Easy Riders*, p. 159. Anjelica as Evelyn: Jay Carr, *The A List*, Cambridge: Da Capo, p. 64.
27. Brode, *The Films of Jack Nicholson*, p. 159.
28. Michael Eaton, *Chinatown*, London: British Film Institute, 1997, p. 19, quoted in Philip Simpson, "Chinatown," in Brottman, editor, *Jack Nicholson: Movie Top Ten*, p. 73.
29. Tom Burke, *Rolling Stone*, July 18, 1974, quoted in Dickens, *Jack Nicholson*, pp. 133–134.
30. Brode, *The Films of Jack Nicholson*, p. 159.
31. Biskind, *Easy Riders*, p. 189.
32. Ibid.
33. Hadleigh, *Celebrity Lies!*, p. 175.
34. Byrne, "Jack Enthralls," *LA Today*, October 20, 1976, p. 1.
35. Darrach, "Jack Is Nimble" *People*, December 8, 1975, p. 54.
36. Dickens, *Jack Nicholson*, pp. 85, 149, 150.
37. Thompson, *Jack Nicholson*, p. 104.
38. Dickens, *Jack Nicholson*, p. 149.
39. Mark Seal, "For Love of Aspen," *Vanity Fair*, March 2003, p. 329.
40. Guy Flatley, "Jack Nicholson—Down to the Very *Last Detail*," February 10, 1974, *New York Times*, no page listed.
41. Dickens, *Jack Nicholson*, p. 155.
42. Booth Moore, *Los Angeles Times*, October 28, 2003, latimes.com, p. 1.
43. Hunter S. Thompson, *The Great Shark Hunt*, New York: Simon and Schuster, 1979, p. 155.
44. Biskind, *Easy Riders*, p. 187.
45. Judy Weider, "Chastity Bono: Out at Last/Virtuous Reality," *Advocate*, April 18, 1995, quoted in Mark Bego, *Cher*, New York: Cooper Square Press, 2003, p. 209.
46. McGilligan, *Jack's Life*, p. 362.
47. Grobel, *The Hustons*, p. 675.
48. Thompson, *Jack's Life*, p. 165
49. Mikita Brottman, *Jack Nicholson*, p. 16.

50. Thompson, *Jack Nicholson*, p. 135. The quotations, "What's this crap" and "Yes, June is your" are from Collins, "Jack the Wolf," *Vanity Fair*, April 1994, p. 124.

51. Thompson, *Jack Nicholson*, p. 58.

52. Collins, "Happy Jack," *Vanity Fair*, April 1992, p. 228.

53. *Rolling Stone*, March 29, 1984, p. 17.

54. Sheff, "Jack Nicholson," *Playboy*, January 2004, p. 88.

55. Thompson, *Jack Nicholson*, p. 134. "He": Griffin-Gittes interview.

56. Sheff, "Jack Nicholson," *Playboy*, January 2004, p. 88.

57. Thompson, *Jack Nicholson*, p. 256.

58. Ibid.

59. Pat York, "Legends of the Fall," *Hollywood Life*, September 2003, p. 54.

60. McGilligan, *Jack's Life*, p. 269. Lorraine: Ibid, p. 286.

61. Grobel, *The Hustons*, p. 679.

62. Lisa Zeidner, "Rebels Who Were More Angry Than Mad," *New York Times*, November 26, 2000, p. 11.

63. Anthony Holden, *Behind the Oscar*, New York: Simon and Schuster, 1993, p. 304. McGilligan, *Jack's Life*, says $4 million.

64. According to coproducer Saul Zaentz, who was interviewed for the 2002 digital DVD of the film, the budget was $4.4 million, but earlier, on June 14, 1985, the *Washington Post* wrote that the budget was $3 million, and that Nicholson's fee was one-third of that amount.

65. Patrick McGilligan, *Alfred Hitchcock*, New York: ReganBooks, 2003, pp. 722, 727.

66. Evelyn Renold, "The Entertainer," *Midwest*, March 28, 1976, p. 10.

67. Thompson, *Jack Nicholson*, p. 139.

68. Rosenbaum, "Acting: The Method and Mystique," *New York Times Magazine*, July 13, 1986, p. 17.

69. Biskind, *Easy Riders*, p. 192.

70. *The Making of One Flew Over the Cuckoo's Nest*, DVD documentary, Quest Productions, Saul Zaentz Company: 2002.

71. Darrach, "Jack Is Nimble," *People*, December 8, 1975, p. 51.

72. No byline, "Last Year, etc.," *Newsweek*, August 5, 2002, p. 52.

73. Fury, "Jack Nicholson," *Ladies' Home Journal*, April 1976.

74. McGilligan, *Jack's Life*, p. 296.

75. Patty Bosworth, *Marlon Brando*, New York: Viking, 2001, p. 207.

76. Ibid., p. 208.

77. Ibid., p 191.

78. Manso, *Brando*, p. 792.

79. Thompson, *Jack Nicholson*, p. 148.

80. Manso, *Brando*, p. 811.

81. Ibid., p. 834. The story was related by Brando's friend, Jay Baldwin of *The Whole Earth Catalogue*.

82. McGilligan, *Jack's Life*, p. 281.

83. Lori Weisberg, "Nicholson Uses Humor to Field Flak on New Film," *UCLA Daily Bruin*, May 21, 1976, pp. 1–3.

84. Manso, *Brando*, p. 813.

85. Ibid., p. 810. Kathleen Lloyd: McGilligan, *Jack's Life*, p. 283.

86. Fury, "Jack Nicholson," *Ladies' Home Journal*, April 1976, p. 189.

87. McGilligan, *Jack's Life*, p. 296.

88. Ibid., p. 284.

89. Harrison, *Off to the Side*, p. 248.

90. George Lois, *$elebrity: My Angling and Tangling With Famous People*, New York: Phaidon, 2003.

91. Manso, *Brando*, pp. 817–818.

92. Ibid., pp. 791, 876.

93. Natasha Fraser-Cavassoni, *Sam Spiegel*, New York: Simon & Schuster, 2003, pp. 93, 317.

94. Ibid., pp. 318–319.

95. Ibid., p. 322.

96. Ibid., p. 321.

97. Ibid., pp. 309, 322.

98. Ibid., p. 323.

99. Ibid., p. 326.

100. Ibid.

101. Andy Warhol, *The Andy Warhol Diaries*, edited by Pat Hackett, New York: Warner Books, 1989, p. 19.

102. Ibid., p. 47. Trapped in elevator: Andy Warhol and Bob Colacello, "Jack Nicholson," *Interview*, December 1976, p. 24.

103. Roderick Mann, no title listed, *Los Angeles Times*, April 27, 1978, no page listed.

104. No byline, no headline, *Dallas Times Herald*, May 30, 1983; the joint Peellaert acquisition: no byline, no headline, *Los Angeles Herald-Examiner*, July 23, 1975, no page listed.

105. No byline, "Every Picture Tells a Story," *New York*, October 9, 1978, p. 3.

106. McGilligan, *Jack's Life*, pp. 295–296.

107. No byline, "Images," *People*, March 1, 1976, no page listed. "Heidigate"—Fleiss's arrest in 1993 for pandering, money laundering, and tax evasion—"As long as I remembered what I had learned, success came relatively easy, but as time went by, I forgot," she recalled. "I got caught up in my lifestyle."

108. Emanuel Levy, *Oscar Fever*, New York: Continuum, 2001, p. 304.

109. "The worst": Levy, *Oscar Fever*, p. 212. "Nicer": Holden, *Behind the Oscar*, p. 307.

110. Harrison, "Off to the Side," p. 248.

111. Shepherd, *Jack Nicholson*, p. 120.

112. Thompson, *Jack Nicholson*, p. 152.

113. Shepherd, *Jack Nicholson*, p. 113.

114. Ibid., p. 114; Beth Ann Krier, "Sprouts in Hair Transplants," *Los Angeles Times*, October 13, 1976; *People*, May 22, 1976. In a 2003 interview, Nicholson denied any such work on his hair, remarking, "They said I was wrinkling and balding in my early thirties. Most of the people who wrote that who thought they were younger than me are now bald and wrinkled. As you can see, I don't have any plugs or tucks, but let people do what they want. I look at it as mutilation."

115. Thompson, *Jack Nicholson*, p. 153.

116. "Cuckoo Love Story," *WWD*, March 24, 1976, no page listed.

117. Fraser-Cavassoni, *Sam Spiegel*, p. 313.

118. No byline, no headline, *People*, August 16, 1976, no page listed.

119. Fraser-Cavassoni, *Sam Spiegel*, pp. 259, 260, 264, 265, 271.

120. Thompson, *Jack Nicholson*, p. 153.

121. Downing, *Jack Nicholson*, p. 166.

122. Grobel, *The Hustons*, p. 702.

123. John Hurst, "Defense Rests in Trial of Miss Longet," *Los Angeles Times*, January 14, 1977, no page listed.

124. Paul Winfield, narrator, *City Confidential*, A&E, Channel 31, November 13, 2003, produced by Jupiter Entertainment.

125. Fury, "Jack Nicholson," *Ladies' Home Journal*, April 1976, p. 188.

126. Jeff Sillifant and Clyde Wess, "Polanski Sex Charge Arraignment," *Los Angeles Herald-Express*, March 13, 1977.

127. John Parker, *Polanski*, London: Gollancz, 1993, p. 214; cunnilingus, intercourse, sodomy: Leaming, *Polanski*, p. 113; also see Roman Polanski, *Roman*, New York: Morrow, 1984, p. 393.

128. Leaming, *Polanski*, p. 116.

129. Ibid.

130. Ibid.

131. Ibid.

132. Ibid., pp. 113–114.

133. Ibid., p. 116.

134. Thompson, *Jack Nicholson*, pp. 155–157.

135. Polanski, *Roman*, p. 398.

136. Ibid.

137. "Polanski Charged in Rape," *Los Angeles Herald-Examiner*, March 12, 1977.

138. No byline, "Actor's Fingerprints Not Same as Those on Hashish Container," *Los Angeles Times*, April 9, 1978, no page listed.

139. Grobel, *The Hustons*, p. 702.

140. James Bacon, "'Deeply Shocked,' Declares Friend Jack Nicholson," *Los Angeles Herald-Examiner*, February 1, 1978.

141. "How Roman Polanski Fled Country," *Globe*, March 18, 2003.

142. Polanski, *Roman*, p. 422.

143. Grobel, *The Hustons*, pp. 699–701.

144. Bacon, "'Deeply Shocked,'" *Los Angeles Herald-Examiner*, February 1, 1978.

145. "How Roman Polanski Fled Country," *Globe*, March 18, 2003.
146. Sheff, "Jack Nicholson," *Playboy*, January 2004, p. 88.

Chapter Six: Midlife Crises and Crescendos

1. Thompson, *Jack Nicholson*, p. 158. Re: Bancroft in earlier paragraph, "After both": *Viva*, circa 1975, p. 100. Stephen Schiff, "Jumping Jack," *Vanity Fair*, August 1986.
2. Biskind, *Easy Riders*, p. 273.
3. Harrison, *Off to the Side*, p. 249.
4. McGilligan, *Jack's Life*, pp. 303–304, 306.
5. Julia Phillips, *You'll Never Eat Lunch in This Town Again*, New York: NAL, 1991, pp. 238–239.
6. McGilligan, *Jack's Life*, p. 307. "Christine": Griffin-Gittes interview.
7. Gliatto and Hannah, "The House That Jack Owns," *People*, July 1, 1996, p. 48.
8. Thompson, *Jack Nicholson*, p. 182.
9. Ibid., p. 18.
10. Cathy Griffin interview. Also see *The Andy Warhol Diaries*, edited by Pat Hackett, New York: Warner, 1989, p. 480.
11. Warhol, *The Andy Warhol Diaries*, p. 47.
12. Ibid., p. 55.
13. David Lewin, "Jack Nicholson," *US*, March 16, 1982, p. 45.
14. Brad Darrach, *People*, July 8, 1985, p., 57.
15. Lewin, "Jack Nicholson," *US*, March 16, 1982, p. 45.
16. Fury, "Jack Nicholson," *Ladies' Home Journal*, April 1976, p. 189.
17. Manso, *Brando*, pp. 844, 861, 872. *Bogart Slept Here* and DeNiro "fired," "neurotic": Andy Dougan, *Untouchable*, New York: Thunder Mouth Press, 1996, pp. 67–68, 84.
18. Warhol, *The Andy Warhol Diaries*, pp. 19, 63.
19. Michel Ciment, *Kubrick*, New York: Faber & Faber, 2001, p. 297.
20. Booth Moore, "Here, at Last," *Los Angeles Times*, October 28, 2003, latimes.com, p. 2.
21. Harrison, *Off to the Side*, p. 261.
22. Ciment, *Kubrick*, p. 298.

23. Ibid., p. 188.
24. Nicholson has contradicted himself in discussing Kubrick and the "Heeere's Johnny" line. In *Playboy* in January 2004, he said Kubrick "had to explain that it was a line from a TV show," but in Ciment's *Kubrick*, p. 298, he said, "Stanley didn't exactly know what 'Heeere's Johnny' meant because he didn't watch American TV regularly."
25. Vincent LoBrutto, *Stanley Kubrick*, New York: DeCapo, 1997, p. 451.
26. Lewin, *US*, March 16, 1982, p. 46.
27. Thompson, *Jack Nicholson*, p. 164.
28. McGilligan, *Jack's Life*, p. 333; "Warren and Jack," *Marie Claire*, February 1997.
29. Ibid.
30. Bebe Buell and Victor Bockris, *Rebel Heart*, New York: St. Martin's, 2001, pp. 40, 57–59, 72, 79, 158, 178, 189, 202, 204, 209, 215–221.
31. Steve Eng, *Jimmy Buffett*, New York: St. Martin's, 1996, p. 214; Albert Watson, "Jack Nicholson," *Rolling Stone*, December 16–23, 1999, p. 46.
32. McGilligan, *Jack's Life*, p. 312.
33. *People*, February 28, 1980.
34. *Rolling Stone*, March 29, 1984, p. 18.
35. McGilligan, *Jack's Life*, p. 365.
36. Grobel, *The Hustons*, p. 720.
37. Ibid., pp. 718–719.
38. Jack Nicholson quoted by Nancy Collins in McGilligan, *Jack's Life*, p. 365; originally appeared in *Smart*, October–November 1990, according to McGilligan, p. 427.
39. Fraser-Cavassoni, *Sam Spiegel*, p. 345.
40. Schruers, "Jack Nicholson: The *Rolling Stone* Interview," *Rolling Stone*, August 14, 1986, p. 48.
41. Torgoff, *Interview*, August 1984.
42. Steve Harvey "Only in LA," *Los Angeles Times*, February 16, 1999.
43. Booth Moore and Michael Quintanilla, "Heeeere's Jennifer!" *Los Angeles Times*, April 5, 2002, p. 32; Booth Moore, "Here, at Last," *Los Angeles Times*, October 28, 2003, latimes.com, page 2.
44. Buell and Bockris, *Rebel Heart*, pp. 222, 225, 227.

45. Chris Chase, "At the Movies," *New York Times*, February 5, 1982, p. C8.
46. *Variety*, May 27, 1981.
47. Terry Pristin, "Hutton Wins $9.75 Million in MGM Suit," *Los Angeles Times*, February 26, 1989, no page listed; "Just for Variety," *Variety*, April 13, 1983.

Chapter Seven: The Model Wars

1. Janice Dickinson, *No Lifeguard on Duty*, New York: ReganBooks, 2002, pp. 126–127, 160, 162.
2. Michael Gross, *Model*, New York: William Morrow, 1995, pp. 494, 359.
3. Interview conducted by Cathy Griffin for this book.
4. William Wright, *All the Pain That Money Can Buy*, New York: Simon & Schuster, 1991, pp. 258, 293, 315–316, 329.
5. Cathy Griffin interview.
6. Warhol, *The Andy Warhol Diaries*, p. 113.
7. Ibid., p. 102.
8. Ibid., p. 103.
9. Ibid., p. 114.
10. Cathy Griffin interview.
11. Warhol, *Diaries*, p. 424.
12. No byline, "Scandals of the Supermodels: Romance Shattered After Romp," *Star*, April 17, 2001, p. 30; Mark Dagostino, "Insider: Mum's the Word," *People*, September 15, 2003, p. 55. McEnroe and Taylor: Warhol, *The Andy Warhol Diaries*, p. 424.
13. Dickinson, *No Lifeguard on Duty*, p. 281; Gross, *Model*, pp. 332, 335.
14. Gross, *Model*, p. 366.
15. No byline, "Scandals of the Supermodels: Party's Over After Rock 'n' Brawl," *Star*, April 17, 2001, p. 30.
16. Arlene Walsh, no headline, *Beverly Hills [213]*, June 4, 2003, p. 14.
17. No byline, "The Sexiest Man Alive: Johnny Depp," *People*, December 1, 2003, p. 78; no byline, "Kate Moss Wedding Plans," *Star*, December 2, 2003, p. 60.
18. No byline, "Bra-Vo!" *National Enquirer*, no page or date listed.
19. Dickinson, *No Lifeguard on Duty*, pp. 183, 240, 249.

20. No byline, no headline, *Esquire*, October 1997, no page listed.

21. Harrison, *Off to the Side*, p. 276.

22. Gross, *Model*, p. 348.

23. Ibid., p. 343.

24. Hall and Jagger met at Gallant party: Joey Green, *How They Met*, New York: Black Dog & Leventhal, 2003, p. 118; Jagger's child with Morad: Hadleigh, *Celebrity Lies!* p. 132.

25. Dickinson, *No Lifeguard on Duty*, pp. 163, 7–8, 137.

26. Gross, *Model*, pp., 367–368.

27. Dickinson, *No Lifeguard on Duty*, pp. 164, 170–171, 173.

28. Gross, *Model*, p. 328.

29. Thompson, *Jack Nicholson*, p. 275.

30. Gross, *Model*, pp. 351, 355.

31. Thompson, *Jack Nicholson*, p. 45.

32. Collins, "Happy Jack," *Vanity Fair*, April 1992, p. 228.

33. Ibid.

34. Cathy Griffin interview.

35. Thompson, *Jack Nicholson*, pp. 188–189.

36. Gross, *Model*, pp. 365, 372.

37. Flatley, "Jack Nicholson—Down to the Very 'Last Detail,'" *New York Times*, February 10, 1974, page 3 in clipping in Margaret Herrick Library's Nicholson file.

38. Chase, "Nicholson," *Cosmopolitan*, February 1983, p. 169.

39. No byline, "ICM Touting Nicholson-Nolte-Mancuso Project," *Variety*, February 2, 1993, p. 2; Claudia Eller, no headline, *Variety*, February 16, 1993, no page listed.

40. Cathy Griffin interview.

41. Manso, *Brando*, pp. 884–885.

42. Thompson, *Jack Nicholson*, p. 207.

43. *Rolling Stone*, March 24, 1984, p. 20.

44. Thompson, *Jack Nicholson*, pp. 183, 18.

45. "If Caleb needs me": Tom Gliatto and John Hannah, "The House That Jack Owns," *People*, July 1, 1996, p. 46 "What kind of shit":

Andrew Breithart and Mark Ebner, *Hollywood Interrupted*, Hoboken, New Jersey: John Wiley, 2004, pp. 54–56.

46. Collins, "Jack Nicholson," *Rolling Stone*, March 29, 1984, p. 47; Flatley, "Jack Nicholson—Down to the Very *Last Detail*," *New York Times*, February 10 1974; Ian Markham-Smith, "Nicholson," *US*, April 9, 1984, p. 64; Stephen Farber, "Jack Nicholson Comes to Terms With Middle Age," *Los Angeles Herald-Examiner*, November 27, 1983.

47. Brode, *The Films of Jack Nicholson*, p. 236. Brode adds that Newman rejected *Terms of Endearment*.

48. DVD commentary, *Terms of Endearment*, Paramount Pictures, 2000.

49. Ibid.

50. No byline, "Top 50 Worldwide Grossers," *Variety*, July 15–21, 2002, p. 52.

51. Liz Smith quoted in *Hollywood Reporter*, October 3, 1984, no page listed.

52. Attanasio, "Jack Nicholson, Genuinely," *Washington Post*, June 14, 1985, p. C-1.

53. Collins, "Jack the Wolf," *Vanity Fair*, April 1994, p. 169.

54. Schruers, *Rolling Stone*, March 29, 1984, p. 20.

55. No byline, "Crazy Mountain High," *People*, May 21, 1984, p. 128.

56. *Variety*, April 13, 1984.

57. Torgoff, "Jack Nicholson," *Interview*, August 1984, p. 46.

58. No byline, "Nicholson Settles Suit," Reuters, May 11, 1984, *Los Angeles Times*.

59. No byline, "*Sun* to Pay Nicholson Damages," *Screen International*, May 19, 1984, no page listed.

60. Ibid.

61. Deborah Caulfield, "Nicholson on the Matter of His Honor," *Los Angeles Times Calendar*, June 16, 1985, p. 28.

62. Martin Torgoff, *Interview*, "Jack Nicholson," August 1984, p. 46; also see Thompson, *Jack Nicholson*, pp. 174–175.

63. James Robert Parish, *The Hollywood Book of Death*, New York: Contemporary Books, 2002, p. 52.

64. Nancy Collins, "The Great Seducer: Jack Nicholson," *Rolling Stone*, March 29, 1984, p. 15.

65. Ibid., p. 20.

66. "Extremely": Schruers, *Rolling Stone*, March 29, 1984, p. 20. "Jack's got a real hurt": Collins, "The Great Seducer: Jack Nicholson, *Rolling Stone*, March 29, 1984, p. 17. "Basically unknowable": Shepherd, *Jack Nicholson*, p. 81.

67. Buell and Bockris, *Rebel Heart*, pp. 253, 256, 263, 320, 329.

68. Grobel, *The Hustons*, pp. 689–691.

69. Sheff, "Jack Nicholson," *Playboy*, January 2004, p. 284.

70. McGilligan, *Jack's Life*, p. 365. In Collins, "Happy Jack," *Vanity Fair*, April 1992, p. 226, Nicholson commented on hints in Anjelica's interviews that he'd curtailed her career.

71. Brad Darrach, "Jack Finds His Queen of Hearts," *People*, July 8, 1985, p. 56.

72. Jack Mathews, no headline, *Los Angeles Times Magazine*, August 5, 1990, no page listed. John Evan Frook wrote in "Huston and Nicholson on *Guard*," *Variety*, December 28, 1993, "Nicholson helped revive Huston's career by landing her a choice supporting role in the 1981 release *The Postman Always Rings Twice*, and Huston won a supporting actress Academy Award in 1985 opposite Nicholson in *Prizzi's Honor*."

73. Rosenbaum, "Acting: The Method and Mystique," *New York Times Magazine*, July 13, 1986, p. 18.

74. Grobel, *The Hustons*, p. 780.

75. Ibid., p. 775.

76. Attanasio, "Jack Nicholson Genuinely," *Washington Post*, June 14, 1985, p. C-1.

77. Gene Siskel, "Terms of Fulfillment," *Chicago Tribune*, June 16, 1985, p. 9.

78. Attanasio, "Jack Nicholson, Genuinely," *Washington Post*, June 14, 1985, p. C-1.

79. McGilligan, *Jack's Life*, pp. 339–340.

80. Schruers, "Jack Nicholson: The *Rolling Stone* Interview," *Rolling Stone*, August 14, 1986, p. 62.

Chapter Eight: Devil in the Flesh

1. Schruers, "Jack Nicholson: The *Rolling Stone* Interview," *Rolling Stone*, August 14, 1986, p. 34.
2. Brode, *The Films of Jack Nicholson*, p. 246.
3. Ibid., p. 250.
4. Schruers, "Jack Nicholson: The *Rolling Stone* Interview," *Rolling Stone*, August 14, 1986, p. 34.
5. Brad Darrach, "The Father, the Director, and the Holy Terror," *Life*, September 1990, pp. 70–72: "Nicholson's name has also been linked with a score of famous beauties—among them: Meryl Streep, Diane Keaton, Michelle Phillips, Susan Anspach, and Margaret Trudeau. . . . Karen Mayo-Chandler."
6. Jack Nicholson press conference for *About Schmidt*, 2003, L.A.
7. Thompson, *Jack Nicholson*, p. 192.
8. No byline, "Streep," *Star*, April 1, 2003, p. 8.
9. Thompson, *Jack Nicholson*, p. 191; McGilligan, *Jack's Life*, p. 348. According to the latter, Nicholson said, "There's something autobiographical in a man who might do something as heinous as buy a woman a bracelet while his wife is pregnant. This may be grounds for execution in most people's minds, but we wouldn't have many men left if these executions were carried out."
10. Schruers, "Jack Nicholson: The *Rolling Stone* Interview," *Rolling Stone*, August 14, 1986, p. 48.
11. McGilligan, *Jack's Life*, p. 364.
12. Nancy Griffin and Kim Masters, *Hit and Run*, p. 140.
13. Ibid., p. 139.
14. Ibid.
15. George Miller, "Jack of All Trades," *Time Out* (London), May 18–25, 1986, p. 19.
16. *Time Out*, August 17, 1994, p. 22.
17. Mitchell Fink, "Happy Birthday, Jack," *Los Angeles Herald-Examiner*, April 22, 1987, no page listed.
18. Ibid.

19. McGilligan, *Jack's Life*, p. 357.
20. Collins, "Jack the Wolf" *Vanity Fair*, April 1994, p. 168.
21. Collins, "Happy Jack," *Vanity Fair*, April 1992, p. 222.
22. Lynn Hirschberg, "Jack Nicholson" *Rolling Stone*, November 5–December 10, 1987, p. 238.
23. No byline, "Streep Scene," *Los Angeles Herald-Examiner*, August 18, 1987, no page listed.
24. Thompson, *Jack Nicholson*, p. 221.
25. Jeannie Williams, "Jack as a Fling, but Not a Father," *USA Today*, October 30, 1989, p. D-2, quoted in Shepherd, *Jack Nicholson*, pp. 171, 184.
26. Thompson, *Jack Nicholson*, p. 221, quoting *Playboy*, December 1989.
27. Grobel, *The Hustons*, p. 782.
28. Ibid., pp. 782, 647, 688.
29. Ibid., p. 782.
30. Robert Evans, *The Kid Stays in the Picture*, Beverly Hills: New Millennium Press, 1994, p. 371; Julian Schnabel, "Jack Nicholson," *Interview*, April 2003, p. 150. Next paragraph ("Busy with other"): *Bonfire of the Vanities* (Julie Salamon, *The Devil's Candy*, New York: De Capo Press, 1991, 2002, p. 16). *Rain Man* (Griffin and Masters, *Hit and Run*, p. 161).
31. Alvarez: Thompson, *Jack Nicholson*, p. 51. Jennifer Howard: Cathy Griffin interview.
32. Thompson, *Jack Nicholson*, pp. 204–205.
33. Cathy Griffin interview.
34. Ibid.
35. Collins, "Happy Jack," *Vanity Fair*, April 1992, p. 226.
36. Thompson, *Jack Nicholson*, p. 210.
37. Collins, "Jack the Wolf," *Vanity Fair*, April 1996 p. 169.
38. Ibid., p. 224.
39. Ibid., p. 169.
40. Thompson, *Jack Nicholson*, p. 209.
41. Ibid., p. 210.
42. Ibid., p. 220.

43. Collins, "Happy Jack," *Vanity Fair*, April 1992, p. 224.

44. Ibid.

45. Booth Moore, "Here, at Last," *Los Angeles Times*, October 28, 2003, latimes.com, p. 2.

46. Schruers, "Jack Nicholson," *Rolling Stone*, March 19, 1998, no page listed. Also see Collins, "Happy Jack," *Vanity Fair*, April 1992, p. 226.

47. Thompson, *Jack Nicholson*, p. 211.

48. Peter Bart, no headline listed, *Variety*, November 16, 1992, no page listed.

49. Thompson, *Jack Nicholson*, p. 213.

50. Ibid., p. 224.

51. Ibid.

52. *Sight and Sound*'s Ian Penman scolded Nicholson for appearing in cartoonish fare despite the actor's statement in a 1985 *Film Comment*.

53. Adam Adamides, *"Batman,"* Mikita Brottman, editor, *Jack Nicholson: Movie Top Ten*, p. 137.

54. Fred Schruers, "Gentleman Jack," *US*, July 1994, p. 65.

55. Nancy Campbell, *Jack Nicholson*, New York: Smithmark, 1994, p. 76.

56. Sally Ogle Davis, "Jack Nicholson: Really Good at Being Evil," *Senior Life*, July 1989, p. 4.

57. McGilligan, *Jack's Life*, p. 360.

58. Griffin and Masters, *Hit and Run*, p. 168.

59. Ibid.

60. Ibid., p. 169.

61. Ibid.

62. No byline, "Devil of a Joker," *Sunday Times* (London), August 16, 1989; Richard Brooks, "You've Got to Be Joking, Jack," *Observer* (London), March 14, 1993, no page listed.

63. Griffin and Masters, *Hit and Run*, p. 172.

64. Ibid.

65. No byline, "Jack 'n' Meryl," *Los Angeles Herald Examiner*, December 8, 1988.

66. Mary Murphy, "Jack Nicholson: Why the Joker's Too Wild for TV," *TV Guide*, August 11, 1990, no page listed.

67. No byline, no headline, *Variety*, June 14, 1994.

68. Don Schiach, *Jack Nicholson: The Complete Film Guide*, London: B.T. Batsford, 1999, p. 126.

69. Army Archerd, "Just for Variety," *Variety*, July 19,1988; Thompson, *Jack Nicholson*, p. 214; Darrach, "The Father, the Director, and the Holy Terror," *Life*, September 1990, no page listed; David Denby, "Jack Nicholson: A Joker Turns Director for *The Two Jakes*, at Long Last!" *New York*, September 11, 1989, no page listed: "Estimates of Nicholson's earnings from *Batman*, including both movie and merchandise, land at around $60 million."

70. Liz Smith, "Liz Smith," *Los Angeles Times*, June 28, 1991, no page listed; ranch: "The New Credit Line," *Los Angeles Magazine*, November 1990, no page listed.

71. Darrach, "The Father, the Director, and the Holy Terror," *Life*, September 1990, no page listed.

72. Army Archerd, no headline listed, *Variety*, April 6, 1990, no page listed.

73. Hilary de Vries, no headline listed, *Los Angeles Times Calendar* December 6, 1992, p. 80.

74. Thompson, *Jack Nicholson*, p. 215.

75. Russell Ash, *Top 10 of Film*, London: DK Publishers, 2003.

76. No byline, "Hollywood Cinefile," *Screen International*, March 10, 1990, no page listed.

77. Brad Darrach, *Life*, September 1990.

78. Charles Champlin, "Star and Director: Jack, Be Nimble," *Los Angeles Times*, July 9, 1989, no page listed.

79. Biskind, *Easy Riders, Raging Bulls*, p. 432; David Thomson, "Jack and the Women," *Independent on Sunday* (London), March 2, 1997, p. 5; McGilligan, *Jack's Life*, pp. 371–373.

80. McGilligan, *Jack's Life*, p. 370; Joe Morgenstern in *GQ*, "Remember It, Jack," January 1990, p. 130, reported that the budget for *The Two Jakes* was $19 million.

81. Collins, "Jack Baby Love," *Vanity Fair*, April 1992, p. 226.

82. Booth Moore, "Here, at Last," *Los Angeles Times*, October 28, 2003, latimes.com, p. 2.

83. Collins, "Jack Baby Love," *Vanity Fair*, April 1992, p. 226.

84. McGilligan, *Jack's Life*, p. 373; salary: "Rambling Reporter," *Hollywood Reporter*, February 24, 1989.

85. McGilligan, *Jack's Life*, pp. 362–363.

86. Ibid., p. 363.

87. Ibid.

88. *Time Out*, August 17, 1994, p. 21.

89. No byline, no headline listed, *Los Angeles Times Magazine*, August 5, 1990, no page listed.

90. Collins, "Jack: Baby Love," *Vanity Fair*, April 1992, p. 226.

91. No byline, "People," *Los Angeles Press-Telegram*, August 9, 1990, no page listed.

92. Geena Davis interview with David Letterman, *The Late Show*, CBS-TV, July 18, 2002.

93. Larry Haley, Maggie Harbour, and Steve Tinney, "Brando Risks Life on Deadly Crash Diet," *Star*, March 11, 2003, p. 14.

94. Manso, *Brando*, pp. 952–953.

95. Ibid., pp. 1014–1015.

96. Ibid., p. 958.

97. Ibid., pp. 960–961.

98. Ibid., p. 989.

99. Ibid., pp. 996–997.

100. Ibid., p. 949.

101. Ibid., p. 983.

102. Ibid., p. 965.

103. Bosworth, *Marlon Brando*, pp. 208–211.

104. Diana Ecker and Monica Rizzo, "The Odd Couple: Jack Moves in With Marlon," *US Weekly*, March 12, 2001, p. 39.

105. Collins, "Jack: Baby Love," *Vanity Fair*, April 1992, p. 226.

106. Marius Brill, "Talk of the Devil," *Sunday Times* (London), July 21, 1996, p. 12.

107. *Variety*, June 14, 1994.

108. No byline, no headline, *Variety*, March 5, 1991, no page listed.

109. *Vanity Fair*, April 1994, no page listed.

110. Thompson, *Jack Nicholson*, p. 236.

111. No byline, "A Fine Romance '94," *People*, December 26, 1994, no page listed.

112. No byline, "New Jack City," *People*, September 7, 1992, no page listed.

113. No byline, no headline, *Observer*, March 14, 1993, no page listed.

114. Ken Kelley, "Tales From Tosca," *San Francisco Focus*, April 1991, no page listed.

115. Ken Kelley, "Our Town," *San Francisco Focus*, June 1992, no page listed.

116. Moore, "Here, at Last," *Los Angeles Times*, October 28, 2003, latimes.com, p. 2.

117. Thompson, *Jack Nicholson*, p. 227.

118. McGilligan, *Jack's Life*, p. 389.

119. Moore, "Here, at Last," *Los Angeles Times*, October 28, 2003, latimes.com, p. 3.

120. Collins, "Jack the Wolf," *Vanity Fair*, April 14, 1994, p. 140.

121. Thompson, *Jack Nicholson*, p. 228.

122. Ibid.

123. Ibid., pp. 230–231.

124. Ibid., p. 231.

125. Robin Mizrahi and Patricia Towle, "Keanu Reeves Back Together with Former Fiancee," *Enquirer*, January 13, 2004, p. 5.

126. Thompson, *Jack Nicholson*, p. 230.

127. Ibid., p. 228.

128. McGilligan, *Jack's Life*, p. 388.

129. Thompson, *Jack Nicholson*, p. 232.

130. Ibid.

131. Ibid.

132. McGilligan, *Jack's Life*, p. 388.

133. Thompson, *Jack Nicholson*, p. 233.

134. Mitchell Fink, "The Insider: Trouble in the House That Jack Bought," *People*, September 28, 1992, no page listed.

135. Thompson, *Jack Nicholson*, p. 236.

136. Sheff, "Jack Nicholson," *Playboy*, January 2004, p. 79.

137. Mark Gerzon, *Listening to Midlife*, Boston: Shambala, 1996, p. 17.

138. Collins, "Jack the Wolf," *Vanity Fair*, April 1994, p. 119.

139. No byline, no headline, *Observer*, March 14, 1993, no page listed.

140. Harrison, *Off to the Side*, p. 292.

141. Ibid., pp. 293–294.

142. No byline, "Chatter," *People*, December 16, 1991, no page listed.

143. Drew Mackenzie, "Missing! What Happened to Johnny Depp's Biz Partner?" *Globe*, August 5, 2003, p. 33: Depp's partner in the Viper Room was Anthony Fox.

144. No byline, "Justin's Hot New Restaurant," *Us*, December 8, 2003, p. 44.

145. Caroline Graham, "Dishy," *Sun* (London), June 8, 1995, p. 14.

146. Thompson, *Jack Nicholson*, p. 237.

147. Ibid., p. 239.

148. Heidi Fleiss, *Pandering*, Los Angeles: One Hour Entertainment, 2002, unpaged.

149. David Rensin, *The Mailroom*, pp. 338–339.

150. David Templeton, "Rinse, Lather, Repeat," *Hollywood Life*, September 2003, p. 116.

151. No byline, "Heidi Dismissing Madam Movie," *In Touch*, March 8, 2004, p. 72. See also Arlene Walsh, column, *Beverly Hills [213]*, April 16, 2003, p. 6; Patricia Shipp, "Madam Nicole!" *National Enquirer*, no date listed, circa summer 2003, p. 26; no byline, "Bossing Around," *Globe*, December 2, 2003, p. 15.

152. Templeton, "Rinse, Lather, Repeat," *Hollywood Life*, September 2003, p. 117.

153. Thompson, *Jack Nicholson*, p. 238.

154. Cathy Griffin interview.

Chapter Nine: The Big Muddy

1. Steven Strauss, "Jack Nicholson's Secret Daughter," *Star*, April 8, 2003, p. 20.

2. "Letters," *Vanity Fair*, June 1994, no page listed.

3. Mike Sager, "Jack Nicholson, 66," *Esquire*, January 2004, p. 70.

4. Mitchell Fink, "Trouble in the House That Jack Built," *People*, July 1, 1996, p. 47.

5. No byline, no headline, *New York Times*, June 12, 1994, no page listed.

6. Fink, "Trouble in the House That Jack Built," *People*, July 1, 1996, p. 47.

7. Robin Abcarian, "Never a Borrower or a Lender Be—Especially in Hollywood," *Los Angeles Times*, May 29, 1996, p. E-1.

8. Gliatto and Hannah, "The House That Jack Owns," *People*, July 1, 1996, p. 48.

9. Marilyn Beck and Stacy Jenel Smith, "Anspach Hopes She's Home Free After Years-long Legal Dispute," *Los Angeles Daily News*, March 1, 1997, no page listed.

10. Thompson, *Jack Nicholson*, pp. 16–17.

11. Gliatto and Hannah, *People*, July 1, 1996, p. 48.

12. Abcarian, "Never a Borrower or a Lender Be—Especially in Hollywood," *Los Angeles Times*, May 29, 1996, p. E-1. Rush and Molloy, "Daily Dish," *New York Daily News*, November 4, 2002, dailynews.com.

13. Thompson, *Jack Nicholson*, p. 21.

14. Ibid.

15. No byline, "Morning Report," *Los Angeles Times*, November 3, 1995, no page listed.

16. Abcarian, "Never a Borrower or a Lender Be—Especially in Hollywood," *Los Angeles Times*, May 29, 1996, p. E-1.

17. Chrissy Iley, *Sunday Times* (London), June 23, 1996, no page listed.

18. Walter Scott, "Walter Scott's Personality Parade," *Parade*, May 21, 2000, no page listed.

19. No byline, no headline, *People*, September 16, 1996, no page listed.

20. No byline, no headline, *Parade*, December 26, 1996, no page listed.

21. Ann W. O'Neill, "The Court Files," *Los Angeles Times*, May 14, 2000, no page listed.

22. No byline, no headline, *People*, November 25, 1996, no page listed.

23. Thompson, *Jack Nicholson*, p. 279.

24. Ibid.

25. No byline, no headline, *US Weekly*, May 29, 2000, no page listed; $32,500 settlement: No byline, "Jack Nicholson," *National Enquirer*, no date listed, p. 24.

26. No byline, "Jack's Back in Court," *Globe*, May 30, 2000, p. 37. Sheehan's alleged injuries were suffered in 1996. The $32,500 settlement was in 1998. Sheehan filed her suit in Los Angeles Superior Court on May 2, 2000.

27. Ann W. O'Neill, "The Court Files," *Los Angeles Times*, May 14, 2000, no page listed.

28. Sheff, "Jack Nicholson," *Playboy*, January 2004, p. 85.

29. Schruers, "Gentleman Jack," *US*, July 1994, p. 66.

30. No byline, "Nicholson Allegedly Golf-Clubs Car," *Los Angeles Press-Telegram*, February 24, 1994, no page listed.

31. Sheff, "Jack Nicholson," *Playboy*, January 2004, p. 87.

32. Chip Johnson, "Actor Nicholson Charged After Attack on Car," *Los Angeles Times*, March 1, 1994, no page listed; no byline, "Nicholson Allegedly Golf-clubs Car," *Press-Telegram*, February 24, 1994, p. A2; no byline, "Nicholson Charged," *Hollywood Reporter*, March 1, 1994, no page listed; no byline, "Brief: Man Sues, Says Nicholson Attacked Him," unsourced clipping in Nicholson clip file, Margaret Herrick Library, February 16, 1994, no page listed.

33. Tom Mrozek, "Arraignment Delayed for Jack Nicholson," *Los Angeles Times*, April 15, 1994, no page listed.

34. No byline, "Nicholson Charged," *Hollywood Reporter*, March 1, 1994, no page listed.

35. No byline, "Jack, Driver Cut a Deal," *Variety*, March 14, 1994, no page listed. From Reuters.

36. No byline, no headline, *People*, July 1, 1996, p. 46.

37. Schruers, "Gentleman Jack," *US*, July 1994, p. 66.

38. Attanasio, "Jack Nicholson, Genuinely," *Washington Post*, June 14, 1985, p. C-1.

39. No byline, "Morning Report: Nicholson Settles," *Los Angeles Times*, March 12, 1994, no page listed.

40. Thom Mrozek, "Prosecutors Will Fight Jack Nicholson's Legal Moves," *Los Angeles Times*, April 15, 1994, p. B-5.

41. Thom Mrozek, "Nicholson Settles Case," *Los Angeles Times*, May 3, 1994, p. B-4.

42. No byline, "Nicholson Suit Dropped," *Variety*, May 3, 1994, no page listed.

43. No byline, "Only in LA," *Los Angeles Times*, March 3, 1994.

44. Column, *Beverly Hills (213)*, November 20, 2002, p. 15.

45. Abcarian, "Never a Borrower or a Lender Be—Especially in Hollywood," *Los Angeles Times*, May 29, 1996, p. E-1.

46. Richard Johnson, Paula Froelich, and Chris Wilson, "Nicholson's A-bombs of Truth," *New York Post*, November 17, 2003, p. 10.

47. Wolf Schneider and Katie Kolpas, editors, *Jack Nicholson Tribute Book: American Film Institute Life Achievement Award*, Los Angeles: Hershel D. Sinay, Project Marketing, 1994, pp. 2, 5.

48. Thompson, *Jack Nicholson*, p. 243.

49. Ibid., p. 23.

50. Mike Barnes, "Legal Briefs," *Hollywood Reporter*, March 11, 1994, no page listed.

51. Thompson, *Jack Nicholson*, p. 244.

52. Ibid., pp. 245–246.

53. Ibid., p. 244.

54. Ibid., p. 245.

55. *W*, September 21, 1984, no page listed.

56. Schruers, no title listed, *US*, July 1994, p. 63.

57. Lucy Kaylin, "Nicholson Has Never Been to an Orgy," *GQ*, January 1996, p. 96.

58. Collins, "Happy Jack," *Vanity Fair*, April 1992, p. 229.

59. Cathy Griffin Interview.

60. No byline, "Who'd Have Guessed They're So Hot?" *Star*, September 16, 2003, p. 32.

61. Andrew Goldman, "Lara Flynn Boyle's Remote Control," *Talk*, October 2001, p. 146; in the paragraph beginning "Nicholson had

first," the quotation "He started . . . together" is from *People* unbylined article, "Warming to a Boyle," November 1, 1999, p. 151.

62. Kevin Sessums, "Call of the Wild," *Vanity Fair*, February 2001, p. 142.
63. No byline, "Her Most Hateful Quotes," *US*, July 15, 2002, p. 46.
64. No byline, "The Weight Loss Finally Explained (Sort Of)," *US*, July 15, 2002, p. 45.
65. No byline, "5 Reasons to Love Her," *US*, July 15, 2002, p. 45.
66. Daisie Garnett, "Life in the Fast Lane," *Talk*, November 2000, p. 110.
67. No byline, "The Weight Loss Finally Explained (Sort Of)," *US*, July 15, 2002, p. 45.
68. Steven Strauss, "The Truth About *Practice* Beauty and Her Father," *Star*, October 31, 2000, p. 10.
69. David Garnett, "Life in the Fast Lane," *Talk*, November 2000, p. 110.
70. No byline, "Warming to a Boyle," *People*, November 1, 1999, p. 151.
71. No byline, "Eavesdropping," *Star*, October 29, 2002, p. 3.
72. Garnett, "Life in the Fast Lane," *Talk*, November 2000, p. 110.
73. Patrice Sturtevant, "Love 'Em and Leave 'Em Lara," *Star*, August 6, 2002, p. 51.
74. No byline, "Gossiping Under the Influence," *National Enquirer*, circa 2002, no date listed, p. 26.
75. Martin Gould and Jennifer Pearson, "Dumped," *Star*, October 3, 2000, p. 16.
76. Steve Herz, "Dumped," *Globe*, October 3, 2000, p. 37.
77. John South and Richard Gooding, "Harrison Ford Romance Shocker," *National Enquirer*, November 14, 2000, pp. 8–9.
78. No byline, "Man-Eating, Lara-Style," *US*, July 15, 2002, p. 46.
79. Sessums, "Call of the Wild," *Vanity Fair*, February 2001, p. 160.
80. Mike Walker, "All the Gossip," *National Enquirer*, no date listed, p. 12.
81. Jennifer Pearson, "Jack Nicholson and *Practice* Beauty Together Again," *Star*, October 24, 2000, p. 45.
82. Sessums, "Call of the Wild," *Vanity Fair*, February 2001, p. 160.
83. Sean Mitchell, "As Funny as It Gets?" *Los Angeles Times/Weekend*, December 25, 1997, p. 10.

84. Samantha Miller, "Jack of Hearts," *People*, December 16, 2002, p. 103.

85. Richard Ashton, "Nicholson Is as Good as Video Gets," *Rave*, May 1, 1998, no page listed.

86. Pearson, "Jack Nicholson and *Practice* Beauty Together Again," *Star*, October 24, 2000, p. 46.

87. Garnett, "Life in the Fast Lane," *Talk*, November 2000, p. 110.

88. Clif H. Dunn, "Hit the Road, Jack," *Star*, May 8, 2001, p. 7.

89. Deborah Hughes, "Lost and Found," *National Enquirer*, no date listed, p. 13.

90. Sessums, "Call of the Wild," *Vanity Fair*, February 2001, p. 142.

91. Strauss, "The Truth About *Practice* Beauty and Her Father, *Star*, October 31, 2000, p. 10.

92. Sturtevant, "Love 'Em and Leave 'Em Lara," *Star*, August 6, 2002, p. 51.

93. Thompson, *Jack Nicholson*, p. 240.

94. Cynthia Zwahlen, "Helping Cardholders Read the Fine Print," *Los Angeles Times*, March 17, 1999, pp. 1, C-6.

95. Ciment, *Kubrick*, p. 308.

Chapter Ten: Anger Mismanagement

1. No byline, "Nicholson Speaks Out on Clinton," *Outlook*, January 30, 1998, p. C2.

2. Lee Siegel, "The New King of Irony," *Talk*, April 2000, p. 156.

3. "Bull's fan": Sessums, "Call of the Wild," *Vanity Fair*, February 2001, pp. 142, 159–161.

4. Pete Trujillo, "Nicholson Moves in With Brando," *Globe*, March 13, 2001, p. 37.

5. Sarah Saffian, Diana Ecker, and Monica Rizzo, "The Odd Couple: Jack Moves in With Marlon," *US Weekly*, March 12, 2001, p. 39.

6. Grace Bradberry and Charles Bremner, "Just Wild About Bad Boys," *The Times* (London), March 2, 2001, p. 1.

7. Manso, *Brando*, p. 604.

8. No byline, "Lara Dumps Jack," *Globe*, May 8, 2001, p. 69.

9. Clif H. Dunn, "Hit the Road, Jack," *Star*, May 8, 2001, p. 7.

10. No byline, "Lara Dumps Jack," *Globe*, May 8, 2001, p. 69.

11. Dunn, "Hit the Road, Jack," *Star*, May 8, 2001, p. 7.

12. No byline, "Interior Motive," *Star*, May 29, 2001, p. 14.

13. Walker, "All the Gossip," *National Enquirer*, circa 2002 (no date listed), p. 12; no byline, "Love on an Escalator," *Star*, May 7, 2002, p. 15.

14. Kelly Carter, "Glitterati's Latest Status Symbol: Lakers' Final," *USA Today*, June 8, 2001, p. 4E.

15. Jack's Room: Julie L. Belcove, "Access Hollywood," *W*, February 2004, p. 64. Chairman's Room, $1,900 seats, VIP guests: Kimberly Cutter, "The Seater," *W*, February 2004, p. 131. Cannon's muffins: No byline, "Of All the Hollywood," *People*, June 25, 2001, no page listed.

16. No byline, "Short Takes," *Globe*, February 11, 2003, p. 14.

17. No byline, "Boyle-ing Hot," *National Enquirer*, circa 2001, no date listed, p. 13.

18. No byline, "Star Tracks," *People*, July 23, 2001, p. 14.

19. No byline, "Jack in the (Old) U.S.S.R.," *People*, July 16, 2001, p. 18.

20. Nick Holdsworth, "Moscow Applauds Nicholson," July 3–9, 2001, www.hollywoodreporter.com.

21. No byline, "Nicholson Is Treated Like a Ground Zero Hero," *US Weekly*, December 3, 2001, no page listed.

22. No byline, *People*, November 19, 2001, no page listed.

23. No byline, "Scoop: Pop Quiz With Jack Nicholson," *People*, December 17, 2001, no page listed.

24. Neil Genzlinger, "Taking Their Medicine for Achievement," *New York Times*, December 26, 2001, p. E3.

25. Moore, "Here, at Last," *Los Angeles Times*, October 28, 2003, latimes.com, p. 3.

26. Hadleigh, *Celebrity Lies!*, p. 252.

27. Thomson, "Jack and the Women," *Independent on Sunday* (London), March 2, 1997, p. 5.

28. Collins, "Jack the Wolf," *Vanity Fair*, April 1994, p. 170.

29. Schruers, "Jack Nicholson," *Rolling Stone*, March 19, 1998, no page listed.

30. Hughes, "He Can't Handle the Truth," *National Enquirer*, no date listed, p. 13.

31. No byline, "Laud of the Rinks," *People*, February 9, 1998, no page listed.

32. Jeffrey Slonim, "Unforgettable," *New York Post*, July 7, 2002, p. 36.

33. No byline, "5 Reasons to Hate Her," *US*, July 15, 2002, p. 44.

34. Charlton, "Star People: On Again," *Star*, April 16, 2002, p. 16.

35. Charlton, "Jack Flips for Boyle's Pancakes," *Star*, May 13, 2003, p. 12.

36. Walker, "More Gossip," *Enquirer*, no date listed, circa summer 2003, p. 14.

37. No byline, "Jack Nicholson's Ex Goes Wacko at 30,000 Feet," *Star*, July 9, 2002, p. 50.

38. Olivia Abel, "Passages: Arrested," *People*, July 8, 2002, p. 71.

39. No byline, "Jack Nicholson's Ex Goes Wacko at 30,000 Feet," *Star*, July 9, 2002, p. 50.

40. Abel, "Passages: Arrested," *People*, July 8, 2002, p. 71.

41. Ibid.

42. Walker, "All the Gossip," *National Enquirer*, circa 2002, no date listed, p. 12.

43. Matthew Perry: No byline, "Lara Flynn Boyle Hits the Jackpot With Younger Man," *National Enquirer*, circa summer 2002, no date listed, p. 26; Michael Lewittes, "Lara's New Love?" *US*, August 5, 2002, p. 1.

44. No byline, "Lara Flynn Boyle Shunned by Ex," *Star*, July 30, 2002, p. 16.

45. Sturtevant, "Love 'Em and Leave 'Em Lara," *Star*, August, 2002, p. 51.

46. Deborah Rogers, "Gossip Party," *National Enquirer*, undated clip, p. 14.

47. Robin Mizrahi, "Brando, Slapped With $100 Million Palimony Suit," *Globe*, May 7, 2002, p. 37.

48. Untitled column, *Beverly Hills (213)*, February 5, 2003, p. 19.

49. Ibid.

50. Michael Lewittes, "Jack and Lara Are Back—Off," *US*, February 3, 2003, p. 8.

51. Untitled column, *Beverly Hills (213)*, February 5, 2003, p. 19.

52. No byline, "Gossip Party: Hit the Road, Jack," *National Enquirer*, p. 14, no date listed.

53. José Lambiet, *Practice* Makes Perfect Feud," *Star*, March 18, 2003, p. 28.

54. Mizrahi, "Lara Flynn Boyle Down to 96 Lbs.," *Globe*, May 20, 2003, p. 6.

55. Jim Nelson, Robert Blackmon, Maggie Harbour, and Ellen Goodstein, "*The Practice* Bloodbath," *Enquirer*, June 10, 2003, p. 2.

56. Carole Glines, "Out of Practice! Six Stars Dumped," *Star*, June 10, 2003, p. 62.

57. No byline, "Hey Lara, Who's the New Guy?" *Star*, July 8, 2003, p. 29.

58. No byline, "Morning Report," *Los Angeles Times*, November 7, 1997, no page listed.

59. Shauna Snow, "Morning Report," *Los Angeles Times*, March 4, 1998, no page listed; Tod Volpe, *Framed*, Toronto: ECW Press, 2003, pp. 15, 69, 98, 195–196, 225, 242–243, 246–247, 250.

60. No byline, "Hollywood," *National Enquirer*, undated clip, p. 30.

61. Cathy Griffin interview.

62. William R. Newcott, "Movies for the Rest of Us," *AARP*, May–June 2003, p. 44.

63. Julian Schnabel, *Interview*, April 2003, p. 152.

64. Claudia Puig, "Playing Against Type: There's No Trace of Hollywood's Wild Man in *About Schmidt*," *USA Today*, March 11, 2003, America Online: Clgrif.

65. Ibid.

66. A. Scott Berg, *Kate Remembered*," New York: Putnam's, 2003, p. 320.

67. Mary Colbert, "Roll the Film—and the High-Powered Fashions," *Los Angeles Times*, May 26, 2002, p. E3.

68. No byline, "Passages," *People*, August 25, 2003, p. 105.

69. Lewittes, "Jack and Lara Are Back—Off," *US*, February 3, 2003, p. 8.

70. No byline, "Venice, Calif., July 20," *People*, August 4, 2003, p. 9.

71. Tom Cunneff, "Insider," *People*, August 11, 2003, p. 45.

72. Richard Johnson, Paula Froelich, and Chris Wilson, "Nicholson's A-bombs of Truth," *New York Post*, November 17, 2003, p. 10.

73. Walter Scott, "Personality Parade," *Parade*, September 1, 2002, page 2.

74. Untitled column, *Beverly Hills (213)*, January 29, 2003, p. 12.

75. Cader, Michael, editor, *2001 People Entertainment Almanac*, New York: Cader, 2000, p. 388.

76. Arlene Walsh, column, *Beverly Hills [213]*, February 19, 2003, p. 8.

77. Lewittes, "Hot Stuff: Jack and Lara Are Back—Off," *US*, February 3, 2003, p. 8.

78. Walsh, untitled columns, *Beverly Hills [213]*, February 12, 2003, p. 6, and February 5, 2003, p. 17.

79. Charlton, "Star People: Mouthing Off," *Star*, January 21, 2003, p. 7.

80. Photo caption, *Globe*, November 12, 2002, p. 47.

81. No byline, no headline, *VLife*, March 2003, p. 64.

82. Caroline Glines, "About Jack," *Star*, March 11, 2003, p. 59.

83. Jack Martin, untitled column, *Beverly Hills (213)*, February 5, 2003, p. 8.

84. Kenneth Turan, "It's Likely Their Kind of Year," *Los Angeles Times*, March 23, 2003, p. E10.

85. Allison Adato, Greg Adkins, and others, "The Oscar Show Inside Out," *People*, April 7, 2003, p. 94.

86. Lucy Kaylin, "Adrien Brody," *GQ*, November 2003, p. 314.

87. No byline, "Know About the *US* Buzz-Couple," no date listed, circa April 2003, no page listed.

88. Sheff, "Jack Nicholson," *Playboy*, January 2004, p. 88.

89. Daniel Fierman, "The Big Night," *Entertainment Weekly*, April 4, 2003, p. 34.

90. Walker, "All the Gossip," *National Enquirer*, circa April 2003, no date listed, p. 13.

91. A.A.M., "About Stephenson," *Angeleno*, April 2003, p.,77.

92. Laura Kang, "Annie, Get Your Guys," *Vanity Fair*, April 2003, p. 128.

93. Hadleigh, *Celebrity Lies!*, p. 205.

94. Charlton, "Star People," *Star*, July 15, 2003, p. 10.

95. Gabriel Bill, "Adam Sandler," *FYI*, April 9, 2003, p. 3. Sandler was born September 9, 1966.

96. Samantha Miller, "Jack of Hearts," *People*, December 16, 2002, p. 98.

97. Michael Fleming, "*Anger* Gets Best of Jack," *Variety*, December 21, 2001, pp. 1, 36.

98. Adam Sandler interview with David Letterman, *The Late Show*, CBS-TV, June 25, 2002.

99. No byline, "Spring Movie Preview," *Entertainment Weekly*, February 14, 2003, p. 31.

100. Lycia Naff, "Jack's Attack Leaves Keanu Taken Aback," *Globe*, March 11, 2003, p. 12.

101. Charlton, "Hot Waterboy," *Star*, May 28, 2002, p. 14.

102. Jim Nelson and Ellen Goodstein, "Adam Sandler to Wed," *National Enquirer*, no date listed, circa May 2003, pp. 34–35.

103. Ibid.

104. *Entertainment Weekly* cover illustration, February 14, 2003.

105. No byline, "Star Tracks," *People*, July 29, 2002, p. 10.

106. Charlton, "Star People: Sour Note," *Star*, May 27, 2003, p. 12.

107. Shelby Loosch, "Nutty Gift," *Globe*, July 15, 2003, p. 13.

108. Jim Nelson and Ellen Goodstein, "Adam Sandler to Wed," *National Enquirer*, no date listed, circa May 2003, pp. 34–35.

109. No byline, "Leading Role," *Sunday Times* (London), July 12, 1998, no page listed.

110. No byline, "Sued" *People*, October 11, 1999, no page listed.

111. Flo Anthony, "It's All Rosie All the Time at Her New Magazine," *Examiner*, March 13, 2001, p. 44.

112. Thompson, *Jack Nicholson*, p. 201.

113. Schruers, *Rolling Stone*, August 14, 1986, p. 62.

114. David Wharton, "Down in Front!" *Los Angeles Times*, October 10, 1999, no page listed.

115. Chris Erskine, "Schmoozers and Shakers Cheer on the Lakers," *Los Angeles Times*, May 8, 2002, p. E3.

116. No byline, "Nicholson Anger Management Skills Slip at NBA Game," May 12, 2003, *Hello Magazine* internet printout. "If he keeps": Kimberly Cutter, "The Seater," *W*, February 2004, p. 131.

117. No byline, "Loose Lips," *Star*, May 22, 2001, p. 12.

118. Charlton, "Star People: Hammy Hamlets," *Star*, March 18, 2003, p. 12.

119. Patricia Shipp, Reginald Fitz, Alan Smith, Tony Brenna, "New Health Crisis for Marlon Brando," *Enquirer*, November 18, 2003, p. 5.

120. Patricia Shipp and Tony Brenna, "Marlon Brando Suffering Heart Failure," *National Enquirer*, no date listed, circa spring 2003, p. 6.

121. Maxine Stern and Ian Drew, "Is Brando Broke? Or Is It a Big Fat Lie?" *Globe*, April 29, 2003, p. 8.

122. Sheff, "Jack Nicholson," *Playboy*, January 2004, p. 284.

123. Sager, "Jack Nicholson, 66," *Esquire*, January 2004, p. 68.

124. Nancy Griffin, "Diane Keaton Meets Both Her Matches," *New York Times*, December 14, 2003, p. AR15.

125. Nancy Meyers and Amy Barrett, "Sex and the Single Older Woman," *New York Times Magazine*, November 9, 2003, p. 132.

126. Pat Gregor, "Jack Nicholson Romancing Diane Keaton," *Globe*, October 14, 2003, p. 57.

127. Lycia Naff, "Jack's Attack Leaves Keanu Taken Aback," *Globe*, March 11, 2003, p. 12.

128. Walker, "All the Gossip," *National Enquirer*, circa May 2003, no date listed, pp. 12–13.

129. Shelby Loosch, "Lickety-split," *Globe*, July 8, 2003, p. 12.

130. Walker, "More Gossip," circa spring 2003, p. 14.

131. Loosch, "Jack & Amanda Have It Made in the Shade," *Globe*, August 5, 2003, p. 12.

132. Sheff, "Jack Nicholson," *Playboy*, January 2004, p. 80.

133. No byline, "Scene & Heard," *Star*, August 5, 2003, p. 29.

134. Walker, column, *National Enquirer*, September 23, 2003, p. 14.

135. No byline, "StarTracks," *People*, August 11, 2003, p. 11.

136. Gregor, "Jack Nicholson Romancing Diane Keaton," *Globe*, October 14, 2003, p. 57; Arlene Walsh, column, *Beverly Hills (213)*, October 22, 2003, p. 12.

137. Gregor, "Jack Nicholson Romancing Diane Keaton," *Globe*, October 14, 2003.

138. Sheff, "Jack Nicholson," *Playboy*, January 2004, p. 80.

139. Gregor, "Jack Nicholson Romancing Diane Keaton," *Globe*, October 14, 2003.

140. "He's the original": Diane Keaton on *Today*, NBC-TV, December 3,

2003. "Hey, I'm up for it": Diane Keaton to Barbara Walters, 2004 Oscar telecast, ABC-TV.

141. No byline, "Heir-Raising Lara Flynn on Again off Again With Jay Penske," *Star*, November 18, 2003, p. 72.

142. No byline, "It's a Good Week for . . .", *Star*, September 23, 2003, p. 64.

143. Loosch, "Tattoo Much," *Globe*, December 16, 2003, p. 12.

144. *Entertainment Tonight*, December 9, 2003.

145. "I asked": Diane Keaton, *The Tonight Show*, February 13, 2004. "A dandy English lord": No byline, "Diane Keaton in Ralph Lauren," *People*, March 15, 2004, p. 58. Dani Janssen: No byline, "Where Was," *People*, March 15, 2004, p. 99.

146. Sager, "Jack Nicholson, 66," *Esquire*, January 2004, p. 71.

147. Griffin, "Diane Keaton," *New York Times*, December 14, 2003, pp. AR15, AR27.

148. Sheff, "Jack Nicholson," *Playboy*, January 2004, p. 284.

149. Ibid., p. 88.

150. Moore, "Here, at Last," *Los Angeles Times*, October 28, 2003, latimes.com, pp. 1, 4.

151. Ibid., p. 3; "Jack Nicholson's Daughter Has Designs on Larger Gals," *Globe*, November 25, 2003, p. 47.

152. Cunneff, "Insider: Skirting Hoops," *People*, November 17, 2003, p. 49.

153. Moore, "Here, at Last," *Los Angeles Times*, October 28, 2003, latimes.com, pp. 1–4.

154. "This is not the time": Mike Sager, "Jack Nicholson, 66," *Esquire*, January 2004, p. 68. "You are, indeed, a conservative" and "an asshole": Letters to the editor by Pete Gordon Michael Brecklin, respectively, "The Sound and the Fury," *Esquire*, March 2004, p. 38.

155. Johnson, Froelich, and Wilson, "Nicholson's A-bombs of Truth," *New York Post*, November 17, 2003, p. 10.

156. Sheff, "Jack Nicholson," *Playboy*, January 2004, p. 84.

Epilogue

1. Collins, "Jack the Wolf," *Vanity Fair*, April 1994, p. 168.
2. "Warren and Jack," *Marie Claire*, February 1997.
3. Jay Carr, "Nicholson at Peace—Not Such a Big, Bad Wolf," *Long Beach Press-Telegram*, June 18, 1994, no page listed.
4. Collins, "Happy Jack," *Vanity Fair*, April 1992, p. 224.
5. Sager, "Jack Nicholson, 66," *Esquire*, January 2004, p. 71.
6. Albert Watson, "Jack Nicholson," *Rolling Stone*, December 16–23, 1999, p. 146.
7. Sheff, "Jack Nicholson," *Playboy*, January 2004, p. 84.
8. Sager, "Jack Nicholson, 66," *Esquire*, January 2004, p. 70.
9. Sheff, "Jack Nicholson," *Playboy*, January 2004, p. 84.
10. Ibid.
11. Sheff, "Jack Nicholson," *Playboy*, January 2004, p. 84.

INDEX